HOW TO
cheat
IN
Photoshop CS6

The art of creating
realistic photomontages

Steve Caplin

Focal Press
Taylor & Francis Group
NEW YORK AND LONDON

Seventh edition first published 2012 by Focal Press
70 Blanchard Road, Suite 402, Burlington, MA 01803

Simultaneously published in the UK by Focal Press
2 Park Square, Milton Park, Abingdon, Oxon OX14 4RN

Focal Press is an imprint of the Taylor & Francis Group, an informa business

First published as How to Cheat in Photoshop 2002 by Elsevier Ltd
Reprinted 2002, 2003
Second edition 2004
Third edition 2005
Reprinted 2006
Fourth edition 2007
Fifth edition 2009
Sixth edition 2010

First published as How to Cheat in Photoshop CS6 2012 by Focal Press, an imprint of the Taylor & Francis Group

Library of Congress Cataloging in Publication Data
A catalog record has been applied for

ISBN: 978-0-240-52592-1

For information on all Focal Press publications visit our website at www.focalpress.com

Book design and cover by Steve Caplin

Printed and bound in the United States

12 13 14 15 10 9 8 7 6 5 4 3 2 1

Contents How to Cheat in Photoshop CS6

Contents

How to cheat, and why

The truth about cheating

I've used the word 'cheating' in the title of this book in two ways. The most obvious is that I'm describing how to make images look as much as possible like photographs, when they're not. In this sense, it simply means creating photographic work without the need for a studio.

The other sense of 'cheating' is finding shortcuts to help you work more quickly and more economically. Too often you'll see Photoshop techniques explained using long-winded, complex operations that take an age to complete. Wherever possible, I've used quicker solutions to achieve the same results. For the artist on a deadline, the difference between a perfect work of art and one that's turned in on time means the difference between a happy client and one faced with a blank page in the next day's newspaper.

Workthroughs and examples

Each workthrough in this book is designed as a double page spread. That way, you can prop the book up behind your keyboard while going through the associated file on the DVD. Some of the workthroughs take the form of case studies, where I dissect an illustration I've done as a commissioned job; many of the sections open with one of my illustrations as a real-world example of the technique I'm talking about. One reason I've used my own artwork is that I know how it was created, and have the original files to take apart.

Messing about in Photoshop can be the most fun you can have without breaking the law, and it's tempting to experiment with filters and special effects. But it's not until you produce an illustration to a specific brief that you realize the issues and problems involved – and then find a way around them. Almost all the techniques I describe in this book have been learned out of necessity; there's nothing like a tight deadline to concentrate the mind. Adrenaline is sometimes the best drug there is.

At the end of each chapter you'll find an Interlude, in which I discuss an issue of relevance to the Photoshop artist. Think of them as light relief.

What's on the DVD?

I've included most of the workthroughs in this book on the DVD, so that after reading about them you can open up the original Photoshop files and experiment with them for yourself. In some cases I've reduced the image sizes to make them

more manageable, so you'll find yourself working with screen resolution images. And because it's always better to show rather than to tell, I've included over four hours of movies showing specific techniques in action.

In a few cases, I haven't been able to provide the examples on the DVD. These tend to be workthroughs that are case studies, in which I've used images of politicians and other celebrities for which it was impossible to get clearance to include them for electronic distribution. All the other images have been either photographed by me or generously provided by the various image libraries concerned, to whom I owe a debt of gratitude.

Spelling and metaphors

I've tried to use American spelling wherever possible. First, because we're more used to reading US spelling in England than Americans are to reading English spelling; and second, because Photoshop is an American product. Initially I tried not to use any words that were spelled differently in the two languages, but I found it impossible to get through the book without mentioning the words 'color' and 'gray'. My apologies if I've employed any phrases or vernacular that don't work on both sides of the Atlantic. It's a wide ocean, and some expressions don't survive the journey.

Going further

Visit the book's website at www.howtocheatinphotoshop.com and you'll find the user forum. This is where you can post questions or problems, and exchange ideas with other readers: you can also take part in the weekly Friday Challenge, to pit your wits against a wide variety of Photoshop users.

Steve Caplin
London, 2012

Acknowledgments

I'm immeasurably grateful to the following:

Marie Hooper of Focal Press, for getting me to write this book in the first place

Keith Martin, for helping me create the keyboard shortcuts font

David Asch, for keeping the Reader Forum going despite my refusal to follow his advice

All the Reader Forum members, who have provided so much useful advice and inspiration

Adobe Systems Inc., for making Photoshop.

I'm indebted to the art editors of the newspapers and magazines who commissioned the artwork I've used as examples in this book: Jonathan Anstee, Dave Ashmore, Dan Barber, Kevin Bayliss, Andy Bodle, Julian Bovis, Roger Browning, Jo Cochrane, Martin Colyer, Zelda Davey, Miles Dickson, Robin Hedges, Paul Howe, Lisa Irving, Alice Ithier, Ben Jackson, Jasmina Jambresic, Hugh Kyle, Alix Lawrence, Giovanni di Mauro, Fraser McDermott, Garry Mears, John Morris, Doug Morrison, Lawrence Morton, Martin Parfitt, Mark Porter, Tom Reynolds, Caz Roberts, Caroline Sibley, Terri Stone, Matt Straker and Richard Turley.

A couple of the tutorials in this edition have previously been published, in a slightly different form, in the magazines *MacUser* and *Total Digital Photography*. My thanks to their editors for allowing me to repurpose my work here.

Many of the images in this book are from royalty-free photo libraries. My thanks to them for allowing me to include low resolution versions of their images on the DVD.

How to use this book

I doubt if any readers of this book are going to start at the beginning and work their way diligently through to the end. In fact, you're probably only reading this section because your computer's just crashed and you can't follow any more of the workthroughs until it's booted up again. This is the kind of book you should be able to just dip into and extract the information you need.

But I'd like to make a couple of recommendations. The first four chapters deal with the basics of photomontage. There are many Photoshop users who have never learnt how to use the Pen tool, or picked up the essential keyboard shortcuts; I frequently meet experienced users who have never quite figured out how to use layer masks. Because I talk about these techniques throughout the book, I need to bring everyone up to speed before we get onto the harder stuff. So my apologies if I start off by explaining things you already know: it'll get more interesting later on.

The techniques in each chapter build up as you progress through the workthroughs. Frequently, I'll use a technique that's been discussed in more detail earlier in the same chapter, so it may be worth going through the pages in each chapter in order, even if you don't read every chapter in the book.

A DVD icon on a page indicates that the Photoshop file for that tutorial is on the DVD, so you can open it up and try it out for yourself. The Movie icon indicates that there's an associated QuickTime movie on the DVD.

If you get stuck anywhere in the book, or in Photoshop generally, visit the Reader Forum, accessed through the main website:

www.howtocheatinphotoshop.com

This is where you can post queries and suggestions. I visit the forum every day, and will always respond directly to questions from readers. But expect other forum members to weigh in with their opinions as well! It's also a great place to meet other Photoshop users, and to take part in the weekly Friday Challenge – of which you'll see a few examples in this edition.

What's new in Photoshop CS6

ADOBE LOVES TINKERING WITH THE PHOTOSHOP INTERFACE. Every few versions they'll have a rethink and present us with a new look and feel, and usually it's an improvement over what went before. Photoshop CS6 presents just such an overhaul, and we'll go through the most significant changes here.

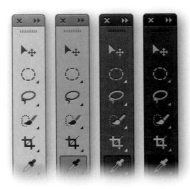

A choice of interface colors

Photoshop now offers users a choice of four shades of gray for the interface – and this includes all windows, dialogs and panels. The two light shades have dark icons and text, whereas the two darker shades correspondingly have light icons and text.

The tones are chosen from Photoshop's Preferences dialog (⌘ K ctrl K), using the four swatches at the top of the Interface pane that correspond with the chosen colors.

Which model you end up using is a matter of personal preference. I've kept the the original bright interface for this book, partly for the sake of familiarity and partly because it's the look that shows up most clearly in print.

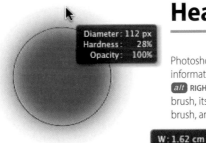

Head-up display of information

Photoshop is now able to tell you much more about what it's doing, thanks to context-specific information that appears when you perform certain actions. When you use the keyboard shortcut ctrl ⌥ alt RIGHT CLICK to resize a brush, for instance, and you'll now get a readout showing the diameter of the brush, its hardness and its opacity. As in CS5, you can drag up and down to change the hardness of the brush, and left and right to change its size.

The head-up display appears when using Free Transform, showing the angle of rotation, scale, and so on. It also shows the distance by which an object as moved when using the Move Tool; and, as seen above, displays the size of a marquee while it's being drawn. There's also now a visual distinction between the 'marching ants' seen while a selection is being drawn and after it has become a selection. Existing selections appear with much shorter marching ant lines, making it easy to see the distinction.

Zippier graphics

Many of the core functions of Photoshop now use the Adobe Mercury graphics engine, which was first developed for Adobe Premiere. This enables Photoshop to use your computer's Graphics Processor Unit (GPU) to speed up graphic-intensive tasks.

What this means in practice is that you'll see a huge increase in speed and smoothness in many areas. The Liquify filter, to take just one example, is now perfectly smooth in operation at any brush size: and the maximum brush size has been boosted to a massive 15,000 pixel radius.

Save as you go

Photoshop now automatically saves your work to disk every few minutes. But you'll still have the ability to revert to an earlier saved version of the file you're working on. Rather than overwriting it, Photoshop creates temporary save data so that, in the event of a crash, you can pick right up from where you left off.

I've had to use this feature several times while writing this book using a series of somewhat unstable beta versions of CS6, and it has saved me a lot of frustration.

True vectors

Shapes layers are now true vector artwork, rather than regular color layers with vector masks. This means that strokes can have such characteristics as dashed and dotted rules.

This brings the technology much more closely into line with full-time vector applications such as Adobe Illustrator.

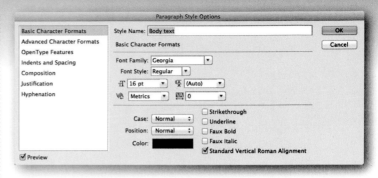

Text styles

It's been a long time coming, but Photoshop has finally caught up with InDesign in offering user-definable styles for text.

For those unfamiliar with the system, here's how it works. Set up a piece of text as you want it, and click the New icon at the bottom of the Paragraph Styles panel. You can then define the font, leading, size, color, indent, spacing and so on, either based on the current text or modified using the panel controls.

When you want to apply the same style to a different piece of text, simply click on the style in the panel to apply it directly. But it gets better: Photoshop will remember which styles you've applied. If you change the definition of a style – choosing a different font, for instance – then all the text in the document that uses that style will be changed accordingly.

Character Styles are used for text which varies from the enclosing Paragraph Style, such as individual words in bold, or in a different color, and so on.

Crop rotation

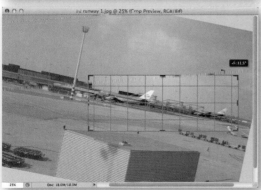

The Crop Tool has undergone a significant change with this version of Photoshop. Previously, dragging the tool would be just like dragging the Marquee Tool. Now, the behavior is somewhat different, and takes a little getting used to.

When you first drag out an area with the tool it behaves as it always has done. The difference becomes apparent when you modify the crop selection. Drag a corner handle and the crop area will resize from the center – that is, the center of the crop location will remain where it is, and the region will balance around it. In effect, the selection area isn't moving – but the image behind it is, as if it's being viewed through an open window. Click and drag on the image to pan it inside this window.

This new behavior makes more sense when you drag outside a crop area to rotate the crop. Now, the crop area remains static, and it's the image itself that rotates. In practice, this is far more natural: after all, you want to see how the image will look when rotated and cropped, so it makes sense for the crop region to remain straight.

The Straighten control now appears in the Options Bar for the Crop Tool, and you can choose between Rule of Thirds or a variety of different proportion indicators to create a well-balanced crop.

If you really can't get on with the new system, you can control its behavior, or revert it to the old method altogether, using the controls under the Gear icon on the tool's Options Bar.

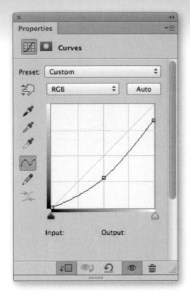

The Properties panel

A new Properties panel combines the function of the old Adjustment Layer and Masks panels. If you create an Adjustment Layer, as I've done (left), it will behave just like the old Adjustment Layer panel. But click the Mask icon at the top of the panel and it will switch to display information to the Adjustment Layer's mask (all Adjustment Layers are born with a premade mask in place), as seen on the right.

If you have the Extended edition of Photoshop CS6, you'll find that some of the information regarding 3D objects has now moved into the Properties panel.

One of the useful features of this panel is that it's expandable. So if you've always found the Curves Adjustment Layer dialog just too small to work with, you can stretch it to the size of its regular counterpart.

This isn't a huge change, but it does make everything just a little bit neater.

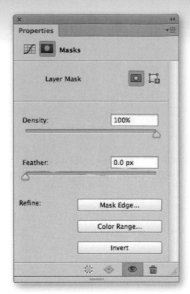

New tool icons

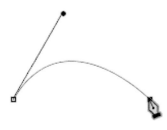

Many of Photoshop's tool icons have been subtly reworked for this release, making them clearer and cleaner in operation. The Pen Tool icon, for example, has been enlarged to make it easier to identify, but has also been rotated so that it's less likely to get in the way of your view of the artwork.

Faster layer location

If you're like me, you'll have documents full of layers, some of which have names, and some which are simply called 'Layer 41' or the like. It makes navigation a major headache, as you'll know.

Now there are filters at the top of the Layers Panel. We can choose to view all layers of a certain kind – text, Adjustment, Smart Objects, and so on. Or we could click on the 'Kind' pop-up menu at the top left of the panel and change it to 'Mode', which will allow us to find, say, all the Hard Light layers in our document. We could search for layers by name or color, or by almost any attribute.

It's now possible to change the characteristics of multiple selected layers, such as mode, opacity, and whether it's locked. So if you select all the Hard Light layers, for instance, it's easy to change all their labels to red so you can spot them easily amongst the pile.

Group operations

You can now perform many more operations on Layer Groups than previously. It's possible to use a whole Group as a Clipping Mask, so – as in the example below – you can paint on a layer so that it only shows up where it overlaps the layers in the Group: here, the title piece is made up of several independent text layers.

It's also now possible to add Layer Effects to an entire group at once: in the bottom example, I've added a Bevel and Satin effect to all the text layers in the group, by applying it to the group itself. And, at last, you can duplicate a group using the same shortcuts you'd use to duplicate a single layer.

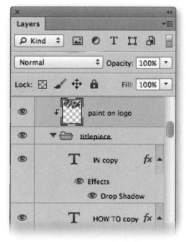

Raw power

Camera Raw has had a behind-the-scenes overhaul. Among the improvements are the Clarity control, which can now be pushed right up to 100 without any of the halo effect previously visible. The Chromatic Aberration controls have been replaced with a single checkbox, which performs the task perfectly.

Mini Bridge

Mini Bridge, the panel that allows you to access your images without switching out of Photoshop, has had some tweaks to make it more efficient. You still need to have the full version of Adobe Bridge running in the background in order to be able to run Mini Bridge, but it's now slicker in operation. It has a Filmstrip mode, so it makes sense to dock it at the bottom of your screen; hitting Spacebar gives a full-screen preview.

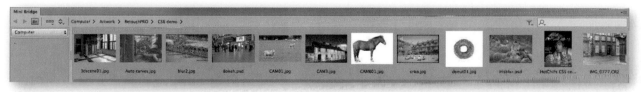

The best of the rest

There are several other new features in this release, some of which will be covered elsewhere in this book. For more on the innovative Content-Aware Move Tool see page 68; for full details on the revised 3D interface see page 352. We'll also take a look at the excellent Adaptive Wide Angle filter on page 74, the new Blur filters on page 374, and Lighting Effects on page 286. The other new filter in Photoshop CS6 is Oil Paint, whose sole purpose is to make images look like they're, er, painted. It doesn't do it very well, so we won't waste any space on it here, but do take a look for yourself. The filter menu has been reworked in CS6, with filters such as those previously found in the Artistic, Sketch and Texture categories now moved into a separate Filter Gallery submenu. Other minor enhancements will be detailed in this book as they crop up.

1

Natural selection

The ability to make good selections is an essential part of every Photoshop artist's job. These can be as simple as rectangular sections of a photograph, or as complex as a person with frizzy hair. But however you work, you'll need to understand how all Photoshop's many selection tools function, so you know which ones to use in each situation.

This book assumes you have a reasonable working knowledge of Photoshop. This introductory chapter is here to get everyone up to speed, to make sure we're all operating at the same level.

Even if you already know most of the stuff in this chapter, it's worth skimming through to make sure you understand all of it. There's an awful lot that's hidden away in Photoshop, and it often takes a book like this to show you where everything is.

Selection: the fundamentals

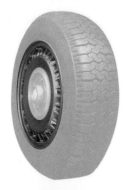

ALL PHOTOSHOP work begins with making selections. Shown here are some of the basic keyboard shortcuts that every Photoshop user should be able to use as second nature: even if you hate learning keyboard commands, you owe it to your productivity and your sanity to learn these.

Temporarily accessing the Move tool, using the shortcut shown in step 8, works when any other tool is active – not just the selection tools. This makes it easy to move any layer around while painting, selecting or using type, without having to reach for the toolbar.

1 Normal drawing with the Marquee tool is from corner to corner. But if you're using the Elliptical Marquee, it's hard to conceive where the 'corner' might be. Hold down ⌥ *alt* *after* you begin drawing to draw from the center outwards. The selected region is shown above, in each case.

2 If you hold ⌥ *alt* *before* you draw a second selection, you will remove this selection from the original one. Be sure to press this key before you begin drawing, or you'll simply draw from the center. Here, we've deselected the center of the hubcap, leaving just the rim.

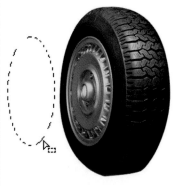

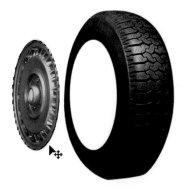

6 If you drag a selected area with a selection tool active (Marquee, Lasso etc), you'll move the selected region but not its contents.

7 To access the Move tool temporarily, hold ⌘ *ctrl* before you drag. Now, the selection itself will be moved when you drag it.

8

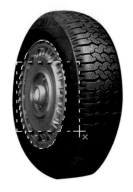

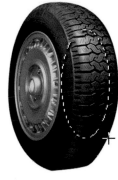

3 Holding [alt] [alt] subtracts from the selection, but holding *Shift* adds to it. Again, be sure to hold the key before you begin drawing. By holding this key down, we're able to add back the middle knob on the hubcap from the section we'd previously deselected.

4 Here's what happens if we combine the two keys. Holding [alt] *Shift* [alt] *Shift* intersects the new selection with the previous one, resulting in just the overlap between the two. Here, the original elliptical selection is intersected with the new rectangular selection.

5 A little-known modifier is the Space bar, which performs a unique task: it allows you to move a selection while you're drawing it, which is of enormous benefit when selecting areas such as the ellipse of the hubcap. Here, we've used the technique to move the selection over to the side.

HOT TIP

Selections can be nudged with the arrow keys, as well as being dragged into position – useful for aligning them precisely. One tap of the arrow keys will move a selection by a single pixel. If you hold the *Shift* key as you tap the arrow, the selection will move by 10 pixels at a time. If you also hold [⌘] [ctrl] you'll move the contents, rather than just the selection boundary.

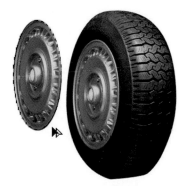

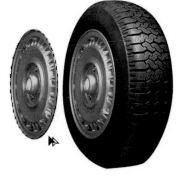

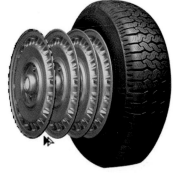

8 Holding down [alt] [alt] as well will move a copy, leaving the original selection where it was – but be sure to hold the modifier before dragging.

9 To constrain the movement to exactly vertical or horizontal, hold the *Shift* key after you've started to drag the selection.

10 You can continue to make several copies by releasing and holding the mouse button while holding the [alt] [alt] key down.

SHORTCUTS
MAC **WIN** **BOTH**

The Lasso and the Magic Wand

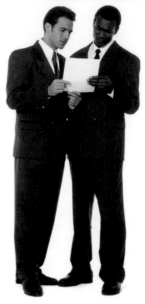

THE LASSO MAY WELL have been the first selection tool to be seen in a digital paint program, having put in its initial appearance over 25 years ago, but these days it's far from being the ideal tool. Clumsy and inaccurate to draw with, it's best reserved for tidying up selections made in other ways, as we'll see here.

There is one surprising use for the Lasso tool, however, and that's for tracing straight lines – thanks to a little-known keyboard shortcut. We'll look at this technique in steps 6 and 7.

The Magic Wand tool is a great all-purpose tool for selecting areas of a similar tonal range, and is widely used for removing simple backgrounds. Its tendency to 'leak' into areas you don't want selected, however, means you have to pay close attention to what's actually been selected – and be prepared to fix it afterwards.

1 This straightforward scene should be an ideal candidate for Magic Wand selection: after all, it's on a plain white background. But even simple selections can have their pitfalls.

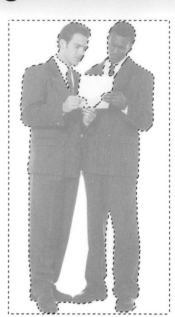

2 Begin by clicking in the white area outside the two figures. (Note that the main image has been knocked back so we can see the selection outlines more clearly.)

6 Although the Lasso tool may seem the obvious choice when drawing freehand selections, it can also be used to select objects made of straight lines, such as this fence. Hold the ⌥ alt key and then click once at each corner of each vertical post, clicking additionally from the bottom of one to the bottom of the next. You can also use the Polygonal Lasso tool to do this job on its own, without holding the modifier key.

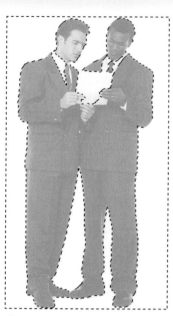

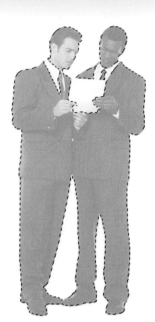

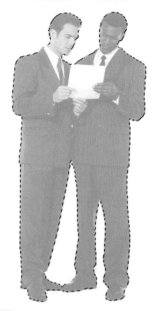

3 The area between the men's legs was not included in the original selection, so we need to hold the **Shift** key and click there to add it to our selection area.

4 So far, we've selected everything except the bodies. We need to inverse the selection, by pressing **⌘ Shift I** **ctrl Shift I**, to select the bodies themselves.

5 Note how the original Magic Wand selection 'leaked' into the paper and the shirt collars. This is easily fixed by holding **Shift** as we add those areas with the Lasso tool.

HOT TIP

The tolerance setting of the Magic Wand affects the extent to which it includes similar colors. The higher the tolerance, the wider the range of shades it sees as being similar to the one you click on. For general use, set a tolerance of 32 and adjust if necessary.

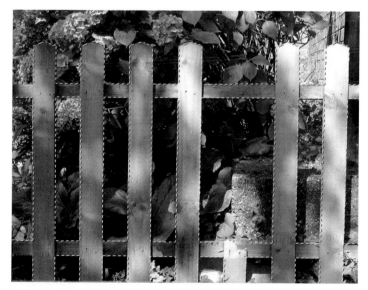

7 Now to add the horizontals. Hold the **Shift** key and then, after clicking the first corner point, add the **⌥ alt** key and continue to click each corner as before. Be sure not to hold **⌥ alt** before beginning to

click or its effect will be to subtract the new selection from the old one, rather than adding to it – see the previous page for details on how these modifier keys work. The fence will now be fully selected.

SHORTCUTS
MAC WIN BOTH

QuickMask 1: better selection

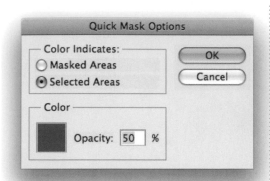

QUICKMASK IS THE MOST powerful tool for creating selections in Photoshop. It uses a red overlay to show the selected area, allowing you to see the image through it; when you leave QuickMask mode, the painted area will be selected.

In QuickMask, painting with black will add to the selection and painting with white will subtract from it (as long as you're set up as described below). This makes it easy to trace around any object: it's far quicker and more controllable than the Lasso tool, and in situations such as the one shown here it's the best solution.

The default setting is for QuickMask to highlight the masked (unselected) areas with a red overlay, leaving the selected areas transparent: I find it far preferable to work the other way around, so that the selected areas are highlighted. To change the settings, you need to double-click the QuickMask icon (near the bottom of the toolbar, just below the foreground/background color swatches) and use the settings shown above.

1 This image would be tricky to select using the Lasso tool, and impossible with the Magic Wand – the background and foreground are just too complex. Press **Q** to enter QuickMask mode so we can begin.

2 Using a hard-edged brush, begin to trace around the inside of the figure. You don't need to paint the whole figure in one go, so take it at your own pace and let the mouse button up every now and again to take a break.

6 With the basic outline selected, we can address the detail. Lower the brush size using **[** until you have a size that's small enough to paint in the outline detail comfortably.

7 Now the outline is selected, leave QuickMask by pressing **Q** again, and the selection will be shown as a familiar 'marching ants' outline. You can now press **⌘ J** **ctrl J** to make a new layer from the selection.

3 It's easy to make a simple mistake when painting the outline, such as going over the edge by accident – as I've done at the elbow here. Don't simply press Undo, or you'll lose the whole brush stroke; there's a better way to correct the error.

4 To paint out the offending selection area, change the foreground color from black to white (the keyboard shortcut to do this is **X**). Paint over the mistake, then press **X** again to switch back to black to paint the rest of the selection.

5 You don't need to worry too much about fine detail at this stage – just get the basic figure highlighted. Fiddly areas, such as around the ear and the collar, can be left till later.

HOT TIP

You can mix hard and soft brushes within the same QuickMask session. For example, if you're cutting out a picture of a dog, you might use a soft-edged brush to trace around the fur, and a hard-edged brush to trace the outline of the nose and mouth. Soft brushes are the equivalent of feathering Lasso selections, but are very much more controllable.

8 When the background is removed, we can see more clearly that the right side of the image is in really deep shadow – too deep to work with. Again, we can use QuickMask to select the shadow area.

9 Enter QuickMask again by pressing **Q**, and this time change to a soft-edged, larger brush. When we paint over the shadows now, we're creating a soft-edged selection; then leave QuickMask with **Q** again.

10 Because our selection has a soft edge, we can use any of the standard Adjustments to lighten up the shadow area (I've used Curves here) without showing a hard line between the changed and unchanged areas.

SHORTCUTS
MAC WIN BOTH

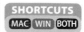

13

QuickMask 2: tips and tricks

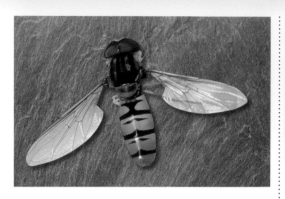

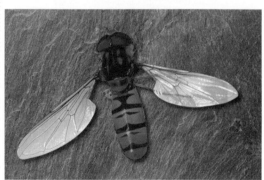

1 Enter QuickMask mode with **Q**. Begin by using a hard-edged brush to trace around the main body of the fly. Don't worry about the legs at this stage – we'll add them in later. Remember that if you make a mistake, you can always swap the foreground color to white and paint it out.

QUICKMASK IS THE BEST TOOL FOR making complex selections, especially of natural or organic objects where there are no hard, straight edges. By switching between large and small brushes, it's easy to trace even the most fiddly of objects with a little patience.

It all becomes more interesting when we look at using shades other than pure black and white to paint the mask. By painting with gray, we create a mask which is semi-transparent: the darker the shade, the more opaque the resulting selection will be. This technique is of particular benefit when selecting objects such as this fly, which has an opaque body and legs but semi-transparent wings. Building that transparency into the selection makes the whole effect far more convincing when we place the fly on a new background: the lowered opacity makes it look far more as if it belongs in its new surroundings.

4 Now for the legs. Switch to a much smaller (but still hard-edged) brush, and trace each leg carefully. You can change brush sizes by using **J** to go to the next size up, and **I** to go to the next size down.

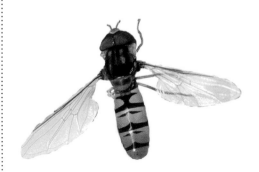

7 Now exit QuickMask by pressing **Q** again, and press **⌘ J** **ctrl J** to make a new layer from this selection. When we hide the underlying layers, we can see a few small errors: a bit of background has crept into the wings.

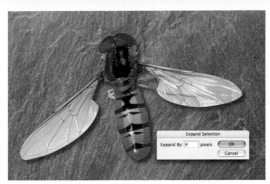

2 We could just paint in the middle of the body – but with a large selection, that would take a while. Here's a shortcut: use the Magic Wand tool to select the middle portion, then expand that selection (Select menu) by, say, 4 pixels to make sure the edges are covered.

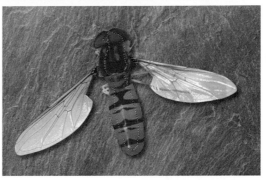

3 Now fill that new selection with the foreground color (the shortcut for doing this is ⌥ ⌫ *alt* ⌫) and then deselect (⌘ D *ctrl* D) to remove the Magic Wand selection. This is a useful technique for large images in particular.

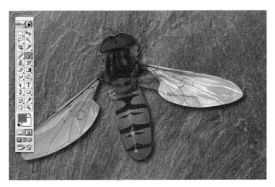

5 Before painting the wing area, we need to switch from black to a dark gray color to give the wings their transparency. Choose a gray from the Swatches panel, and, with a bigger brush, paint over the wings.

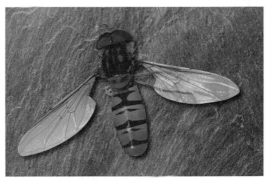

6 The wings may need to be semi-transparent, but those fine legs shouldn't be – so switch back to black (press **D**) and, with a small brush, paint in the legs where they're seen through the wings.

Why didn't we simply paint with a lower brush opacity in step 5, rather than switching to gray? Because if we had, we would have had to paint the whole of each wing in a single brushstroke, without interruption. Otherwise, the new stroke would have overlapped the old one, creating a darker area (and so a stronger opacity) in the intersection.

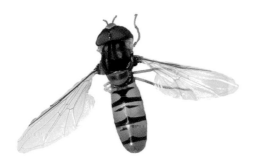

8 The easiest way to fix this is simply to erase the offending areas with a hard-edged Eraser. If you prefer, you could go back to QuickMask and tidy it up there, but it generally isn't worth the extra effort.

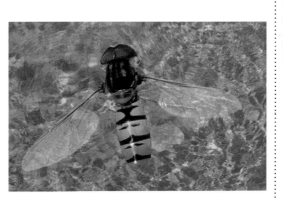

9 Because we selected the wing area using built-in transparency, we can partially see through them when we place the fly on a different background, adding greatly to the realism of the scene.

QuickMask 3: transformations

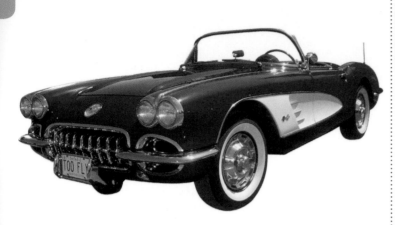

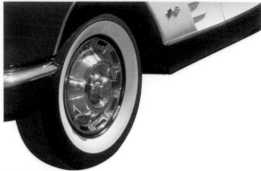

1 The hubcap on this car is a perfect circle photographed from an oblique angle. The Elliptical Marquee tool, however, only works on an orthogonal axis – there's no way to make it draw at an angle, as would be required here.

AS WELL AS USING PAINTING tools, you can use any of the standard transformation tools within QuickMask. This can make it easier to select tricky areas, such as the angled hubcaps on this sports car. Even though the hubcap is an ellipse, the angle at which it's been photographed makes it impossible to select with the standard Elliptical Marquee tool. QuickMask, however, makes short work of the problem.

QuickMask can be used for creating all kinds of shapes from scratch. Hard-edged rectangles and smooth circles can be combined to build lozenge shapes far more quickly than toying with the radius settings of the Shape tools, for example.

There are many more uses to QuickMask than are shown here. Get into the habit of using it for your everyday selections, and you'll find it quickly repays the effort.

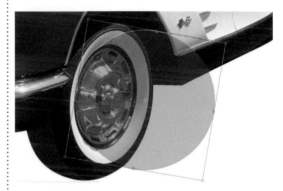

4 Enter Free Transform mode by pressing ⌘ T ctrl T, and selection borders will appear around the circle – no need to make an additional selection first. Drag the circle so one edge touches the edge of the hubcap, and rotate it to roughly the right angle.

7 Here's a simple and quick way to make a lozenge shape to exactly the size you want. First, draw a rectangle of the right height, and press **Q** to enter QuickMask. Choose the Elliptical Marquee tool, and position the cursor just inside the top of the rectangle; hold the *Shift* key and drag to the bottom edge of the rectangle.

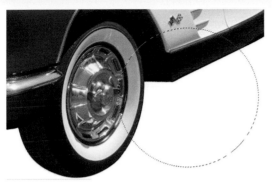

2 To begin, use the Elliptical Marquee tool to draw a circle anywhere on the image (hold the *Shift* key as you draw to constrain the ellipse to a circle). If you can't find the Elliptical Marquee tool, click and hold on the regular Marquee tool in the toolbar and it will pop open for you.

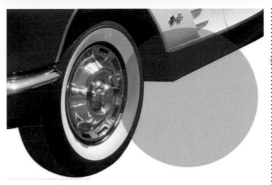

3 Now enter QuickMask mode by pressing *Q*. The circle you just drew will appear as a solid red circle, which will show us exactly where our selection edges lie in the illustration.

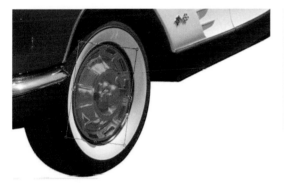

5 Now pull in the opposite handle so it touches the opposite rim of the hubcap, and do the same with the top and bottom edges. At this point, you may need to adjust the angle of rotation of the ellipse so it matches the hubcap perfectly.

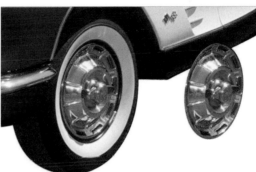

6 With the ellipse perfectly positioned, press *Enter* to leave Free Transform, then press *Q* once again to leave QuickMask mode. You can now move the hubcap, or make a new layer from it.

You might wonder why we bother using QuickMask to make this selection, rather than using Photoshop's Transform Selection tool. The answer is that it's really quite hard to make out an accurately positioned border when it's composed of a row of marching ants; using QuickMask, however, shows us the selection as a solid block of red, which makes it much easier to see through to the underlying image.

8 Assuming you started and ended in the correct place, your circle should now be exactly the same height as the rectangle. Release the mouse button before letting go of the *Shift* key, then switch to the Move tool (press *V*) and hold *⌥* *alt* to move a copy as you drag the circle to the end of the rectangle; add *Shift* to move it horizontally.

9 Now release and then hold the *⌥* *alt* key once again, and hold *Shift* as you drag the circle to the other end of the rectangle. When you leave QuickMask (by pressing *Q* again) you'll be left with a perfect lozenge selection, which you can then fill or stroke as you wish.

The Quick Selection tool

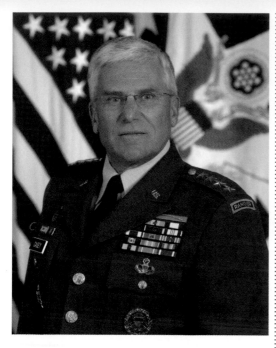

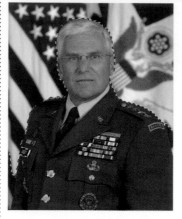

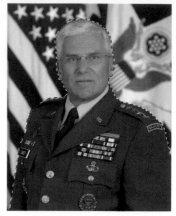

MAKING COMPLEX SELECTIONS automatically has been the wish of every Photoshop artist since photomontage began. The Quick Selection tool is the fulfilment of that wish.

This image of a United States general would be almost impossible to cut out using the Magic Wand tool. It shows a complex uniform against an equally complex background, and would require multiple selections to make the Magic Wand even begin to isolate it.

With the Quick Selection tool, however, cutting the figure out is a straightforward and easy process. It shows the power of the Quick Selection tool at its best.

1 Start by choosing the Quick Selection tool. The keyboard shortcut is **W**, which doubles as the key for the Magic Wand; press **Shift W** to toggle between the two. Drag the tool over the body and head in a single sweeping movement. There may be some errors with the initial selection: here, parts of the flag have been included bottom left and bottom right, and some of the uniform detail – the buttons, the badge, and some ribbons – have been omitted.

2 It's now a straightforward matter to add the missing elements – simply drag over them with the Quick Selection tool. To remove the unwanted areas, such as the pieces of flag, hold **⌥ alt** as you drag over these regions and they will be removed from the selection.

There's an option on the Options Bar for this tool marked Auto-Enhance: check this, and the selection will be automatically smoothed as you drag.

5 When we zoom in on the image, we can see some inaccuracies in the cutout. Here, there's a definite fringe around the uniform, where we can see part of the background starting to show through.

6 There are two ways we can fix this. The first is to use the Decontaminate Colors feature, which blends the color of the cutout into the border area: this removes the red of the flag on the shoulder.

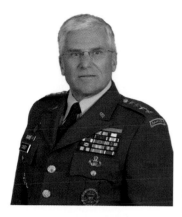

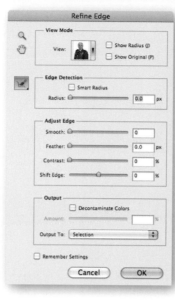

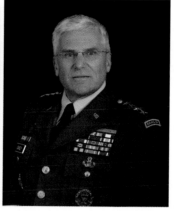

3 To see how the cutout looks, we can use the Refine Edge dialog – choose it from the button on the Quick Selection tool's Options Bar, or press ⌘ ⌥ ℝ *ctrl* *alt* ℝ. By default, this will show the cutout against a plain white background.

We can now see the cutout much more clearly. The Auto-Enhance option for the Quick Selection tool produces a smoother edge that has none of the roughness we might normally associate with the Magic Wand or even the Lasso tool: this complex selection has been made with almost no effort on our part.

4 We can choose a variety of backgrounds against which to view our cutout, all with keyboard shortcuts. Choose them from the View pop-up at the top of the Refine Edge dialog, or press **B** for black, **W** for white, **V** for a QuickMask-style overlay, **L** to show the underlying layers, and **P** to view the original. Switching between black and white allows us to see the accuracy of the cutout in much greater detail.

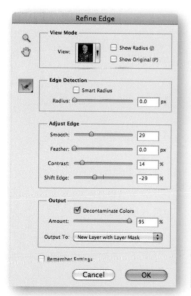

7 The Adjust Edge sliders let us smooth and contract or expand the selection, to produce softer results and a more convincing cutout. After smoothing with Feather, you can tighten up again with the Contrast slider.

8 By raising the Smooth amount, we soften the shoulder; increasing the Contrast stops it being too fuzzy. Dragging the Shift Edge slider to the left reduces the cutout area, so removing the fringe.

9 When we're done, we can choose to output the results in a number of ways. The best method is to save the cutout as a new layer with a Layer Mask attached, which lets us modify it further if we need to.

19

Refine Edge: fuzzy logic

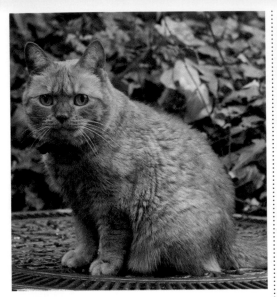

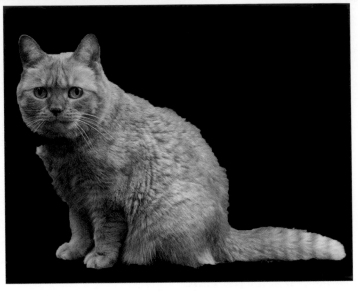

W E LOOKED BRIEFLY AT THE Refine Edge dialog on the previous pages, where we introduced the Quick Selection tool. Now let's go into it in some more detail.

Refine Edge took a huge leap forward in Photoshop CS5, with its ability to deal with fuzzy edges. Here, we'll perform a cutout on this photograph of my cat on a garden table. It's a difficult task: although the fur is a different color from the background, there are no smooth edges here to work with.

With the terrific level of control in Refine Edge, we can complete the cutout of this cat with no pain whatsoever.

You can read more about using the Refine Edge dialog to cut out hair on page 208.

1 Select the cat using the Quick Selection tool, as described on the previous pages. It's a straightforward selection, as the color of the cat is different enough from the background for the tool to be able to select it easily.

Enter the Refine Edge dialog using ⌘ ⌥ R / ctrl alt R. Press B to show the cutout against the black background, so we can see the cutout more effectively. We can now see that it has produced a somewhat rough edge.

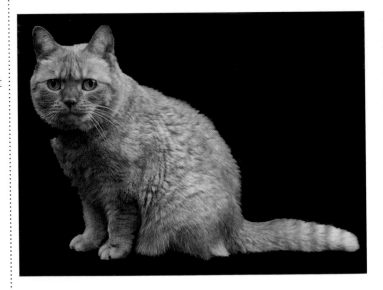

4 Continue to work your way all around the cat in short chunks, dragging over the perimeter of the fur and resizing the brush if necessary (use the square bracket keys [and] for more precise size control). Don't brush over the ears, as there's no stray fur here and we want this area to remain crisp. The Refine Radius tool is only used for fuzzy edges.

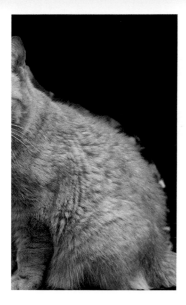
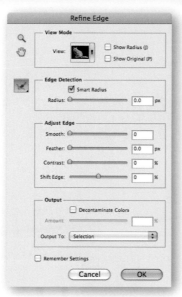
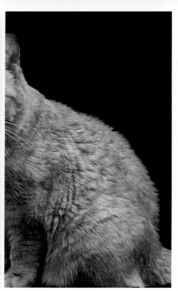

2 Check the Edge Detection box in the Refine Edge dialog, and select the Refine Radius tool, if it isn't already selected by default (keyboard shortcut: **E**). Size the brush so it's just large enough to cover the full extent of the edge fur, from the side where it's fully cat to the side where it's fully background. Drag over the back of the cat, from the ear to the tail. As you drag, you'll see the background being revealed behind it.

3 When you release the mouse button, Refine Edge will work its magic: the background will disappear as the cutout now outlines every strand of fur on the cat's back.

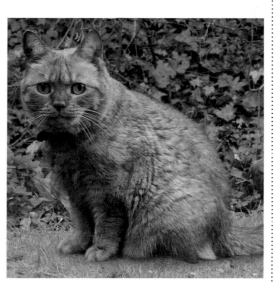

5 When we press **W** to view the cutout on a white background, we can see that it doesn't look perfect: there are a few errors, and some transparency around the chin that shouldn't be there. The best solution, though, is to save it as a new layer with a Layer Mask.

6 Once we place the cat onto any sort of textured background, the inaccuracies are hidden by the complexity of the scene behind. We can, if we wish, continue to adjust the Layer Mask for a more precise fit, but in most cases this simply isn't necessary.

Refine Edge: going further

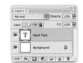

SO FAR, WE'VE LOOKED AT THE Refine Edge dialog purely as an add-on to the new Quick Selection tool. But there's far more to it than that: it can be used in combination with any of the selection tools to tighten up selections – and to loosen them.

The red star above was made using Photoshop's Shapes tool, with a bevel added later. The softer purple star was created in just a few seconds by modifying the outline of the red star using Refine Edge. This is a shape which would have been tricky to create by any other means!

Here, we'll look at using Refine Edge to make round-edged text. It's useful when we want to make lettering that appears to be made of stone, neon, or a natural material; even the most basic fonts can be turned into something special using this method.

1 Begin by creating your text. It will appear on a new layer, as always. Here, we've used plain old Arial Bold. No need to rasterize the layer, since we'll be using a new layer later anyway.

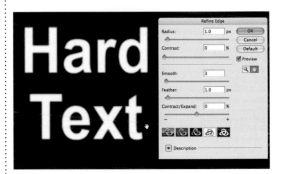

4 Click the final icon at the bottom of the Refine Edge panel to view the selection as an Alpha Channel. Now, we can see how the default settings affect the outline: it's softened it, making it a little blurry.

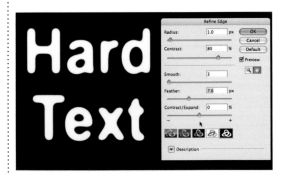

7 The further you drag the Feather slider, the more rounded the edges will become. Where you stop is up to you: it's possible to soften the lettering so much that it's barely legible – which may, of course, be exactly the effect you want.

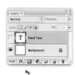

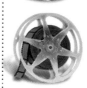

2 Load up the pixels in this layer by holding ⌘ ctrl and clicking on the layer's icon in the Layers panel. The outlines will appear in familiar 'marching ants' form. Now, hide the text layer by clicking the eye icon next to it.

3 Bring up the Refine Edge dialog by pressing ⌘ ⌥ R ctrl alt R. Because the layer itself is hidden, we'll see nothing yet: that's because we're looking at a hidden selection on a white background.

When extreme amounts of feathering are used, it can easily become impossible to create hard edges, even with the contrast value set to 100%. This was true of the stars used in the introduction to this tutorial: the points were so rounded that they remained soft and fuzzy. The solution: repeat the Refine Edge dialog to tighten up the softness.

5 To fix that blurriness, increase the contrast. The further you drag this slider to the right, the harder the edge will become. Beware of dragging it too far, or you'll end up with jagged edges; a setting of around 80% works well.

6 Now to soften the lettering. Drag the Feather slider to the right and, as you do so, you'll see the corners of the text rounding off. Although feathering normally softens a selection, the high amount of contrast keeps it hard here.

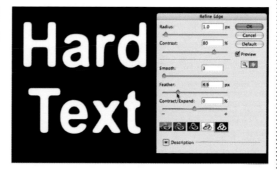

8 When you've got the effect you like, hit OK to dismiss the Refine Edge dialog. You'll be left with the marching ants once more, showing the edges of your selection in the usual way.

9 You can't work on the text layer itself, since it can contain only live text. So make a new layer, and press ⌥ ⌫ alt ⌫ to fill with the current foreground color. You can repeat the process as many times as you like, using the original text layer as a starting point.

The Pen is mightier...

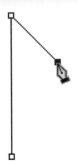

1 To draw straight lines with the Pen tool, simply click each corner you want to create. If you want to constrain a line to horizontal, vertical or 45°, hold down the **Shift** key before clicking the second point on the line.

THE PEN IS ONE OF THE KEY TOOLS available to the digital artist – not just in Photoshop but in Illustrator, Quark XPress, InDesign and many other programs as well.

The Pen tool creates paths using Bézier curves (named after the French designer who devised them, so legend has it, to design the outline of the Citroën 2CV in the 1930s). Bézier curves are unique in that simple curves can be made to fit any shape: they're easily editable after they've been drawn, so you needn't worry about getting the curve perfect first time around – it can always be adjusted later.

The paths created by the Pen tool have another great advantage: they can be used to define selections which can then be stored within the document when it's saved. Most of the cutout objects in royalty-free CD collections are defined with paths.

The problem is that the Pen tool has the steepest learning curve of all. Here, and on the following pages, I'll try to help you get to grips with mastering the essential tool for making perfect selections.

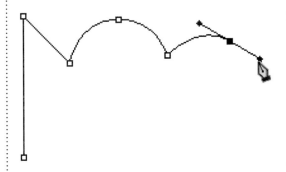

4 Because we clicked and didn't drag in step 3, when the next point is drawn (with a click and drag), the curve coming out of the back of it joins the previous one with a hard corner rather than a smooth curve.

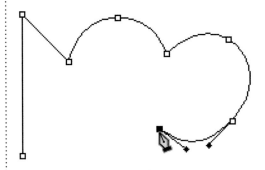

7 If you've clicked and dragged on a point, making a smooth curve, you can turn it into a corner point instead by holding **alt** and clicking on the point again. You can then click and drag on the same point again to make a new curve from that corner.

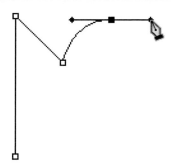

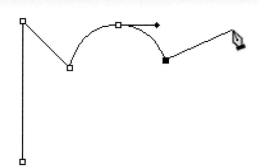

2 If you click and then drag before releasing the button, you'll get a curve. This is the essence of the Pen tool: curves are defined by the anchor points (the dots where you click) and the handles that set their direction and strength.

3 Every time you click and drag, you get a curve; and the point clicked in the previous step shows how the curve operates on both sides of the point. But if you just click without dragging, you make a corner point.

HOT TIP

You don't need to wait until completing a path before making adjustments to it: simply hold ⌘ ctrl at any point while you're drawing to access the path selection tool, and use it to move anchor points or their handles. When you release the key, you can just carry on drawing.

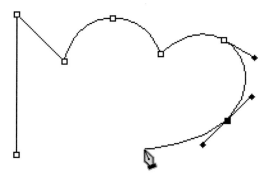

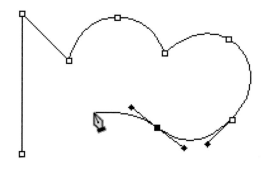

5 The handles operate as tangents to the curve, not crossing it but acting like a surface off which the curve bounces. The points should be placed at positions where the curve changes direction.

6 Sometimes, the handles do appear to cross the curve – but only in cases where the curve is S-shaped, as appears here. The handles are still really tangents to each side of the curve.

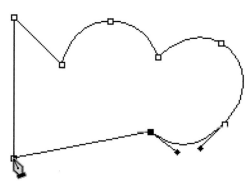

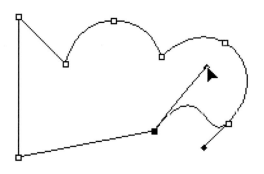

8 When you click on the starting point again, the path will be completed and the anchor points will disappear, showing just the path's outline. You can leave a path open-ended instead, if you like – for example, if you want to stroke it with a painting tool (see pipes and cables in Chapter 12).

9 A path can be adjusted by moving the anchor points, moving the handles, or dragging on the curve itself. Hold ⌘ ctrl to move points with the Pen tool active; or press **A** for the path selection tool – use the filled tool to select an entire path, the hollow version for individual points.

SHORTCUTS
MAC WIN BOTH

The Pen tool by numbers

THE PEN TOOL CONFUSES PEOPLE MORE THAN any other in Photoshop. Here's a step-by-step guide to cutting out a simple object – in this case, a child's toy.

The Photoshop file on the DVD has all the numbers, click points and drag points marked on it, so you can follow the instructions here as you trace around the toy. If you make a mistake, simply use Undo to go back one point – no need to start again.

1 Start at the corner point marked 1. Click the Pen tool and drag the handle to the red dot to set the direction.

4 Click point 4, and drag just a short way to its red dot: this is a very short curve, so the dot is close to it.

5 Click point 5. The curve will look wrong until you drag to its dot, when the curve behind it will be sorted out.

8 Now click point 8, and release the mouse button. No curves needed here: it's our first corner point.

9 Click point 9, and drag downwards a short way to its red dot to start off the next curve.

12 Click point 12, and once again don't drag since this is another corner point.

13 Click point 13, halfway round the next curve, and drag to the red dot. Nearly home now!

2 Click the point marked 2, and drag to its red dot: this completes the curve behind it, and sets the next.

3 Now click point 3, and drag to the red dot. This is the top curve on the toy.

HOT TIP

To make the Pen tool much, much easier to use, make sure it's in Rubber Band mode – this shows you the path you're about to create before you click the tool.

6 Now click point 6, and drag to its red dot: the handles are clearly at a tangent to the curve of the toy.

7 Click point 7: once again, it's only a short drag to make the curves both behind and in front of this point.

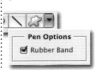

To turn on Rubber Band mode, click the triangle at the end of the Pen Options bar and select it from the pop-up dialog. When you've completed this exercise, try it again without the dots!

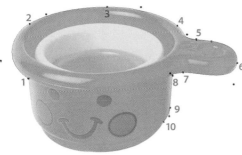

10 Click point 10, but don't drag: once again, this is a corner point, so we don't need a curve here.

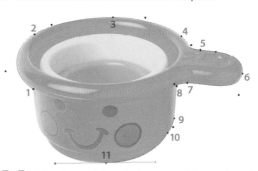

11 Click point 11, right at the bottom, and drag to the red dot to make the large curve along the base.

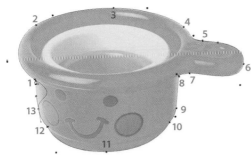

14 Here's what happens when we place the cursor over our starting point: an ugly curve from point 13.

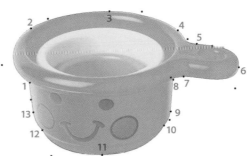

15 Instead, hold ⌥ *alt* as you click the starting point, to make a corner instead of a curve.

Putting the Pen into practice

O N THE PREVIOUS PAGE WE
looked at the basics of using the Pen
tool using a step-by-step, numbered pattern
with all the click and drag points marked. This
time, the task is to outline an object without
any points on the Photoshop file to show you
where to drag to. Of course, you could always
just look at the examples here and use the
paths shown as a guide.

This is a compound path, which means
that it includes one element within another.
You don't need to do anything to the path
within the handle to make it subtract from the
main outline: Photoshop will take care of this
automatically, as long as Exclude Overlapping
Shapes is selected from the Options bar:

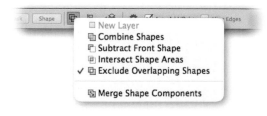

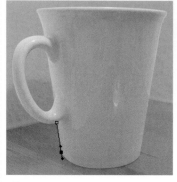

1 Begin by clicking the first point just below the mug's handle, then click and drag down a short way at the bottom of the straight section.

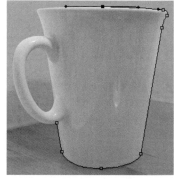

2 Now click and drag at the bottom of the curve: keep your drag horizontal, so it makes a tangent to the curve.

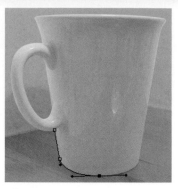

6 Complete this small curve by clicking and dragging just around the corner. Keep the drag parallel to the mug once more.

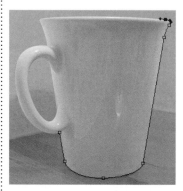

7 Now click and drag at the middle of the top of the mug. This is the mid-point of the curve that makes the mug rim.

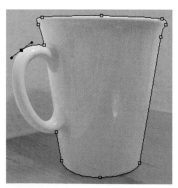

11 Click and drag at the point on the handle where the curve changes direction – just around from the top.

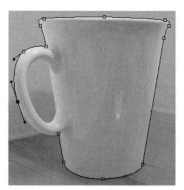

12 Another click and drag, once again where the direction of the curve changes, on the outermost part of the handle.

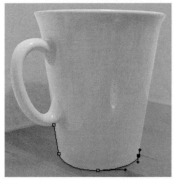

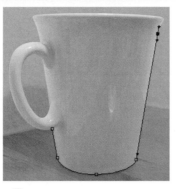

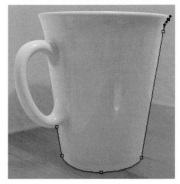

3 Go round the corner, and click and drag a short way up the side of the mug. Drag the handle so that it follows the line of the mug.

4 Now click at the top of the straight section, and drag upwards a short distance to create the start of the curve that follows.

5 Click and drag at the beginning of the lip at the top of the mug: only a short drag is needed to make this curve.

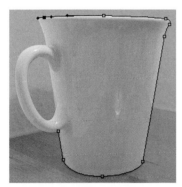

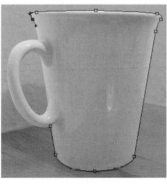

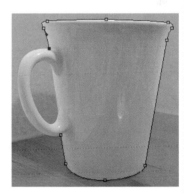

8 Click and drag again at the edge of the rim, just before the lip begins to curve.

9 Now click and drag once more just around the lip, again keeping the drag parallel to the side of the mug.

10 Now click at the top of the handle, but don't drag this time: there's a sharp corner here, and we don't want a curve at this point.

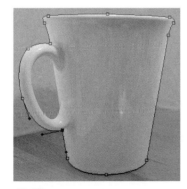

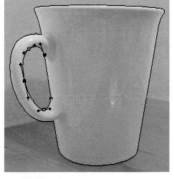

13 Click on the starting point and drag into the mug – it's the back of the handle that defines the curve behind it.

14 Follow the same process to make the inside of the handle, remembering to make corner points where the handle joins the mug.

15 With the path complete, you can turn it into a selection using ⌘ Enter ctrl Enter; inverse the selection and delete the background.

Lock and load

OCKING A LAYER'S transparency is an essential capability, as it allows you to paint on a layer without affecting transparent areas. It's a feature we'll be using throughout this book.

Loading selection areas is another shortcut that you'll see used again and again in the chapters that follow, and it's important to understand how it works.

In the example here, we're working on a document that includes three playing cards, on separate layers. We want to create a shadow on a fourth layer, above the other three: by loading up the transparency of the underlying card layers, we can achieve our aim with ease.

It's worth noting that the shortcuts for adding to and subtracting from selections are the same as those used for standard selections, as described earlier in this chapter.

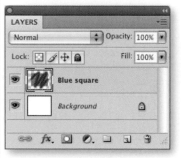

1 Under normal conditions, when we paint on a layer the paint will be applied irrespective of the layer's boundaries, as can be seen here.

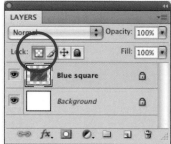

2 If we check the Lock Transparency box on the Layers panel, any painting actions are limited to those pixels already present in the layer: they change color, but aren't added to.

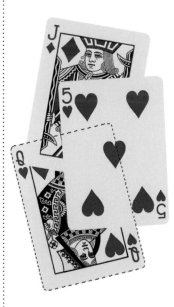

6 Here's another example. Let's load up the Queen of Hearts layer by holding ⌘ *ctrl* and clicking on the thumbnail in the Layers panel. The outlines show that area selected.

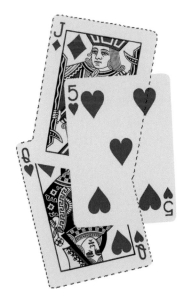

7 We want to add the Jack of Diamonds, so we need an extra key: holding ⌘ *Shift* *ctrl* *Shift* and clicking on its thumbnail will add that layer to the existing selection.

3 So what, you might think. Well, here's a typical example: we want to change the color of this woman's monochromatic jacket into something a little more eye-catching.

4 With the Brush tool set to Color mode, we'd expect the color of the jacket to change without affecting the texture. But the color leaks out, polluting the background as well.

5 Once we lock the transparency of the pixels, we can paint our color directly onto the layer without affecting the rest of the artwork: again, only the pixels present are affected.

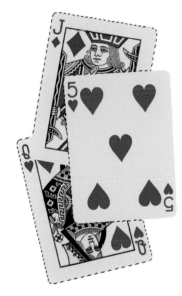

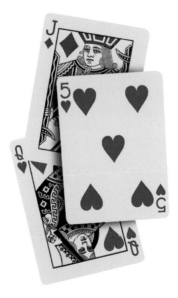

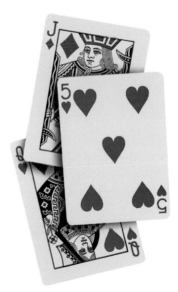

8 We only want to work on the two back cards, so we need to subtract the Five layer. Holding ⌥ ⌘ alt ctrl while clicking on the thumbnail removes that layer's selection.

9 With our selection made, we can now make a new layer for the shadow and begin to paint – hiding the selection edges first (⌘ H ctrl H) so we can see what we're doing.

10 The Jack has to cast a shadow on the Queen as well. Holding ⌥ ⌘ alt ctrl while clicking on its name will remove the Jack's selection, and we can add the shadow we want.

Find and replace

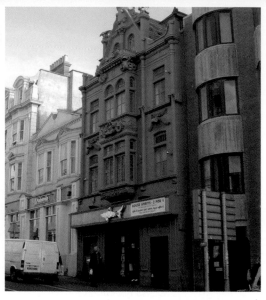

1 The brash blue of this once-elegant Victorian building may not appeal to all tastes. It certainly doesn't appeal to mine, so let's change it to something more environmentally friendly. Choose Image/Adjust/Replace Color to get started.

CHANGING THE COLOR OF THE CAR above from red to blue would be an almost impossible task by conventional means: all those railings in the way would make selecting the car something of a nightmare. But by using Replace Color, we can adjust the hue selectively without having to lay hands on a single selection or painting tool.

Replace Color is a hugely powerful tool that turns what would otherwise be a complex task into one that's enjoyable and effective.

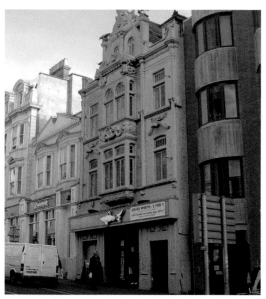

4 To add more colors, hold the **Shift** key and click on an unchanged area, or drag to select a range of colors: that range will be added to the selection, and the color will change in the image. If you select a spot by accident, hold **⌥** **alt** while clicking to deselect that color.

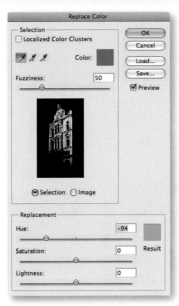

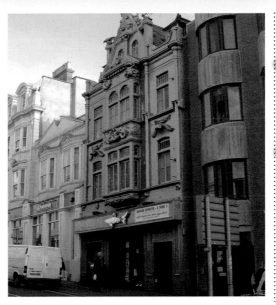

2 By default, the Replace Color dialog shows a monochrome view of what's been selected: white is active, black isn't. By clicking on the image, regions of that color become selected. When you change the Hue value, the image changes to reflect that, as seen in the next step.

3 Here's the result of our initial change, and we're turning the building green. It doesn't matter what color you choose to begin with; go for something bright, so you can see the change. So far, only a portion of the face of the building has changed color.

5 Keep adding more color ranges until the entire building is altered. One way of increasing the range of colors changed is to raise the Fuzziness value; but this draws in unwanted colors in the surrounding area, as can be seen in the color change in the windows of the neighboring building.

6 Now we're sure the building is selected, we can change the hue to a shade more in keeping with its surroundings. It may not be painted white like the building to the left of it, but it certainly blends into the street better than it did before.

HOT TIP

There are often areas in the surrounding image that are close to the target color range, and they will get changed as well. One solution is to duplicate the layer, apply Replace Color, and then simply erase or mask the parts you didn't want to change.

SHORTCUTS
MAC WIN BOTH

Color by numbers

1 This image shows a complex skyline, with many fiddly elements punctuating the heavens – from the street light to the strings of bulbs stretched between them, to the ornate roof on the building on the left. An impossible job using the Lasso tool: but there's a better way. Choose Select/Color Range to begin the replacement operation.

THE SELECT COLOR command works in precisely the same way as the Replace Color dialog detailed on the previous page, except that rather than changing the hue it returns a selection.

This makes it the ideal tool for changing elements such as the sky, as shown in this example: with the sky isolated from the original image, we can paste in any cloud formation we want to strengthen and add drama to the image.

Here, we've taken a sunny day on the Brighton seafront and made the scene altogether more doom-laden simply by replacing the sky with something a touch more dramatic.

3 With the sky selected, open any other sky you have lying around. Select All (⌘ A ctrl A) and Copy (⌘ C ctrl C), then paste it inside the selected area: choose Edit > Paste Special > Paste Into. The new sky will be positioned within the selection, and you can move or scale it as required. It will move independently of the area you've pasted it inside.

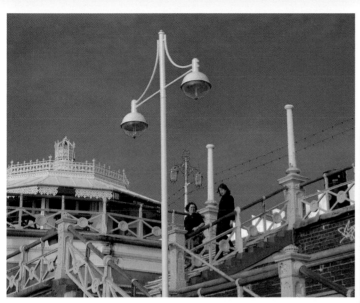

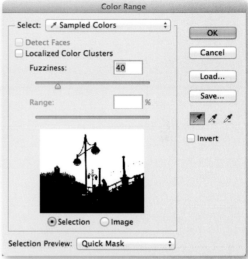

2 The dialog works in the same way as Replace Color: the main difference is that the selected area is shown on the image as a QuickMask selection, although you can change this using the pop-up menu. Use *Shift* and ⌥ *alt* as before, to add and subtract colors to and from the selected range, until the entire sky is selected.

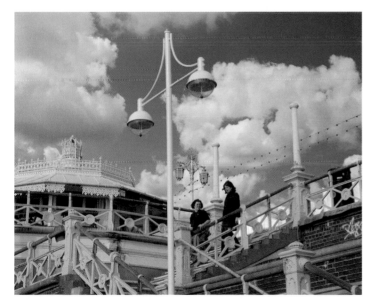

4 Choosing Paste Into creates a layer mask that exactly matches the original selection – see Chapter 3 for more about how to use layer masks. We can now paint on the mask to remove pieces of sky from regions where it shouldn't have appeared, such as halfway up the railings on the left. But note how the new sky even shows through the glass domes of the lamp.

HOT TIP

If you've performed a Select Color operation and want to repeat it exactly, hold ⌥ *alt* as you select it again from the menu. It will reappear with the same settings already loaded up. Holding this modifier will reload the last settings for any of the color adjustments as well.

SHORTCUTS
MAC WIN BOTH

The color of her face

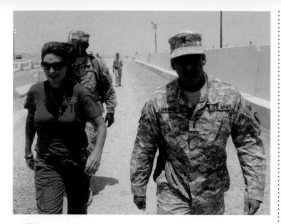

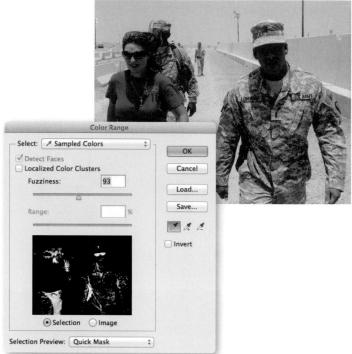

SELECT COLOR, AS WE'VE SEEN, IS an ingenious way to make discontiguous selections of similar tones from all around an image. Photoshop CS6 introduces two enhancements that make the job even easier: skintone recognition and face recognition.

This isn't face recognition in the sense that image libraries understand it, but simply the ability to detect a standard facial configuration and automatically add it to the selection.

The system isn't perfect, but it gets us a long way towards our goal – and it's easy to adjust the results afterwards.

In this photograph of Sarah Palin visiting Kuwait, her face is largely in shadow – and the face of the army officer striding along next to her has almost entirely disappeared into the shade. We'll see how we can rescue this image with the minimum of fuss.

1 Choose Select > Color Range. The default setting will most probably be the last color you selected, which we can ignore. I've turned on Quick Mask as a Selection Preview, so we can see the selected area highlighted in red.

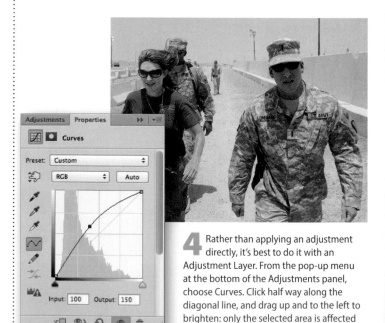

4 Rather than applying an adjustment directly, it's best to do it with an Adjustment Layer. From the pop-up menu at the bottom of the Adjustments panel, choose Curves. Click half way along the diagonal line, and drag up and to the left to brighten: only the selected area is affected by the operation.

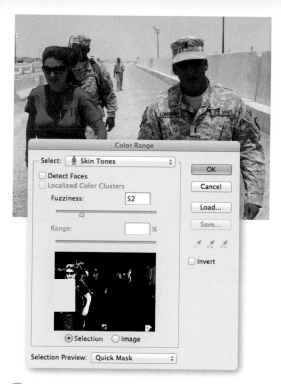

2 Choose Skin Tones from the pop-up menu. Most of the skin color in the image is in the selection – but parts of his face are missing, and the wall is partially selected.

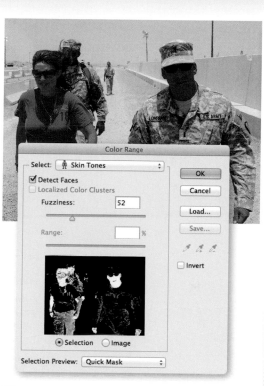

3 Clicking the Detect Faces checkbox modifies the selection. The wall is now entirely deselected, and his face is now fully added to the selection.

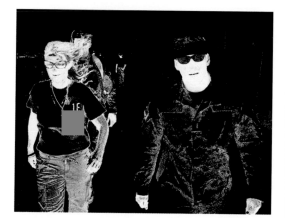

5 Making an Adjustment Layer with an active selection adds a Layer Mask to the adjustment. If we look just at the mask, see the selected area is the white part of the mask. Here, we can see that her pants have been selected along with parts of the soldier's uniform.

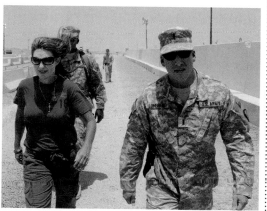

6 Painting in the mask on the Adjustment Layer in black will hide the effect. So we can use a large, soft-edged brush to paint over Palin's arms and pants, to reduce the brightening effect caused by the Curves operation.

HOT TIP

This selection method deals with topics we haven't yet covered in the book. For more on the Curves adjustment, see page 104; to learn about Layer Masks, see page 84 onwards.

You can view just the Adjustment Layer's mask, as we do in step 5, by holding ⌥ alt and clicking on its thumbnail in the Layers Panel.

SHORTCUTS
MAC WIN BOTH

37

Brush-on color

THE COLOR REPLACEMENT TOOL performs a task almost identical to the Replace Color dialog, discussed earlier in this chapter, but it has one significant advantage: you can paint the new color directly onto the image, without having to go through a dialog first.

In one way, it's simply more satisfying to paint the new color straight on. But there are many other advantages to the new tool: where Replace Color would globally change one color for another, the brush allows us to mix our colors at will. In addition, we can control the area we color with more precision than we could with the dialog.

The settings that determine the way the Color Replacement tool operates are the same as those used by the Background Eraser tool, covered later in this book: take a look at Detailed Hair Cutting in Chapter 8 to see how to change the settings for both these tools.

1 Here's our model, wearing a bright red shirt. In color terms, it's pretty close to the skin tones, so the Replace Color dialog would have some difficulty with this image; the Color Replacement Brush is the perfect solution.

2 To begin, choose a color and set a tolerance of around 50%, then paint a test patch. You should watch to see that the color covers all the areas you want, and doesn't leak into unwanted skin regions.

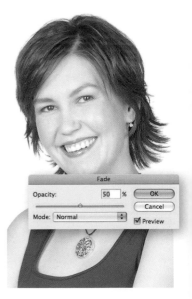

6 Here, we'll use the same tool to change the model's hair color from black to brown. In order to make this process work, you need to complete the whole coloring operation in a single brushstroke. Far too bright – let's fix it.

7 Press ⌘ Shift F ctrl Shift F to bring up the Fade dialog immediately after brushing on the color: now we can reduce the strength of the last operation by dragging the slider, to make it more realistic.

3 Here's what happens if you choose the wrong settings. At the top, too high a tolerance means the skin is being changed along with the shirt; at the bottom, too low a tolerance means not enough of the shirt is changed.

4 Try to change all contiguous areas of color in one go. If you start with a small patch, as we did in step 2, and then carry on with a new brushstroke in the same area you'll get an ugly join which can be hard to get rid of.

5 Because the top half and the bottom half of the shirt are split in two by the arms, we can treat each as a separate region. By coloring each section in one go, we maintain an evenness of color throughout.

8 In general, you'd want to use a soft-edged brush for this tool. Here, we'll paint tiger stripes onto the shirt by using a hard-edged brush. We'll begin by painting the black stripes, in Color mode.

9 Although the last step changed the color, it didn't make the stripes darker. To do this, we need to change the brush mode to Luminosity instead. Now, when we brush over the changed areas, we make them darker as well.

10 Change the brush mode back to Color, and pick a bright orange. We can now change all the remaining red using the new color, to create this convincing tiger pattern on the shirt.

The perfect setup

IN THE FIRST EDITION of *How to Cheat in Photoshop*, published back in 2002, I recommended that any artists who were serious about Photoshop should have at least 512Mb of RAM installed in their computers. That figure gradually crept up over the years, as computers became more powerful, RAM became cheaper and Photoshop became more and more demanding.

Now, ten years after that first edition, I'm recommending another RAM hike. My own current system – a 27-inch iMac with an i7 processor – is fitted with 20Gb of RAM and a 2 Terabyte hard disk. That's 40 times as much RAM as specified in the first edition. Does Photoshop really demand as much as that?

It's all a question of how you value your time. The 16Gb extra RAM chips I added to the base 4Gb configuration of the computer cost me $240. It saves me perhaps half an hour each day – watching the clock spinning round, switching between applications, waiting for Photoshop to perform complex filters. And when using the extraordinary 3D engine that Photoshop now boasts, saving rendering time is significant. The extra RAM eventually pays for itself.

But the other consideration is simply one of pleasure. Working on a really snappy, efficient computer makes every task that much more enjoyable, as Photoshop and other applications can perform both routine and specialized routines in a fraction of the time. And if you enjoy using Photoshop more, you'll feel more free to experiment and to try out new ideas.

Even with enormous amounts of RAM, Photoshop will still write huge temporary files. It deletes these when you quit the application, so you're unlikely to notice them, but they can run into hundreds of megabytes. If your main hard disk is used as a 'scratch disk' Photoshop will be reduced to fitting these files in whatever spaces it can find; they'll be so fragmented that the whole process will become slowed down. The best solution is to buy a second hard disk, or assign a partition of at least 10Gb in a larger disk, and assign this to be Photoshop's scratch disk – you do this using Edit > Preferences > Plug-ins and Scratch Disks. Resist the temptation to put anything else on this disk.

Dock your frequently used panels as icons. They'll appear when you click on them, and disappear when you've finished.

If you're working for print, set your color sliders to CMYK – even if you're working in an RGB document. This will keep your colors in gamut (see page 440).

Save favorite panel set-ups for different tasks – such as illustration and 3D.

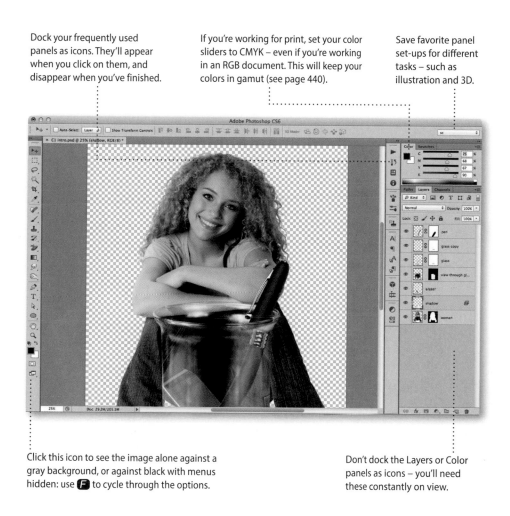

Click this icon to see the image alone against a gray background, or against black with menus hidden: use **F** to cycle through the options.

Don't dock the Layers or Color panels as icons – you'll need these constantly on view.

Get into the habit of using the Purge All command (Edit menu) every time you're sure you won't want to undo what you've just done, when you use the History panel or paste an item from the clipboard. This will clear out the temporary files, and can often take a minute or so to accomplish – which gives you some idea of how large these files can get.

Set up your frequently used panels by storing them as icons attached to the Layers panel, so they can be accessed with a single click; you can set them up in the Preferences dialog so they vanish when you click elsewhere. But if you want to see the image you're working on uncluttered by any screen debris, press the Tab key and all the panels, including the Toolbar and Options bar, will disappear. Press the Tab key once more to bring them back.

How to Cheat in

2

Transformation and distortion

When we assemble multiple picture elements, we always have to transform them in some way – even if it's a process as simple as changing the scale. Photoshop's Free Transform mode is our key tool here, allowing us to scale, rotate and distort all our objects.

But there are many more ways of producing a distortion. We can use Puppet Warp to change the position of a hand, or the pose of a figure; we can use Image Warp to twist an object into just about any shape we can imagine; and we can even use the Clone tool to produce automated transformations as we paint.

The innovative Content-Aware technology, in all its manifestations, helps us to patch backgrounds, remove objects, and perform all manner of tricks. In this chapter we'll look at the best of what Photoshop has to offer.

The Free Transform tool

A LL PHOTOSHOP WORK INVOLVES distorting layers – whether it's simply scaling them so they fit next to each other, or producing complex perspective distortions to match the view in an existing scene.

Free Transform mode is the key to scaling, rotating, shearing and distorting layers. If just one layer is selected, you'll affect just that layer; but if more than one is selected, the distortion will occur on all the layers simultaneously. Similarly, if a group is chosen, then the transformation will affect all the layers in the group in one go.

The Free Transform bounding box has eight handles around its perimeter, and each one transforms the layer in a different way. In addition, you can hold down a variety of modifier keys to change the method of transformation, as detailed here.

1 Enter Free Transform mode by pressing ⌘ T ctrl T. A bounding box will appear around the current layer, or group of layers if more than one is selected. To commit a transformation, press Return.

2 If you grab a corner handle and drag it, you'll scale the layer. The corner you drag will move, and the opposite corner remains where it is. Think of the layer as pinned by the corner opposite the one you drag.

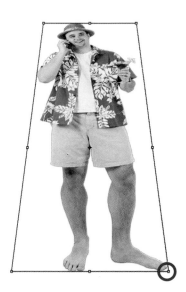

6 If you hold ⌘ ctrl as you drag a center side handle, you'll shear the layer. Adding Shift forces Photoshop to shear in just the horizontal or vertical dimension.

7 To create a perspective effect, hold ⌘ ⌥ Shift ctrl alt Shift as you drag a corner handle. The direction of drag produces a horizontal or vertical distortion.

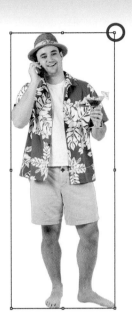

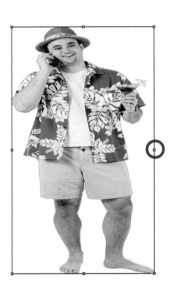

3 Holding the *Shift* key as you drag a corner handle maintains the proportions of the original. Use this when you want to make a layer bigger or smaller, but don't want to change its shape.

4 If you grab a center side handle on the left or right, you'll scale a layer only horizontally. If you grab a top or bottom center handle, you'll scale it vertically.

5 When you position the cursor outside the bounding box and drag, you rotate the layer. The further away from the bounding box you start, the more control you'll get over the rotation amount.

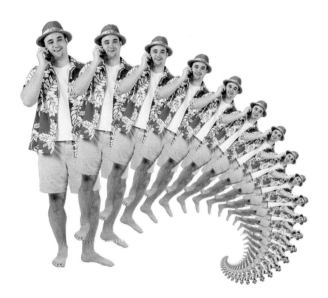

8 Holding just ⌘ *ctrl* as you drag a corner handle distorts the layer in a freeform manner. You can move each of the corner handles to create complex distortions.

9 To repeat the last transformation exactly, press ⌘ *Shift* *T* *ctrl* *Shift* *T*. This can be useful if you distort a layer and then find you should have made some changes to

it first: you can Undo, then perform the transformation again. If you press ⌘ ⌥ *Shift* *T* *ctrl* *alt* *Shift* *T*, however, you'll *duplicate* the last transformation, as shown here.

HOT TIP

Scaling by dragging a handle will always 'pin' the transformation at the opposite corner or side handle. But if you hold ⌥ *alt* as you drag, you'll scale around the center instead – that is, around the center marker. You can move this marker anywhere in your artwork to make that the point around which each transformation takes place.

SHORTCUTS
MAC WIN BOTH

Step and repeat rotation

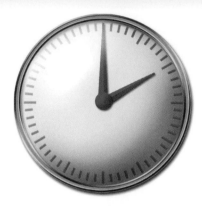

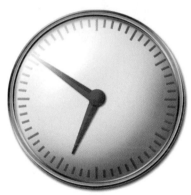

T HE STEP AND REPEAT PROCESS mentioned on the previous page can be used to create regular patterns and arrays. The success of the operation depends largely on where you place the center marker: here, we'll demonstrate the techniques by building a simple clock face.

It's easiest to find the center point of the clock if you create two guidelines first, by dragging them in from the rulers (you'll need to show the rulers if you can't see them already). Make a vertical and a horizontal guide so that they cross in the center of the artwork.

Once the basic clock is complete, it's easy to change the position of the hands to make them tell any time you want.

1 Begin by drawing a tiny rectangle, on a new layer, and filling it with color. This will be the starting point for all the ticks around the perimeter of our clock face.

2 Now enter Free Transform. We want to rotate around the center, so grab the center marker (it's easier to get if you hold ⌥ alt) and drag it vertically downwards.

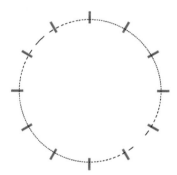

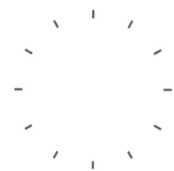

6 Now to make the minute markers. Duplicate the layer, and make an elliptical selection that includes around half of each marker.

7 Now delete to shorten each marker. Here, I've hidden the original hour markers so we can see the difference.

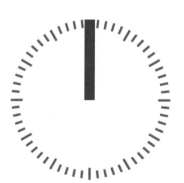

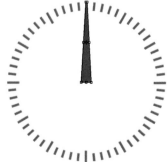

11 Now for the hands. On a new layer, make a simple rectangle and fill it with red. It should be centered on the 12 o'clock position, with its base at the clock center.

12 To make the hand pointed, hold ⌘ Shift ⌥ ctrl Shift alt as you drag a top corner handle: this will produce a symmetrical distortion, making a simple triangle.

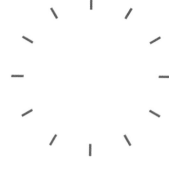

3 Hold *Shift* as you drag to rotate, and it will jump to 15° steps. We want 30° to mark the hour points, so move it two steps round; press *Enter* to apply the transformation.

4 That transformation moved the original marker. Undo, then press ⌘ *Shift* ⌥ *T* *ctrl* *Shift* *alt* *T* to repeat the transformation: this time, it will rotate a copy of the original layer.

5 Press ⌘ *Shift* ⌥ *T* *ctrl* *Shift* *alt* *T* another ten times; each time another marker will be added around the clock face. Then select and merge all the layers.

It's easy to end up with too many layers using this technique – 60 of them, in fact. So take the opportunity to merge layers together whenever appropriate, by selecting them and choosing Merge Layers from the Layer menu, or pressing ⌘ *E* *ctrl* *E*.

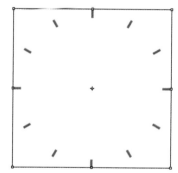

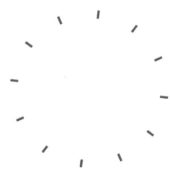

8 Enter Free Transform. We need to rotate by 6° this time, so enter this figure in the Rotate field in the Options bar:

9 Here's our shortened minute marker layer, rotated by 6°. (360° divided by 60, the number of minutes in an hour, if you're wondering.)

10 Press ⌘ *Shift* ⌥ *T* *ctrl* *Shift* *alt* *T* three times, and all the minutes will appear. The hour markers are shown here again.

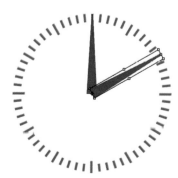

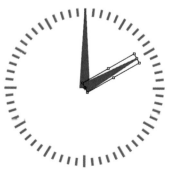

13 Now duplicate that hand layer, and enter Free Transform again: drag the center marker to the bottom center handle, and it will rotate around that point.

14 Before leaving Free Transform, we need to make this hand shorter. So grab the top center handle, and drag it towards the center of the clock: we now have an hour hand.

15 All we need to do now is cover up that ugly join in the center. That's easily done by making a new layer, and filling a circular selection with the same color as the hands.

Image Warp: flag waving

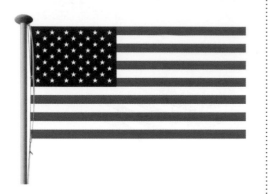

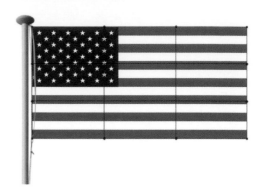

MAGE WARP IS A SPECIAL MODE OF Free Transform, and it's entered by going into Free Transform mode and pressing the Image Warp button on the Options bar, over on the right.

In Photoshop CS6 you can also enter Image Warp mode using Edit > Free Transform > Warp.

There are several preset modes within Image Warp. The default is the versatile Custom mode, which uses an array of control handles to allow the user to distort layers in different ways. But it's easy to get tangled up dragging the handles around; often, the better approach is to start with one of the preset distortions, and then switch to Custom to finish off.

We'll use Image Warp to make the flat flag, above, look much more like it's really attached to that flagpole.

1 Start by entering Image Warp mode, either by going through Free Transform first or by choosing it from the Edit menu. You'll see this grid appear over your flag layer.

4 All the preset distortions have a handle to adjust them – a tiny black square. For the Flag distortion, it's on the top edge. Drag it up to change the way the flag is waving.

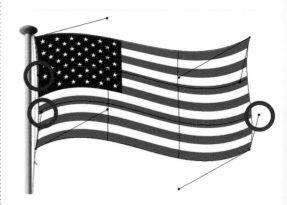

7 We can adjust all the corner handles. Drag those on the left inwards to make the flag follow the shape of the holding tape; drag others to make the ripple less regular.

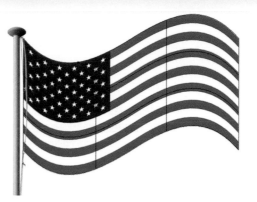

2 From the Warp menu in the Options Bar, click on None and drag down to select Flag.

3 This is the result: a down-and-up movement of the flag. So far, it doesn't look very realistic, but we can customise it to make it suit our purpose.

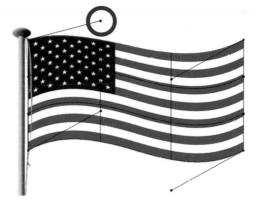

5 From the Warp menu in the Options Bar, now select Custom as the warp type.

6 Now, two Bézier handles appear on each corner. We can grab one – such as the top left handle – and drag it down, to make the top of the flag have a smaller ripple to it.

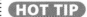

HOT TIP

Once you've applied a distortion it's 'burned into' the pixels, as it were: you can't go back and adjust the handles later. Unless, that is, you first convert your layer to a Smart Object (see page 400). This allows you to manipulate the handles as much as you like: when you enter Image Warp at any time in the future, the handles will be exactly where you left them.

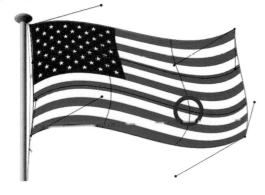

8 We can also distort the flag by dragging on the four internal points, where the grid lines intersect. Dragging the lower right one gives the flag a bit of a bulge.

9 Click OK or press *Enter* to apply the distortion. All that remains to be done now is to add the ripple shading – and you can see how to do that on page 318.

SHORTCUTS
MAC WIN BOTH

Tying yourself in knots

I T'S AN ODD THING, BUT EVERY TIME
I'm asked to do a 'simple job' I know it's
going to turn out to be one of the trickiest jobs
of the year. Not just occasionally, but every
single time.

Tying a pair of scissors into a knot was, I
was assured, going to be a simple job for the
New York magazine *Bloomberg Businessweek*.
After all, we've all seen knots, and I must be
able to lay my hands on a photograph of a pair
of scissors. How hard could it be?

The first problem was that I couldn't find
a suitable shot of a closed pair of scissors –
they were all too ugly. So in the end I took a
photograph of an open pair, above, simply
because it was the right style.

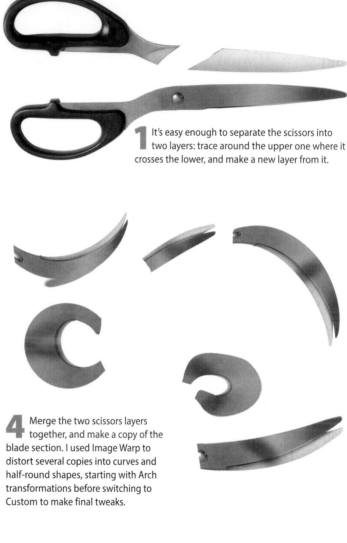

1 It's easy enough to separate the scissors into two layers: trace around the upper one where it crosses the lower, and make a new layer from it.

4 Merge the two scissors layers together, and make a copy of the blade section. I used Image Warp to distort several copies into curves and half-round shapes, starting with Arch transformations before switching to Custom to make final tweaks.

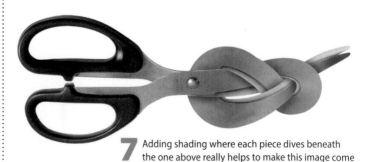

7 Adding shading where each piece dives beneath the one above really helps to make this image come alive, and gives it that three-dimensional quality.

2 Rotate the lower layer, and move it into place. I had to rebuild the bottom part slightly to make it reach the join.

3 A reference photo really comes in useful. Take a look at this image to see how knots are formed.

CASE STUDY

5 Here's how the scissors look when all the pieces are assembled. It's a complete mess, of course, but if you use the knot image as a reference (place it on top, at a low opacity) you'll be able to get everything more or less in the right place.

HOT TIP

Steps 4 and 5 make it look as if I distorted all the pieces and then assembled them in place. In fact, I distorted each one in turn on top of the knot reference image, using Image Warp and Free Transform to twist them into place. Think of each section of the knot as a separate layer, and this makes it easier to imagine how to distort a piece of scissor into that shape.

6 Each layer needs to have a Layer Mask added, and painting the layer out on this mask allows you to intertwine the sections, following the knot template as a guide. You may find you need to keep using Image Warp to tweak the scissor shapes.

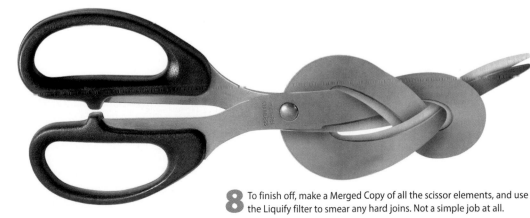

8 To finish off, make a Merged Copy of all the scissor elements, and use the Liquify filter to smear any hard joins. Not a simple job at all.

SHORTCUTS
MAC WIN BOTH

51

Cloning in perspective

PHOTOSHOP'S CLONE TOOL, sometimes referred to as the Rubber Stamp, shows a preview of the area it's going to reproduce and can store up to five clone sources per image. It also has the capability to rotate and scale images as we clone them.

None of this would be any use, of course, if we couldn't see what we were doing before beginning the clone operation. So the Clone tool has the option of showing a ghosted overlay on top of the image, showing not just the clone area but the entire image rotated and scaled according to our settings.

1 Here's our starting image: an old stone building, with a pair of windows casting their light on the ground. We're going to duplicate the near window in perspective, to achieve a seamless blend as it slots into the existing wall.

2 Open the Clone Source panel, and click the Show Overlay button. This will produce a ghosted version of the image to be cloned. Just to be on the safe side, make a new layer so we don't work directly on the base image; and be sure to set the Clone tool to Sample All Layers on the Options bar.

6 The new Clone tool now allows us to rotate the clone source as well. Click in the Rotate field, and press the up and down cursor keys to change the angle: the overlay will rotate as you do so. In this case, an angle of -3.0° produces exactly the right rotation.

7 The overlay now shows the ghosted image to be cloned in place, with the scaling and rotation as we set them. The advantage of the overlay system is clear: we can see exactly what we're going to get before we begin to clone.

3 When we move the cursor back into the image, we can see the overlay: it follows the cursor around as we move it. Hold ⌥ *alt* and click the bottom right corner of the existing image to mark the clone source. Now click where you want the cloning to begin painting on the image.

4 In step 3, we clicked to mark the point where cloning should begin. Undo that with ⌘ Z *ctrl* Z to remove the first cloning operation: the overlay will stay in place. Because the window is too large for its persepective, we need to reduce it. A scale of around 80% works well here.

5 Here's the result of reducing the scale of our window. This is still the overlay: we haven't started cloning yet. But we can see a problem here. In order to match the perspective in the scene, we need to rotate the cloned copy slightly so that it matches the distortion caused by the camera lens.

8 Time to start cloning. Choose a brush appropriate to the size of the window, and begin to paint the new one in. When you release the mouse button, the overlay will reappear; hold the Space Bar to hide it temporarily.

9 The light cast by the window, as seen in the overlay in step 7, is too far from the window itself, resulting in a poor impression of perspective. So, back in the Clone Source dialog, tweak the Offset numbers in order to bring the light closer to the wall.

10 With the offset corrected, we can now continue to clone the light onto the floor. Because we're using a soft edged brush, the blend is seamless; but it's just as well to clone onto a new layer, so we can edit out mistakes if we need to.

HOT TIP

Check the Auto Hide button on the Clone Source panel to make the overlay disappear while you're cloning – far easier to see what you're doing that way. Check the Clipped button to limit the Clone view to just the brush size. For an operation like this, it helps to lower the overlay opacity to between 25% and 50% so we can see the background through it.

SHORTCUTS
MAC WIN BOTH

Special effects with cloning

ON THE PREVIOUS PAGES WE looked at the basics of using offset, scaling and rotation to introduce the new features in the Clone tool. Here, we'll examine some of the special effects that can be produced using a combination of these techniques.

All these examples depend on working on a new layer, behind the target layer. This is essential to making the techniques work: be sure, also, that you have the Clone tool set to Sample All Layers, or you'll be cloning nothing at all.

This is just a taste of the sort of effects that can be achieved using this powerful tool.

1 Here's a security guard: we'll make a whole row of them. Begin by holding **⌥** **alt** as you click the very bottom of the guard's shoe to set the source point; then click the equivalent point behind him, to set the position.

2 Undo that last click operation, and turn to the Clone Source panel. A scale of around 90% produces the efect we want here; you may wish to fiddle with the offset values as well, to make sure the perspective is right.

6 We can apply exactly the same principle to architectural images as well. In this case, we'll begin with this view of a triumphal arch that already has some perspective built into it.

7 As with the guard, click the bottom point of the inside of the arch, and adjust the scaling and offsets until the perspective is correct. Each time you apply the Clone tool, you'll create another set of arches behind.

8 We can apply a similar process to the left side of the arch, so that its apparent depth matches that indicated by the arches within. You'll need to set new offset and scale values to make the effect work, though.

54

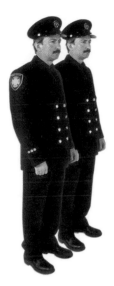

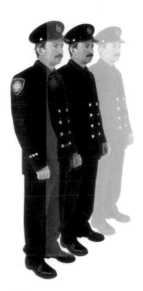

3 On a new empty layer, behind the current (guard) layer, begin to clone the new guard in with a single brush stroke that paints in the entire guard in one step. And there he is, perfectly placed next to the original.

4 When you now release the mouse button, you'll see that the Overlay now updates itself to show a third guard ghosted behind the other two. That's because the Clone tool is now sampling the second guard as well.

5 No need to make new layers: just keep cloning. Each time you clone a guard and release the mouse button, an additional guard will appear on the Overlay. We can make as many as we want, disappearing into the distance.

The key to making these techniques work is to get the perspective right when setting the scale and offset values for the initial cloning operation. There are usually clues in the picture: with the guard, the vanishing points are clearly shown by the eye line and the angles of the bottom rows of buttons on his jacket.

9 Further effects can be obtained by including rotation with scaling. In this example, we'll use this simple cutout of a flower to create a striking graphic image.

10 It can take a little experimentation to get the position and angles right. Here, an angle of 20° with a scale factor of 90% gives us the effect we want.

11 By repeating the cloning process a number of times, we're able to build this spiral of flowers which disappears into the center of the illustration. Simple, but effective.

Puppet Warp: animal tamer

PUPPET WARP USES A grid system that allows us to bend, twist and otherwise manipulate our images to our hearts' content. What's often surprising is how amazingly lifelike the results can be: distortions of the type seen on these pages would previously have involved splitting the object into multiple layers, distorting each one separately, and then masking the joins with masks and cloning.

Puppet Warp performs smooth, realistic distortions with ease: it was one of the most significant enhancements introduced in Photoshop CS5.

1 We can bring up Puppet Warp by choosing it from the Edit menu, or with the shortcut ⌘ ⌥ P ctrl alt P. A grid of triangles appears on top of the image.

2 Start by fixing points at the key joints – here, the shoulder and hip joints – by clicking with the Puppet Warp tool. The placed pins appear as yellow dots.

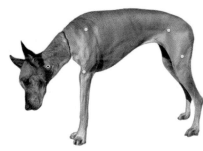

5 Now, when we drag the point at the base of the skull, the head and neck move smoothly down. Note how the shoulder has deformed in a naturalistic manner.

6 If we hold ⌥ alt and move the cursor just away from a selected pin, a ring appears around it and the cursor changes to allow us to rotate the image around that pin.

8 With a bit of practice, it's easy to bend the dog into just about any pose we like. If we hold *Shift* we can select multiple pins, so we can move several together: this is useful for operations like moving the whole front of the dog up so that it can stand on the bucket.

3 If we place a new pin at the base of the skull and drag, we'll deform the whole dog. That's because there aren't enough pins to define the shape yet. Undo the drag operation to go back to the previous state.

4 Add more pins at the tops of both the legs. At the same time, we can choose to hide the underlying grid by unchecking the Show Mesh box on the Options bar. This makes it easier to see the finished result.

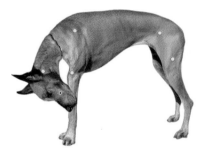

7 We can deform a layer so that it bends in front of itself: the dog's head is here pulled in front of the leg. But what if we want the head behind the leg? The two icons next to the Pin Depth label in the Options bar allow us to move the selected pins up and down in the stack.

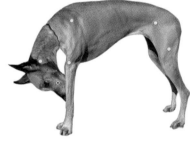

HOT TIP

If you think you might want to reshape a Puppet Warp layer after distorting it, then convert it to a Smart Object first (see page 400). This allows us to deform the layer in the same way, but when we choose Puppet Warp a second time, it will appear with the mesh and all the pins in their previous position, so we can move them at will.

9 So far, we've been using Puppet Warp in Normal mode (chosen from the pop-up on the Options bar). There's also Rigid mode, which performs a less fluid distortion; and Distort mode, used in these two examples. This mode changes the size as we deform the layer, producing amusing and sometimes ridiculous results.

SHORTCUTS
MAC WIN BOTH

Puppet Warp: get to grips

ON THE PREVIOUS pages we introduced Puppet Warp, and showed how it could be used to distort the pose of a dog. Here's a different but equally common task: we want to bend this hand so that it appears to grasp a tiny object.

Once again, this job would be a nightmare if we had to perform it using standard Photoshop techniques. We'd have to separate the fingers and thumb into individual layers, deform them using Image Warp, and then attempt to join them all back together seamlessly. Even after a lot of work, we'd be lucky to produce a convincing result.

With Puppet Warp, though, the job becomes simplicity itself.

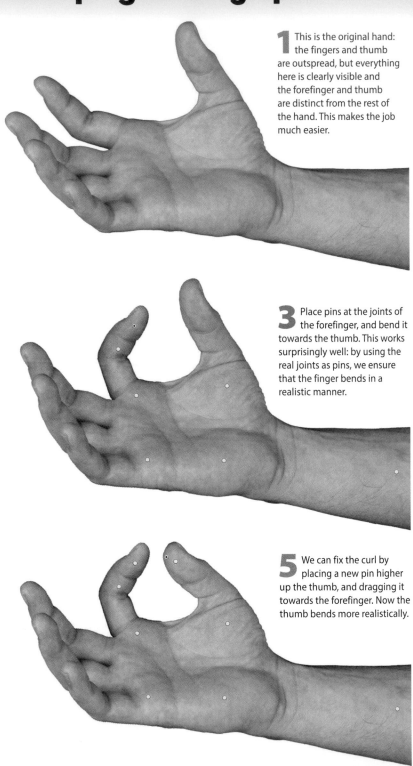

1 This is the original hand: the fingers and thumb are outspread, but everything here is clearly visible and the forefinger and thumb are distinct from the rest of the hand. This makes the job much easier.

3 Place pins at the joints of the forefinger, and bend it towards the thumb. This works surprisingly well: by using the real joints as pins, we ensure that the finger bends in a realistic manner.

5 We can fix the curl by placing a new pin higher up the thumb, and dragging it towards the forefinger. Now the thumb bends more realistically.

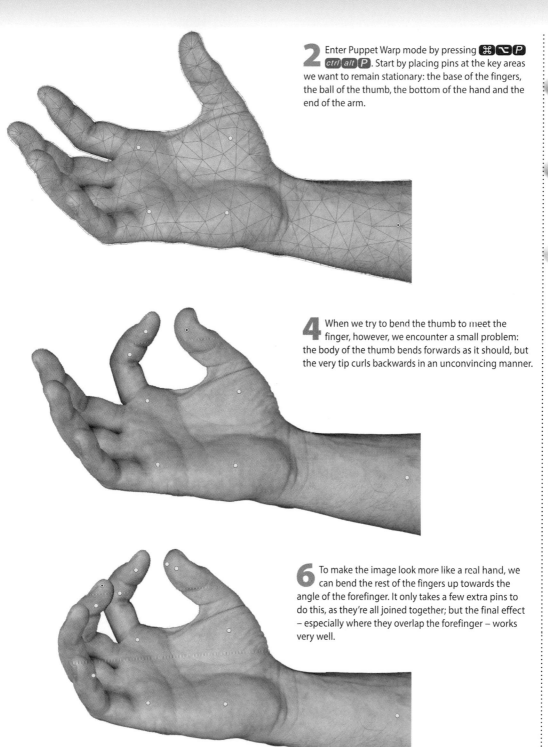

2 Enter Puppet Warp mode by pressing ⌘ ⌥ P / ctrl alt P. Start by placing pins at the key areas we want to remain stationary: the base of the fingers, the ball of the thumb, the bottom of the hand and the end of the arm.

4 When we try to bend the thumb to meet the finger, however, we encounter a small problem: the body of the thumb bends forwards as it should, but the very tip curls backwards in an unconvincing manner.

HOT TIP

The key to making Puppet Warp work effectively is usually to use fewer pins, not more. The placement is critical: position them where the real joints are, and you're guaranteed much better results.

6 To make the image look more like a real hand, we can bend the rest of the fingers up towards the angle of the forefinger. It only takes a few extra pins to do this, as they're all joined together; but the final effect – especially where they overlap the forefinger – works very well.

SHORTCUTS

Cappuccino with sprinkles

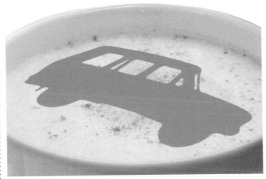

1 The best cup photo I could find was, in fact, an espresso cup. In order to make it work, I isolated the cup from its background and used Free Transform to stretch it horizontally. The handle was undistorted using Puppet Warp.

4 To make the silhouette fit the surface of the coffee, I used Free Transform to rotate and squeeze it into the correct perspective. I also used Image Warp (see page 48) to give it some slight curvature.

IT'S NOT UNUSUAL FOR CAR manufacturers to diversify – but Land Rover's decision to start marketing their own brand of coffee tickled *Reader's Digest* enough for them to write a short feature about it. (Something to do with the fact that the FairTrade growers use Land Rovers to get around their plantations, apparently.)

They wanted a cappuccino cup with a picture of a Land Rover sprinkled on it in chocolate, and a company logo on the side. The result is shown at the top, above the starting images.

It's not a hugely complicated job, but the method is of interest – not least, because the two pictures I started with both needed to be adapted for the purpose in hand.

7 After pasting the copied dots, I applied a small amount of Gaussian Blur – about 1 pixel – and then used Layer Effects to add a very small Inner Bevel, to add some slight three-dimensional depth.

2 I made an elliptical selection of the frothy top from the second image, and used Free Transform to rotate and scale it to match the top of the cup. I used the original saucer, to which I added a drop shadow.

3 I Googled a line drawing of a Land Rover, which then had to be turned into a silhouette. After selecting it with the Magic Wand, I used the Refine Edge dialog to smooth it (see page 22) before filling the selection with mid brown.

In step 9, I added some Gaussian Blur to the logo in order to make it look more convincing on the side of the cup. Because I'd first turned the cup into a Smart Object, I was able to paint a mask on that blur to hide it at the top: this produced a blur that graduated towards the bottom, which looks more realistic.

In step 6, the layer is easily isolated by holding ⌥ *alt* and clicking on its Eye icon in the Layers Panel.

5 Changing the Layer Mode from Normal to Dissolve gives a speckled appearance, and lowering the transparency of the layer movers the sprinkles further apart. Here, I used an opacity of 40% to get the desired effect.

6 I next had to turn those sprinkles into individual dots – as they stood, they were simply a layer appearance caused by the Dissolve mode. Isolating the layer allowed me to make a Merged Copy (⌘ *Shift* **E** *ctrl* *Shift* **E**).

8 On a new layer, I used a small, soft brush to paint some more sprinkles, to add bulk and soften the edges so they weren't so crisp. Again the layer mode set to Dissolve, and the opacity lowered.

9 The Land Rover logo was first turned into a Smart Object (see page 400), then distorted to fit the side of the cup using Image Warp (see page 48). The Layer Mode was then changed to Multiply to make it blend in with the cup side.

61

Content-Aware Scaling

CONTENT-AWARE SCALING WAS ONE OF THE BIG new features in Photoshop CS4. The technology allows us to resize images without distorting the key elements. It's able to recognize details within the image and leave them largely untouched, while compressing or expanding uninteresting areas of background instead.

It's not perfect, but given the right image the results can be extraordinary. We'll use the technique to turn the landscape shot, above, into a portrait view suitable for a magazine cover.

1 Here's what happens when we simply use Free Transform to make the scene narrower. Everything is compressed, and the people look unnaturally thin.

4 Check the Person icon on the Options bar: the golfer is now undistorted. But that golf caddy, second from left, is too squeezed-up.

Scaling cutouts

2 Use ⌘ ⌥ Shift C / ctrl alt Shift C to activate Content-Aware Scale, and drag one of the side handles in. The images is squeezed up, without the people distorting.

3 When we squeeze too much, people do distort – such as the golfer on the far right. He's clearly suffering from serious emaciation.

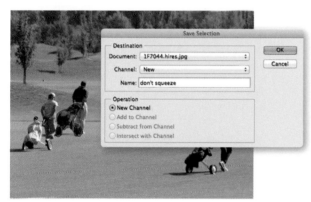

5 We can tell Photoshop not to distort a particular area. Make a selection of it (I've used QuickMask), then use Select > Save Selection to save it as a new channel.

6 Now click the Protect pop-up menu on the Options bar, and choose the channel you just created. This will prevent this selection from being distorted.

7 Content-Aware Scaling works well for cutout objects, too. We can make the pistol, left, as long or as short as we want (the original is at the top) simply by using Content-Aware Scaling to stretch it. No need to make an initial selection: Photoshop automatically works out which are the interesting parts and which are the boring parts, and acts accordingly.

It's the same for the lamp post, right. We can make it any height we choose. Again, no initial selection is necessary.

Content-Aware Fill 1

WE LOOKED AT CONTENT-AWARE SCALING ON the previous pages. Photoshop CS5 introduced a new take on the issue with Content-Aware Fill, which uses the information in the photograph to create an automatic patch.

There are two ways of using this new technology: with a selection, or by painting with a brush. The method you choose depends on the kind of object you want to remove from the original photograph. We'll look at both methods here.

Content-Aware Fill is a curious beast. Sometimes it performs its job perfectly; sometimes it simply gets it horribly wrong. It's certainly worth using for small selections, to remove imperfections such as telephone wires in the sky or unwanted objects in a landscape; here, we'll show how it can be used to take out major objects from the scene, with a good degree of success.

1 Start by making a selection around the object you want to remove – in this case, it's the stone statue on the left. It would be possible to remove this by conventional means, of course, but it would involve a lot of patching and switching back and forth between the Clone tool and the Healing tool. The selection doesn't need to be accurate.

4 The Content-Aware Fill operation contained a few errors: we can see a row of five boats where there were two, there's a break in the diagonal step, the step in the foreground has a lump in it, and so on. It's easy enough to fix these mistakes manually, using the Clone tool and Healing tool, as I've done here. All we're really doing is tidying up; the Content-Aware Fill did the bulk of the work for us.

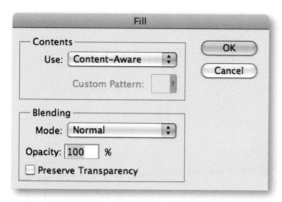

2 Press *Shift* *Backspace* to bring up the Fill dialog. From the Use pop-up, select Content-Aware as the fill type. Make sure the Blending Mode is set to Normal, and the Opacity to 100%, and press OK.

3 This is the immediate result: the statue has been completely removed, and the background patched using textures and objects around it. It's not perfect, but the initial hard work has all been done for us: and as an automatic fill, the results are extraordinary.

5 We can also use the Healing Brush *J* to paint areas for Content-Aware Filling: choose the Content-Aware button on the Options bar to select this mode. When we now paint over the diagonal step in the grass with this tool, we initially see a dark gray, translucent brush stroke.

6 When we release the mouse button, that brush stroke is filled with texture intelligently chosen from the surrounding area. This time, the tool has done its job almost perfectly, and the step has been removed in a single, simple and straightforward operation.

HOT TIP

The Content-Aware Fill system is good, but not infallible. Try selecting a large object in small chunks that line up with significant changes in the background; or try modifying the selection very slightly – this can produce dramatically different results. Although Content-Aware Fill is powerful, it's not always predictable.

SHORTCUTS
MAC WIN BOTH

65

Content-Aware Fill 2

W E'VE SEEN HOW CONTENT-AWARE FILL CAN remove unwanted objects from a scene, almost perfectly. It's a truly extraordinary technology, which consistently manages to amaze seasoned Photoshop users with its sheer power and unprecedented ease of use.

Here, we'll look at another somewhat surprising use of the system: filling in the corners after an image has been rotated. This is a technique that works especially well with panoramas, as well, as it can automatically interpolate the ragged white space we frequently see around the edge of wide landscapes formed by combining multiple original images.

In this tutorial, we'll also make use of the new Straighten option with the Ruler tool – a feature Photoshop users have been asking for for many years.

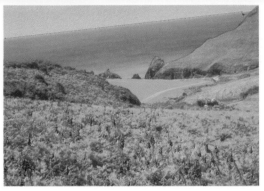

1 This is our starting point: a pleasant enough landscape, unfortunately shot at a rather bizarre angle. Begin by picking the Ruler tool, which is nested behind the Eyedropper tool in the Toolbar. Drag it from left to right (or from right to left, if you prefer) along the horizon line, so that the line drawn by the ruler matches up perfectly with the angle of the horizon in the image.

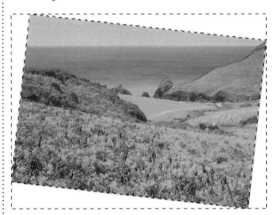

4 Use the Magic Wand to select all the four corners (above), then expand the selection by around 8 pixels so the selection takes in the edge of the landscape (below).

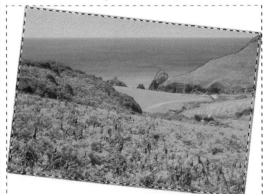

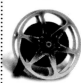

2 Once the horizon is marked, click the Straighten button on the Ruler tool's Options bar. The image will be automatically rotated and cropped to remove the white corners, cropping in on the image to produce the best possible automatic result.

3 Usually, we'd want the image cropped in when we straighten it: but this has resulted in too little sky. Fortunately, the straighten and crop is a two-step process: so we can press ⌘ Z ctrl Z to undo the last crop step, revealing the corners that had been removed.

5 Press Shift Backspace and the familiar Fill dialog will appear. Choose Content-Aware from the Use pop-up menu, and press OK (or hit Enter) to apply the Content-Aware Fill process to the corners of the image.

6 And this is the result: the white corners have been intelligently filled in, using colors and textures sampled from within the image to extend the background seamlessly into the corners.

The process isn't quite perfect, as with any Content-Aware Fill operation, and if we look closely we can see one or two small repetitions: a couple of features on the right have been repeated, for example. But it's an extraordinary first step on our way to fixing the image.

It's now easy enough to correct the errors, using the Spot Healing tool (set to Content-Aware mode, naturally) to paint over the unwanted repetitions. With just a couple of simple strokes, the repeated elements can be painlessly removed, leaving us with a perfectly patched landscape.

HOT TIP

Users of versions of Photoshop earlier than CS5 can't use the Content-Aware Fill system, but they can perform a simple straightening operation – even without the new Ruler tool option. To do this, use the Crop tool to draw a rotated rectangle inside the image, the top edge lining up with the horizon; then zoom out to show the canvas outside the image area, and drag the Crop corners so the whole image is enclosed, then hit Enter.

Content-Aware Moving 1

1 Let's begin by making a selection around the sheep on the right. Use the Content-Aware Move Tool to make a rough selection that includes a fair bit of background: it's actually a mistake to make the selection too precise.

THE CONTENT-AWARE MOVE TOOL is the only new tool in Photoshop CS6, and it's a logical extension of the Content-Aware Fill and Spot Healing Brush Tools.

The tool is located in the pop-up menu beneath the Spot Healing Brush Tool in the Toolbar – or you could just repeatedly press **J** to cycle through the tools until you reach it.

Selecting an area with the new tool is exactly like making the same selection with the Lasso tool. Of course, you don't have to use the tool to make the initial selection; you could use any of the other selection tools instead, and then switch to the Content-Aware Move Tool afterwards.

Spot Healing Brush Tool	J
Healing Brush Tool	J
Patch Tool	J
Content-Aware Move Tool	J
Red Eye Tool	J

4 The technique works with more complex backgrounds, too. When we select the sheep on the left, against the bushes, we can move it to a new location, and – as long as the bush line more or less lines up – we'll get a seamless join.

7 When you release the button, the Content-Aware Move Tool will do its magic. It will attempt to join the two sheep halves together seamlessly, and for the most part it will succeed. It's not perfect, but it's very close.

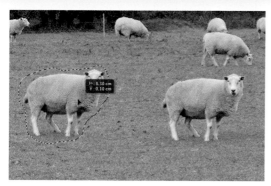

2 Position the cursor within the selected area, and drag the sheep to the left. You'll see a copy of the sheep moving, until you release the mouse button or lift the pen from the tablet: so far, it's the equivalent of moving the sheep with the ⌥ *alt* key held down.

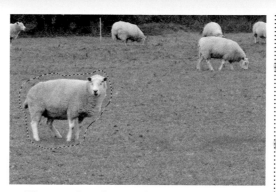

3 When you release the mouse button, the original sheep will disappear, replaced by texture sampled from the surrounding area. In addition, the new, moved sheep will be blended into the background. This is surely the easiest way to move objects around in Photoshop.

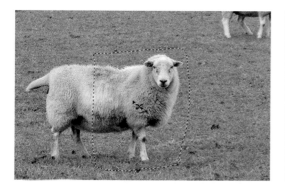

5 So far, we've been using the tool in Move mode. Choose Extend instead from the pop-up Mode menu to change the method, and select half the front sheep.

6 Drag the half-sheep to the right, and position it so that it more or less lines up with the original. (You don't need to be too precise about this, as we'll see on the following spread.) As before, you'll simply be moving a copy.

8 Sometimes some errors will remain. In the previous step we saw that although most of the middle leg had been removed, a vestige of it remained. It's easy to remove it using the same tool, set to Move mode.

9 We can remove the obviously duplicated parts of the sheep's back, as well as the fake-looking join underneath, by using the tool set to Move mode and selecting and dragging other pieces of the sheep into place.

HOT TIP

If you find ugly artefacts remain after moving or extending, or if the joins aren't as seamless as you'd like, then Undo the operation and repeat it, this time moving the selection to a slightly different location. Often, the difference of just a pixel or two can be enough to produce markedly better results.

SHORTCUTS

MAC WIN BOTH

Content-Aware Moving 2

THE CONTENT-AWARE MOVE TOOL works best with natural backgrounds, such as grass and landscapes. However, it is capable of working with straight lines – as long as you're prepared to put in some experimentation.

The tool also works remarkably well with cutouts. It has the ability to smooth out joins, not just within the selected area, but outside it as well, and this makes it unique among Photoshop tools. It all comes down to the choice of Adaptation method, as we'll see.

1 In this example we'll move the window from the right to a position further over to the left of the roof. We'll start by selecting the whole window, including a small amount of roof around it.

5 Here, we'll move the chimney from the center of the roof further towards the middle. Once again, we can begin by making a selection around it with the Content-Aware Move Tool, taking in a little sky as well.

6 With the Adaptation method set to *Medium*, we can see that the chimney blends in reasonably well – but a chunk of misplaced roof texture has appeared where the old chimney used to be.

9 The process works well with cutout objects, such as this horse. Here, we'll use the Content-Aware Move Tool set to Extend mode to make this horse longer.

10 With the Adaptation method set to *Medium*, the horse is fairly neatly extended. Not only has the texture blended together, but the outline has been reshaped smoothly. There's a piece of leg left behind, but this is easily removed.

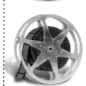

2 We can choose the Adaptation method from the pop-up menu in the Options bar. Set to the default of *Medium*, the window is slightly distorted.

3 Changing the Adaptation method to *Very Strict* means that the window itself is undistorted. But the join with the roof isn't as good.

4 When the method is set to *Very Loose*, the window blends in better with the roof line. But at a cost: the window itself is now too wavy.

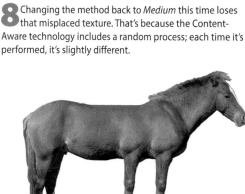

7 Changing the Adaptation method to *Very Loose* smoothes out the old roofline, patching it so that there's now no trace of the original chimney. It is, however, slightly more wiggly than we'd like.

8 Changing the method back to *Medium* this time loses that misplaced texture. That's because the Content-Aware technology includes a random process; each time it's performed, it's slightly different.

11 With the Adaptation method set to *Very Strict*, we can see that while the interior of the horse blends in well, the outline has not been allowed to deform much. This results in a double-hump effect.

12 When the Adaptation method is set to *Very Loose*, the back of the horse is much smoother. But, unaccountably, the original front legs remain. The Content-Aware Move tool can be very unpredictable!

Choose your distortion

1 It might seem that Image Warp would be the best approach, as it gives smooth, curves. But I didn't want to distort the whole object.

2 Making a selection sometimes helps – such as the middle of the machine. But this produced hard corner joins top and bottom.

WITH SO MANY distortion methods available to the Photoshop artist, the hard part can be deciding which one to use.

This job was a commission for *Bloomberg Businessweek* magazine, to accompany a story about a vending company dedicated to selling healthy produce. The art editor wanted me to take the shot of the vending machine, above, and wrap a tape measure around its waist.

The first problem, of course, was to make the waist.

5 I drew three versions of the tape measure using a technique similar to the clock face (see page 46).

6 Before distorting the tape, convert it to a Smart Object (see page 400). This allows easy editing later. Use Image Warp with the Flag distortion to create the basic shape.

7 One of the great things about Image Warp is that you can switch between it and regular Free Transform without committing yourself. Changing to Free Transform (⌘ T ctrl T) allows you to add a perspective distortion to the whole tape.

8 It's now possible to switch back to Image Warp mode by pressing its button on the Options bar. Change the mode from Flag to Custom, and you can adjust the handles for a more natural-looking curve.

3 It turned out that the Liquify filter (see page 224) produced the smoothest, most controllable distortions. Using a large brush, it's possible to push the pixels exactly where they need to be.

4 This is the machine after the Liquify process. It has a natural-looking waist, the curves bending in smoothly from the straight sides.

HOT TIP

As well as allowing us to use Smart Filters, turning the tape into a Smart Object means we can edit the Image Warp effect at any point, and the handles will reappear exactly where we left them. Turn a layer into a Smart Object using Layer > Smart Objects > Convert to Smart Object.

9 When we tuck the tape behind the machine, we need it to be a little out of focus. Add some Gaussian Blur to the tape layer – about 2 pixels should do.

10 Because the tape is a Smart Object, we can paint on the filter's mask to hide the effect, so bringing the front of the tape into sharp focus.

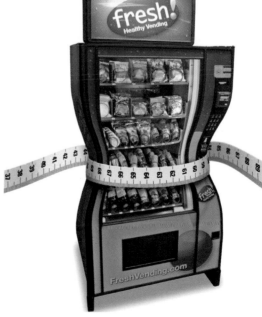

11 Adding an edge to the tape, with color and shading, completes the process.

12 The finished illustration, with the same process applied to the two other pieces of tape, and shadows added onto and beneath the machine.

Wide-angle wonder

W HEN WE'RE WORKING WITH backgrounds, it's always much easier to open doors, place furniture and integrate new items if the verticals are properly squared up for us. Previously, this was a tricky task, involving complex manipulation using the Lens Distort filter.

Now, a new filter – Adaptive Wide Angle – enables us to correct both perspective and fisheye distortions with ease. It's as simple as drawing lines on the screen to indicate how the image should be straightened up.

Here, we'll look at a typical use of this innovative and remarkably helpful new piece of Photoshop technology.

1 When you open the Adaptive Wide Angle filter (it's at the top of the Filter menu) it will attempt to find the camera lens in its database; otherwise, it defaults to Perspective. Because it automatically attempts to correct the image, in this case it's actually exaggerated the distortion.

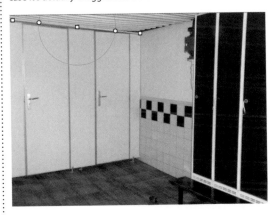

4 After drawing the line, the image will recompose itself so that it really does become a straight line. This is the key to the filter: the image reshapes after each action.

7 We can repeat the process with the line between the right pair of locker doors, again holding *Shift* to mark a vertical. Once again, the image recomposes itself.

2 Here the problem is clearly a fisheye distortion, rather than a perspective one, so we need to change the method in the pop-menu – and the image adjust itself accordingly, so much of the distortion of the original is removed. From here on we'll omit the filter frame for a closer view.

3 We can now click to mark each end of a line we know to be straight – such as the top of the doors. We can also adjust the midpoint, if we need to, for a better fit.

HOT TIP

You can mark as many straight lines as you like: each one will refine the image a bit further. If you have horizontal elements in your image, of course, you can hold *Shift* to mark horizontal as well as vertical lines.

5 Let's now mark a line we know to be vertical – the side of the left door. Click at the top, then hold *Shift* and click at the bottom: the line color changes from blue to purple.

6 When we release the mouse button, the image once again recomposes so that the line we just drew becomes a true vertical. But the right side is still way off.

8 We can continue the process, adding lines to mark both vertical and non-vertical straight lines (just don't hold *Shift* when drawing these), until the image is perfect.

Easy panorama correction

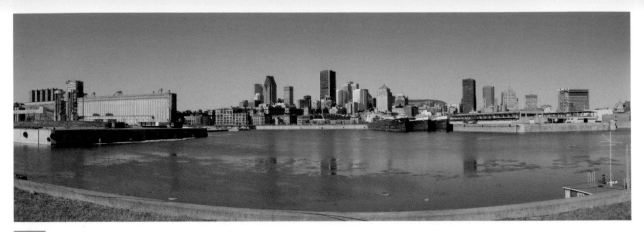

T O CREATE WIDE shots, we're used to taking multiple images and stitching them together, either manually or using Photoshop's Auto-Align capabilities. The problem is, we're often left with very distorted images, such as the one above. The center of the frame was much nearer the camera than the sides, so the concrete shore edge appears to bend down before us.

In the past, this would have been a difficult problem to remedy. But the Adaptive Wide Angle filter in Photoshop CS6 makes it easy to fix.

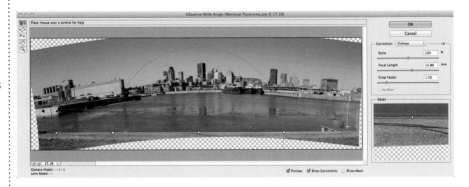

2 Although the yellow line approximated the curvature of the scene, it wasn't perfect – and we need to fix that before we can continue. Grab the center point of the line, and drag it down until it meets the concrete edge. The image will now reshape itself to make that perfectly straight.

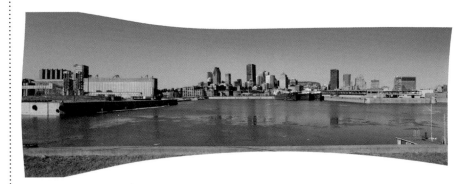

4 Here's the result of adding all those marker lines, after we click OK and return to Photoshop. The scene has now been perfectly straightened out, and is far more useable. but there's just one more thing left to do. Because of the undistortion, there's now a lot of white space in the image. How can we deal with this? Within the Adaptive Wide Angle filter, there's an option to enlarge the scene to fill the space. But we've got a better method.

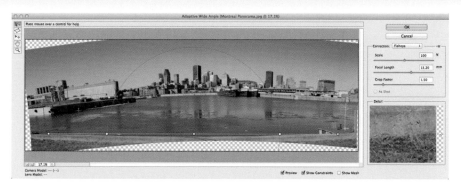

1 Open the image using Filter > Adaptive Wide Angle. We want to make that front edge not only straight, but exactly horizontal. Click one end of it, then hold **Shift** as you click the other end to constrain it to horizontal. Here's the result: not a bad guess at the shape of the distortion.

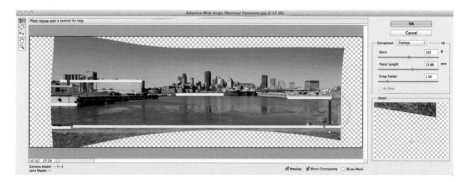

3 Continue to draw in the visible horizontals, such as the tops of the buildings on the left, the bottom of the waterfront in the center back, and so on – holding **Shift** with each line. Also mark the obvious verticals, if necessary. I've exaggerated the lines I've drawn so you can see them more clearly.

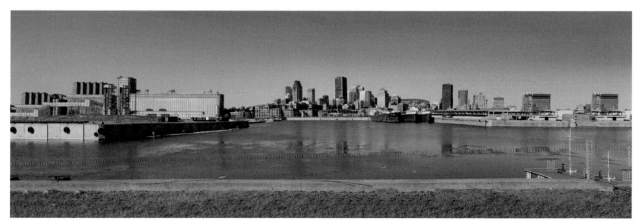

5 Use the Magic Wand to select the area outside the scene, and use Select > Modify > Expand to make it 2 pixels larger. Then press **Shift** **Backspace** to open the Fill dialog, and choose Content-Aware. And here's the result: all that white filled with a remarkably convincing background. It isn't perfect, but it's very close. It won't take much to fix those small errors at the edges.

SHORTCUTS
MAC WIN BOTH

INTERLUDE

The freelance artist

FOR THE FREELANCER, working at home is one of the main attractions of the job. It can also be one of the major drawbacks.

The advantages are plentiful. No need to worry about bus and train times; no commuting; and above all, no office politics. On the down side, there's the problem that you're always at work, even when you're off-duty. In order to complete the first edition of this book I had to rent a flat at the seaside simply to get away from the phone: it's hard to complete a long-term project when the phone's constantly offering you short-term work.

When you work at home, it's important that you have a separate room in which to work. Partly it's because you need somewhere you know won't be littered with washing, children's toys and bicycle parts; but mainly, so you can escape in the evening and get back to reality. In the days when I used to have my computer set up in the back of the living room I felt I could never completely get away from it.

I now never work at weekends. It's a golden rule that I break only two or three times a year, and even then it's only when I'm called out to deliver a lecture or seminar. I occasionally have to turn work down that would require me to work over a weekend to meet a deadline, but my sanity is all the better for the restriction.

Try to arrange your workspace so that your desk faces the window, so the light doesn't glare on the screen, and make sure you use sidelights rather than ceiling lights for the same reason. Don't push your desk right up against the wall or window: you'll need to get round the back to plug in cables, and you want to make this as easy as possible.

I'd also recommend renting a water cooler. Partly because water's good for you, but mainly because since I got mine my coffee intake has dropped considerably. And, at the risk of sounding like your mother, I'd also suggest eating lunch now and again. Falling over from hunger at 4.30 in the afternoon will do little to help you meet a 6pm deadline.

There are two main problems with the freelance lifestyle: not having enough work, and having too much. It's hard to decide which is the more onerous: if you

don't have enough work, you can always spend the spare time putting up shelves. But if you have too much, at some point you'll get to that dreaded stage when you realize that you'll have to turn a job away.

The first time you turn work down it feels awful: after all, there's a job that needs doing, and if you don't do it they'll get someone else – so what will happen next time? Will they come back to you, or go straight to the person they know could get it done last time? The answer is that if you're any good, people will come back; and if you're too much in demand to do the work one week, they'll be all the more keen next time. But if you take on more than you can handle, you'll do neither job well.

There are many factors that determine whether a freelance artist gets plenty of work: whether your work's any good, whether it's original, whether you can interpret a brief, and so on. But without doubt the strongest factor is this: can you meet a deadline?

Unlike trains, TV shows and your brother's birthday, you can't miss a deadline. Period. If a newspaper phones you at 1pm and requires an illustration delivered by 5pm, then that's the time you have to have it finished. It's no good spending an extra couple of hours turning your illustration into a work of art if the paper's gone to press by the time you've finished: they'll be faced with a blank page, which they'll have to fill with a stock photograph, and the phone will go strangely silent for the next few weeks.

The tightest deadline I ever had was 45 minutes, for an illustration for the front page of a newspaper: it ended up with me right up against the deadline, asking for an extra ten minutes and being granted five. The next day a quarter of a million copies were distributed around the country, each one showing the bits I hadn't finished yet; the day after that it was lining the bottom of the cat litter tray. So much for posterity.

3

Hiding and showing

THE EASIEST WAY to remove something from a picture is to erase it. But the simplest way isn't always best: once something has been erased, it's gone, and it can be hard to get it back. Using a Layer Mask, on the other hand, allows us to hide part of a layer without ever deleting it – which means we can choose to show it again later if we change our mind.

There's much more to hiding and showing picture elements than merely painting them out on a mask. We can use all of Photoshop's tools and techniques to make layers interact with each other, using different modes to allow us to see the layers beneath, or automatically making parts of a layer invisible depending on their brightness.

A mastery of all these tools will make you a better Photoshop artist, and put you more in control to make you both more efficient and more effective.

Texture with layer modes

1 The jacket has been separated from the figure and made into a new layer. The texture (a piece of wallpaper) is placed over the top, and completely obscures the jacket.

2 We can use the jacket as a Clipping Mask for the layer by pressing ⌥ ⌘ **G** *alt ctrl* **G** (for versions prior to CS2, use ⌘ **G** *ctrl* **G**).

C LIPPING MASKS ARE the easiest way of constraining the visibility of one layer to that of the layer beneath.

It all gets more interesting when you start to change the mode of the masked layer. (In versions of Photoshop prior to CS, making a Clipping Mask was called Grouping a layer with the one beneath.)

6 Lighten mode is similar to Screen, but with a twist: it only brightens those parts of the underlying layer that are darker than the target layer.

7 Darken mode does the opposite of Lighten. Since the background of the pattern is brighter than the suit color, it has no effect; only the relief on the pattern shows through.

3 Layer modes are changed by selecting from the pop-up menu at the top of the Layers palette. This mode is Multiply, which adds the darkness of the layer to the one beneath.

4 The opposite of Multiply is Screen: this adds the brightness of the layer to the brightness of the layer beneath, resulting in an image that's brighter than either.

5 Overlay mode is a kind of mid-point between Multiply and Screen. It's a more subtle effect than either, and allows the full texture of the jacket to show through.

8 Hard Light is a stronger version of Overlay, which increases the saturation of both layers. Some of the underlying layer's detail is often lost using Hard Light.

9 Soft Light is a toned-down version of Hard Light, producing an altogether subtler effect. The textures of the original jacket are clearly visible beneath the pattern.

10 Color Burn darkens the underlying layer, but adds a strong color element to it, producing a deeply hued result that's quite different to any of the others.

HOT TIP

You can use keyboard shortcuts to change layer modes, so you don't have to keep reaching for the pop-up menu. Hold down *Shift* ⌥ *Shift* *alt* while typing the first letter of the mode's name – so use *Shift* ⌥ **M** *Shift* *alt* **M** for Multiply, *Shift* ⌥ **H** *Shift* *alt* **H** for Hard Light, and so on.

SHORTCUTS
MAC WIN BOTH

Layer masks 1: intersections

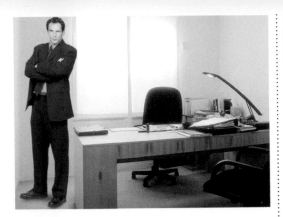

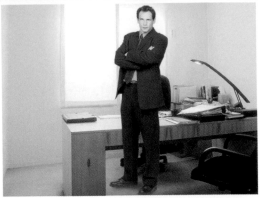

1 When we move the man to the right, we can see the problem: he's in front of the desk, and he needs to be behind it. We could, of course, make a new layer from the desk; but this is a better method.

MOST MONTAGES INVOLVE combining objects in such a way that they interact with each other. In the scene above, for instance, the businessman is standing next to his desk; we want to place him behind it. The simplest way of putting him into this scene is to use a layer mask, which allows one object to appear to be simultaneously in front of and behind another.

Painting in black on a layer mask hides the layer; painting in white reveals it again. Although you'd frequently use a brush to paint a layer mask, because this desk is composed of straight edges we'll use the Lasso tool instead to make the selection, and then fill the selected area with black.

Layer masks have more uses than this, as we'll see later in this chapter: they're one of the most powerful weapons in the photomontage artist's arsenal, and deserve closer inspection to see how you can achieve the best results from them.

4 With the desk area outlined, fill the selected area with black – use `⌥` `Delete` `alt` `Delete` to fill the area with the foreground color. The mask now takes effect.

7 The key lies in the little chain icon between the layer and its mask. Click here to remove it; then click on the layer icon, rather than the mask icon, to select it.

2 Choose Layer > Add Layer Mask > Reveal All. This will make a new, empty mask with the Man layer. When we paint on this mask, black will hide the layer; painting in white will reveal it again.

3 We'll use the Lasso tool to select this desk. It helps to reduce the opacity of the Man layer so we can see the background. Trace the shape of the left half of the desk, holding ⌥ *alt* as you click with the Lasso.

HOT TIP

Painting on a mask with black hides the layer; painting with white reveals it. A useful shortcut is to press **X**, which swaps foreground and background colors over. This makes it easy to adjust the mask without having to swap colors in the toolbox.

5 When we bring the Man layer back to full opacity, we can see that the mask has done its job: he's now effectively hidden behind the desk.

6 When we move the man, though, we can see a problem. The mask is moving with him, which looks ridiculous. We want to move the layer, while leaving the mask where it is.

8 Now that the layer is unchained from the mask, we can move the man around – and the mask remains in place. We can position him anywhere behind the desk with ease.

9 Because the background is still a single layer, we can adjust it as we like: here, we've boosted the brightness considerably. The man, of course, remains untouched.

SHORTCUTS
MAC WIN BOTH

Layer masks 2: soft edges

1 A patch of cloud has been placed directly over the top of the grass in this image. The effect is clearly desperately unconvincing, and even raising the horizon line by deleting a section of sky would look like a poor montage. To enhance the misty effect, we'll blend the sky smoothly into the grass.

ANY OF THE painting tools can be used on a layer mask – not just the Brush. If a tool can be used in a regular Photoshop layer, it can be used on the mask as well.

This greatly extends the scope of masking, as well as allowing us to create some interesting and unusual effects. Here, we'll use the Gradient tool to produce a softly feathered edge to a bank of cloud, looking just as if we'd removed it with a huge Eraser.

More interesting is the second effect, which uses the Smudge tool to create the mask by bringing in the black around the figures, so that the grass appears to overlap them convincingly.

3 This sultry pair seem unaware of the fog rolling in behind them – but we need to make them fit into their environment better. After creating their layer mask, we first hold ⌘ ctrl and click on the icon in the Layers palette, which loads up the area taken up by the pixels in the layer. Then inverse the selection, using ⌘ Shift I ctrl Shift I; fill the new selection (which includes everything except the couple) with black. You won't see any change: that comes later.

2 After creating a layer mask for the cloud layer, choose the Gradient tool and set it to Foreground to Background, using black and white as the respective foreground and background colors. Now position the Gradient tool at the bottom of the clouds and drag vertically, holding the Shift key down as you do so to create a pure vertical. The result is a smoothly fading mask: the mask itself is shown inset.

HOT TIP

Experiment with different brushes and tools on layer masks to see the effect. Using a brush set to Dissolve, for instance, would be a good way of masking these figures if they were lying on sand rather than grass. For less defined background surfaces, try using the Blur tool instead – set it to Darken, or it will have little effect.

4 The layer mask we just created looks like the inset (above right). Because white is the selected area, the hidden region (black) hides nothing. Now for the interesting bit: using the Smudge tool, gradually streak up the black mask where the bodies touch the ground. Each streak will hide a part of them, and the result will look as if the blades of grass are truly in front of the bodies. The minimal shadow, painted on a new layer behind them, simply adds to the effect.

SHORTCUTS

Layer masks 3: smoothing

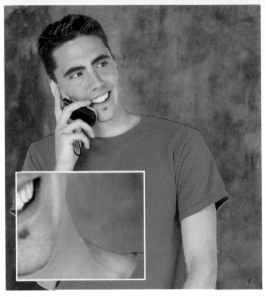

CUTOUT OBJECTS CAN LOOK TOO crisp, particularly if they've been silhouetted using the Pen tool. This figure appears false against the slightly out-of-focus background: it's an obvious montage that wouldn't fool anyone.

One technique might simply be to feather the edges of the hand. But that's an irrevocable step: anything that has been permanently deleted will be hard to put back afterwards.

Photoshop can add feathering to Layer Masks, which allows us to soften a mask's edge. First, of course, we need to create a mask for the layer.

1 First, hold ⌘ *ctrl* and click on the layer name to load the selection. Make a layer mask using Layer > Layer Mask > Reveal Selection. (Users of Photoshop CS5 and above can omit the first step, instead choosing Layer > Layer Mask > From Transparency.) Here's how the mask looks: its crisp edges won't affect the layer yet, since it's only masked what isn't visible anyway.

4 We can add a soft shadow using the same technique. First, make a new layer behind the target layer and fill with black. Hold ⌥ *alt* and drag the Layer 1 mask's thumbnail onto the Shadow layer to duplicate it, then offset the whole layer slightly by dragging it down and to the right.

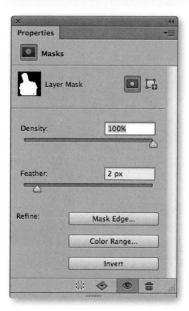

2 Now open the Masks panel, and drag the Feather amount. What's happening here is that the mask, which was previously wholly outside the pixel area of the image, is now encroaching upon it as it becomes softer: the layer is being progressively hidden from the outside in.

3 Here's the result of softening that mask. The layer now blends more smoothly into the background, and we lose that crisp edge. The benefit of this approach is that we can adjust or remove the feather at any point, to suit the image requirements.

HOT TIP

For users without Photoshop CS4, there is a workaround: simply use Gaussian Blur on the layer mask (not on the layer itself) after it's been created, or feather the selection at the time of creation. You won't have the same editability later, of course, but it will give broadly the same effect. See the deleted Layer Mask spread from earlier editions of this book, on the DVD.

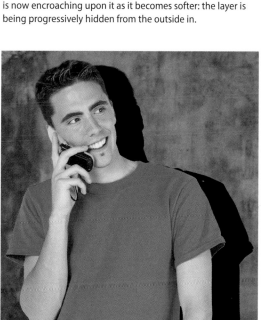

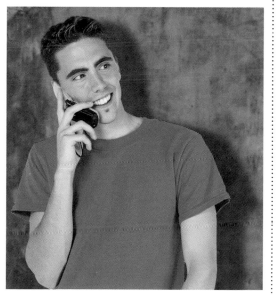

5 This is the result: the black layer is visible only where the mask permits. By feathering the mask, as in step 2 above, we can soften it as much as we like: and unlike simply feathering a selection, we can change the amount at any time.

6 You might expect that lowering the Density value on the mask layer would produce the effect shown above – a paler version of the shadow. In fact, it will have the opposite effect: the hidden background will start to reveal itself. To make the shadow lighter, lower its layer opacity instead.

89

Layer masks 4: auto masking

AS WELL AS PAINTING MASKS manually, we can make them using a method comparable to the Color Range selection method, as explained on page 34. The difference is that when we make a selection within the mask environment, the selected colors are hidden in the image.

We can now also refine the edges of a mask, in the same way that we might use Refine Edge on a selection.

In this example, we'll look at this photograph of trees. A different, more dramatic sky has already been placed on a layer behind, to provide a new backdrop.

This technique is similar to using the Background Eraser, in that it removes ranges of colors: the difference, of course, is that nothing is erased, only hidden. What was previously a multi-step process looks set to become the de facto standard for masking unwanted image areas.

1 The first step is to make a Layer Mask for the layer, then open the Masks panel and click the Color Range button. Click in the sky to select that range of colors. If you see an image like this, the color clicked on is the range that remains visible – but this is easy to fix.

4 With our whole color range selected, we can still see some slight fringing. It might be possible to select this within the Color Range dialog – but there's another method of smoothing out the mask, and that's to press the Mask Edge button.

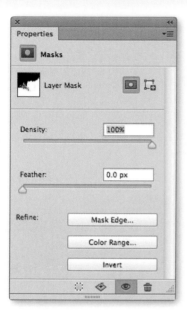

2 Click the Invert button in the Masks panel to swap the Layer Mask around so that what was hidden becomes visible, and vice versa.

3 Here's a true view of the image, with the color clicked on duly hidden, revealing the new sky behind. To add more colors to the selection, hold *Shift* and click on them: they'll disappear as the mask becomes applied to them.

HOT TIP

Although the Color Range mode will provide good, quick results, it shouldn't always be relied upon to complete the job. But that's the advantage of using a layer mask, rather than erasing: we can always edit the mask by hand, painting areas in and out as we see fit.

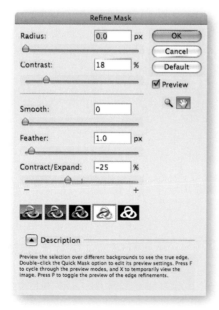

5 The default setting here is to see the layer on a white background. Click the first icon so we see the sky behind, and use ⌘ *H* *ctrl* *H* to hide the 'marching ants' border. A tiny amount of feathering, and no smoothing, is required here.

6 Experimenting with the sliders in the Refine Mask dialog will give us the best results. We don't want a soft edge in this instance, so raise the Contrast setting; but contracting the selection slightly will remove the unwanted blue fringe.

SHORTCUTS
MAC WIN BOTH

Weaving in and out

S OMETIMES, WHAT SEEMS TO BE THE most straightforward of jobs can prove to be surprisingly time-consuming. So it was with this one, a cover for the New York magazine *Bloomberg Businessweek*.

The idea was simple: they wanted the headline that they'd already laid out (above), together with the masthead, woven into a mess of wires and cables. They evern provided me with a photograph of the wires and cables.

It was the actual weaving that took the time: deciding which parts of the lettering were hidden, and which visible. The text had to be integrated into the cables, but with enough of it still visible to be legible.

Here's how the process turned out.

1 This is the original wiring image. Although the wires themselves are clear enough, there's too much going on in the background: all those labels and panels would detract from the cover, making it too confusing.

4 I made a Layer Mask for the type layer, and, using a small, hard brush, painted out each cable where I wanted it to cross in front of the text. I tried to make as many cables as possible weave in and out – such as on the 'e' of 'The' – to make the integration look more dynamic.

2 On a new layer, I made a Curves Adjustment Layer (see page 114) to darken the whole cover, then painted out on the Layer Mask to reveal the middle more clearly. All the labels and so on were painted out on a new layer.

3 I moved the text to the top of the layer stack, inverting it so that the black turned to white. With the text in place, I could now move the image around so that it fit the cover shape better.

A job like this is always a balance between impact and legibility. I would have liked to have tied the Bloomberg Businessweek masthead into the cables rather more, but it was essential that this should be legible – and any further concealment might have reduced that property.

5 With the text now inserted into the cables, I needed to add shading to make it look like it was really in place. I made a new layer, using the type layer as a Clipping Mask, and painted shadows on here in black, using a soft-edged brush at an opacity of about 50%.

6 As well has the cables casting shadows on the type, the type had to create shadows on the cables beneath. On another new layer, beneath the type layer, I painted shadows that curved around the cables on which they appeared, for a more three-dimensional appearance.

Blending 1: fire power

1 Here are the two elements of this montage – the hand holding the gun, and the photograph of the firework which has been rotated to match the gun's angle. Simply changing the mode of this layer to Screen would get rid of the black, but the flame would be pale against a light background – and would become invisible against white.

THE BLENDING OPTIONS FEATURE, tucked away within the Layer Style palette, is one of the most overlooked features in Photoshop. But it's an enormously powerful tool that allows you to hide or show picture elements automatically, without touching a brush or layer mask.

In the image above, for the *Guardian*, I used Blending Options to make the bottle surface show through the distorted G2 logo, and the label 'printed' on the bottle.

3 When we zoom in on the image, however, we can see that moving the slider produces a sharp cut-off between what's visible and what's hidden. It's an ugly, stepping effect; in order to make the effect more realistic, we need to look more closely at exactly how that black slider operates.

5 Further adjustment of both sliders allows us to set the visibility of this layer exactly as we want it. Now, the left slider is set to 50 and the right slider to 120, which removes exactly the right amount of black without weakening the effect of the rather enthusiastic gunshot.

2 Double-click the layer's name or choose Layer/Layer Style/Blending Options to bring up the dialog. It's the bottom section we want to look at, the one headed Blend If. On the This

Layer section, drag the black triangle to the right – here, it's at a position of 10 (working on a scale of 0=black to 255=white). This hides everything darker than 10 in the image.

4 What appears to be a single triangle is, in fact, two. Hold down ⌘ *alt* as you drag and it will split into its two sections, which can be

manipulated individually. With the left slider still set to 10, we now drag the right one out to a position of 75. This is what happens: everything darker than

10 is hidden, and everything brighter than 75 is fully visible. But now, all the values in between fade smoothly between the two states.

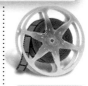

6 When placed against a suitable background (somehow libraries always come to mind when I think of gunshots) the effect is dramatic. I don't

believe there's any other way that this flame could have been isolated from its background as convincingly as this in Photoshop.

HOT TIP

Blending Options can be used to remove light colors as well as dark ones: simply drag the right-hand (white) slider to the left instead, and split it in the same manner.

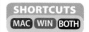
SHORTCUTS
MAC WIN BOTH

95

Blending 2: plane view

THIS SECTION DEALS with the other half of the Blending Options dialog – the Underlying Layer section. This controls the visibility of the target layer depending on all the layers beneath it, not just the one directly below.

The illustration above was for a *Sunday Times Magazine* cover, illustrating the crowded state of Britain's air traffic. Rather than creating an Underlying Layer adjustment for each plane, I duplicated the cloud layer to the front and removed the blue sky from that layer: seen through it were not only the planes, but the original sky as well.

1 In this example, we're going to make the plane fly through the clouds rather than just sitting on top. Working on the plane layer, it's clear that we don't want to hide that layer depending on its brightness values: unlike the example on the previous page, this isn't simply a case of removing the black element from the target layer.

3 Since we're working with blending values rather than with a layer mask, we can move the plane anywhere we want within the artwork and the effect will still apply. This is a great technique for animation, and works well if you're planning to import Photoshop artwork into After Effects.

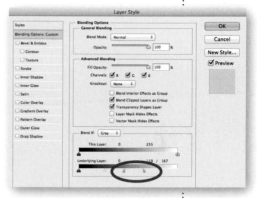

2 Because we want the visibility of the plane to be affected by the presence of cloud in the layer beneath, we need to turn our attention away from the This Layer section of the Blending Options dialog, and look instead at the Underlying Layer section. This works in exactly the same way, except – as its name implies – the visibility of the target layer is determined by what's going on underneath. Here, we've dragged and split the right (white) slider rather than the left (black) one; settings of 118 and 167 do the job well.

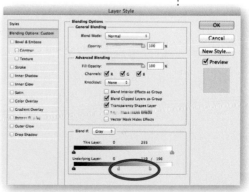

4 Although we hid the plane in the clouds correctly, the overall effect can be made more realistic by allowing a little of the plane to show through – after all, clouds are not solid objects. This is achieved by dragging the right slider back towards the right, increasing the number: in this instance, a value of 196 as the white cutoff point is enough to add just a touch of translucence to what would otherwise be over-opaque clouds.

Graphics tablets

ONE OF THE QUESTIONS that's most frequently asked on the How to Cheat in Photoshop reader forum is: should I buy a graphics tablet? Many readers have them; others consider them too unwieldy, and prefer to stick to a mouse.

Whenever I weigh in on one of these discussions, I always advise any serious Photoshop user to invest in a Wacom tablet. They provide a higher degree of control and flexibility than can be achieved with a mouse: pressure sensitivity means we can apply shading and brushstrokes with far more freedom and accuracy than can ever be possible with a mouse alone. In addition, Photoshop now takes advantage of pressure sensitivity in custom brush design, where the variation in pressure can be used to control anything from the size of the brush to the angle of the brush tip, to the variance between foreground and background colors.

There's just one problem: graphics tablets do take an awfully long time to get used to.

Most new users will happily pick one up, assuming it will feel and operate like a pencil. And this is the issue. Because graphics tablets feel nothing like a pencil. They don't weigh the same, they don't feel the same in your hand, and above all they don't behave in the same way. Why? Because you're drawing on a tablet on the desk, and your strokes are appearing on the screen in front of you. It's a totally different experience.

It's a sad fact that most users, when they buy a tablet, begin by hating it. Not just finding it a little clumsy, or somewhat awkward and hard to control, but actually despising the thing and resenting the money they've laid out on it. The only solution is to persevere, however. Within two weeks at the most, you'll find that the technique suddenly clicks, and drawing with a pen and tablet becomes the most natural thing in the world.

Suddenly, it's the mouse that feels unwieldy and cumbersome. I now use the tablet exclusively when working in Photoshop – to the extent that I carry one with me to plug into my laptop when I give lectures. So my advice here is: stick with it, and it will make sense in the end.

The next question is one of size. With so many variations available, how on earth do we decide? If we're using a 27-inch monitor, as I am, does that mean we need a huge tablet to go with it?

Not in my view, no. I use the smallest tablet there is – the A6 model, which has an active area of just 4½ by 5½ inches. It's small enough to fit neatly on my desk, yet provides all the space I need to make grand, sweeping gestures covering the whole screen. And my arm doesn't get worn out in the process, as it would with a much larger model. It's called the Wacom Intuos, and despite its small size it works perfectly with my 27-inch monitor.

Wacom also make the tempting Cintiq model, which incorporates a good-looking LCD screen into the tablet. The Cintiq perches on your desk, and you draw straight onto the screen, just as if you were painting on canvas.

This approach has its advantages, certainly. Drawing on the screen is far more natural than drawing at a distance, and there's an immediacy here that you don't get when using a conventional tablet. But there are two big problems. One is that with the monitor so close, there's nowhere to put the keyboard other than out of the way to one side – which makes it awkward to get to when using shortcuts, of which there are dozens in Photoshop.

The other problem is more fundamental: when you're drawing with the stylus, your hand gets in the way. This may be an issue that artists have contended with since the first painter picked up his brush, but for me it's a dealbreaker.

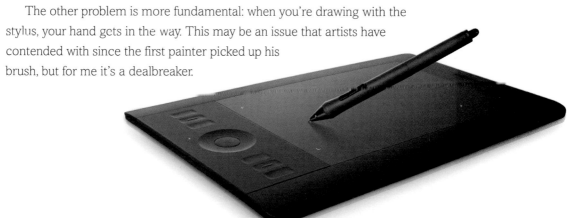

4

Image adjustment

IN AN IDEAL WORLD, our digital cameras would capture exactly what we see and everything we photograph would look perfect. But cameras are limited in scope, and the scenes we shoot rarely look as good as they could.

In the bad old days before Photoshop, photographers would spend hours in darkened rooms reeking of chemicals in order to produce the perfect image. With Photoshop, of course, our task is vastly easier: we're able to adjust colors, tweak contrasts, and change every aspect of the way a picture looks without having to turn the light off.

Photoshop is awash with adjustment tools. But which one should you use for a particular job? In this chapter we'll look at the main methods Photoshop artists use to fix their images, so you can decide which you need in each situation.

Shadows and highlights

1 This view of London's Trafalgar Square shows Nelson's column – but the sky was so bright it overwhelmed the camera, and we can hardly make out any detail in here.

THE SHADOW/HIGHLIGHT ADJUSTMENT IS AN enormously powerful and time-saving tool. This bust of Liszt (top) has been photographed outdoors against a dark background. Hard to remedy conventionally, the default settings of Shadow/Highlight (bottom) produce great results. The background is duly brightened, and none of the fine bright detail of the bust has been lost in the process.

4 This figure poses the opposite problem. The lighting on the skintones is fine, but the white coat is very bright – it almost disappears against this white background. We'll use Shadow/Highlight once again, but this time we'll turn our attention to the Highlights area rather than the Shadows section.

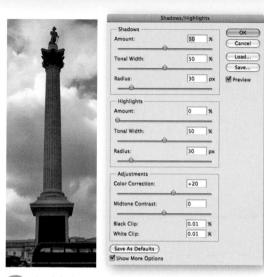

2 The default settings of Shadow/Highlight produce a markedly better image, with much of the detail that seemed to be lost in the shadows being returned to view. Note how the sky has not been affected by this operation: it still contains all its original detail.

3 We can increase the Amount setting further: here, at 90%, we can see much more of the column. Raising the Tonal Width slider slightly allows for more dramatic results. But note how the sky is still full of detail: had we attempted this operation with Curves, it would be blown out.

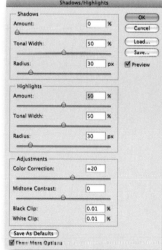

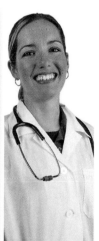

5 To start with, reduce the Shadows amount to zero so there's no change in that area. Now we can increase the Highlights value to, say, 50%, which darkens up the coat well. The coat is looking good, but some of the Highlight setting has 'leaked' into the skin, making it too dark and over-saturated.

6 To fix this problem, we need to reduce the scope of the Highlights adjustment. The Tonal Width slider in the Highlights setting has a default value of 50%; by reducing this to around 20%, we're able to limit the range of the effect so that the skintones are not included. Now, the coat has been reduced in brightness, while the skin has been toned down only slightly.

HOT TIP

Photoshop allows you to customize keyboard shortcuts, and it's well worth assigning a custom shortcut to this feature, since it's likely to be one you'll use on almost every image you open. Dodgy lighting was never this easy to cope with!

Learning Curves

1 When you open the Curves dialog you see, perhaps surprisingly, not a curve but a straight line. As a default, the input values are the same as the output, so there's no change.

THERE ARE MANY WAYS OF adjusting images in Photoshop – Levels, Brightness & Contrast, Hue & Saturation, Color Balance. The most powerful of the lot is Curves, which allows you to make both fine and sweeping alterations in a single dialog.

The Curves dialog is one which confuses many new users, but it's worth getting to grips with. The graph shows how the input values (the original image) translate into the output values (the result of the operation); by subtly tweaking this graph, we can adjust not only the overall brightness and contrast but each of the red, green and blue channels as well.

Using Curves often involves thinking backwards: so if an image is too red, for example, the best fix is often to increase the blue and green components, rather than to reduce the red (which would result in too dark a result). Subtlety is the key: small adjustments are always the best way forward.

4 As well as clicking in the center, we can also adjust the endpoints. Clicking the top right point and dragging down limits the brightest part of the image, reducing contrast.

7 We can also adjust each color individually. Choose the color channel from the pop-up menu: we'll correct the red cast by adding green to the image.

2 By clicking in the center of the line and dragging upwards, we make our first curve. Raising the curve increases the overall brightness of the scene.

3 Conversely, clicking in the center and dragging downwards lowers the brightness, producing an image that's darker overall.

HOT TIP

If you find that Curves behaves in the opposite way for you, make sure the gradient bar beneath the graph is dark on the left and light on the right. If it isn't, click the double-headed arrow in the center and it will be changed for you.

5 If we drag that top right point to the left rather than down, we produce the opposite effect – increasing the contrast of the image. This is a very useful and controllable quick fix.

6 By dragging the top and bottom points towards the center, we create a stylized, posterized effect that turns any photograph into more of a graphic object.

8 To correct our image further, we need to add more blue. Switching to the Blue channel allows us to raise the blue content. But the image is now too washed-out.

9 Click once in the center of the RGB curve to 'pin' that midpoint; now drag just the top half of the curve to make this S shape, and the result is to increase the overall contrast.

Matching colors with Curves

MATCHING COLORS between two photographs is at the heart of the photomontage artist's craft. Variations in lighting can produce enormous differences in color and tonal range, which need to be balanced in order to make a montage work.

While the hand shown here was a reasonably good original digital capture, it looks completely wrong when placed against a face which appears to be a totally different color.

The Curves adjustment is the ideal tool for this job. The process involves several steps, and it's a good way of learning how to manipulate Curves to achieve precisely the results you want.

1 At first glance, the hand needs to have much more yellow in order to match the face. There's a problem here: we have access to each of the Red, Green and Blue channels, but there's no yellow. The trick is to think in reverse, taking out colors we don't want rather than adding colors we do.

It's fairly clear, if we look at it this way, that the hand is far too blue. So open Curves (using ⌘ M ctrl M) and switch to the Blue channel using the pop-up menu. Click in the center of the line and drag down slightly to remove that blue cast from the skintones.

2 Removing the blue from the midtones, as we've just done, helped a lot; but we can still see some blue in the highlights, most noticeable in the shine on the backs of the fingers and in the fingernails. To fix this, click on the right side of the curve and drag vertically downwards. This limits the brightest part of the Blue channel, reducing the highlight glare.

3 So far, so good – but the image still isn't quite the right color. Taking out the blue has left it with a greenish tint. We could simply take out the green, but that would make the whole thing too dark; instead, if we compare it to the face, we see that the face has more red in it. So switch to the Red channel, click in the center of the line and drag upwards slightly to increase the red content in the midtones.

4 The result of the last three operations left us with a hand that is now the right color, but which is too highly contrasted: the shadow on the left of the hand is much darker than anything we can see in the face.

Switch now to the RGB channel, which affects the overall contrast and brightness. Because we want to remove the shadow, we need to click on the extreme left of the line – which marks the darkest point – and drag upwards, to limit the darkness of the layer.

5 Much better – but not quite there yet. By reducing the shadows, we've also left ourselves with a hand which is somewhat lacking in contrast. We can boost this by clicking on the top right corner of the line, and dragging it to the left: the result of this is to compress the tonal range, so boosting the contrast overall. It's important to make only a small adjustment here, as it's easy to go too far. In the end, though, we've got a hand which matches the face almost exactly.

The photographer's level

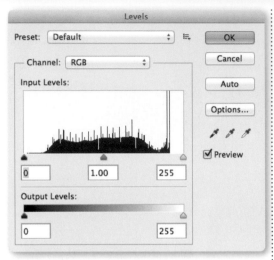

THE LEVELS ADJUSTMENT HAS long been favored by photographers for its control set, based around a histogram that shows the make-up of tones in the image.

It's also a useful tool for the rest of us, allowing us to apply brightness and contrast and midtone adjustments to an image, as well as balancing colors.

Much of this can be performed automatically, either by using the one-click solution or, better, by marking the white, black and mid gray points yourself using the tools provided.

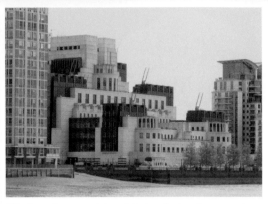

1 This is the original shot of the London headquarters of MI5 – the UK equivalent of the CIA. The shot is lacking in contrast, and poorly exposed.

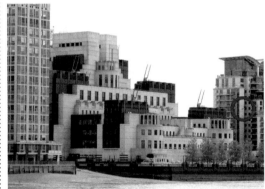

4 We can correct that pink color cast as well. Select the Gray eyedropper, and click on a gray part of the building – such as the concrete next door.

6 By way of comparison, let's try just hitting the Auto button in the Levels dialog. The contrast is OK, but the pink color cast remains. Doing it yourself is often better.

2 Beneath the word 'Options' are three cursors. Pick the White eyedropper, and click in a white area of the shot – the sky in this case – to adjust the image.

3 Switch to the Black eyedropper, and click in a black area of the image. Here, the blackest area I could find is the low doorways.

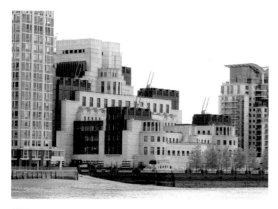

5 If that all looks rather dark, we can brighten the midtones. Grab the gray slider beneath the histogram, and drag it to the left.

The advantage of being able to see the histogram is that you can tell at a glance when a region has been adjusted too much, because gaps will appear in the form of vertical lines. While these may not matter too much for everyday montage purposes, too many gaps would give smooth contours, such as skies, an unwanted stepping appearance.

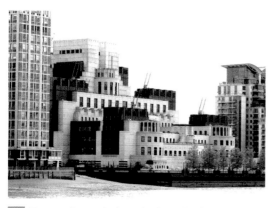

7 You can adjust each channel independently, as well. And to adjust the overall contrast, drag the white and black sliders beneath the histogram closer together.

Selective hue and saturation

T HERE ARE MANY WAYS TO CHANGE an object's color in Photoshop, and we've looked at a few of them in this chapter. One often overlooked method is the Hue/Saturation dialog – not to reduce saturation globally or to colorize an image, as is usually done with this tool, but to adjust selective colors within a document.

The ability to select broad color ranges has been in the Hue/Saturation adjustment for a long time. Photoshop CS4 brought us the ability to drag directly on our images. We'll use the technique to fix this over-saturated boxer.

1 One approach would be to open the Hue/Saturation dialog (⌘ U ctrl U) and reduce the opacity of the whole image. But this takes all the color out of the skintones as well, making the boxer look unappealingly gray. Fortunately, there is an alternative within the Hue/Saturation dialog.

2 Click the 'scrubber' button at the bottom left of the dialog, to activate the direct action tool. When we now click on the shorts and drag to the left, all the blues in the image are desaturated: the pop-up in the dialog changes automatically to 'Blues' to show what's happening.

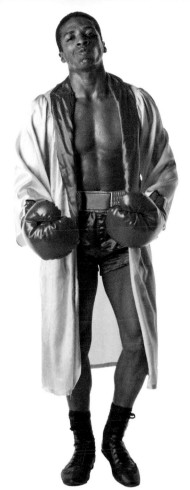

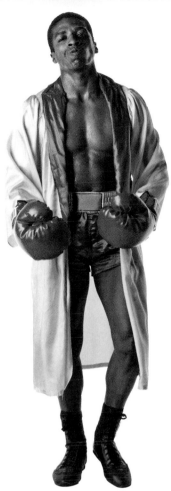

3 When we try the same technique with the red gloves, however, we hit a snag. The gloves have desaturated, certainly; but the skintones have also been affected. We want to change the gloves, but to leave the skin intact.

4 At the bottom of the dialog, we can see what's going on: the sliders highlight the range of colors affected by the operation. By dragging the right sliders towards the left, we limit the effect on the more orange end of the spectrum – which means the skintones are left alone.

5 If we hold ⌘ *ctrl* while dragging we're able to change the hue, rather than the saturation. Here, we've completed the process by clicking on the shorts, dragging to change them to a color more in keeping with the new glove and trim shade – increasing the saturation slightly as well.

SHORTCUTS
MAC WIN BOTH

Sharpening: Unsharp Mask

SHARPENING MEANS bringing back definition to soft or slightly out-of-focus images. Rather than using the uncontrollable Sharpen and Sharpen More filters, the best way of proceeding is to use the Unsharp Mask filter.

The very name is enough to put you off, let alone the confusing interface. It's the single filter that confuses Photoshop users more than any other. The Unsharp Mask filter works by enhancing border regions between areas of contrasting color or brightness, giving the impression of a more tightly focussed original photograph.

The amount of sharpening you apply depends on the original image – and also on the paper the final image will be printed on. Glossy art paper, such as that used in this book, is capable of reproducing images at high quality; but if your work will end up on newsprint, say, you'll need to sharpen your images twice as much as normal so they don't look fuzzy when they're finally printed.

1 Here's our image, shown magnified (above) so we can see the effect. It's simply a dark gray letter placed on a light gray background, with no color to distract the eye.

2 Here's the result of applying 100% sharpening with a radius of 1 pixel. The inside of the dark gray is darkened and the inside of the light gray brightened to increase contrast.

The interface

Toggle the Preview on and off to compare the before and after images before committing yourself

Hold ⌥ *alt* and click Cancel to revert

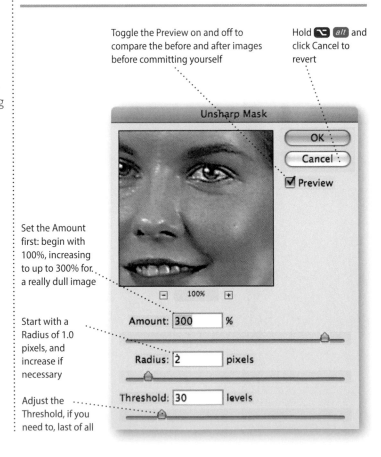

Set the Amount first: begin with 100%, increasing to up to 300% for a really dull image

Start with a Radius of 1.0 pixels, and increase if necessary

Adjust the Threshold, if you need to, last of all

3 Increasing the amount to 200% makes the contrast between light and dark even stronger, producing a much crisper result.

4 When we increase the radius to 2.0 pixels, we can see that the lightening and darkening operation now occupies a wider border around the hard edges – 2 pixels wide, in fact.

5 By increasing the Threshold value, we determined how much of the image is affected by the operation – in this case, the darkening doesn't eat into the gray to such an extent.

Putting Unsharp Mask into practice

HOT TIP

As well as varying the settings while inside the Unsharp Mask dialog, you can fade the effect immediately after applying it. Press ⌘ Shift F ctrl Shift F to bring up the Fade dialog, which gives you a slider that can be used to lower the strength of the filter you've just applied.

1 Our original image is fairly soft, especially around high contrast areas such as the eyes. There's also little detail visible in the hair, and we can use Unsharp Mask to bring both of these into stronger focus.

2 In this exaggerated example, I've used an amount of 300% with a radius of 2.0 pixels. But note how the skintones have become over-sharpened by this operation: that's the area we want left smooth.

3 This is where the Threshold feature comes into play. By raising this to a level of 30, we prevent the filter from acting on the low-contrast skin area, while still enhancing the contrast in the eyes, mouth and hair.

SHORTCUTS

MAC WIN BOTH

Adjustment layers

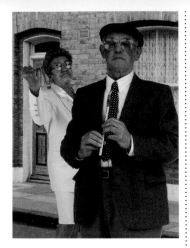

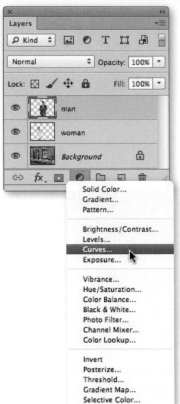

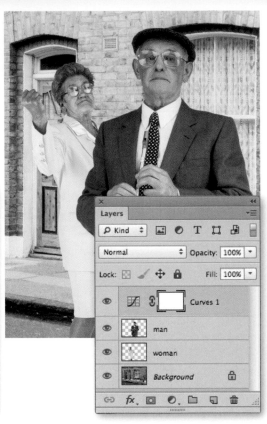

ALL THE STANDARD adjustments – Curves, Levels, Brightness & Contrast, Hue & Saturation – can be applied directly to a layer, as we've seen so far. But they can also be applied as Adjustment Layers, which operate independently of the layer they're applied to. They're also editable at any future point, which is a huge bonus: you don't need to commit yourself to an adjustment at any stage, as you can always go back and change your mind later.

We'll start with a street scene, in which the man and woman are far too dark for the background.

1 Adjustment Layers are chosen from the pop-up menu at the bottom of the Layers Panel. They appear in the Properties Panel, as smaller versions of regular adjustments (below).

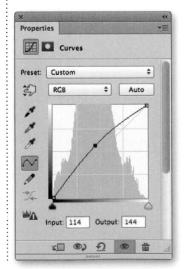

2 An Adjustment Layer will affect all the layers beneath it. Here, we've chosen a Curves Adjustment Layer. Clicking in the middle of the diagonal line and dragging upwards, as seen in step 1, brightens the over-dark people. But because the Background layer is behind the Man and Woman layers, the street has been brightened as well.

5 Adjustment Layers can also be selected from the Adjustments Panel. You can add several adjustments on top of each other, if you like, using each one to modify a different aspect of the image. It gives you a great deal of control over the way a picture looks.

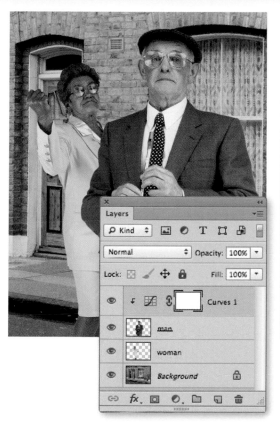

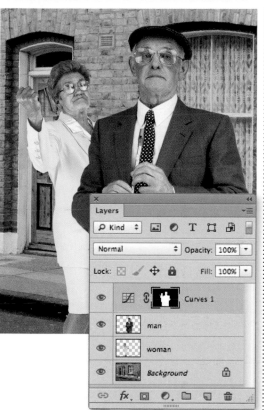

3 One solution is use the layer beneath as a Clipping Mask, by using the shortcut ⌘⌥G ctrl alt G. The Adjustment Layer's icon now appears indented in the Layers Panel, and we can see that it only affects the Man layer. But the woman is now too dark; we need the Adjustment Layer to affect her layer as well. So let's delete that Adjustment Layer, and start again.

4 Load the man as a selection by holding ⌘ ctrl and clicking his thumbnail in the Layers Panel. Add the woman as a selection, by holding ⌘ Shift ctrl Shift and clicking on her layer's thumbnail as well. Now choose the Curves Adjustment Layer as before. As each Adjustment Layer is created, it appears with a built-in Layer Mask. Now, when we drag on the curve, only the selected area is affected.

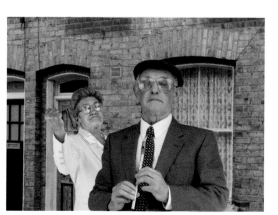

6 You can use masks to apply Adjustment Layers selectively. Here, I've added a Black & White Adjustment Layer at the top, and painted on the mask so only a portion of the image remains in color. I've also added a Vibrance Adjustment Layer above the background, to make the bricks more colorful.

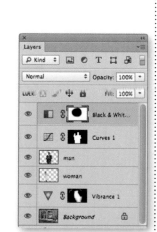

SHORTCUTS
MAC WIN BOTH

Hard Light layer adjustment

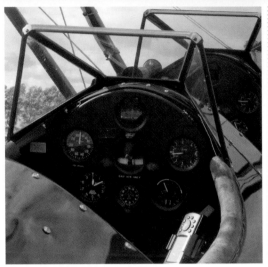

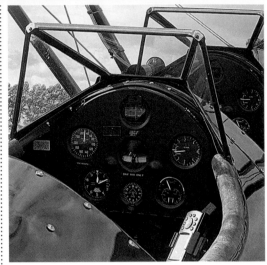

HOW DO YOU MAKE A SOFT IMAGE LOOK MORE crisp? The immediate choice might be to turn to the Unsharp Mask filter. But very often, this produces too much noise, resulting in an image that's altogether unusable.

Here, we'll look at two different methods that both involve duplicating the image, and using a grayscale version of it to strengthen the layer below. Both these techniques work well; it's up to you to gauge which will be best for your particular tasks.

We'll use a High Pass filter on the soft image of the cockpit, and then a Hard Light layer to make Clint Eastwood look sharper.

1 Normally, we might try to treat a soft image by applying the Unsharp Mask filter. But in order to get the degree of sharpness needed for those dials, we're also increasing the amount of noise in the image to an unreasonable level.

4 We could try treating the Clint Eastwood image in the same way, using a desaturated High Pass layer to enhance his features. But the effect is just too strong: he looks altogether too craggy and over-defined.

What worked well for the instrument dials turns out to be overkill for this portrait shot.

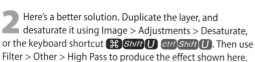

2 Here's a better solution. Duplicate the layer, and desaturate it using Image > Adjustments > Desaturate, or the keyboard shortcut ⌘ *Shift* U *ctrl* *Shift* U. Then use Filter > Other > High Pass to produce the effect shown here.

3 The High Pass filter on its own looks awful – but that's because it's not meant to be seen on its own. Change the Layer mode from Normal to Hard Light, and this is the result: crisp, clear edges and far more readable dials.

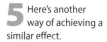

5 Here's another way of achieving a similar effect.

Duplicate the layer, as before, and this time just change the Layer mode from Normal to Hard Light, without running any filter first.

It certainly sharpens up the image, but perhaps too much: the stark look is fine for some purposes, but for general use it's a little overwhelming.

6 We can modify that Hard Light layer to make it more acceptable.

Use Image > Adjustment > Shadows/Highlights, on the Hard Light layer, to control the amount of bright and dark. Taking the Shadows amount up to 100% will brighten all those over-dark shadows for us; drag the Highlights slider until it looks right.

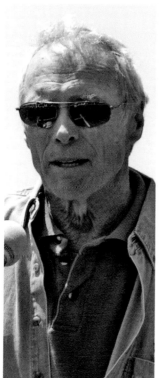

Shadows/Highlights

Shadows
Amount: 100 %

Highlights
Amount: 48 %

OK
Cancel
Load...
Save...
☑ Preview

☐ Show More Options

Taking the initiative

I RECENTLY GAVE A LECTURE to a group of film studies students at a university (which I won't name), to help them brush up their Photoshop skills – even film students need to use Photoshop every now and then. They were an intelligent, perceptive and interested group.

After the lecture was over there was a question-and-answer session, at which they asked the usual questions: where do you get your ideas from, how much do you get paid, and so on. They also asked the most common question of all: how do you get started?

I explained how the process worked in my case – after leaving university with a degree in Philosophy I got a job playing the piano in a wine bar, the manager of the wine bar left to start a local listings magazine and I joined him in that venture, he dropped out after four editions and I spent the next 10 years publishing and editing magazines… and so on.

But, I pointed out, it's so much easier for you guys. You all have digital cameras or phones that are capable of shooting high definition video. Most of you have Macs, which means you have iMovie, which allows you to edit your video, right on your computer, for free. Macs come with GarageBand, which allows even the most unmusical of you to put together a soundtrack for your film. And you all have internet access, which means you can publish your creations instantly, to the entire world, for free.

So the real question is: how many of you have movies on YouTube?

Silence. They all looked nervously at each other and shuffled in their seats. Because the reality was that *not a single one of them* had uploaded a movie to YouTube, Vimeo, Dailymotion or any of the other film-sharing sites.

OK, I went on, here's the situation. You're going to leave here with a degree in film studies, or practical movie making, or whatever your particular course happens to be called. And at some point you'll apply for a job with a film studio, and if you're lucky you'll get an interview. Sitting next to you will be a graduate from another film school, who has a similar qualification. The only difference is that he's

put a movie he made up on YouTube, and it's had half a million hits. So let me ask this question: which of you is more likely to get the job?

I asked why none of them had thought to make and upload any movies, and the reply came back: 'No-one told us we had to'.

It's true, no-one did tell them they had to do that. They didn't *have* to make movies in their own time, of course: that's a strictly extra-curricular activity. They didn't have to use their initiative to demonstrate that their interest in film went beyond doing the bare minimum required to get their grades. They didn't have to think of the internet, of YouTube in particular, as a medium to which they could contribute, rather than as something that they passively consumed.

But ultimately, it's those who grab life by the horns that actually get anything done in this world. Sitting there waiting for Steven Spielberg to come knocking on your door will involve a long wait.

It's the same with Photoshop, of course. I'm often asked how you get started as a Photoshop artist. And the answer is: you just do it. You start by creating illustrations and montages for your own amusement, and you upload them to sites such as deviantart.com, worth1000.com and even the *How to Cheat in Photoshop* Reader Forum. You offer to do montages for your local parish magazine, for the sports team flyers, for local news websites. You design CD covers for friends who are in bands, you enter competitions. The only way to get any good at what you do is simply to do it, and to keep doing it until somebody notices. The more practice you get, the better you will be.

I spoke to the nine-year old son of a friend recently, and asked him what he wanted to do when he grew up. 'I want to be an artist,' he told me proudly. I replied that I hadn't realised he was into art – could I see his drawings? 'Oh, no,' he said, 'I don't do any of that now. Being an artist is what I want to do when I grow up.' But it doesn't work that way – with art, or with anything else. If there's something you want to do – whether it's becoming a professional designer, playing the piano or running a marathon – the only way to do it is just to do it.

5
Composing the scene

IT'S IMPORTANT THAT EVERY ELEMENT in your montages should be perfectly cut out, properly lit, and color balanced to match all the other picture elements. But the most important factor of all is arrangement: how the objects relate to each other is critical.

And yet composition is an area that's often overlooked by Photoshop artists: so tied up are they in the detail, they forget to look at the bigger picture.

In this chapter, we'll look at how the arrangement of figures in your scene tells the story – and how that story can be radically changed by making subtle adjustments to the position of the characters involved. The direction of travel, the body language, the angle of interaction – all these factors determine how the reader interprets your picture.

Location tells the story

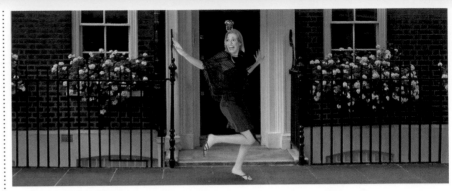

THE POSITION OF figures in a scene can have dramatic results in terms of the story being told. Here, we're looking at a woman running in terror down a street. In the original photograph, she was running out of joy – it only took a touch of Liquify (see page 224) and eye moving (see page 222) to produce the appearance of fear.

But what message are we getting across to our readers? The aim of the photomontage artist is not just to present the bare elements, but to tell a story. And the position of our figures affects the story being told to a large degree.

1 Our running figure starts off right in the middle of the picture. The street is also exactly centered, with the front door directly behind the figure. Apart from the visual inconvenience of having a figure in a black dress against a black door, the story isn't clear from this montage. What is she running from? Where is she going? The image is just too static. Bang in the middle is never a good location.

3 When we put her on the far left, we're telling a very different story. Positioning her here suggests that she's only just escaped the clutches of whatever is chasing her. In addition, that door – which previously could have been the house from which she was escaping – now appears to be a possible refuge.

5 Putting distance between the woman and the door, with the door on the left, makes it clearer that this is what she's escaping from. Compare this with step 2: there, some ambiguity meant that the door could have been just another house on the street. In this version, the door's dominant position means that it is clearly not just part of the background, but a key player in the scene.

2 When we move her over to the right, so she's running out of the frame, the picture becomes clearer. We still don't know if she's running from someone further down the street, or if she's just escaped from the house; but certainly, she's managing to escape from the danger. She's so close to the edge of the frame that she's nearly made it to safety.

4 We can move the background as well as the figure, to change the emphasis. Now it seems that the door is indeed her goal, and that she will find safety behind it. But will she get there in time? The door is way over to the right, but she's far to the left – only just having escaped the object of her fear.

6 In all the shots so far, the woman has been running from left to right. This is never an arbitrary choice. Let's try flipping her, so she's running to the left and the door is on the right: it doesn't work nearly as well. That's because in Western countries we read from left to right – and that applies to images as well as text. If this book is translated into Arabic or Hebrew, it's to be hoped the publisher will flip all these images.

HOT TIP

If you're creating a montage purely for your own pleasure, then you can make it any shape you want. If it has been commissioned for a publication, then you'll always be constrained by the size and shape they want you to fill. Whatever the shape you end up with, you need to use the available space to tell the story as best you can. Figures don't have to be entirely enclosed within the frame, and backgrounds don't have to be squared up: try experimenting with angled views for added drama, and to help fit the shot into an awkward space.

123

Relative values: interaction

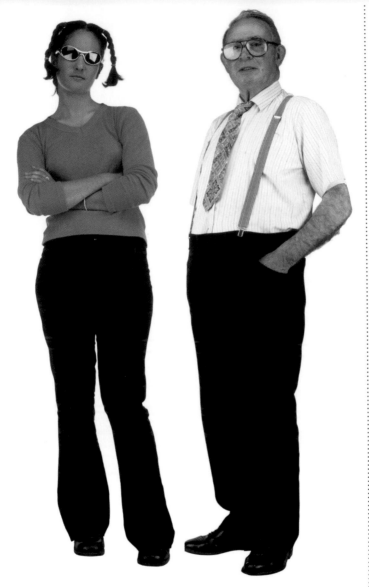

1 Simply moving them closer together so that they overlap helps to establish a link between them. By flipping the girl horizontally, both figures are now angled towards the center of the image.

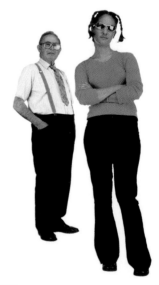

5 Now the tables have been turned. It's the daughter who is in the dominant position, while the father remains distanced from her: like most parents, he's now concerned that she's moving away from him.

COMBINING TWO PEOPLE IN A MONTAGE ENTAILS more than just placing them on the same background. You've got to work out the relationship between them, and position them to tell the story in the best way. The image above shows, let's say, a father and daughter. They may share the same space but the reader gets no hint of how they might interact; by varying their position we can make their relationship clear.

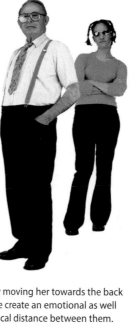

2 A simple additional device such as the hand on her shoulder puts the father in a more protective role. His body language is one of pride with, perhaps, a hint of restraint.

3 Bringing the father to the front still establishes his protectiveness, but now there's a sense that the safeguard is needed: he's shielding her from the viewer, while she is content to take refuge behind him.

4 By moving her towards the back we create an emotional as well as physical distance between them. Flipping her so that her shoulders point away from his accentuates the disparity: she now resents his control.

HOT TIP

Varying the size of characters within a montage always places the front figure in the dominant position. The problem comes when you want the two to engage each other: in cases such as this, the interactive work has to be done by the rear figure to prevent the one at the front from glancing nervously over his or her shoulder.

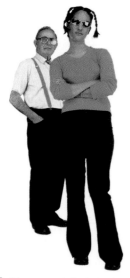

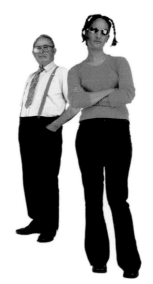

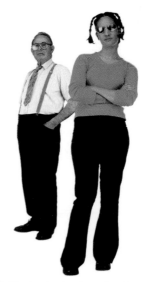

6 When we tuck the father behind the daughter, we strengthen the sense of her supremacy over him. In the previous example, she was merely moving away; now she's beginning to eclipse him.

7 Flipping the father horizontally makes him face away from his daughter metaphorically. His understanding of her is less than in the last example, but her pose shows she's prepared to turn back to him.

8 Flipping the daughter alters her body language as well: the two figures are now opposed, their shoulders pointing in different directions as she now turns her back on him absolutely.

I only have eyes for you

1 With both characters gazing directly at us, there's no contact between them – and we're left with no idea what either of them is thinking.

ON THE PREVIOUS PAGE, WE looked at how changing body position can make a difference to the apparent relationship between people in a montage. But body language is only one way of explaining a relationship: far more subtle – and just as effective – is eye contact.

The photomontage artist often has to work with mugshots of politicians and celebrities, or images from a royalty-free collection. Either way, you're more or less guaranteed that the subjects will be gazing straight at the camera, and probably grinning inanely at the same time. This may suit the needs of the celebrity's publicist, but it's of little help when combining two or more people within a scene.

Here, we've taken a glamorous couple – so glamorous that he's just won an Oscar – and moved their eyes around from frame to frame. Nothing else has been changed, and yet the entire expression alters with the position of the eyes. The nine examples here are just a small part of the infinite range of expressions that can be achieved by simply changing the eyes.

4 He now looks a little over-protective of his trophy, as if someone might be about to snatch it from him: but she's downcast, as if the prize should have been hers.

7 He now gazes excitedly into the future – who knows what doors this prize will open? She isn't so much annoyed with him as just plain bored by the whole evening.

2 He's looking at her hopefully, and the grin has become almost a leer. Her reply is ambiguous, but not wholly negative – she might go along with his plans, she might not.

3 His expression hasn't changed, but hers certainly has. No chance for him tonight: she's fed up with the whole idea and can't wait to be rid of him.

HOT TIP

To change the direction a character's eyes are looking in, you need to create two new layers – one for the eyeball, and one for the iris: make a clipping mask for the iris with the eyeball, and you can move it around within the eye. For more about working with eyes, see page 222.

5 Now he's gazing up at his adoring audience – a subtle difference from the previous example. She, however, only has eyes for the trophy.

6 Now he's really worried, glancing over his shoulder as if he expects to be mugged – and that grin looks more false than ever. Her mind is somewhere else entirely.

8 He stares in wonder at his trophy as if he can't believe he's really won it. She ponders the situation, wondering if next time the accolade will go to her instead.

9 Now he's thanking heaven for the prize which has been awarded him – whereas she is wondering if she just saw a mouse scuttle across the floor.

Back to the foreground

P LACING PEOPLE WITHIN A SCENE IS RARELY A
matter of sticking them on top – because they never
look like they belong there. Here are some ways to treat your
montages so that the people are integrated into the shot.

1 The simple montage of a man on a park background,
left, looks wholly unconvincing. There's no sense that
he's really occupying that space. The simple trick of blurring the
background with Gaussian Blur, above, adds extra depth.

4 I photographed this piece of fenced ground in front of
a road intersection some years ago. Placing the farmer
in front of the whole scene, left, doesn't really tie him into it.
But when he's moved behind the fence, by painting it out on a
Layer Mask, he looks far more as if he belongs in the field.

2 To integrate him into the scene, we need to grab some of that background and push it in front of him. Well, the background is too far away – but we can grab any piece of foliage we happen to have lying around, such as this plant.

3 Applying a huge amount of blur to the object right in the foreground means we can no longer tell what variety of plant it is. In fact, it's so blurred we barely see it. But it does the job: our man is now *in* the scene, not just in front of it.

HOT TIP

The final step requires that the background be selectively blurred – more at the back, less at the front. Go into QuickMask mode and, using the Gradient tool set to black-white, drag from top to bottom. This creates an area that's 100% selected at the top and 0% selected at the bottom; when you exit QuickMask and apply the blur, the image will be affected more at the top than at the bottom.

5 It's always fun to play a few visual tricks to tie people in closer to the scene. Here, I've painted out the pitchfork on the Layer Mask to bring it in front of the fence.

6 Adding shadows is the key to blending him in. A few around the feet, some soft shadows cast by the pitchfork onto the fence, and the whole thing looks much more realistic.

7 Pushing the background out of focus helps us to concentrate on the farmer without all that busy distraction around his head – and it strengthens the scene.

129

Composition tips and tricks

1 We'll learn how to create torn posters like this one in Chapter 11. In the meantime, let's just look at the placement of the image. When it's positioned dead center, it's so in-your-face that it loses all subtlety. Da Vinci aside, the center is rarely the best place for a focal point.

4 The placement may have been better at the end of the previous step, but there was a busyness to the background that made it hard to focus on the poster: the tones of the building were too similar to the wood tones in the board. Brightening the background overcomes this.

DA VINCI'S *LAST SUPPER* IS NOT ONLY THE painting that inspired *The Da Vinci Code*, it's also a masterpiece of classical composition.

Jesus sits right in the center, surrounded by his apostles – who form four distinct groups of three. Each group would be a perfectly composed painting in its own right if it were taken in isolation.

But what really makes this picture work is the background: in the original version (top) all the diagonals in the walls and that carefully painted lattice ceiling are balanced, and point directly to the central figure. Wherever we look, our eye is drawn back to him. When we shift the background (bottom) the integrity of the whole image falls apart. That Leonardo certainly knew a thing or two about composition.

7 In the previous step, the figure in the foreground added a much-needed human element. But the distance between the figure and the poster, although tiny, made the two elements look disconnected. By overlapping the figure with the poster we unify the two.

2 Adding a little perspective to the object greatly increases the sense of it existing in real space. Of course, it's necessary to add a side edge to the wooden board and the post, to complete the new viewpoint. The trouble now is that the perspective of the poster points to that horse statue.

3 Objects in the background can distract the eye and lose the central focus. The statue pulled our eye away; and that traffic bollard in the bottom right was an unnecessary intrusion. By sliding the whole background to the right we create a less distracting, more harmonious image.

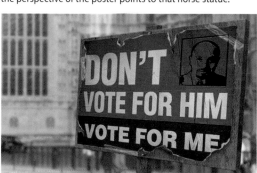

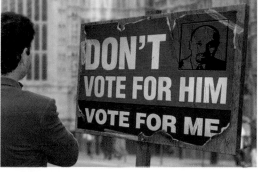

HOT TIP

5 We can make the background recede still further by giving the impression of it being out of focus, using the Gaussian Blur filter. This sort of depth-of-field effect makes it impossible for the eye to focus on the background, bringing our attention back to the poster.

6 As every cartoonist knows, a block of text on its own is meaningless without a figure looking at it. Build up a stock of photographs of people from the back – they'll always prove useful. This is one of a series of shots I took of myself for just this purpose.

It's often hard to judge whether a composition is working as a whole, especially when there are strong foreground elements that shout for attention. One trick used by both artists and graphic designers is to turn the image upside down: that way, none of the image elements make much sense on their own, and we're free to concentrate on the way they fit together.

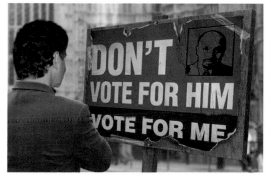

8 Make sure your figure is looking at the poster, and not off into the distance! Here, replacing the original head with one taken from a more appropriate angle leaves us in no doubt that he's really looking at the poster, drawing the viewer's eye back to the main focus.

9 It's important to make sure any foreground elements really do their job of drawing the eye in, and don't distract from the image. The jacket on our rear-view figure was far too stong a color: we can use the Hue/Saturation adjustment to make it blend in with the background tones.

The left and right of things

UNTIL THE MIDDLE of the 19th Century, footwear wasn't made differently for left and right feet. You just bought a pair of shoes, boots, clogs or whatever, and slipped them onto whichever foot you felt like.

The principle of handedness – chirality, as it's known – applies to many areas of our lives. Gloves, obviously, have chirality, but there are many more unexpected places where handedness turns up: in screws, scissors, pencil sharpeners, book spines, and so on. It's not a life-or-death issue, although there are times when it *is* a life-or-death issue: in operating theaters, for instance, the oxygen and nitrogen gas canisters are threaded in opposite directions, so it's impossible to screw a tube onto the wrong canister. Sometimes handedness is used for mechanical gain: for instance, in a turnbuckle, seen on the left (used to tighten pairs of ropes or cables) two screws are threaded in opposite directions, so when the turnbuckle is tightened the screws are pulled closer together.

As photomontage artists, we're used to being able to manipulate objects so that they fit the scene. We can flip them vertically and horizontally, if we wish, so that they slot more neatly into our montages. But while most objects are agnostic when it comes to handedness, it's all too easy to make mistakes: a car with the steering wheel on the wrong side, a clock with the numbers backwards, a computer keyboard with the numerical keypad on the left rather than the right. You may not notice these errors while you're compiling the montage, but you can be sure your readers will when it's made public.

Ironically, one of the most common mistakes – flipping someone's head when they have a distinctive asymmetry – is unlikely to be noticed by the subject themselves, as that's the way they're used to seeing their face in the mirror. But other people will. They may not be able to pin down exactly what's wrong, but the flash of recognition you get when you see a familiar face won't be there. Few people are completely symmetrical, and we tend to notice when something is out of the ordinary.

Flipping errors can appear in the unlikeliest of places. Take a look at this simple montage, showing John F Kennedy making a phone call. There are at least ten mistakes here to do with handedness. How many of them can you spot?

His wristwatch should be on his left hand. His shirt pocket should be on his left, and the shirt buttons are done up the way women's clothes are made, not men's. The flag pin badge is facing the wrong way. The bible in his hand has the crucifix on the back, not the front. The belt is buckled up back to front. The coin pocket on the pants, which should be on the right, is on his left side. The telephone dial is back to front, as is the K insignia in the middle of the table support.

Worst of all, Kennedy's hair is parted on the wrong side. And take another look at the face: does it look right? Or is there something intangibly uncomfortable about the arrangement of features?

I'm not saying that you should never flip a layer to make it fit, just that it's important to be aware of what can be flipped, and what can't. Take a moment to check, to avoid being exposed later.

6

Getting into perspective

PERSPECTIVE IS ONE OF THOSE THINGS that Photoshop artists either love or hate. It can plague them with its complexities, or delight them with its simplicity. But love it or hate it, you can't create a realistic image without considering it carefully.

The correct use of perspective makes all the difference between a montage that looks convincing, and one that readers will examine with a sense of unease. They may not be able to put their fingers on it, but something will definitely appear to be wrong.

And yet it's easy enough to learn the few simple rules that make working with perspective a pleasure rather than a chore. It can still be tricky to read the perspective out of an existing background, but if you like a puzzle, you'll love this.

Establishing the horizon

THE HORIZON LINE IS the defining point in any drawing, painting or montage. It determines the shape of the entire scene, and establishes the position of the viewer within that scene.

The horizon line is easily established using a simple, but absolute rule:

The horizon is always at the same height as the eyeline of the viewer.

It sometimes seems incredible that the key to a successful montage can be expressed in terms as simple as that: but this is the one area most people get wrong.

In practice, this means that the head height of all the adult figures in an illustration should be on the same level as each other, except for special purposes, such as when you want to give the impression that your viewer is sitting down, or looking from a child's perspective.

We'll demonstrate this principle on these pages, using a foreground figure to show how the horizon line varies with the height of the viewer.

1 For most purposes, we can assume our viewer to be standing up. In these examples, the viewer is shown by the figure on the far left, and our viewpoint is taken to be the same as his. The horizon line, clearly seen in this seascape, is on the same eyeline; and so any adults in the scene have their eyes on the same line, since they're roughly the same height as us. Smaller figures, such as children, will appear below the horizon line to indicate their lesser size.

3 When our viewer is even closer to the ground, the view to the horizon is further compressed so that it remains precisely on his eyeline. Now, the adults in the scene are significantly higher than us – our head is on a level with this woman's knees – and even children appear to tower over us. Because of the reduced eye height, children will once again appear to be proportionally larger. We can now see much more sky, and much less sea.

HOT TIP

In the examples shown here we've included a clear, visible horizon line to explain the theory. You frequently won't have such a clear line in your images: but keep adult heads at the same height as each other, and your montages will look instantly that much more convincing.

2 When the viewer is sitting down, the horizon is lowered so that it remains on his eyeline. In these cases, adult figures will appear with their heads some distance above the horizon, as we're now looking up at them. Children will now show their eyelines to be lined up with the horizon. Nearby figures, such as the child in this example, will appear correspondingly larger as the perspective of the scene changes to match the angle of view.

4 As a general rule, we can expect the viewer to be standing at standard head height. This means that all adults in the scene will have their heads on the same line, which will once again correspond exactly with the horizon (give or take the usual slight variations in adult height). This simple rule makes it easy to position a large number of people, at different distances from us, so that they all look as if they truly belong in the same visual space.

5 It doesn't matter if we're lying down, or standing at the top of a tall building: the horizon is always at the height of our eyes. Look out of the window and try it for yourself!

Introducing vanishing points

1 This straightforward street scene includes strong diagonal lines – the tops and bottoms of the shop fronts. We know that, in reality, these lines will be absolutely horizontal: and so we can use them to calculate the horizon line for this image.

GETTING PERSPECTIVE RIGHT IS the key to an illustration succeeding or failing. In the cover montage for the *Guardian*, above, I chose a low viewpoint to increase the drama of the scene. With this extreme perspective, the sheet of paper, the text and the door frame all had to fit in with the typewriter's perspective or it would have made no sense to the reader.

In this section we'll look at vanishing points, and how they can be used to enable us to create convincing three-dimensional images. There's also a fantastic time-saving technique that will enable you to make rows of people or objects in seconds!

4 Now let's bring in a security guard to stand outside the first shop. We position him, naturally, so that his eyeline is exactly on the horizon. (We've assumed him to be the same height that we are.) I've added a bit of shadow below and behind him to make him look more part of the image.

7 Here's a good trick: pressing ⌘ *Shift* T *ctrl Shift* T will repeat the last transformation. But pressing ⌘ *Shift* ⌥ T *ctrl Shift alt* T will *duplicate* the last transformation. By pressing it several times, we can build an entire row of security guards.

2 Use the Line tool, set to Shape Layers mode, to draw two lines along these diagonals. (The Line tool is one of the Shapes tools.) Where they cross is the vanishing point, towards which all perspective lines in the image will tend.

3 Now draw a horizon line: a horizontal, again drawn with the Shapes tool, that intersects the vanishing point. Note how this horizon passes through the heads of the distant pedestrians, as predicted by the previous lesson. See! It really is true!

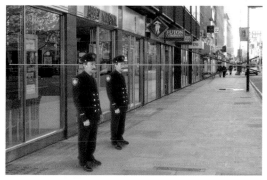

5 Next, duplicate the guard layer. Enter Free Transform mode (⌘ T *ctrl* T) and drag the center point marker out so it sits directly on top of the vanishing point. Now grab the bottom left corner handle and, while holding ⌥ *Shift* *alt* *Shift*, drag the cursor towards the vanishing point.

6 The ⌥ *alt* key scales from the 'center' – in this case, the vanishing point; adding *Shift* keeps the transformation in proportion. The result is an identical guard, positioned further down the street – but in exactly the correct perspective for this view, eyeline on the horizon.

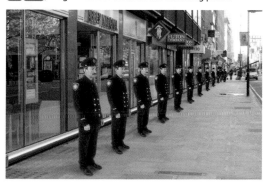

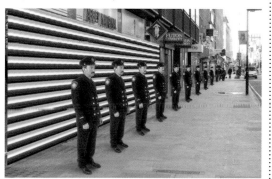

8 We'll use a similar technique to build shutters. The first shutter is drawn in perspective by adding lines from the vanishing point: in addition, we need to paint a tiny circle on the vanishing point itself as part of the shutter layer. That's because we can't move the center marker for this operation.

9 Duplicate the layer again, but this time shear the layer instead of scaling it. Enter Free Transform, and hold ⌘ *Shift* *ctrl* *Shift* while dragging the center left handle vertically. Again, ⌘ *Shift* ⌥ T *ctrl* *Shift* *alt* T will repeat the transformation to make this row of shutters.

Two point perspective

O N THE PREVIOUS PAGE WE looked at setting the vanishing point. When you're looking at the inside of things – boxes, rooms, streets – there's just a single vanishing point: this is one point perspective. When you're looking at the outside corners of objects you need to use not one, but two vanishing points, at the far left (VPL) and far right (VPR) of the field of view. All planes in the image will tend to one or other of these vanishing points.

Deciding where to place the VPL and VPR is a tricky matter, since it affects the perspective of the image in the same way as when you switch between a wide angle and a telephoto lens.

Fortunately, technology has come to our rescue. The screen shot above is from a java applet written by the talented programmer Cathi Sanders, which she has kindly agreed to let me include with this book. It shows how the perspective process works: you can move either the VPL or the VPR along the horizon line, and change the dimensions and position of the yellow box by dragging any of the red dots, to see exactly how altering the vanishing points affects the perspective of the scene. You'll find this java applet on the DVD, and it can be opened in any standard browser.

1 Here's our task: we've got a field with a clear, visible horizon in it, and a cow gazing out at us. Fortunately, the cow's on a separate layer so we can hide it easily. Our job is to put the cow in a glass tank, Damien Hirst style: and there's a panel of framed glass there waiting for us.

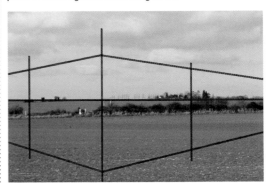

3 Now draw two more verticals, again with the Shapes tool, at the left and right corners of the tank. So far, we've drawn in the two sides facing us: but because this is a glass tank, we'll need to draw in the back panels as well, which we'll do next.

6 Move the original panel well out of the way, then take a copy of it (hold ⌥ *alt* and drag with the Move tool) and enter Free Transform mode. Now hold ⌘ *ctrl* as you move each corner handle to distort the panel to fit the guide lines: hold *Shift* as you drag to keep the verticals straight!

2 The trouble is, the image isn't nearly wide enough to draw our vanishing point lines. There's a simple solution: we'll draw them using pen paths. First, zoom out until your image has plenty of spare window space around it (hide the panel and cow layers, so you can see what's going on). Now,

using the Line tool set to Path mode, draw in the horizon line on the visible horizon. Draw a vertical for the nearest corner, then add perspective lines to arbitrary left and right vanishing points. The position of these points is largely up to you.

4 Starting at the four back corners, draw lines from each to the opposite vanishing points. All the lines drawn will now be perfectly in perspective: just for good measure, we can add a final vertical in the far corner to aid us in positioning the back panels.

5 We now want to distort those panels to fit the space. But you can't use Free Transform when a path is visible, or the path will be distorted instead; so make a new layer, turn the path into a selection, and fill the perspective lines with a color. Time to show that cow and panel again!

7 Repeat this procedure with three more copies of the original panel to make the other front side and the two back sides. Remember to move the back side layers behind the cow! As long as you make the panels fit the guide lines, the perspective should work perfectly.

8 As a final step, I've darkened the right-hand panel and added a lid and base to the tank. The shadow is easily made by desaturating a further copy of the panel (using ⌘ Shift U ctrl Shift U), setting its layer mode to Multiply, and then distorting it so it lies along the ground.

Three point perspective

ONE AND TWO POINT perspectives may work for most tasks, but they both assume that verticals in the image are truly vertical. This isn't always the case: the cover of the second edition of this book featured a top-down view that used a more complex system.

The further you are from the subject, the less important perspective becomes. I made the panorama of London below by stitching together a dozen photographs: each had its own vanishing points, so the result shouldn't make sense. But so great is the distance that the eye ignores the discrepancies.

1 When we're looking at a scene from an angle off the horizontal, the verticals will no longer be straight up and down. A third perspective vanishing point needs to be created – either below the object, if we're looking down on it, or above it if we're looking up.

3 The same panels we used in the previous example have been distorted using Free Transform once again, to fit the perspective lines. But we could just as well have used brick walls to build a view of a house.

2 The perspective lines can get very hard to interpret, so it can be worth creating them in two batches. Here, Shapes paths making up the front edges and the horizon have been made into a selection and filled with red; the rear edges have been filled with green on a new layer.

4 With all the perspective lines removed, and some shading added, the box looks convincing enough. It would have been almost impossible to draw this view without using vanishing lines. Trying to find a cow to fit this extreme view would be another matter entirely!

HOT TIP

The lower the third vanishing point is, the less extreme the perspective viewpoint will be. Even with it way down, as it is in this example, there's still a strong distortion on those verticals: for a less exaggerated effect, you need to zoom out a long way and place the third vanishing point at a great distance from the artwork.

Correcting perspective

OBJECTS DON'T ALWAYS FIT INTO the scene as neatly as we'd like them to: frequently, the perspective needs to be adjusted to fit in with the background.

The montage above was for the front page of the *Guardian*, and was to illustrate the relative heights of London buildings – the big colorful one at the back is the proposed Vortex skyscraper. The rest of the buildings came from a variety of sources, and had to be adapted to make them look as if they all belonged in the same visual space. There was a lot of dividing up into planes and shearing involved, exactly as described here.

1 A typical suburban street scene. I photographed this with plenty of spare road in front, so it would be easy to add in extra vehicles, pedestrians or galumphing space monsters as required. No nearby corners – so one-point perspective.

4 Let's bring the truck back, and draw some perspective lines (in yellow) on a new layer attached to it. Right away, we can see the problem: the bottom line should be going upwards, not crossing the red perspective line.

7 Well, the front may look OK, but the back end's all over the place. Unlink the layers, then draw a marquee selection around the back end of the truck. Be sure to place the right edge of the marquee so it aligns precisely with the corner of the truck nearest to us.

2 When this dirty white truck is placed in the scene, we can see that something's not quite right. It's hard to pin it down, but there's a feeling of unease about the composition. Let's hide the van and find out why.

3 With the truck hidden, we can now draw in perspective lines using the Line tool, following the angles of the road and the roof line. Where they meet is the horizon, here drawn in green. Note that it's at head height on the doors!

5 In fact, this is how we'd position this truck in order for it to be in the correct perspective for the street. I'd obviously photographed it from a low viewpoint, which is why it's now floating in the air! Let's see how to fix it.

6 Link the truck and its perspective line layers together. Now enter Free Transform, and move the center marker on top of the vanishing point: then grab the middle handle on the left side and shear it downwards.

8 Now enter Free Transform once more, grab the center handle on the left side and drag it upwards. The top edge of this side should be aligned with the angle of the roof of the house directly behind it – another clue to drawing this scene in perspective.

9 The truck itself may be a convenient rectangular box, but the same can't be said for the wheels. There's almost always a little tidying-up to be done in cases like this; here, a simple brush with a hard-edged eraser can fix the wheel. And a well-placed shadow can hide a number of errors!

HOT TIP

With practice, you don't need to draw in the perspective lines at all: after a while you get to the stage where you can imagine where they are without having to see them exactly. Looking at step 2, it's possible to see at a glance that the bottom edge of the truck side is at a contrary angle to the low wall behind it, and to the edge of the road; correcting the perspective can be done purely visually.

145

Fixing wide angle objects

THE CAR IN THE SCENE ABOVE HAS been photographed close up – which means it has a strong, pronounced perspective. When placed this far back in the composition it looks unnatural: we'd only see this amount of distortion if we were up close to the vehicle.

Adjusting the perspective on images like this is not a straightforward process, but it's not that difficult. It can help to have a copy of the original image open in a separate window, so you can remind yourself of the overall proportions and balance. It's easy to distort something beyond recognition without realizing that you're doing it.

1 We can see the car by itself above: and it's clearly showing a marked, very strong perspective distortion. To begin the process, use ⌘ T ctrl T to enter Free Transform mode. Then hold ⌘ ⌥ Shift ctrl alt Shift as you drag the top right handle upwards, to make the back larger. Don't leave Free Transform – we're not done yet.

2 The previous step has made the whole car too tall. We can return it to its proper height by dragging down on the center handle on the top edge of the Free Transform bounding box.

3 Switch straight into Image Warp mode by pressing the button on the toolbar. What we're doing here is dragging up/down on all four corners, to restore the shape of the car and remove yet more of the extreme perspective. Apply the transformation by pressing *Enter* when you're done.

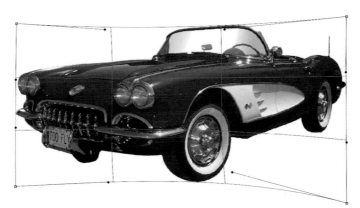

HOT TIP

The advantage of using Image Warp mode in steps 4 and 5 is that we can distort the corner of the selection without distorting the remainder of the object. Try using standard distortion here, and you'll see what happens: Photoshop will assume you want a perspective transformation, and will change the line along the bottom edge so it no longer fits.

4 Now to address some of the details. Make a rectangular selection around the windscreen, and enter Image Warp mode of Free Transform. Drag the top left corner handle upwards.

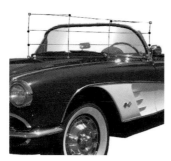

5 Repeat this process with the back wheel – we need to make it appear wider so the perspective doesn't look as strong. Here, we're dragging the corner direction indicators outwards to produce the effect.

6 Here's the finished car, with the transformations applied. Casual viewers won't see a huge difference between this and the original, and that's just as it should be: we're not going for a radical transformation, but rather a subtle change of emphasis.

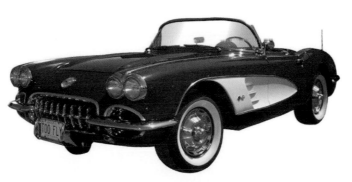

SHORTCUTS
MAC WIN BOTH

Using existing perspective

HORIZONS AND VANISHING POINTS are able to give you accurate guidelines for drawing scenes in perspective. But if you can't see the horizon – as is usually the case – how are you to tell what point perspective lines should tend towards?

The answer is to read perspective lines out of clues already present in the image. Although it may not look like it, even a simple picture such as the one shown here contains many perspective hints.

This example was first posted as a Friday Challenge on the Reader Forum section of the website that accompanies this book, and some of the entries are shown below. The Challenge was simply entitled Open the Door: it was up to the readers to make what use they chose of the view beyond.

1 Here's our starting point: the corner of an ordinary room, showing the door closed. The object of the exercise is to open the door.

2 The door itself is easily removed: selected with the Pen or Lasso tools, it's cut to a new layer for safe keeping. I've hidden the layer for now.

6 A copy of the original door is flipped horizontally, and distorted using Free Transform to follow the perspective lines once again.

7 The back wall is simply a flat layer behind both the door and carpet layers: a little shading helps it to blend in better.

maiden

raymardo

Russ Davey

atomicfog

3 We can use the horizontals on those bookshelves to project perspective lines through the open door. Use the Line tool for this!

4 We can also show the perspective on the left wall (although it's not needed here): the frames, lamp stand and skirting board all give us clues.

5 The carpet is made on a new layer behind the open doorway, following the perspective lines to get the angle right.

8 Other elements can be added using these perspective lines: the picture and the skirting board are easy to place in this image.

9 Here's the image with the perspective lines hidden. All the elements seen through the door now conform to the scene's perspective.

10 Finally, the original door is opened (see Chapter 12) and shading added to make the scene more realistic.

HOT TIP

Partly hiding some elements helps to make the scene more realistic. Because both the far door and the picture are cut off by the door frame, our sense of the view continuing is accentuated. If we'd been able to see the second door in its entirety, the image would have been far less convincing as a montage. Try it for yourself on the DVD image, and you'll see what I mean.

droo31k

tabitha

David Asch

Tweaknik

Boxing clever: doubling up

BUILDING TOWERS OF OBJECTS IS not a difficult task. We don't even need to worry about vanishing points, or locating horizons: we can rely on the perspective that's already built into the starting object, and trust that perspective to be carried through when we apply our distortions.

The technique is used here to distort boxes piled on top of each other. The text here deals with distorting just one box, but it's easy to follow through and build a stack of them like the one above.

Of course, this isn't a technique reserved for the somewhat occasional need to pile cash boxes on top of each other. The principle also applies to making office blocks twice as high, or any application which requires doubling up.

1 Here's our original box. We can see the lid, which means we're viewing it from above: in other words, the entire box sits below the horizon line (although the handle may stick up above that line). When another box is added on top, however, we'll no longer be able to see that lid, although we may be able to catch sight of the handle poking up.

4 Select the first side, and use Free Transform (⌘ T *ctrl* T) to shear it. Grab the left center handle (not a corner!) and drag straight down, adding *Shift* to keep the movement vertical: this will move the whole side in the correct perspective.

2 The first step is to duplicate the box and drag the copy directly above it. Clearly, this isn't enough: the perspective error is glaringly obvious. In order to distort the box we need to split it into its constituent parts. To do this, use the Lasso tool to first select one of the sides, and cut it to a new layer using ⌘ Shift J ctrl Shift J .

3 Once you've made the new layer, you'll need to go back down to the duplicate layer (using ⌥ [alt [) and cut the other side into a new layer as well. Don't drag the layers apart as shown above – I've only done that here to show you how the box has been split up into its three visible faces.

HOT TIP

If you need to distort the perspective of a box so that the lid remains visible, you'll find it hard to distort the lid itself accurately. A simple solution is to duplicate the lid to a new document, and then use Perspective Crop (see page 156) to square it up: you can then bring it back and use Free Transform with ease, to move each corner to its correct location.

5 Now repeat the process with the opposite side. Once again, a simple shear moves the side in correct perspective. There may be a small gap at the top corner nearest us, which can easily be fixed using a hard-edged Smudge tool.

6 All that's left now is the lid. Make sure it's behind the two side layers, and shear it using Free Transform once more to follow the angle of the front edge of the lid. It may be necessary to erase some stray bits of lid that project out of the top, but that's the only adjustment required.

SHORTCUTS
MAC WIN BOTH

151

Vanishing Point filter 1

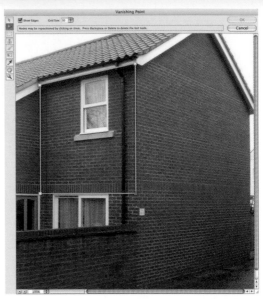

THE VANISHING POINT FILTER IS one of those tour-de-force extras that astonishes anyone to whom it's demonstrated. No-one expected Adobe to come up with this one, and it's unique in computer software: this is the first time a two-dimensional illustration program has addressed the third dimension in this way.

Simply put, the Vanishing Point filter allows you to move, copy and clone in perspective, dragging objects around corners with a freedom that's hard to comprehend even when you've seen it done.

We'll begin by showing the basics of this filter, and continue over the next few pages to give just an idea of how impressive this revolutionary tool really is. To demonstrate its capabilities, we'll be using this photograph of an urban dwelling that's sorely in need of refurbishment.

1 Enter the Vanishing Point filter by pressing ⌘ ⌥ V / ctrl alt V, or choose it from the Filter menu. You begin by placing four points at the corners of any element in the scene that is truly rectangular: here, we can follow the lines of the bricks and the corners of the building.

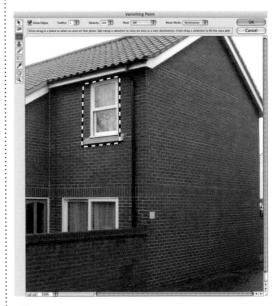

4 Now switch to the Marquee tool within the Vanishing Point filter (M), and make a selection of the upstairs window, as shown here. Even though we're drawing a rectangular selection, notice how it's being drawn in perspective: the marquee is following our perspective grid.

2 Holding the **X** key allows you to zoom in for more accurate placement of these corner points: here, we're a little high. The aim at the bottom here is to follow the line of the vertically-arranged bricks, to guarantee that the bottom of our box is parallel to the world in this image.

3 When all four points have been placed, a grid will appear showing perspective lines that fill the space we've defined. There's still the chance, at this stage, to adjust the corners if they don't match the perspective of the building perfectly.

HOT TIP

If you don't want to see the selection outlines when you're moving elements around, press ⌘ **H** ctrl **H** and they'll be hidden. That's how we're able to check how well the window blends in with the wall around it in steps 5 and 6 here.

5 Let's make a copy of that window. Hold ⌥ alt and drag the window to the left to make a duplicate: it will move in true perspective. Add the Shift key and it will stay in the line. But note how the window is now getting smaller, as it moves further away from us!

6 At the end of the last step, the window fitted perfectly, but the shading was wrong: the left edge of the brickwork was too bright to match the corner. At the top of this window, check the Heal pop-up: Healing automatically blends the selection in with its surroundings.

SHORTCUTS
MAC WIN BOTH

Vanishing Point filter 2

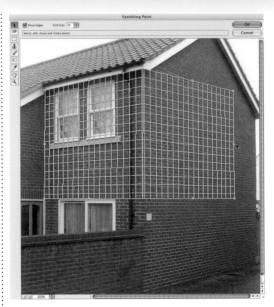

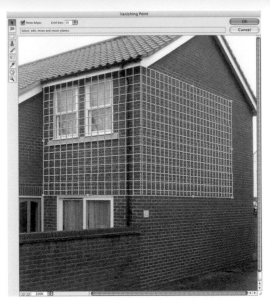

1 On the previous page we looked at how to create and use the basic 3D grid. Now let's take it into another dimension. Switch to the Arrow tool to show the grid, then hold the ⌘ *ctrl* key and grab the center right-hand handle. Drag the handle to 'tear off' the grid around the corner.

2 It's likely that the grid won't match the side wall perspective perfectly: the top and bottom points on the right will need adjusting. If the whole grid goes red or yellow, it indicates an 'illegal' perspective; adjust the grid until it turns blue again.

5 We can paste into Vanishing Point, as well. Open the file VP Graffiti.psd: Select All and Copy, then close the file. Back on our house, create a new, empty layer. We'll work entirely within this layer so we don't risk damaging the underlying building.

6 Open the Vanishing Point filter again, and the grids will already be in place. (I'm working on the original house, without the extra windows in place.) Choose Paste, and the copied graffiti will appear up in the top left corner.

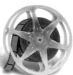

3 We can now drag the center handles on the right and bottom, to extend the grid to the end of the wall and to the floor. Note how it still follows the wall's perspective! Once again, adjust the corners if it doesn't appear to be precisely in the right position.

4 Select the original window again, and hold ⌥ *alt* as you drag it around the corner – add *Shift* to move it in a horizontal line. Once it passes the corner, the window will snap to the second wall; check the Flip button at the top of the window to flip the window horizontally.

HOT TIP

We can create as many perspective grids as we like, tearing them off to fit additional surfaces in the scene. It's worth taking the trouble to get it right on the first two walls, as things get more complex when the grid extends to a third wall.

7 As we move the graffiti onto a perspective plane, it will flatten itself onto that wall and move in perspective as we drag. Drag it onto the blank side wall, and it will glide smoothly around the plane of that wall. Any object can be included by copying and pasting: it's like an Import function.

8 Let's imagine that graffiti was painted directly onto the wall, and we want to erase it. Open Vanishing Point again, and choose the Clone tool. Hold ⌥ *alt* and click to define a source point: the Clone tool also clones in perspective as we drag it over the wall surface.

SHORTCUTS
MAC WIN BOTH

155

Cropping in perspective

S O FAR IN THIS chapter, we've been looking at how to use and match existing perspective to make montages look more realistic.

But there are times when you simply want to get rid of the perspective that's already in a photographed scene, as is the case with the picture used here. The Perspective Crop tool is perfect for straightening out skewed images: it takes images photographed at an angle and squares them up.

I photographed the Japanese print on this page in a museum in Norway. But when I stood right in front of it, I could see my strong reflection in the glass. Shooting from the side was the only way to avoid the reflection.

1 I had to get quite a sharp angle on the print in order to lose my reflection. There's still some reflection in the upper right, but this would be easy to clean up afterwards.

2 Choose the Perspective Crop tool – it's nested beneath the Crop tool in the Tool panel – and drag from corner to corner on the image, just touching opposite corners of the frame.

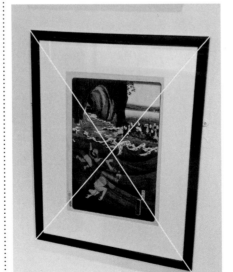

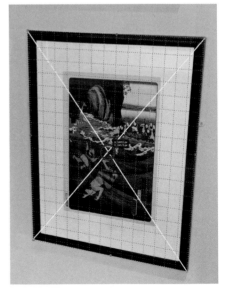

5 Cancel the Crop operation, and make a new layer. On that layer, draw diagonals from each corner of the frame to the opposite corner. You can do this most easily using the Shapes tool, and in CS6 you can change the stroke width afterwards.

6 Use the Perspective Crop tool as before, only this time drag the midpoint marker (it's right in the middle, and isn't easy to see) to the intersection of the diagonals. Then hit Enter to apply the crop operation.

3 When you drag the other two corners, they'll move independently: a grid appears, showing the perspective of the scene as it will be corrected after the operation.

4 But there's a problem with Adobe's math. There's a center point marker, and by default it's located at the intersection of the mid points of each side, as shown here. This is incorrect: for true perspective correction, it should be located on the intersection of the diagonals.

7 Here's the result of the crop operation, after I've applied a little extra contrast correction and painted out the slight reflection in the white mount at the top. Compare this with the photograph taken straight-on, right, and you'll see that the size and shape of the print is identical: the only difference is that it doesn't have my silhouette bending over it.

A piece of cake

PERSPECTIVE PLAYS ITS PART IN JUST ABOUT every montage we create – often to the annoyance of *How to Cheat in Photoshop* Reader Forum members, who frequently find it one of the hardest techniques to master.

The Friday Challenge shown here coincided with the 20th anniversary of Photoshop, when Adobe rather generously sent me this splendid birthday cake. I was reluctant to break open such a historic memento, so I asked the Forum members: can you open the cake for me?

The results are shown below. As you can see, there was a wide range of styles and approaches.

1 This is the original cake, which I photographed and then cut out. Because I was fairly close to it when I took the picture, there's a rather extreme perspective on it: this is what we need to follow.

4 With the new ribbons in place, we can work on the cake itself. Use the Clone tool to remove the original ribbons, copying texture from the cake. The deckled edge at the base is copied from the left hand side, and placed at the front.

5 The interior is a photograph of a real piece of cake, distorted to follow the cake angle.

6 The icing edge is drawn on a new layer, and the base cloned over the gap.

7 Use the Clone tool, on a very small brush, to copy pieces of cake to make the crumbs.

Ben Mills

brewell

Carlo Allesandro Della Valle

China

color

Jota120

Katew

laddition

LonnieK

michael sinclair

2 Cutting out the initial slice is easily done with the Lasso tool. The only thing to remember is to follow the angles set by the cake itself. The left side of the cut has an angle equidistant between the left and right sides of the cake.

3 Copy the bow and the right ribbon to new layers, and use Image Warp to distort them. We can use Image Warp to bend a layer back on itself, as I've done with the right ribbon: it's a useful technique in cases such as this.

HOT TIP

One of the keys to making this sort of image work is not to be too precise. The cut in the cake was made with the Lasso, rather than the Pen tool, precisely because it's rougher; I then smeared the edges of the icing with the Smudge tool to make them less regular, and more organic.

8 With the cake just about complete, it's time to add some shading – inside the opened cake, and beneath the ribbon and bow. I've also taken the right ribbon and copied it, flipping and distorting it, to add to the bow on the left.

9 The final touch: the silvery base reflects the colors in the cake, and in particular of the blue ribbon at the front. When the ribbon is gone, this looks wrong. Set a new layer to Color mode, and paint in colors sampled from the cake.

borah Morley

Emil

GKB

james

Jeepy

Nick Curtain

redsnapper

tomiloi

tooquilos

vibeke

INTERLUDE

Photomontage ethics

A FEW YEARS AGO the issue of photomontage was brought into question when a photograph of a prominent left-wing politician, on a night out with his wife, appeared in a London newspaper. In front of him on the table were a couple of bottles of beer, the kind that has a foil-wrapped cap. Someone at the newspaper had enlarged one of the beer bottles so that it looked more like a bottle of champagne – a deception magnified by the headline 'Champagne Socialist' that proclaimed his decadence.

As distortion of the truth goes, it seemed like a minor infraction. But the issue made national news. I was interviewed about it on a national radio station, and asked whether I condoned this sort of underhand trickery. I pointed out that, had the photographer merely rearranged the scene, moving one of the bottles to the foreground so that it obscured less of the politician in question, there would have been no debate; yet the results would have been identical. It's only because the change was made in the cold light of the newspaper offices that it caused an outrage. That's all very well, opined the interviewer, but how would I feel if he took the interview he'd just done with me and then rearranged it back at the studio to suit his own purposes? But that, I pointed out, was exactly his intention: he was going to boil down 40 minutes of interview into a five minute segment, choosing the parts that told the story he wanted to tell. My comment never made it into the final broadcast.

There's a lot of confusion about photomontage, much of it stemming from the misconception that photographs somehow tell the truth, as if there's an absolute truth out there that can be captured in one-sixtieth of a second; any tinkering with that truth must be a lie.

But photographs don't tell the truth any more than words. The photographer may take several rolls of film, each frame capturing a slice of time; the photo editor will then choose the picture that tells the story his newspaper wants told. The sub-editor may then crop the picture to fit the space available, and in doing so will again retell the story.

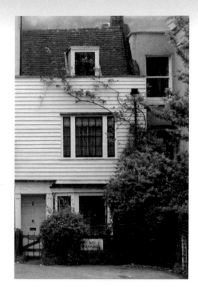

The photograph on the right shows an idyllic view of a small cottage, set amid verdant foliage. But it's a lie: the picture has been cropped from the original image, below, which tells a very different story. Anyone who had rented this as a holiday home after seeing it on a website would have every right to feel cheated: and yet there's been no Photoshop trickery involved, simply a selective decision about how much of the 'truth' to tell.

We may take a hundred photographs on vacation, from which we choose half a dozen to go in the album. The rest are discarded – one person has their eyes closed, the expression isn't so appealing, a tourist got into shot in the background. Yet we are just as guilty of editing the truth as if we'd montaged the elements together in Photoshop: we're telling the story we want told.

Is deliberate manipulation of photographs a new occurrence? Not at all. The creator of Sherlock Holmes, Sir Arthur Conan Doyle, was fooled in 1912 by the Cottingley Fairies, a set of photographs of paper sprites faked by two young girls in their suburban garden. During the American Civil War, photographer Alex Gardner produced a best-selling book of images, *Gardner's Photographic Sketch Book of the War*. He didn't mention the fact that he had hauled a cart load of dead bodies

between locations, dressing them up in appropriate uniforms and posing them in each place.

I'm not saying there aren't limits to what should be done with photomontage. But if obvious montages make people realize that the camera nearly always lies, then the world will be a marginally better place.

7

Light and shade

WHEN WE ASSEMBLE MONTAGES, we almost always use picture elements from a variety of sources. These will have been photographed under very different lighting conditions, and when we put them together it's vital to ensure that they all look as if they belong in the same scene. Adjusting the lighting on an object is a key Photoshop skill, and we'll look at a couple of ways in which we can change the lighting on a figure.

One important fact that's often overlooked is that everything casts a shadow. If your figures don't cast shadows, then they're probably vampires. Adding shadows helps objects to look as if they're sitting on the ground, rather than floating in space; it makes everything look more coherent, and more consistent.

Shadows on wall and ground

1 Here's our starting image: a boy against a plain wood panel wall. We'll use the boy's layer to create a soft shadow on this wall.

BASIC SHADOWS ON THE WALL AND GROUND ARE easy and straightforward to create. They can make all the difference to the success or failure of an image. In the montage above, for the *Sunday Telegraph*, I needed to show the 'ISA bombshell' coming through the letterbox but not yet touching the doormat: the shadow shows the distance it still has to fall.

On these pages we'll look at the simplest way to create shadows on the wall, which are simply offset copies of the layer to which they belong, and shadows on the ground, which are distorted versions of the same thing.

It's possible to create drop shadows using Layer Styles, of course, with a single click. But this method gives us far more control, and allows us to modify shadows where they need to bend over objects in the scene.

When we place shadows, especially on walls, we need to consider the light source. The direction is key, obviously, but so is the placement of the shadow: the closer it is to the figure, the closer the figure will appear to be to the wall.

5 To make the floor shadow, duplicate the layer and fill with black, as above; move the layer behind the boy, and use Free Transform to shear and scale it so it lies on the floor.

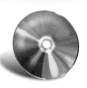

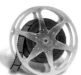

2 Duplicate the boy layer, and press **D** to set the foreground and background colors to black and white, then press ⌥ *Shift* *Backspace* *alt* *Shift* *Backspace* to fill the layer with black.

3 Move the shadow layer behind the boy's layer, dragging it down a little way. The exact position depends on how close to the wall you want the boy to appear to be situated.

4 Lower the opacity of the layer – around 50% is a good starting point. Use Filter > Gaussian Blur to soften the layer; a value of around 3 pixels works well in this instance.

HOT TIP

In step 2, we add the Shift key when filling the layer with black. This preserves the transparency of the layer: if we didn't hold it, the entire layer would be flooded with black.

In step 6, I recommend touching up the shadow around the feet before applying the blur and lowering the opacity. It's much easier to paint with a hard edged brush and eraser, than to try to match the blur radius later with a soft brush.

6 You may need to touch up around the feet, painting in and erasing awkward points. When this is done, apply Gaussian blur and lower the opacity, as in step 4 above.

7 To make the shadow fade into the distance, make a Layer Mask for it. Use the Gradient tool, set to Black to White, and drag vertically on the mask to make the soft fade.

8 We can combine both techniques to make the shadow run along the floor and up the wall: simply create both shadows, then erase or mask them to fit the wall edge.

SHORTCUTS
MAC WIN BOTH

Tricky ground shadows

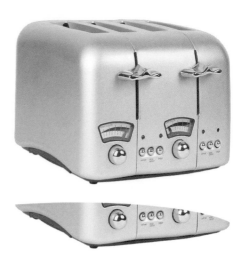

1 To make the shadow for this toaster, let's first select a piece of the bottom edge and use ⌘ J ctrl J to make a new layer from it. The exact cutout at the top doesn't matter: it's only the bottom section we're interested in.

WHEN I CREATED THE IMAGE above for the *Guardian*, I wanted to give the impression of the huge crate hovering just above the road surface. The shadow here is all that gives it the required sense of distance: where we normally use shadows to fix objects firmly on the ground, it's here used to the opposite effect.

On the previous pages, we looked at the simple way to create ground shadows. But not all objects are as obliging as the figure we used before. Sometimes we need to select a portion of our object to create the shadow; sometimes, we need to draw the whole thing from scratch.

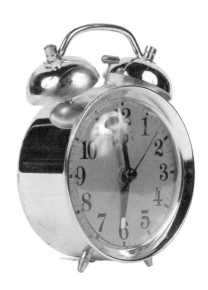

4 In real life, multiple diffuse lighting means that we don't often get the well defined, perfectly formed shadows we've been looking at so far. In these cases, we need to draw our shadow by hand.

2 Fill this section with black. It's exactly the same shape as the front and left bottom corners of the toaster, and we can see how this will make a good shadow. But notice that projecting foot at the bottom corner: we need to erase this, as it would make an awkward bulge.

3 Reducing the opacity of the shadow and softening it using Gaussian Blur helps to make it look more like a real shadow. And when we move it into place behind the toaster, it grounds it perfectly. For some objects, this is the easiest method.

HOT TIP

When drawing the shadow for the clock, you may well find the whole thing looks too dark at the end. Reduce the opacity of the layer, if you like. A better method is often to use a large, soft-edged eraser at a low opacity, and to gently erase the darkest parts of the shadow in order to shape and tone it better.

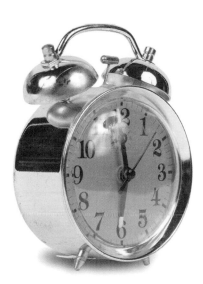

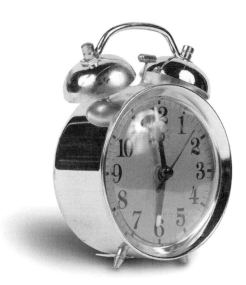

5 Choose a soft-edged brush, and set it to a very low opacity – around 40% if you're using a graphics tablet, or around 20% if you're paintig with a mouse. Start to paint in the shadow where it's darkest, directly beneath the base of the clock.

6 Using a larger brush, build up the rest of the shadow in short brushstrokes. We're not after replicating the shape of the clock, but rather drawing a suggestive shadow that places it on the ground. It can take a while to get this right, so use a low opacity and build it up slowly.

SHORTCUTS
MAC WIN BOTH

Creating complex shadows

1 Before we begin to create our shadow, it's important to check the light direction. The near side of the arm is darker than the front: the light's coming from the top left.

4 Now inverse the selection, and then hold ⌘ ⌥ Shift / ctrl alt Shift as you click on the glasses thumbnail to limit the selection to that area. Fill with black.

7 Bring in the far leg shadow, flip it vertically and rotate and scale it. Remember the light position: the shadow needs to fall on this side of the arm in order to look right.

E ARLIER IN THIS CHAPTER WE'VE been looking at how to create shadows from figures. It's not always that straightforward: in the illustration for the *Guardian*, above, the shadow had to be created from scratch – there was no way it could be interpolated from the vertical view of the line marker.

Sometimes we can use the existing data, but have to split it up into its constituent parts in order to distort each one individually. The task of creating a shadow for these sunglasses was originally set as a Friday Challenge on the How to Cheat Reader Forum – results below.

2bfree

atomicfog

BigVern

dave.cox

David Asch

david urquhart

Neal

pauline

photosynth

Pierre

Pierre

rufus

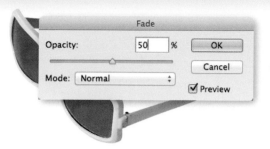

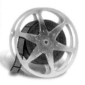

2 To begin, select the lens area of the sunglasses with the Magic Wand tool. Make a new layer for the shadow, and fill this selection with black.

3 Immediately press ⌘ *Shift* F *ctrl* *Shift* F to open the Fade dialog. Here, we can reduce the opacity of that fill to 50%, so that the lens area is partially transparent.

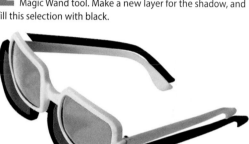

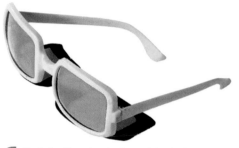

HOT TIP

In step 3 we used the Fade command to reduce the opacity of the fill. We can use Fade immediately after any brush stroke, fill or filter: not only can it be used to reduce the opacity of the operation, we can also make it change the mode, just as if the operation had taken place on a separate layer.

5 In order to make this shadow work, we're going to have to split it up into separate layers for the front, and the two arms, and move it behind the glasses.

6 Begin by distorting the front of the shadow, using Free Transform, so the bottom touches the bottom of the glasses, and the top falls away along the ground plane.

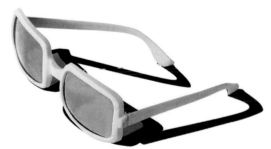

8 Even though we're viewing the near arm from above, its shadow will still be cast from the side. Duplicate the previous arm's shadow, and use that instead.

9 Now merge all the shadow layers, and apply Gaussian Blur to the whole shadow. Reduce the opacity to around 50% (darker if it's on a dark background), and we're done.

SHORTCUTS
MAC WIN BOTH

Deborah Morley · Eggbox · GKB · Glen · james · mguyer · michael sinclair

Sophie · Steve Mac · Toby · Tom · vibeke · Whaler · Wayne

7 Light and shade

Light from windows

1 A pleasant enough scene: attractive wood paneling, an Atkinson Grimshaw oil painting, and even a statue of Benjamin Franklin to keep an eye on things. But the scene is still a bit flat; it could do with some more interesting lighting.

THE ROOM ABOVE WAS BUILT FROM scratch, and needed the feeling of a light source to make sense of it. A financial illustration for the *Sunday Telegraph*, it may be cartoony in its appearance – that was the intention – but it still needed to have that extra element of realism if it was going to look good on the page.

Adding the effect of late afternoon light streaming through a window helps to add interest and warmth to a picture. It's a relatively easy technique to master, and can be used to great effect.

4 Select the pixels in this layer by holding ⌘ ctrl as you click on the layer's icon in the Layers palette. Now inverse the selection (⌘ Shift I ctrl Shift I), then feather it (Select>Modify>Feather) by about 8 pixels. Make a new layer, and fill the selection with black; then lower its opacity to around 50%, and hide the white layer.

2 On a new layer, make a grid of white rectangles in the shape of your chosen window. The size isn't important: although we're going to enlarge this quite a lot, we'll end up by blurring the edges so any pixellation that may creep in will be lost.

3 Distort the array of panes using Free Transform, so that they fall at an angle across the image. Keep the top edge more or less in a line with a horizontal line in your photograph for a more realistic effect.

5 You can choose to bend the shadows around any protruding objects with the Smudge tool or Liquify filter; here I've moved the shadow to the left where it falls on the front of the cupboard, and bent it slightly over the chair. Be sure, though, to erase the shadows where they fall on any light sources, such as the table lamp shown here.

6 Now for the rosy glow from the window light. Load up the pixels in the shadow layer, and inverse the selection so that only the soft-edged panes are selected. From the Adjustment Layer icon at the bottom of the Layers palette, make a new Curves adjustment: add some red and a little green to the Curve to complete the effect.

Multiple shadowed objects

THROUGHOUT THIS CHAPTER I'VE recommended always creating shadows on a separate layer. But there are times when a shadow should be part of the layer to which it belongs, as in the example shown here.

It would have been possible to create this stack of cards using a separate layer for each card, and then simply flattening all the layers at the end. But since a pack like this could include up to 52 layers (54 if you include jokers), we'd be talking about a document that's unnecessarily unwieldy for the effect we're trying to create. This way, we can draw an entire pack of cards in a single layer.

The technique used to get rid of the overhanging shadows in steps 9 to 11 is a little tricky. Here's how it works: when we go into QuickMask mode, the solid cards are shown as solid red; the partly transparent shadows are a paler pink. Using the Levels control, we can work on the mask as if it were a normal layer. So we adjust the mask so that the pale pink disappears, leaving just the solid red – the fully selected area. When we then exit QuickMask, our selection will be constrained to just the area that was fully opaque initially, so inversing and deleting the rest will get rid of the unwanted shadows.

1 This photograph of a playing card has been distorted using Free Transform to make it appear as if it's lying on a horizontal surface.

4 Select the card pixels again. Then use ⌥⌘D *alt ctrl D* to feather the selection: with the Marquee tool selected, nudge the selection area down a couple of pixels, set the foreground color to black, and use Fill (Edit menu) to fill *behind* at an opacity of 50%.

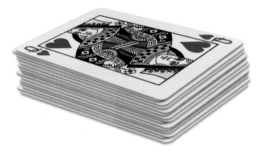

7 Any number of cards can be stacked up in this way: as long as you keep the ⌥ *alt* key held down, you'll keep moving copies. Don't make the offsets too regular!

10 Now we can 'tighten up' that shadow using the Levels control. Drag the white arrow slider to the right, and the partly selected (lighter red) area will vanish.

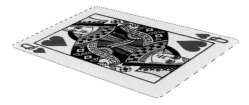

2 The first step is to give some depth to the card. Begin by 'loading up' the pixels in its layer – hold ⌘ *ctrl* and click on the thumbnail in the Layers palette.

3 Now hold ⌥ *alt* and nudge the card up a couple of pixels: then inverse the selection using *Shift* ⌘ *I* *Shift* *ctrl* *I* and darken up the edge you've just created.

5 This creates a soft shadow beneath the card – but on the same layer as the card. Make a duplicate of this layer to work on, as we'll need the original later.

6 Now Select All using ⌘ *A* *ctrl* *A*. Holding down the ⌥ *alt* key with the Move tool selected, move the card to create a copy on top – and the shadow moves with it.

HOT TIP

The nudge keys will behave differently depending on which tool is currently active. If the Move tool is selected, as in steps 3 and 6, the selected pixels within the layer will be moved: if another selection tool (the Marquee or Lasso, for instance) is active, the selection area will move but not the pixels themselves. You can always hold ⌘ *ctrl* to access the Move tool temporarily while a selection or painting tool is active.

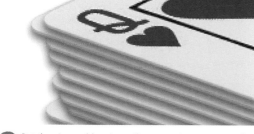

8 But there's a problem here: if we zoom in, we can see that there are shadows beneath the overhang of the cards where there's nothing for them to sit on.

9 To get rid of the excess shadows, select the card layers by ⌘ *ctrl* clicking on the layer name, and go into QuickMask mode by pressing *Q*.

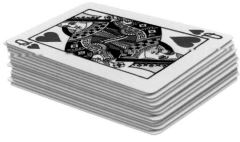

11 All we need to do now is to exit QuickMask and inverse the selection, then press Delete: those extraneous shadows will simply disappear.

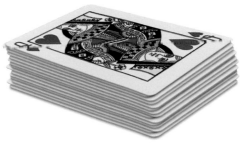

12 The last step is to bring back that original card that we duplicated, so we return the shadow beneath the bottom card in the stack.

SHORTCUTS
MAC **WIN** **BOTH**

Shading on Hard Light layers

O N THE PREVIOUS PAGES, WE looked at adding shadows to multiple objects. But to preserve editability, it's a good idea to keep all your shadows on a separate layer. There were a lot of shadows required in this illustration for the *Independent*, above; by keeping them separate from their layers I knew I'd be able to make any changes asked for.

We'll use a Hard Light layer to add shadows to the elements within this box. We'll also show how to remove selected areas from the Hard Light layer, so we can paint the shadow of one object cast upon another.

The first three steps involve loading up selections, making a Hard Light layer, filling it with mid tone gray, deleting the region outside the selection, and locking its transparency. This sequence is an obvious candidate for a Photoshop Action: being able to perform all the operations with a single keystroke can be a huge time-saver.

1 To make the shading layer, hold ⌘ ctrl and click on the thumbnail for the Blocks layer. Then hold ⌘ Shift ctrl Shift and click on the Book and Ball thumbnails to add them to the selection.

4 We can use the Burn tool, set to Highlights, to paint shadows onto the new layer. But this isn't enough: we also want shadows cast from each object onto those behind it. We can do this on the Hard Light layer as well.

New Layer

Name: Hard Light OK

☐ Use Previous Layer to Create Clipping Mask Cancel

Color: ☐ None

Mode: Hard Light Opacity: 100 ▸ %

☑ Fill with Hard-Light-neutral color (50% gray)

2 Now make a new layer above these three: set its mode to Hard Light, and check Fill with Hard Light neutral color. The entire layer will be filled with gray – but we can't see it, as gray is invisible in Hard Light mode.

3 To make the layer match the selection, first inverse it using ⌘ *Shift* *I* *ctrl* *Shift* *I*, then delete. Finally, lock the transparency of the Hard Light layer using the check box at the top of the Layers palette.

HOT TIP

In step 3, we locked the transparency of the Hard Light layer. This prevents the Burn tool from affecting areas outside the original selection, even when the area is deselected. It also means we can paint in color on the Hard Light layer for special effects.

5 Load up the Hard Light layer's pixels by ⌘ *ctrl* clicking on its thumbnail. Hold ⌥ ⌘ *alt* *ctrl* and click on the Ball layer's thumbnail to remove that area. Still on the Hard Light layer, paint the ball's shadow onto the book.

6 Now remove the book's area in the same way – by holding ⌘ ⌥ *ctrl* *alt* and clicking on its thumbnail in the Layers palette. We can now paint the shadow of the book onto the blocks.

SHORTCUTS
MAC WIN BOTH

175

Visible light sources

1 Begin by adding a shadow to the scene. This is simply painted on a new layer, using a large soft-edged brush. Setting the brush to a low opacity allows us to paint the shadow on in small stages, being careful to leave an unshaded area where the light will eventually be cast.

SO FAR THIS CHAPTER HAS DEALT with shadows cast by far-off light sources. When the light itself is in the frame, we obviously need to show it. In this workthrough, we're straying into the realms of hyper-realism: by deliberately over-emphasizing the visible light, the montage becomes more appealing than if we simply tried to reproduce reality. In real life, a light source wouldn't cast a visible beam unless the room were full of smoke; but then real life is often far duller than fiction.

Shadows are still important, for two reasons: first, because they add life to the image; and second, because a dark background will make the light itself stand out better. Here, we'll take the simple montage shown above and add both lighting and shadow to make it into a far more entertaining image.

4 Now exit QuickMask and, on a new layer, pick a pale yellow color (about 20% Yellow should do the trick) and then use the Gradient tool, set to Foreground to Transparent. Drag it from within the shade perpendicular to the shade edge, away from the lamp.

2 Next, we need to define the light. This is best drawn with the Pen tool, following the contour of the edge of the lamp shade and radiating outwards from the light source. Turn the path into a selection using ⌘ Enter *ctrl* Enter, then go into QuickMask to adjust the selected area.

3 In QuickMask, trace around the edges of the light area with the Lasso tool, omitting the edge around the shade. Then use Gaussian Blur to soften the edge – here, an 8-pixel radius blur was applied. Because the edge by the lamp shade was not selected, that part remains crisp and unblurred.

5 We now need an extra glow around the bulb itself. With the light area still selected, use a soft-edged brush to paint a spot of white at the focal point. Don't use a hard-edged brush: although bulbs are solid, you can't look at them when lit without seeing a haze around them.

6 Now we need to show the light acting upon the table surface. Using the Elliptical Marquee tool, draw an ellipse on the table. Feather the selection (an 8-pixel radius was used here), and delete that area from the shadow to return the table to its previous brightness.

HOT TIP

By using QuickMask to blur the light area, we're able to apply the blur just where we want it. If we'd simply feathered the selection instead, the whole area would have been blurred, leaving the light looking disconnected from the shade; this way, we're able to maintain the hard edge around the shade itself.

SHORTCUTS
MAC WIN BOTH

177

Turn the lamp on

MORE LIGHTING UP: BUT THIS version offers a rather different sort of problem. The main difference is that we're working with a single composite image, rather than a montage composed of several separate parts. When you don't have the luxury of being able to arrange the elements within your scene to suit your whim, you need to approach the problem from a different angle.

This was set as a Friday Challenge on the website that accompanies this book, and some of the readers' entries are shown below. There was a variety of different approaches, but all managed to convey the impression of a hidden, yet still visible, light source within the shade.

1 The first task is to even out the shading already present in the scene. The most obvious offender is the lampshade, which has strong side lighting coming from the window to the right of it. This is best outlined with the pen tool and copied to a new layer, where the right side can easily be cloned out. And don't forget to remove that hard shadow at the bottom left!

4 The next step is a subtle one, but it makes a big difference. At the end of the previous stage, we had the glow in place behind the lampshade: but the hard edge of the shade looked unnatural against the bright glow. Make a layer mask for the shade layer, and paint out the very bottom of the shade so we can see the glow through it.

THE FRIDAY CHALLENGE
www.howtocheatinphotoshop.com

atomicfog

maiden

raymardo

2 Since we made a new layer from the lampshade, we can work on it independently – which makes adding the glow within a piece of cake. Use the Dodge tool, set to Highlights, and simply build up the glow in brief strokes: the result can be extremely convincing. The white spot that shows where the bulb is can be painted in with the Brush tool afterwards.

3 Now for the glow outside the shade. Make a new layer and move it behind the lampshade layer – another good reason for having copied the shade to its own layer. The glow is painted in using a soft, low opacity brush, and a pale yellow foreground color; this is followed by a small amount of painting in white closest to the shade.

5 Now for the rest of the scene. On a new layer, paint a shadow on the bottom half of the lamp base, and on the table beneath it. Then, on another layer, use a large, soft brush set to a low opacity to add shadows in the corners of the scene, stronger the further they get from the lamp source.

6 Finally, the *pièce de resistance* that makes the whole scene come to life. Make an elliptical selection within that last shadow layer, feather the edges slightly, and delete (or make a layer mask and fill with black). The lamp now casts a convincing light beneath it on the wall, greatly adding to the overall realism.

HOT TIP

When in doubt, make a new layer. Here, I copied the lamp base to a new layer before adding shading beneath it. By making new layers each time you're going to make a big change you keep your options open, so you can always retrieve the original later in case the effect looks wrong.

Russ Davey

tabitha

Tweaknik

Uk2usadaz

Shading using light modes

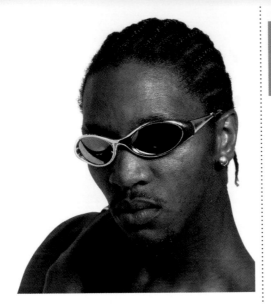

SHADING USING THE THREE LIGHT modes – Hard Light, Soft Light and Overlay – can have a far more cinematic effect than shading using the Dodge and Burn tools. But if Dodge and Burn are *Nosferatu*, then Hard Light is more *Saturday Night Fever*: shadows can take on a strong hue of their own. There are, of course, more than three light modes; shown here are some personal favorites.

Rather than painting directly onto the layer, create a new layer and set it to Hard Light mode. You then have the option of filling the layer with 50% gray: this makes a good background when applying the shading to multiple layers. By filling your selection area with 50% gray and then locking the transparency, you can be sure that the light you paint will only be applied within the area where you want it.

If you must paint directly onto the layer, you can set the brush mode to Hard Light (or any of the other Light modes) to get the same results.

1 Be careful to use reasonably muted colors when painting shadows, or the effect will be too bright and unrealistic. This light blue is too bright for use either as shading or as a light reflection: it merely swamps the image with its color.

4 Now for the spotlight effect. Too bright a shade would have the unfortunate results shown in step 1 above; a muted brown gives us a color that lets the original skin texture show through, while adding a good amount of extra color to it.

2 Using a darker blue allows us to paint a shadow that's far more moody and evocative. This is the kind of shading that's often seen in films, where day-for-night shooting produces shadows that have a strong blue cast to them.

3 Switching to a strong pink gives us a good color with which to paint a transition on the face, between the shaded and the brightly lit areas. It's the effect produced by theatrical lighting, where colored gels are used instead of plain white lights to add emphasis to the actors' faces.

5 Here's the same effect set to Overlay mode instead. This is rather softer: the colors still have their effect on the image, but obscure the shading and texture of the original to a lesser degree.

6 More muted still is Soft Light mode, which produces an altogether subtler result. The three modes are variants of each other, and can be used in combination on different layers to build up the overall lighting effect.

HOT TIP

If you're using multiple colors when painting with Hard Light, as we are here, it's easy to apply the wrong color by accident – there's some trial and error involved in choosing shades that work. To prevent the possibility of losing a good effect, you can work on multiple Hard Light layers so that the effect is produced by the combination of all of them.

SHORTCUTS
MAC WIN BOTH

Reverse shading with Curves

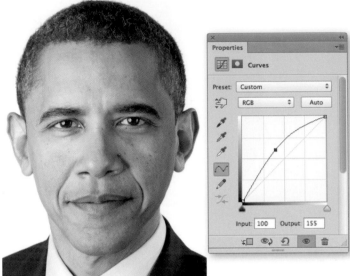

1 Start by making a new Curves Adjustment Layer, using the Obama portrait as a Clipping Mask (click the Clipping Mask icon, third from the left, at the bottom of the Adjustment Layer panel). Raise the midtone of the curve until the right side of the face is as light as the left side used to be. Don't worry about the left side for now – it's only the right side we're working on at this stage.

W E OFTEN HAVE TO WORK WITH the best images that come to hand – even when they're not ideally suited to the task. This official portrait of Barack Obama shows strong side lighting, which could be difficult to work with in a montage if the lighting in the scene doesn't happen to come from the same direction as in the original photo.

Here, we'll show a simple way to correct the lighting, first to produce a balanced image with no clear lighting direction, and then to create a light source on the opposite side to that which was originally applied to the photograph.

The portrait of Obama has been cut out, on top of a separate white background. This is to stop the Adjustment Layer affecting the white of the background.

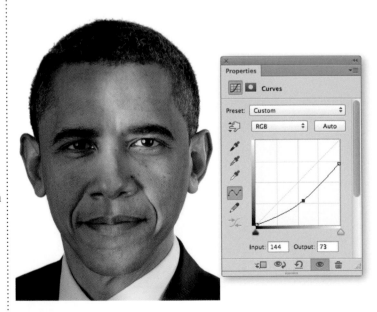

4 Open the second Curves Adjustment Layer's dialog, and drag the curve downwards so we darken up the left side of the face instead of brightening it. Because we inverted the mask we'd added previously, the process has no effect on the right side of the face.

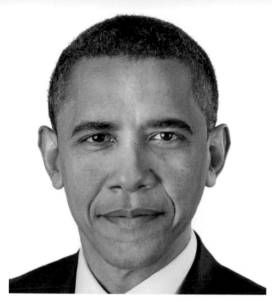

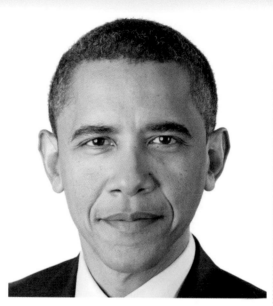

2 Every Adjustment Layer comes with a built-in Layer Mask. We can paint over the left side of the face on this mask, using a large, soft-edged brush, to hide the Curves effect, revealing the original portrait beneath. The result is a much more balanced image.

3 To shade the left side of the face, first duplicate the Adjustment Layer, again using the portrait as a Clipping Mask. Then click on the Mask itself in the Layers Panel, and use ⌘ I ctrl I to invert the mask. Now, the Curves effect is only applied to the left side of the face.

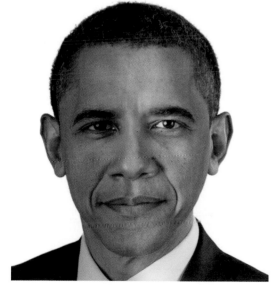

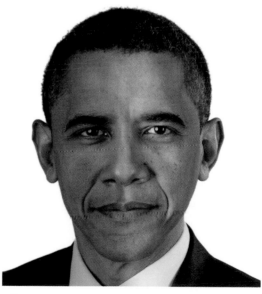

5 Simply inverting the mask is a good first step, but it doesn't always produce perfect results. We can use a soft-edged brush to refine the edge of the mask, softening the hard edge produced by inverting the original.

6 Finally, use a small, soft-edged brush to paint out the Adjustment Layer over the left eye. This allows it to shine out more brightly, as eyes catch the light more than skin. The result is now a perfectly inverted lighting direction.

Making smoke without fire

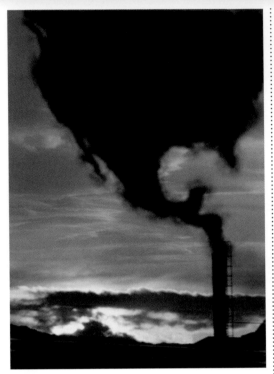

1 Here's our starting image: an apparently dead oil refinery. It's our task to bring it back to life. Here, the refinery and the background clouds are on two different layers; this will make it much easier to place the smoke behind the refinery, which will blend it into the scene better.

THIS IMAGE OF SMOKE FROM AN OIL refinery, for the *Independent*, tells its own story: industrial pollution in America. This is an extreme example – but every Photoshop artist needs to know how to create convincing smoke for any purpose.

It's not a difficult technique, as long as you take it slowly and build up the initial smoke pattern in small stages. This isn't the kind of effect that will happen instantly!

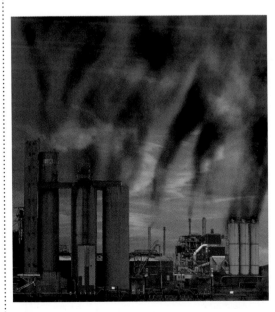

4 The texture we created in the previous step looked far too hard for realistic smoke. But that was just the beginning: by changing the mode of this layer, we can change the appearance. Here, we've changed the mode to Multiply for a dirty look.

2 On a new layer, use a soft-edged brush with a white foreground color to paint the smoke. Use a low opacity – if you have a graphics tablet, you'll find the job easier. Paint in small strokes, building up a convincing shape. It's worth taking the time at this stage to get it right.

3 Now for the texture. Lock the transparency of the layer by pressing the **/** key. Set the foreground and background colors to their default black and white (press **D** to do this), and choose Filter > Render > Clouds. This fills the smoke area with a random marbled texture.

5 Just as we used Multiply mode in the previous step to make dirty smoke, so we can change the mode to Screen – the opposite of Multiply – for a bright, clean smoke effect.

6 To make the smoke blend in better with the surroundings, make a new layer and set it to Hard Light mode; then press **⌥ ⌘ G** *alt ctrl G* to make a clipping layer with the smoke. Sample colors from the background, and paint with a large, soft brush to blend the smoke.

HOT TIP

The fact that we've used the Clouds filter in step 3 has nothing to do with smoke and clouds being similar substances! This filter simply creates random textures, and can be used for any purpose where natural texture is required. Hold **⌥** *alt* as you choose the filter for a tighter, smaller pattern effect.

SHORTCUTS
MAC WIN BOTH

185

Making fire without smoke

1 Begin by making a new layer. Paint a random shape in white, using a soft-edged brush. All we're after at this stage is a shape with some slight variation in density. Because we're painting with white, it helps to have a black background so we can see it more clearly.

THERE ARE MANY WAYS TO MAKE explosions in Photoshop: the controlled example in this illustration for the magazine *PC Pro*, above, uses a variety of techniques.

Elsewhere, we've looked at using fireworks to give the impression of a destructive explosion. Here's another method, which is good for making fireballs: it's easy to create, and is a curious process which doesn't really make sense until the final step of the operation.

4 Now, with the transparency still locked, set the foreground and background colors to the default black and white (use the **D** key to do this). Apply the Clouds filter again. All the color will have been lost: but we'll get that back in the next step.

2 Use the Smudge tool, set to a soft brush at about 70% opacity, to streak out the mass of white from the center. Try not to let the streaks waver too much: each one should look as if it's radiating directly from the middle of the object.

3 Now lock the transparency of the layer, by pressing ⃞. Set the foreground color to yellow, and the background color to red. Now choose Filter > Render > Clouds, which will add a random texture of red and yellow to our object. Repeat the filter, if you like, until you achieve a pleasing effect.

HOT TIP

Because the Clouds filter produces a random texture, there's no way to control its effect. All we can do is apply the filter a number of times, until we're happy with the result. Remember, you can hold ⌥ *alt* as you choose the filter to apply its effect in a tighter pattern.

5 Before you do anything else, apply the Fade command to that last filter by pressing *Shift* ⌘ *F* *Shift* *ctrl* *F*. From the resulting dialog, choose Linear Light. This is a layer mode we haven't looked at before: it produces a harsher version of the Hard Light mode.

6 On its own, the explosion works well enough; but it really comes into its own when we place it on a suitable background. Here, we have the effect of a powerful airburst exploding over a nighttime city.

Lighting up: perfect neon

1 Start by choosing your lettering style. Avoid fonts that have a huge variation between thick and thin, as these won't carry the neon effect well: the plainer, the better. Select all the lettering by holding ⌘ ctrl and clicking on the layer's thumbnail in the Layers Palette.

4 Now hide the original text layer, and erase portions of the stroke to simulate the way neon lettering is constructed in the real world. Since all the lettering is made from a single bent glass tube, it needs to break within each letter where it turns to join the next letter.

NEON LETTERING IS ONE OF THOSE effects you can knock up in a few moments: simply create the outlines and add a glow to them. But to do it properly takes rather more time and patience.

The hardest part about creating the book cover above was not making the neon, but producing a convincing cutout of the celebrity chef's hair. Taken against a dark (but not black) background, it had to be given enough translucency to look convincing with the neon lettering shining through it.

7 The glow is created on a new layer, behind the tubing layer. First load up the pixels as outlined in step 5, then hold *Shift* ⌥ *Shift* alt as you enclose it with the Marquee tool to limit the selection to just the top word. Feather the selection (8 pixels used here), and fill with the same color as the tubing; then repeat with the bottom line of text.

2 We can use the Refine Edge dialog to round off the corners of the type – see page 22 for more on this technique. This turns the standard font we started with into one that's ideally suited for being turned into neon.

3 Select the pixels in the text layer using the Magic Wand tool and then, on a new layer, create a stroke outline using the Edit/Stroke menu. Don't use Layer Effects to make the stroke, or you won't be able to edit the outlines afterwards.

HOT TIP

If you're after a quick and simple neon effect, you can create this fairly easily using Layer Styles. Use an Outer Glow to create the glow, and an Inner Glow to make the tubing itself. You won't be able to add the shading to the tubing in the same way, but it is a quick alternative.

5 To create the inner glow, select the layer's pixels by holding ⌘ *ctrl* and clicking on the thumbnail in the Layers palette. Use Select/Modify/Contract to reduce the selection size by, say, 3 pixels; then apply a 3-pixel Gaussian Blur to it. Now turn on the Lock Transparency checkbox, and fill the selected area with white.

6 Now's a good time to add a background, with shadows as appropriate. I've also changed the color of the bottom row of text for the sake of interest, using Hue/Saturation. The next step is to make the outline look like tubing: this is achieved by darkening it with the Burn tool (set to Midtones) at the points where it's been strongly bent.

8 Now to add the details. The wires are drawn on a new layer, shaded and shadowed using the Pipes and Cables technique shown in Chapter 12. One clip, which holds the lettering to the wall, is created on a separate layer; this clip is then copied around each letter in turn, rotated as appropriate so it appears to grip the neon tubing.

9 If you want to give the impression of your neon lettering being placed on a sheet of glass, such as a window, it will benefit greatly from a reflection. To do this, hide all the layers except the neon itself, then Select All (⌘ *A* *ctrl* *A*) and use ⌘ *Shift* *C* *ctrl* *Shift* *C* to make a merged copy. Paste, move behind the neon layers, and lower the opacity.

SHORTCUTS
MAC WIN BOTH

Day for night

1 Begin by removing the existing sky. The Background Eraser Tool (see page 204) proves invaluable for this task, easily cutting all the bright sky away for us. A dark background layer helps us to see the result as we erase.

MOVIES SET AT NIGHT ARE generally filmed during the day, using special filters to simulate the effect. In Photoshop, turning a day scene into a night one is not difficult – and it turns out to be one of the more enjoyable photomontage jobs, particularly since the results can be spectacular.

We'll look at how to turn this view of Paris rooftops into a night scene, with remarkably few steps. The technique makes extensive use of Adjustment Layers, to preserve editability.

This task was set as a Friday Challenge on the How to Cheat website, and produced many striking images, reproduced below.

4 Select each of the windows you want illuminated with the Lasso tool (holding ⌥ *alt* to create straight line joins), and copy them to their own layer.

2bfree BabyBiker Ben Mills Cat Dave.Cox

Neal Pierre Stefan Steve Mac Toby

2 We can use a new Curves Adjustment Layer, using the background as a Clipping Mask, to lower the brightness of the scene. As well as reducing the RGB curve, lower the red and green channels for a blue cast.

3 The building on the far right remained too bright. Select it with the Lasso tool: a second Curves Adjustment Layer can be used to reduce the brightness of this layer, and will automatically be masked by the selection. Note the new sky!

5 Make a third Curves Adjustment Layer, using the windows as a clipping mask; lift the curve to brighten the windows, adding red and green for a yellow glow.

6 Finally, add another Curves Adjustment Layer, masked so it brightens just the bottom of the buildings, giving a sense of street-level glow.

HOT TIP

It's important that the Adjustment Layers should affect only the layer directly beneath. To do this, hold ⌥ *alt* as you choose Curves from the Adjustment Layer menu at the bottom of the Layers palette; a dialog will pop up, where you can check 'Use previous layer as clipping mask'.

SHORTCUTS
MAC **WIN** **BOTH**

Deborah Morley

Dek_101

James

MGuyer

Michael Sinclair

Tom

Valter

Vibeke

Wayne

Whaler

I want to tell you a story

I WAS IDLY BROWSING in a model shop while writing this edition of the book, finding myself intrigued and entertained by all the model railway supplies, which included thoroughly realistic buildings, trains and other props. I was particularly drawn to a series of large-scale human figures made by the German model maker Preiser, which stood out from the crowd due to their realism, both in the modeling and in the choice of situation in which the characters were portrayed.

One set of figures baffled me. It was a group containing three elements: a man slumped in a chair, a woman holding a brassiere, and an open suitcase. It was a while before the scenario dawned on me: the man has just returned from a trip and his wife, unpacking his suitcase, has come across a piece of underwear belonging to another woman.

Whole novels and movies have been based on plots such as this – and yet here was the entire story, told with just three figures, all packaged in a box measuring just a few inches on each side. The body language all makes sense: the fury in the face of the woman, her mouth open mid-yell, her finger pointing accusingly. There's a look of utter resignation on the face of the man; unable to meet his wife's eye, his whole body is slumped in an attitude of defeat. He's dressed for work rather than pleasure – this has clearly been a business trip rather than a vacation. Her more casual clothing, meanwhile, confirms that she has not been on the trip with him. And finally, the crucial third element: the suitcase, its crumpled contents signifying that this is the end of a trip rather than the beginning of one.

There isn't a wasted element in this box, and it tells its story with total economy. Every detail is essential to the tale, and has been calculated to perfection. It's all muscle, and no fat.

This is the ideal we strive for when we construct a montage in Photoshop. We're not just throwing elements onto the page, we're telling a story. And we have to bear in mind the questions the viewer will be asking: what are these people doing in this situation? What's their relationship with each other? Where are they located? What happens next?

Earlier in this book, we looked at how the relationship between characters could, to a large extent, be explained by their body language, by their relative poses. The same considerations come into play when we choose a background sky, for example. If it's doom-laden, is this because we want to convey an air of foreboding? If it's bright and sunny, then are we being optimistic in our outlook?

Every element we incorporate into a montage helps to tell the story, and we have to be sure that every element earns its place. The temptation to chuck in various items of interest is a trap we all fall into, myself included – but the best illustrations are usually those that get their point across with simplicity and elegance.

When you're creating your montages, bear in mind that people like to read pictures in much the same way as they read a book. They start with no knowledge of the plot, and their job is to interpret the sense of the image from the visual clues. Your job, as the illustrator, is to feed them the story. It doesn't have to be obvious at first glance: like the railway model, you can choose to make it reveal its true nature only upon close inspection.

The most complex stories can often be told with surprising conciseness. Ernest Hemingway once claimed that the best thing he'd ever written was the following six-word story: *For sale. Baby shoes. Never worn*. It's poignant, elegant, almost heart-breaking in its resonance. This is the simplicity we seek as illustrators: we can play with the emotions of our audience as we gradually reveal to them the story we want to tell.

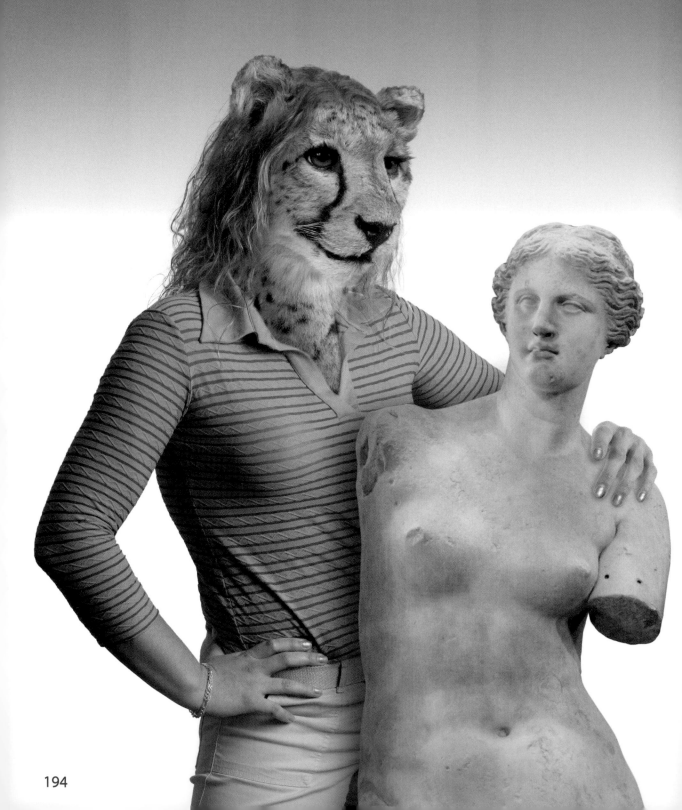

8

Heads and bodies

IF THERE'S ONE THING PEOPLE NOTICE, it's people. People catch our eye in landscapes; we invent people in clouds. Without people, montages can look dull and uninviting.

Which means we need to find images of people to populate our scenes. But it's rare that we'll find exactly the right shot of exactly the right model, in exactly the right pose, with exactly the right expression; more often than not, we need to modify the models we find in order to make them fit both the sense and the layout of the scene.

This means combining heads with different bodies, of course – a staple procedure that every Photoshop artist should be fully familiar with. But it also frequently entails adjusting poses, whether individual limbs or entire bodies. We'll look at all kinds of manipulation in this chapter.

Making the head fit

1 Here's our base image: the tennis player Nicole Vaidisova. We're going to place the head of another tennis player, Anna Kournikova, on top of this one to achieve a perfect fit.

P UBLICITY PHOTOGRAPHS OF celebrities and politicians tend to be either highly staged or snatched papparazzi images. Taking the head from one body and placing it on another, as in the illustration of Tony Blair above for the *Guardian* newspaper, is an essential skill.

When the head you want to use already has a similar color and shading to the body on which you're fitting it, it's a relatively easy job to graft the new head in place. Overleaf, we'll see how to work with more difficult bodies, with very different lighting conditions.

4 With the head in place, make a new Layer Mask and, using a small, soft brush, paint out the neck and T-shirt – see Chapter 3 for more on Layer Masks. It's a neat touch to have the hair hanging down behind her: use a hard edged brush to hide it behind the shoulder.

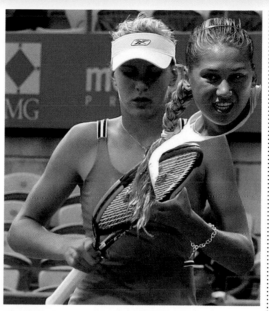

2 We first need to cut Kournikova's head from the background. The tricky part is the hair, which is most easily lifted from the background using the Magic Eraser tool (see Detailed Hair Cutting later in this chapter); we don't need to worry about the neck and shirt much at this stage.

3 With the basic cutout done, place the new head next to the old one. Don't put it on top at this stage: we want to scale it using Free Transform so it looks the right size, and it's easiest to judge this when we can see the two together. Once the scale is right, move it in place.

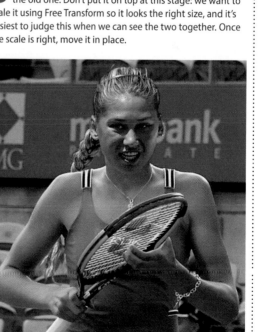

5 Kournikova's chin had a white highlight on it, caused by reflection from her dazzling white shirt. We need to lose that glare. Switch from the mask to the main layer, lock the transparency with and, with a small soft brush, paint over the highlight in a color sampled from her chin.

6 Finally, we need to remove those pieces of Vaidisova just visible on the background. Use the Clone tool to sample and paint out those stray strands of hair that are still visible. The skin tones are a good fit between these two images: this simple montage is now complete.

Complex head fitting

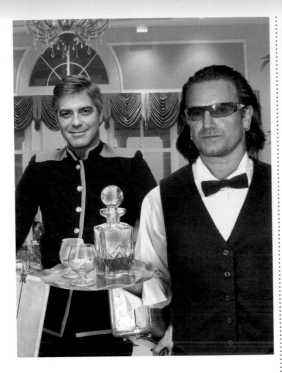

PLACING HEADS ON bodies involves matching the color and tone of the two. In the illustration above, for *The Caterer* magazine, George Clooney and Bono had to look as realistic as possible.

There are several potential dangers. There may be objects in the background photo that fall in front of the face; the head and body could be of radically different colors; there could be peculiar lighting on the original; and the grain of the two images may not match perfectly. We'll look at all those issues here.

1 Here's an unlikely pairing: Bill Gates, promoting the latest version of Windows, and Eric Clapton, showing a few of the moves that has made ol' Slowhand a guitar legend. They're both performing; they're viewed from a similar angle; so let's see if we can put the two together.

5 With the head the right color, we can add a layer mask and, using a soft edged brush, paint out the bottom of Gates' neck so it blends in smoothly. We can also soften around the edge of his face and hair with the mask. Now's also a good time to clone Clapton's head out of the background.

6 We need to capture some of that stage lighting effect. Make a new layer, set to Hard Light mode. Make a Clipping Group with the head layer using ⌘ ⌥ G ctrl alt G, and paint around the top of the hair with a soft brush, using colors sampled from the blue highlight on the shoulder.

2 Begin by cutting out Gates' head and neck. Place and scale it over Clapton's body, using the techniques described in the previous pages.

3 That microphone has to come in front of Gates. Hide his layer, draw a Pen path to select the microphone, and bring it to the front on a new layer.

4 Use Curves (see page 106) to make Gates' face match Clapton's body. Here we need to lower the blue and green, and raise the red amount.

HOT TIP

On the previous pages, we fit the two tennis players' heads together by masking directly beneath the chin. In most cases, it's worth grabbing as much neck as you can when you cut out the new head: the more neck you have, the easier it will be to create a seamless blend between the new head and the old body.

7 There's a graininess on the Clapton photo: we need to add this to the Gates layer. Make a new layer from a clear area of background, and lighten it with Curves; move it on top of Gates. When the mode of this layer is set to Hard light, it will result in a grain that closely matches the original (right).

SHORTCUTS
MAC WIN BOTH

Combining body parts

C OMPLEX MONTAGES FREQUENTLY require several bodies to be combined to produce the finished character. The image above, for the *Daily Telegraph*, was composed of a large number of separate limbs; the coloring and patterns helped to unify the coat and trousers.

Here, we'll look at a more straightforward problem: combining a man removing his shirt with a woman's body for comic effect. The key lies in choosing images photographed from similar angles: once you've found the right pictures to work with, it's a straightforward montage.

1 Here's our starting image: a man ripping off his shirt. If he had a costume underneath, he could be a superhero; I reckon he's just a sloppy dresser.

2 This woman has been photographed from a similar angle, and we can use her to replace his exposed body. Never mind the position of the arms: we won't be using them.

6 We can blend the body in more easily by painting a little of the man back in on the layer mask, using a soft edged brush, around the neck and above the belt. This helps to follow the original through to the new body.

7 There's still a gap behind the shirt on the left. Make a new layer, filled with mid gray, behind the whole assembly, that covers this region.

3 First, make a layer mask for the man and paint out his chest. The tie gives us a neat line to work to at the top, so there are no blending issues to worry about.

4 A section of the woman's chest, placed behind the male figure, needs to be rotated slightly to fit: the belly button and the neck need to line up with the belt and neck of the man.

5 The more slender back of the woman doesn't fill out the shirt enough. Copy a portion of the back to a new layer, and stretch it so it fills that white space behind the shirt.

8 Adding a little shading to the woman's chest, on a new layer, helps to make it look more like it's slightly in the shadow of the shirt. It's a subtle difference!

9 Now that we've got the body finished, let's give him/her a new head. This shot of Arnold Schwarzenegger seems the ideal candidate – but his head is the wrong color.

10 We can adjust Arnie's head with Curves to brighten it and add some red to match the body. While we're at it, let's distort the features, add some new eyes and recolor that tie to look better with the bikini top.

SHORTCUTS
MAC WIN BOTH

Changing history

1 Here are our three film stars – and an awkwardly placed soldier in the background. Let's close up this grouping.

S O FAR, WE'VE LOOKED AT MONTAGE in terms of assembling images from a variety of sources. Here, we'll see how to adjust a single image to remove one of the characters. In this case, we'll take Matt Damon out of a photograph showing him with Brad Pitt and George Clooney.

Removing people from photographs is the sort of practice that has given photomontage a bad name ever since the days following the Russian revolution, when protagonists were taken out of the frame to suit political ends.

The image above shows Lenin addressing a crowd in 1920: the figure of Trotsky, originally on the right of the frame, has been airbrushed out of the picture.

4 Scaling Clooney down so that Pitt is now looking at his eyeline helps; but he still seems too big in comparison. This is a good time to crop the image, too.

7 Now we can simply stretch the bottom half of his body down to fill the frame. With clothing like this, it's impossible to see that it's been stretched.

2 Make a selection of George Clooney, including some sky and background, as in this QuickMask representation.

3 When we move Clooney over to the left, we can see a scale problem: Pitt's looking at someone behind him.

5 There's a problem here. When we make Clooney the right size – keeping his eyes on a line with Pitt – his body is now too short to reach the bottom of the frame.

6 The best solution is to scale the bottom half of his body. Make a rectangular selection of Clooney, shown here in QuickMask mode to show the selected area.

8 There's still a hard edge where the sky behind Clooney's head cuts into the building immediately behind. Add a Layer Mask and paint it out where it overlaps the building.

9 So far, so good: but Clooney's edge is still too hard and crisp. Using either a Layer Mask, we can soften his layer to complete the picture.

HOT TIP

The technique used in steps 6 and 7, to extend Clooney's clothing to reach the bottom of the frame, can be applied to many purposes. In general, we are able to spot when a person's head has been distorted; but bodies – particularly in loose clothing – can be stretched by a surprising amount before we notice something amiss.

SHORTCUTS
MAC WIN BOTH

Detailed hair cutting

THE COMBINATION OF THE QUICK Selection Tool and the Refine Edge dialog (see page 20) has made it easier than ever before to cut hair from its background. But for some fine, detailed hair, Refine Edge just isn't up to the job. And that's where the Background Eraser comes into its own.

The Background Eraser Tool is found beneath the Eraser tool in the Toolbar. It's a powerful implement, but it needs careful handling to get the best out of it.

It's also wise to prepare the ground first, using the History Panel to safeguard against future disaster.

1 Start by duplicating the layer you want to cut out. Then make a new layer between the two filled with a strikingly different color, so you can see exactly where you're erasing.

2 Open the History Panel, and click next to the last step. This will 'pin' the history at that point, so you can revert to it later if you need to – and you almost certainly will.

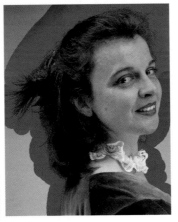

4 Using the Background Eraser Tool, hold ⌥ *alt* and click to sample the skin tone as the foreground color, then drag the tool over the edge of the face, so that the crosshair starts inside the blue background, to erase it where it's adjacent to the skin.

Don't try to complete the whole cutout in one go. Keep holding ⌥ *alt* to sample the foreground color as the 'keep' color changes – over the hair, the dress, and the white lace at the throat.

5 Large chunks of background, such as those missed out in the previous step, can be selected with the Lasso tool and simply deleted.

Although the colored background helps to see where you're erasing, it can also hide stray background pieces. Change the color of that layer to white, and you'll more clearly be able to see background pixels that have got left behind.

Brush size: Always work with a hard-edged brush. It sounds odd, but it performs much better.

Discontiguous: Will find and erase colors similar to the sampled color even if they're bounded by a different color.

Contiguous: Will find and erase colors similar to the sampled color only if they're joined together.

Find Edges: Actively separates hard edges within cutouts.

Limits: Discontiguous Tolerance: 50% ✓ Protect Foreground Color

Continuous: Samples the color beneath the crosshair constantly. Only useful when you have a very variegated background.

Once: Samples the color beneath the crosshair only where you first click. This generally produces the best results.

Background: Uses the background color as the color to be erased. Used only in rare cases.

Tolerance: Sets the range of colors erased based on the sampled color.

Protect Foreground Color: Prevents the foregorund color, sampled by ⌥ *alt*-clicking, from being erased.

3 The Background Eraser Tool works by sampling the color under the crosshair in the center, and erasing all similar colors within its radius. It has a number of variables on the Options Bar that you need to take a look at. The Sampling method is key: choose Once for maximum control. Choosing

Continuous will sample the colors under the crosshair all the while you drag the tool, and if the crosshair strays into the hair area that color will be inadvertently sampled. Try to avoid using it. For the Tolerance, start at around 50% and increase or decrease as necessary while you erase.

6 There's a fairly simple way to erase these stray pixels. Usually, they'll be individual tiny dots at a low opacity. Load the layer as a selection by ⌘ *ctrl*-clicking on the thumbnail in the Layers Panel, then Inverse the selection (⌘ *Shift* I *ctrl* *Shift* I).

Switch to the regular Eraser Tool, set to a hard-edged brush, and manually paint out the stray pixels – but be careful not to erase too close to the hair. Most of the errant dots will disappear this way.

7 It's easy to miss stray pixels of a light color when viewed against a white background. So invert that background color, and check the cutout again for any pixels that shouldn't be there.

If you find that the inversing process in the previous step didn't allow you to erase all the unwanted pixels, repeat the process and then Expand the Inverted selection by 1 pixel. This will allow a wide range of pixels to be inverted.

8 Once all the background has been removed, try changing the color of that background to check that no parts of the face or clothing have been removed accidentally.

If they have, all is not lost. Select the History Brush *Y*, and, using a small, hard-edged brush, paint them back in: because the History was pinned at an early stage, painting with this brush will selectively revert the image where you paint, so you can recover anything that has been mistakenly erased.

HOT TIP

When you use the History Brush to restore accidentally erased areas, it's best to use a hard-edged brush at 100% opacity. When painting back the lace at the throat, though, you may find it easier to build up a transparent lace effect by lowering the opacity of the brush somewhat.

The solution for flyaway hair

1 Start by creating a smooth cutout of the hair, being careful not to include any of the background. If you use images from royalty-free libraries or CD collections, you'll find that in most cases the clipping path will cut just inside the hair edge, making them perfect for this technique.

THIS COVER FOR THE *SUNDAY TIMES Magazine* was a surprisingly complex montage – the owl and background were two separate layers, and no less than four images were comped together to make Harry Potter. His original hair was cut out using the techniques shown on the previous pages; but to make it more windswept, I added stray strands using the Smudge tool, as shown here.

The Smudge tool is by far the quickest way of creating a soft hair effect. Here we'll take this photograph of Nicole Kidman and place her on a background.

4 For the bottom right section of hair, it looks more convincing to work the other way: starting outside the image with the Smudge tool, and brushing into the hair. This approach works better when the hair is in clumps, rather than flowing directly from the head.

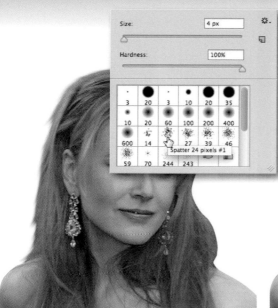

2 Use the Smudge tool, and choose a small Spatter brush with an opacity of around 70%. Begin at the crown and work down one side of the head, smudging from the hair outwards, tweaking out strands as you go. A pressure sensitive graphics tablet is very helpful here.

3 Now go back to the crown and work the other way, making sure you follow the direction of the hair as you brush. Here, we've stopped just before the bottom of the hair on the right side: this clump will require a slightly different treatment.

HOT TIP

If you don't have a graphics tablet, you'll need to constantly adjust the pressure of the Smudge tool to get the right effect. Remember you can always change the pressure from the keyboard: press 7 for 70%, 8 for 80%, and so on. For intermediate values, press two numbers in rapid succession: so pressing 8 then 5 will give you 85%, for example.

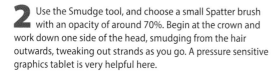

5 Using the Spatter brush with the Smudge tool is a quick method of moving several strands of hair at once. For greater realism, though, switch to a small soft round brush and pull out one strand at a time. You may need to increase the pressure to 80% or even up to 95% for this.

6 When viewed against a white background, hair treated in this way will always tend to look a little fabricated. But when placed against any texture or image, it will blend in perfectly: the translucence of the hair strands will pick up any background they're positioned on.

SHORTCUTS
MAC WIN BOTH

Cutting hair with Refine Edge

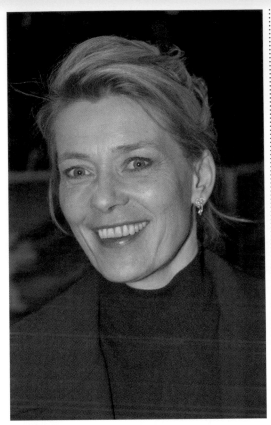

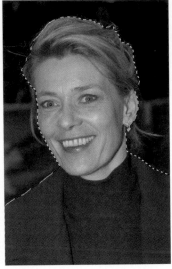

1 The first step is to make the initial selection, most easily done using the Quick Selection tool (see page 18). It may take a little refinement – that patch of red on the left tends to get selected – but it's an easy task.

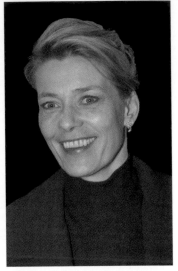

2 We enter Refine Edge, either by choosing the button on the Options bar when the Quick Selection tool is active, or by pressing ⌘ ⌥ R ctrl alt R. The default view is to show the image on a black background.

AUTOMATING THE CUTTING OUT of figures, especially those with flyaway hair, has been the holy grail of Photoshop developers since the earliest days. That goal moves one step closer with the Refine Edge dialog, which allows wispy cutouts to be made more easily than ever before.

This photograph of the late, great German actress Barbara Rudnik is a tricky cutout by conventional means: the background is close in tone to her hair, and those wispy strands can be hard to deal with.

Refine Edge can handle this job relatively easily. See page 20 for a closer look at how Refine Edge operates.

5 We can deal with individual strands of hair by brushing over them using the Edge Detection brush. First, though, set the tool to Smart Radius, using the checkbox. When we brush over the hair area, we see the original image beneath (left); when we release the mouse button, the area is refined into a true cutout (right).

6 We can use the same process to brush over other flyway strands of hair, such as those on the side of the head. Again, we first see the background, then the cutout is performed for us. There's no need to attempt to complete the whole hair perimeter in one go: small steps often work better.

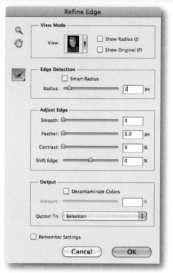

3 There are several adjustments we can make to improve the way Refine Edge deals with the cutout. The first control is the Radius setting in the Edge Detection section. This sets the radius of the border around the perimeter: if we press **J**, we can toggle this view on and off. Shown here is our initial selection with a 2-pixel border, which works well for this image.

4 The second control is the Decontaminate Colors checkbox near the bottom. This blends colors from the cutout into the border, so the red fringe on the shoulder (left) can be easily removed (right).

HOT TIP

Get used to viewing the cutout in a variety of ways, within the Refine Edge dialog. Use **B** for a black background, **W** for white, **L** to show the underlying layers, and **P** to show the original image – or just choose the view you want from the pop-up menu at the top of the dialog.

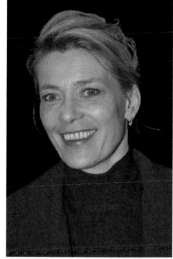

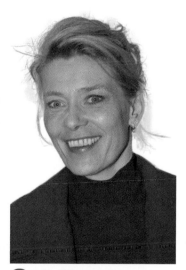

7 We can continue working all the way around the head, brushing over all the stray strands of hair until we reveal them in all their glory. It's important not to use this tool over areas we want left hard, though, such as the edge of the face and the jacket: hold **⌥** *alt* to remove unwanted soft areas with the brush.

8 Refine Edge now gives us the option of outputting its results in a variety of ways. The best solution is usually to output to a new layer with a layer mask, as this leaves the original intact. We can now see how the image works against a white background – it isn't perfect, but the layer masks allows us to fine-tune it.

9 Once we place the image on any background other than white or a flat color, the slight transparency and inaccuracy is concealed by the underlying texture, and the cutout works perfectly.

SHORTCUTS
MAC WIN BOTH

209

The problem of hair loss

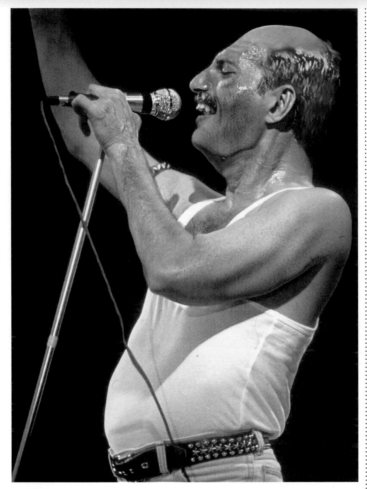

1 Here's our original portrait of Obama, cut out from its background and placed against plain white so we can see the effect more clearly. He has a high forehead, which is perfect for our purposes.

5 Now we need to take away the hair from behind the new bald head. Move to the original Obama layer, and make a layer mask: paint out the hair behind the dome, using a soft-edged brush.

HOW WOULD QUEEN'S FREDDIE MERCURY HAVE looked if he had survived to enjoy a disgraceful old age? That's what *Radio Times* magazine wanted to know – and I was happy to oblige.

Removing a celebrity's hair isn't hard, but it can be tricky to make it work well. The key is to use existing texture as far as possible, stretching and cloning it to fill the desired space.

Barack Obama, with his high, clear forehead, is the ideal candidate for such a treatment. Let's see how he'll look once the rigors of presidential office make their mark.

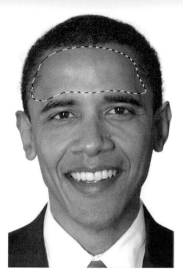

2 Begin by making a large elliptical selection of the forehead, then use the Lasso tool with the *Shift* key to add some extra skin from the lower region. The elliptical top will form the shape of the shiny bald dome.

3 Make a new layer from the selection, then use Free Transform to scale and rotate it so it now reaches right to the top of Obama's head. This is a little way below the top of the hair – but only a little in his case.

4 Make a layer mask for the new dome layer, and paint it out on the edges so that the original hair shows through. We'll be able to see the original forehead here, as well, which will increase the realism.

HOT TIP

If not enough forehead is visible in the original image, you'll need to copy a section of skin from another photograph. Matching skin tones and shadows can be difficult when you choose this route; it's far better to take your skin from the image you're working on. If there's no visible forehead, consider using a patch of cheek instead.

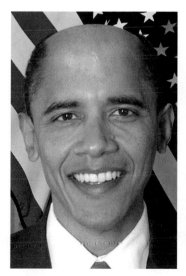

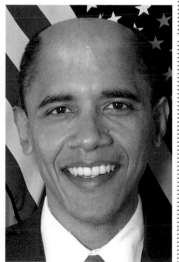

6 We need to make the edges of the hair more convincing in the area where they touch the bald dome. The easiest way to do this is to change the mode of the Brush tool to Dissolve, and paint on the layer mask: then select that area on the mask and add a touch of Gaussian Blur to soften it.

7 When we place the head on a background, the image looks far more consistent, and the hair blends into the complexity of the flag behind. But there's some strong side shadow on this image: we need to carry that through on to the flag for added realism.

8 The shadow behind the head is easily added using the shadow techniques described in Chapter 7: duplicate the Obama layer, fill with black, then blur and lower the opacity, finally moving it into place to the right and below the original head.

SHORTCUTS
MAC WIN BOTH

Instant hair growth

ON THE PREVIOUS PAGES WE removed some of Barack Obama's hair. Now, to redress the balance, let's try adding a little more facial hair instead.

The technique involves creating a custom brush to do the deed for us. Making your own brushes in Photoshop can be a tricky affair: this relatively simple example will give you an idea of how it's done, so you can go on to create your own brushes later.

It's easy to see why so few politicians have beards.

1 Begin by making a new, empty layer in a Photoshop document. With a small, soft brush, draw some random squiggles like those above. It helps to vary the opacity as you paint, for a less uniform effect – most easily done with a graphics tablet. Then choose Define Brush Preset from the Edit menu to make a brush from the squiggles.

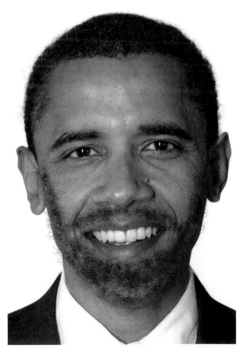

5 To set the foreground and background colors, sample the darkest and lightest parts of Obama's hair. There's not a lot of variation to choose from, but we can fix this later. Start to paint with the brush, reducing the brush size greatly to create small, tight curls.

6 Although it looks a little patchy at first, we can build up the density by painting over the hair. Vary the brush size, if you like, to add some tighter strands of hair. We don't need to be concerned about the shape too much, since we can adjust that later.

2 Open the Brush Presets panel, and our newly created brush appears right at the bottom. As the preview shows, at present it's set to paint a steady stream; we'll change this in the following steps.

3 Switch to the Shape Dynamics section and set both the Size and Angle Jitter to 100%. This will make each brush stroke rotate and scale randomly as you paint with it, as the preview at the bottom now shows.

4 Now change to the Color Dynamics section, and set the Foreground/ Background Jitter to 100% as well. This will bring variation into the color of the brush, which will help it to match the hair in the photograph.

HOT TIP

If you have a graphics tablet (and you really should, you know) then you can make the whole operation more controllable. In the Size Jitter section, for instance, you can add pen pressure control; in the Other Dynamics section, you can add pressure control to the opacity of the brush as well.

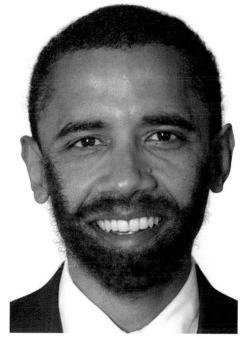

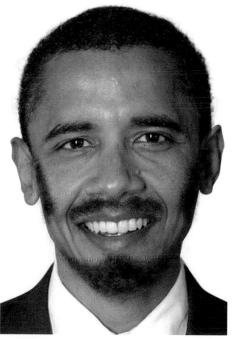

7 The colors weren't quite right, but it's easy enough to fix this: use Curves or Levels to take out some red and add a little blue to get darker, stronger hair. It's now a good match for the hair on his head.

8 We can create a layer mask to paint out unwanted hair areas, allowing us to style it as we choose. A soft brush will create a soft, unnatural edge, though; try using the hair-shaped brush itself on the mask to paint some edges back in after hiding the bulk of the hair.

SHORTCUTS
MAC WIN BOTH

213

Beards and stubble

DESIGNER STUBBLE has always been a matter of some consternation for me. How do rugged actors like Bruce Willis and George Clooney always manage to be interviewed sporting just a couple of days' worth of growth? Do they only use blunt razors? Or do they shave with hair clippers?

Fortunately, we don't need to concern ourselves too much with the vanities of Hollywood's finest. We can draw exactly the level of stubble we want, from a simple five o'clock shadow to a neatly trimmed goatee, using a few simple steps.

We'll add some facial fuzz to our own tough guy, and see how to achieve a more carefully coiffured appearance as well.

1 Our original figure is gazing moodily into the camera, with just the hint of a bow tie suggesting his status as a club bouncer. But he doesn't look tough enough yet; a bit of designer stubble will help.

2 On a new layer, paint the beard area using a midtone gray and a soft-edged brush. Accuracy isn't that important at this stage, as we can always mask out any stray areas later, but try to avoid the nose and mouth.

6 We now need to make that stubble more transparent – and we do this by changing the layer mode to Hard Light, which causes all the midtone gray to disappear.

7 Turning the layer to Hard Light mode allows us to see through to the skin beneath. This level of stubble is OK for a day's growth, but let's see if we can beef it up. Make a new Curves Adjustment Layer, grouping it with the beard layer, and lower the brightness of the beard to bring some more strength back into it.

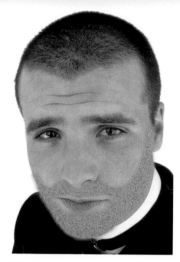

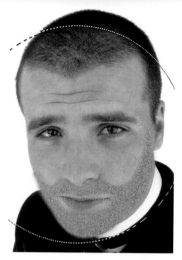

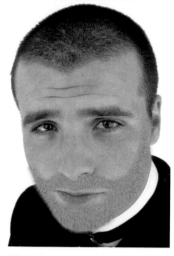

3 Add some Gaussian Noise to the gray you've just painted. I've used about 30% Noise here, but the precise amount you use will depend on the size of the image you're working on.

4 Next, we're going to use Radial Blur to make the stubble; but first, we need to set the midpoint for the blur to act on. Hold ⌥ *alt* as you draw an elliptical marquee from the center out, starting from the bridge of the nose and enclosing the whole beard area.

5 Now use the Zoom setting in the Radial Blur filter at a low setting: around 5% will be appropriate for this length of stubble. (Higher settings will result in facial fur that looks like it belongs on a dog.) Radiating from the bridge of the nose makes the stubble lie in the right direction.

8 The result so far is a beard that looks far too neat. So create a Layer Mask for the beard layer, and paint out some of the harder edges. Painting inside the beard with a low opacity brush also helps the stubble to look more varied in depth, which adds to its realism.

9 As well as creating convincing stubble, we can also modify what we've drawn to make a stronger beard. The effect here is achieved by changing the Curve in the Adjustment Layer to darken the beard further; more sections are painted out on the beard's Layer Mask to give it a more tailored shape.

10 If all you want is to draw a mustache, there's a simple solution: use an eyebrow. QuickMask was used here to make a soft-edged selection of one of the eyebrows, which was then duplicated and distorted to sit on the upper lip. Using the eyebrow ensured that it matched the original.

HOT TIP

When painting the layer mask on a 'real' beard (as opposed to stubble) as in step 9, remember that you can use any of the painting tools on the mask – not just the brush. Added realism can be achieved by using the Smudge tool set to a scatter brush to push hairs into the skin.

SHORTCUTS
MAC WIN BOTH

The ageing process

ADDING A FEW YEARS TO A FACE IS an enjoyable process: you can keep working on the image until you get exactly the state of decrepitude you need. Graying up the hair is an obvious starting point; but there are other, more subtle indications of advancing years. The most noticeable change is not so much the hair or even the wrinkles, but the way a face changes shape with advancing years.

The pair of illustrations seen in steps 5 and 6 was a commission for *People* magazine, who wanted to show the effects of age on a young model. The original photograph, above, was the starting point; to make the difference between young and old more pronounced, I made the starting image more youthful, as we'll see in the final step.

1 The Liquify filter is the obvious choice to distort the shape of the face, as it allows us to push and pull the outlines: here, we've sagged the jaw line, thickened the nose slightly and made the eyes a little more doleful.

4 We need to remove some of that healthy glow from the skin. The simplest method is to make a new Hue/ Saturation Adjustment layer and lower the saturation: paint out the areas where you don't want it applied on the mask.

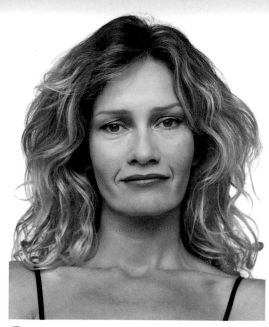

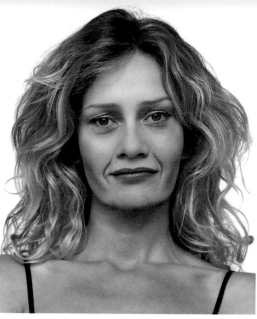

2 To make the hair more gray, first make a new layer and set its mode to Color. Now, using a soft edged brush, paint in either black or white (it makes no difference) to knock the color out of the hair.

3 Make another new layer, set to Hard Light mode. With a low opacity brush, sample colors from the darker parts of the face and build up shadows around the cheeks and under the eyes, and paint in darker lines around the mouth.

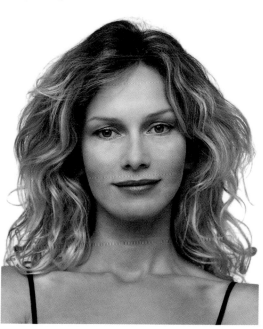

5 We could have stopped at the previous stage, but the client wanted a more pronounced effect. So we can continue to accentuate the lines in the neck and the bags – again, painting on a Hard Light layer.

6 To make the difference between the before and after images clearer, I made the original photo a little more youthful. Using the Healing Tool to sample clear areas of skin, it was easy to paint out the mouth lines and eye bags.

HOT TIP

The techniques shown here apply equally to ageing pictures of men and women. But when working with male faces, it's a good idea to add some stubble as well, as this really completes the effect. Use the technique described in Beards and Stubble, on page 214.

217

Reversing the ageing process

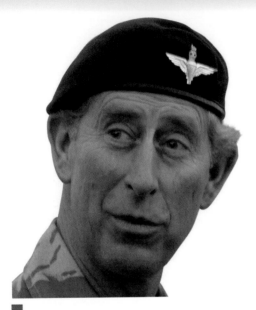

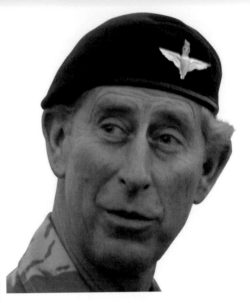

I N A PREVIOUS EDITION OF THIS BOOK we looked at how to add age to a youthful Prince Charles (you'll find that tutorial on the DVD if you want to compare the two).

Here, we'll perform the operation in reverse: starting with a photograph of Prince Charles as he is today, we'll look at how to remove the wrinkles and restore some of his erstwhile youthful vigor.

It's an extreme version of the sort of retouching that's standard practice among glossy magazine publishers: models are routinely retouched to remove blemishes, wrinkles and other signs of age.

1 Before we get down to details, we need to smooth out that craggy skin. Here's a good technique: use the Median filter (under 'Noise') – I've used a setting of 3 – to smooth the entire image. If anything, it's too effective: look at the cap badge to see how much detail we've lost.

4 As we grow older the five o'clock shadow remains more visible throughout the day. Sample the color from a clear area of skin before selecting a soft brush, set to Color mode; paint out the dark area around the chin. It doesn't hurt to lose some of that redness in the cheeks, as well.

2 As soon as you perform the Median filter, open the History panel. Click the space next to the Median line to mark it; then click the previous step to undo the operation. Use the History Brush to paint the Median filter back in where we want it – around the large areas of skin.

3 The next step is to remove all those wrinkles. This is best done using the Healing brush: hold ⌥ alt and click to set a source point in the middle of the cheek, then paint over each wrinkle, eye bag and blemish in turn. Already, this makes him look very much younger.

HOT TIP

The technique introduced in step 2 is a new one, but has many applications. By applying a filter – and it could be any filter – then pinning it in the History panel and undoing it immediately, we can paint the effect of that filter selectively, exactly where we want it. The possibilities are endless!

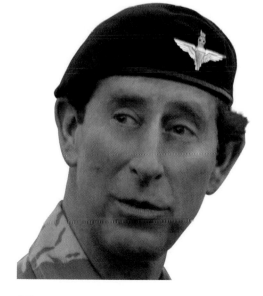

5 The hair is a simple task: select it using QuickMask, and then use Curves to lower the brightness. It's remarkably effective: we can get rid of all that gray in seconds by simply taking all the brightness out of it. The process would be exactly the same even if he weren't wearing a cap!

6 Finally, we need to address how faces sag when they age. Here, I've used the Liquify filter to make the chin tighter and the cheeks a little less saggy. I've also enlarged the eyes very slightly, as eyes tend to close up as we become older; and brightened them a little with the Dodge tool.

SHORTCUTS
MAC WIN BOTH

Lewis shows his age

1 I began by cutting Lewis out from the background, so I could work on the body in isolation.

2 After using Free Transfom to make the body wider, Image Warp was the obvious choice to thicken it up even more.

THE POPULAR CRIME SERIES *Inspector Morse* was a hit on both sides of the Atlantic. It featured the morose Inspector Morse accompanied by his slim, youthful sidekick, Sergeant Lewis.

Except that in the original books by Colin Dexter, the character of Lewis was larger than Morse, overweight, and considerably older than he appeared as played by Kevin Whately in the television series.

Radio Times thought it would be fun to show how Lewis would appear if the series had stayed faithful to the original – and they were right. This job was a lot of fun.

6 I distorted the head using the Liquify filter as well, increasing the size of the jowls and pushing the forehead back to make the hair look more receding.

7 It was an easy matter to clone some of the forehead texture into the hair area, leaving a free region in which to add the gray hair later. I also used the Burn tool, set to Midtones, to deepen and accentuate the wrinkles and the bags under the eyes.

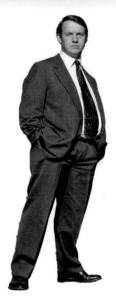

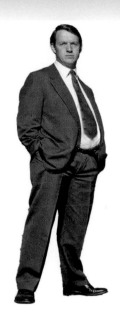

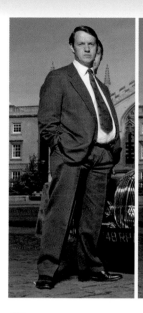

CASE STUDY

3 I created the overhanging, distorted belly using the Liquify filter, which allowed me to stretch it with ease.

4 By shortening the tie (and replacing it with a Welsh version) I was able to accentuate the belly, rebuilding the shirt behind.

5 When placed onto the original background, the different shape of the new body meant that there was some show-through of the original body behind. The easiest way to fix this is to create a new layer, and use the Clone tool – set to Sample All Layers – to patch the background.

HOT TIP

The only hard part of this sort of job is knowing when to stop. It's easy to get carried away, producing a figure that looks like a caricature; it's the subtlety of producing an image that looks plausible that makes all the difference.

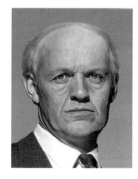

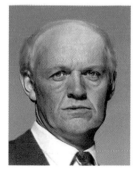

8 I selected the original hair in QuickMask, copied it to a new layer and brightened and desaturated it to make the gray hair of the older Lewis. Then, with a small brush, I painted in individual strands of hair arcing over the forehead, suggesting the vanity of a combover hair style.

9 Painting in red on a new layer, set to Hard Light, was the way to add a boozy glow to the cheeks and nose; a few extra fine lines and veins made the transformation complete.

10 In the final image, Lewis now stands taller than Morse, looking much more like the character Colin Dexter originally had in mind.

It's all in the eyes

1 This figure has eyes that are wide enough for us to be able to position the eyeballs wherever we choose. More importantly, there's enough of the pupil visible to allow us to use it later. Begin by making a circular selection that encompasses the iris.

THIS ILLUSTRATION FOR THE *Sunday Telegraph* shows two captains of industry slugging it out in the boardroom. Both images were standard publicity shots, with the central figures gazing directly at the camera. But by moving the eyes of both so that they stared at each other, it was possible to create some emotional interaction between them that would have been lacking if they'd remained gazing at the viewer.

In Chapter 5 we looked at how important eye contact is – which necessitates having the ability to move eyes at will. Here, we'll take one of the figures used in that chapter and show how to prepare the eyes so that people can be made to look in any direction you choose.

4 Turn the path into a selection by pressing ⌘ Enter *ctrl* Enter, then make a new layer named Eyeball and fill the selected area with white. This will form the basis for our new eyeball.

7 We can now show the iris layer again. Position it above the Eyeball layer and make a Clipping Mask using ⌘ ⌥ G *ctrl* *alt* G, so that we only see it where it overlaps the eyeball. Select the iris and drag a copy until both are looking in the same direction.

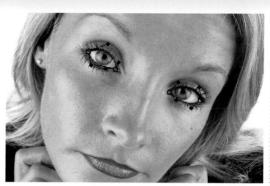

2 Make a new layer from the selection using ⌘ J ctrl J, then duplicate the layer and rotate it 180°. Now erase the eyelid showing on the new layer, and continue erasing until the two halves of the iris become one. When the eyeball looks convincing, merge the two layers.

3 Hide the new iris – we'll come back to it later. Now, using the Pen tool, draw a Bézier path around each eyeball. Use as few points as possible for a smooth outline: I try to use anchor points just in the corners of each eye, making the path handles do all the work.

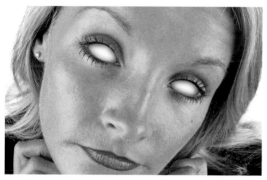

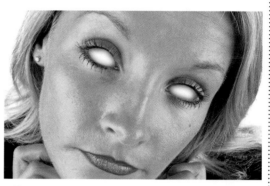

5 Add shading around the edge of the eyeball using the Burn tool set to Highlights, using a low opacity. Build up the shading slowly, so that it doesn't appear too harsh.

6 The original shading will appear to have a bluish tint, although in fact it is purely gray. Use Color Balance to add a little red and a little yellow to the eyeball, then soften the edges using the Blur tool.

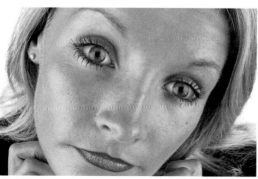

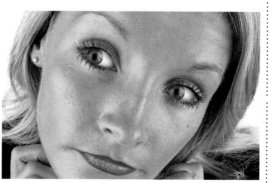

8 So far, so good: but the eyes still don't look real. The solution is to change the layer mode of the irises from Normal to Multiply, so that the shading we applied to the eyeballs shows through onto the irises. It's a subtle difference, but it completes the effect.

9 With both eyes now complete, we can move the irises independently of the eyeballs to make them look in any direction we choose. Because the two layers are grouped together, the irises always appear to move within the range of the eyeballs.

HOT TIP

It isn't always possible to lift the original irises from a face: sometimes the eyes are just too closed to be able to see them clearly. In cases like these, it's worth taking an iris from another image (keeping it handy for future use), and simply dragging it into the composition. You can change the color of the eyes using the Hue/Saturation dialog, so that they match the original.

SHORTCUTS
MAC WIN BOTH

223

Face changing with Liquify

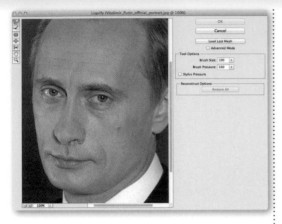

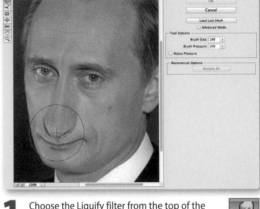

1 Choose the Liquify filter from the top of the Filter menu. The main tool is Forward Warp **W**, which smears the pixels in the direction you drag. It's like the Smudge tool, only it produces less smeary results.

THE LIQUIFY FILTER IS A powerful tool for distorting images – far stronger than the Smudge tool in its effects, and much more controllable. It has undergone a massive refit under the hood in Photoshop CS6, tapping directly into your computer's GPU (Graphics Processing Unit). This all means it's very much faster and smoother, and allows for enormous brush sizes.

Liquify is great for caricature, and we'll look at that briefly here. But for the Photoshop artist, its main benefit is its ability to produce subtle changes of expression. Here, we'll take an official portrait of Vladimir Putin, the Prime Minister of the Russian Federation – not a man given to displaying his emotions.

4 Let's try some expressions. Pushing the eyebrows down in the middle makes Putin look cross; dragging the corner of the mouth down helps.

5 We can make him look worried by pushing both eyebrows up, one at a time. Note how the Mask Frozen eyes remain undistorted.

9 Raising a corner of the mouth increases the querulous look – try making the expression yourself.

10 To complete the querulous expression, push the other eyebrow down in the center.

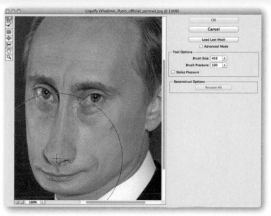

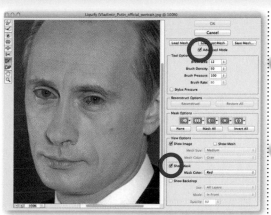

2 The larger the brush size, the more pixels are affected by the drag. You can change brush size just as you would elsewhere in Photoshop – using the **[]** keys, or holding **ctrl** **⌥** **alt** -RIGHT CLICK and dragging in the image.

3 In the last step, the eyes got distorted – it looks all wrong. Check the box to turn on Advanced Mode, and use the Freeze Mask Tool **F** to paint in the eye area. You can hide the mask area when you've painted it.

The main times Liquify fails to produce the results you want are where you use the wrong brush size. Generally, you should use a brush rather larger than you'd expect. This is because the brushes are soft-edged, which means their effect is weighted more towards the middle than the outside. Too large, and you'll simply push a lot more pixels than you want. Too small is even worse: you'll get a wrinkling effect as only small batches of pixels are moved with each push.

6 To help that quizzical look, we can twisth the mouth with the Twirl Clockwise Tool **C** – hold **⌥** **alt** for anti-clockwise.

7 Press the Reconstruct slider button to revert the image, or revert it selectively by painting over with the Reconstruct Tool **R**.

8 Expressions often have multiple components. We can begin to make Putin look quizzical by raising one eyebrow in the center.

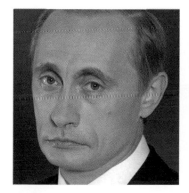

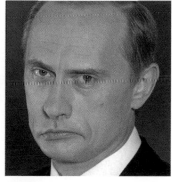

11 For a look of surprise, raise both eyebrows in the middle, and turn the corners of the mouth down.

12 A sense of disbelief is achieved by bringing both eyebrows down, and giving the mouth a twist.

13 You can use Liquify for caricatures too, but make sure you don't offend anyone too powerful…

Liquify: turning heads

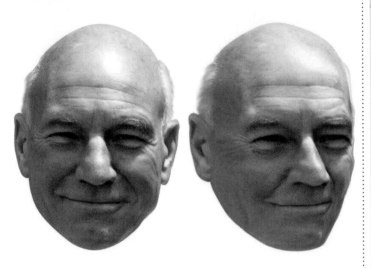

ON THE PREVIOUS PAGES WE looked at ways of using the Liquify filter to change the expression on a character's face. Now we'll use this powerful filter to turn an entire head, to make it look as if it's pointing in a different direction.

This is a tricky maneuver, which takes both skill and patience to complete successfully. It helps greatly to arrange your monitor so that you can see the original head while working in the Liquify dialog: it's easy to lose track of the character's original appearance, and it's important to remember what he really looked like before you started.

Because there are so many small brushstrokes in this tutorial, it isn't possible to show every tiny step on these pages: check out the QuickTime movie on the DVD to see the full transformation in real time.

We'll use everyone's favorite starship captain, Jean-Luc Picard – as played by actor Patrick Stewart – as our guinea pig for this experiment. The Borg was never this terrifying.

1 Begin by opening the head in the Liquify filter. I've isolated this head from its background, as it's hard enough to distort just the head without worrying about the neck as well; we can always find a suitable body later.

4 It's important to remember that while the nose was photographed head-on, in the three-quarter view we're aiming for it's going to have a lot more apparent depth. Using a smaller brush, drag the tip and the left nostril (as we're looking at it) apart to give the impression of scale.

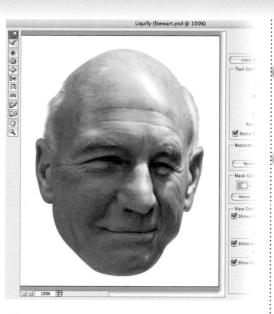

2 With the Warp tool (**W**) on a large brush size, move all the center line elements – the nose, the middle of the mouth, the middle of the forehead – to the right, in the direction we want the head to point. So far, it will look fairly awful, so don't worry about details yet!

3 Now follow on behind with the same brush, moving all the elements to the left of that center line: the eye, the cheek, the bone in the temple, and so on. The left side of the face is starting to look more plausible now.

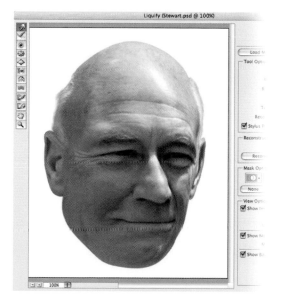

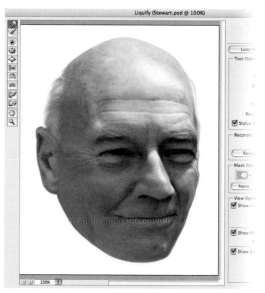

5 The philtrum – that indent in the upper lip directly beneath the nose – needs to be vertical, not slanted. At this point we can also stretch the right eye into shape, and move the line of the mouth so that it more closely resembles the original.

6 A lot more tweaking and pulling gives us the result we want. Note the newly pointed chin, the line of the left of the jaw, and the compressed right cheek. All that remains is to hide the right ear (as we see it) with a Layer Mask, and the transformation is complete.

HOT TIP

This technique is one of the more difficult in this book. It helps if you've seen images of the subject in profile. Because we're stretching the pixels on one side of the face to fill a much larger area of the image, it helps to begin with a high quality original photograph. Don't expect to complete the process within the Liquify dialog: here, we've erased the hidden ear afterwards.

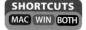

Skin patching and healing

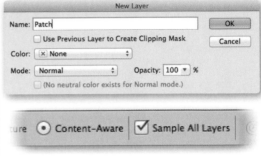

WE LOOKED AT THE CONTENT-Aware Fill tool, and its associated technologies, in Chapter 4. The Content-Aware element also appears in the Spot Healing Brush, which we'll use here – appropriately enough – to heal a few spots on this model.

The tool does a fantastic job of removing all kinds of blemishes – not just spots from faces, but litter from grass, telephone wires from skies, and much more. It's a very powerful way of cleaning up photographs, and requires very little effort.

Before it was introduced, we had the regular Healing Brush. But that tool isn't consigned to history: we often need to use both together in a single job, as we'll see here. The brushes are nested beneath one another in the Tools panel, or you can use *Shift* *J* to cycle through them.

1 Start by making a new layer. It's always best to work on a separate layer, so mistakes can be rectified later if necessary. Choose the Spot Healing Brush, and make sure the mode is set to Content-Aware, and that Sample All Layers is checked.

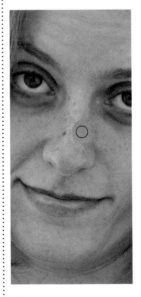

4 Switch to the regular Healing Brush. Like the Clone tool, set the area you're sampling from. Choose an area of clear skin, such as the neck, and *⌥* *alt*-click there. When you paint over the freckles, it will look as if you're simply cloning that area, and the color won't match (left): but when you release the button, the patch will blend in seamlessly (right).

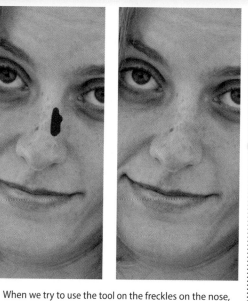
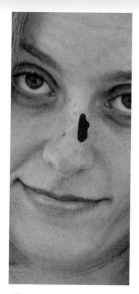

2 Using a hard-edged brush, paint over a blemish in the image – I've chosen the mole on the girl's chin. As you paint, you'll see a dark gray color following the brush (left). When you release the button, the area you painted will be seamlessly patched (right).

3 When we try to use the tool on the freckles on the nose, it doesn't work quite as well. When we release the button the area is filled not with clear skin, but by even more freckles. The Spot Healing Brush samples texture from the neighboring region – and if that's freckle-filled, then that's what you'll get.

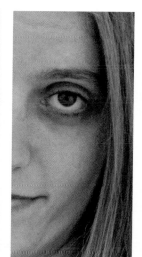

5 We can take out the bags under the eyes, as well. Using the Spot Healing Brush, paint over one of the bags and it will disappear (left). But this is too strong a result: she looks rather inhuman. To bring some of the original back, use the Fade command (⌘ *Shift* F *ctrl* *Shift* F) to reduce the opacity of that operation to about 50% of its original strength. Note: you can only use Fade straight after the operation.

6 Use a combination of the two tools to clean up the rest of the face. As long as the 'Aligned' box is not checked, the Healing Brush will continue to sample the same clear area of skin wherever you paint with it (if the box is checked, it will move the sample area as you move the cursor).

HOT TIP

It can be hard to know which tool to use sometimes. Always start with the Spot Healing Brush, as that's the most simple to operate, needing no sample point to be set. If that doesn't work, then try the regular Healing Brush – and if that can't manage it either, use the standard Clone tool. Be sure to work on one or more new layers, though, so you can always get back to your original.

Cosmetic makeover

EVEN THE PLAINEST FACE CAN BE given a lift with some judicious surgery – and a little makeup. This is the kind of Photoshop effect you can spend a lifetime perfecting – and then get a job on *Vogue*. Beauty is clearly in the eye of the beholder, though, as the Friday Challenge entries below demonstrate.

1 The first step in a job like this is to use Filter > Liquify and tighten up some of the excess cellulite. The most obvious candidate here is the jaw line: using the Forward Warp tool (the default Liquify tool) we can push from the side to tighten the flesh, producing a sharper jaw. Here, I've also used the tool to extend the eyebrows slightly, and to flatten out the slight bump in the nose.

Andy L Ben Mills bjansen brewell Ctee Dan Lundberg dave.cox Deborah Morley

Josephine Harvatt katherine Luis Maja mariong Meltonian mguyer michael sinclair

THE FRIDAY CHALLENGE
www.howtocheatinphotoshop.com

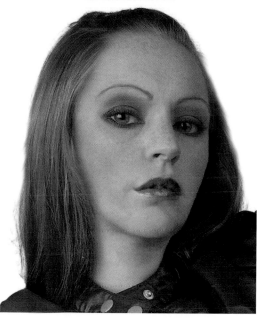

2 The large hoop earrings and nose stud can be removed using the Clone and Healing tools. The most dramatic change here, though, has been to extend the hair to make it appear fuller. Switch to QuickMask mode and, using a soft-edged brush, select the hair from the left-hand side. Leave QuickMask and make a new layer from the hair, then shear it so it lies across the left of the face. The new hair color is most easily made by selecting it in QuickMask, then making a new Adjustment Layer to that selection – either Curves or Hue/Saturation, whichever you find most comfortable.

3 The makeup itself should be painted on a new layer, set to Hard Light mode. This allows the original features to show through beneath. I chose colors here that would match the new hair color, but of course you can choose any hues you like. Colors sometimes behave a little oddly in Hard Light mode: you may have to try several samples before you get the combination just right. Use a low opacity brush, and build the color up in small stages.

llen Elliott Eva Ruth Frazetta Gaoxiguo GKB gothic007 james Jeppe Junior

Nick Malkemus Nick Curtain pdcollins Steve Mac Taylour Tom tooquilos vibeke vicho

Coloring black and white images

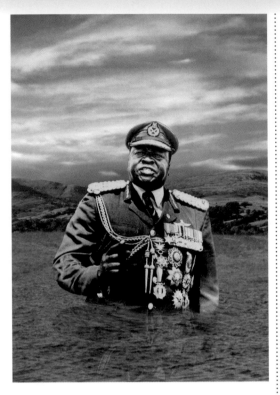

1 Our starting image is a great retro photograph taken from a royalty-free collection. Since the original image is, naturally, grayscale, we need to make sure we convert it to RGB before continuing. Even in RGB, it's always worth keeping your swatches in CMYK so they'll work in print.

ALTHOUGH PHOTO LIBRARIES supply many thousands of color images, there are times when the Photoshop artist needs to color up black and white photographs. It may be to repurpose a historical figure, such as the image of Idi Amin, above, for the cover of Giles Foden's novel *The Last King of Scotland*.

The more usual scenario is those cases where only a genuine 1950s photograph will supply that retro look. Coloring monochrome images is fiddly, but not difficult; the secret lies in choosing the right colors to work with.

Because painting with color can produce dramatic changes in an image, it's worth always working with a very low opacity brush when painting in color mode: I frequently use just 5% opacity when painting the beard area.

Cyan	8
Magenta	65
Yellow	71
Black	0

4 Now for the blush color. Set the foreground color as shown above and, using the same brush opacity, paint dabs of color on the cheeks, nose, ears and forehead. With a much smaller brush, set the opacity to around 30% and paint the color on the lips.

Cyan	28
Magenta	56
Yellow	70
Black	9

2 We'll start by applying a general flesh-colored wash to the whole image. After setting your foreground color according to the swatch above, choose Fill from the Edit menu and select Color Fill with Preserve Transparency: this will flood the image with our skintone color.

Cyan	28
Magenta	11
Yellow	9
Black	0

3 The next step is to paint the beard area. Set the foreground color as shown, and use a soft-edged brush set to Color mode: make sure the transparency of the layer is locked in the Layers panel. Set the brush to a very low opacity – 10% or less – and paint the beard area.

Cyan	2
Magenta	7
Yellow	11
Black	0

5 We need to color the eyes and teeth as well, but painting with pure white will make them look blue (try it). Set the color as above and use a very small brush, still set to Color mode, to paint those areas. Use the Dodge tool here as well to bring some sparkle into the teeth and eyes.

6 To color the clothing, select all but the skin areas and make a new layer from it using ⌘ J ctrl J . Then use Curves, Color Balance or Hue and Saturation to recolor those areas, making additional selections as necessary. You can still use the brush set to Color for details such as the tie.

HOT TIP

The color makeup shown in the swatches here are ones I've evolved over time; you don't need to copy them exactly. To save time, I've included the swatches in the Heads and Bodies folder on the DVD: load the file named Fleshtone Swatches.aco using the Preset Manager, or directly from the pop-up menu in the Swatches panel. Remember to choose Append rather than Replace, or you'll lose all your original swatches.

SHORTCUTS
MAC WIN BOTH

A change of skin

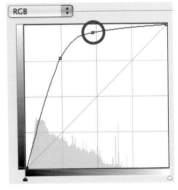

POLITICAL SENSITIVITY aside, there are times when we need to change a figure's skin color to match the head we've placed on it.

It's most urgent when using images which show a lot of flesh, such as the sporting pictures used here: we very often find ourselves with a body that's in exactly the right pose, but of a skin tone that doesn't match our brief. Here, we'll change a couple of bodies to match the heads we want to use with them.

1 Select the skin and copy it to a new layer. Hold *alt* ⌥ as you choose a Curves Adjustment Layer, and check 'Use Previous Layer to Create Clipping Mask'; then grab the center of the curve and drag up and to the right.

2 The previous step produced some rather hard highlights, which we can address next. Grab the middle of the curve, right at the top, and drag down a short way. This reduces the glare to some degree.

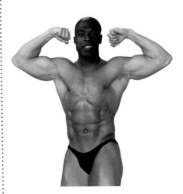

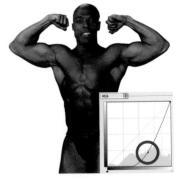

1 Here's the same problem in reverse: we want to darken this body to match the head. It's a similar process, but one or two steps work differently here.

2 Make a new Curves Adjustment Layer, as before, and drag the center point of the curve down to darken up all the skintones. Don't worry about the color yet!

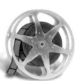

3 So far, so good: but there's too much contrast here. The shadows are darker than we need. So grab the bottom left point on the curve, and drag it up around a quarter of the way towards the top.

4 With the tonal range more or less right, we can address the color. Our head is extremely pale; so let's first switch to the Green channel (⌘ 2 ctrl 2) and raise the center point on the curve slightly.

5 Finally, we need to boost the Blue channel as well. Switch to it using ⌘ 3 ctrl 3, and raise the midpoint of the curve here as well. you may need to apply further adjustments to the RGB Composite (⌘ ` ctrl `).

3 There's too much contrast here: the highlights are once again too strong. So grab the top right end of the curve, and drag this down a little way to reduce the effect.

4 It's hard to fix that over-saturated body in Curves; so add a new Hue/ Saturation Adjustment Layer. Lower the saturation and, if you like, tweak the Hue setting slightly as well.

5 That's very close: but there's still too much green in the highlights. Open the Curves Adjustment Layer once more, and lower the bright point on the Green curve.

HOT TIP

Every case is different: you have to use your eye when judging how much to adjust the settings. The state of the body in step 3 here would be enough for many heads – but this one is particularly pale, which is why the next two steps were needed. Working with Adjustment Layers means we can always go back and tweak the settings at any time. When you've worked on a figure for a while, leave the room and have a cup of coffee. When you come back in, any mismatch between the head and body will jump out.

SHORTCUTS
MAC WIN BOTH

235

Sourcing images for free

Not everyone has the budget to invest in photography or to buy images from photo libraries. Fortunately, the internet offers us an infinite library of photographs to use in our montages.

The best source of images is Google. Check the Images button, and Google will search just for pictures: select the Large option and you'll find photographs that are generally of good enough quality to use. Anything you find in this way will, however, be subject to copyright, so while it's acceptable to use them for your own personal projects, don't be tempted to use them for any commercial work. Companies such as Disney, in particular, guard the use of their images with a ferocity matched only by the zeal of their lawyers. Seriously! This means you!

Several websites offer royalty-free images on a zero cost basis. Among the best are stockxchng (www.sxc.hu) and MorgueFile (www.morguefile.com), both of which take contributions from the public and make them available for public use. They both have good category and keyword search, and can be the perfect source for hard-to-locate shots of just about any subject you can imagine. The best place for textures of all kinds is Mayang (www.mayang.com/textures) which includes a huge range, freely downloadable.

Many of the images on Flickr (www.flickr.com) and Deviant Art (www. deviantart.com) have been made available for public use – check the licence that's published with each image. If in doubt, drop an email to the photographer, and they'll usually be happy for you to use their work in return for a printed credit.

Company logos can be particularly hard to track down. The Russian website www.logotypes.ru holds around 5000 company logos from around the world.

If you need a high res logo from a particular company, you're almost sure to find it on their own website. Ignore the obvious masthead logos found on the front page: these are bound to be too small to be used, and will often be adaptations of the original logos that have been reworked to reflect the electronic nature of the web page. Instead, search for the company's annual reports, usually found in the Investor Relations section, which will almost always be in the form of

downloadable PDF files. The great thing about these is that they're infinitely scalable: so while the photographic images will become badly bitmapped when you zoom in, the logos themselves are almost always embedded in the documents in their original EPS format. Zoom in as far as you can, and take a screenshot of the logo: it will be crisp and clear at any size.

Product photography, particularly from technology companies (computers, cell phones, consumer electronics) is usually available in high resolution on company websites, generally in the Press area. Normally, no registration is required: you can just go in and download the images you need. Again, though, you may need to be careful how you use them.

For free photographs of individual objects at a reasonable resolution, there's no better place to look than eBay. Everyone with something to sell will include decent photographs of their wares: I've used www.ebay.com to find garden gnomes, fireworks and antiques when all other sources have failed.

Finding useable images of people is very much harder. They're almost all protected by a variety of copyrights, and should be used with extreme caution: there have been a few occasions when photo libraries have contacted me after I've inadvertently used one of their images, and demanded payment. The same goes for famous paintings. The best place for celebrities and politicians is Wikipedia (commons.wikimedia.org), whose Creative Commons license permits use of images unless otherwise marked.

The US Government has a policy of putting images in the public domain, which means they're freely available for download and use. A good source of politicians of all flavors – and a fine set of generals' bodies. Check out www.nasaimages.org for space images, www.photolib.noaa.gov for skies and nature, and www.defense. gov/photos for all things military – including past and current presidents and other world leaders.

The golden rule, however, is: be careful. If you're in any doubt as to the copyright status of an image, don't use it. It's not worth the repercussions.

9
Shiny surfaces

A GLASS OF WATER on a table: what could be more natural. But look again: there is no glass. What we're seeing is a simulation of glassy refraction, which changes character depending on whether we're looking through one piece of glass or two, whether that glass has water in it, and whether we're looking at the water from the side or from the top. All the shading is created not by painting, but by using Layer Styles – bevels, satin, inner glows and shadows.

We're surrounded by shiny surfaces in everyday life, but we rarely notice them. As Photoshop artists, though, we have to pay attention to how they appear, to the fact that they have a physical presence. Glazing a window with a slight reflection will make it look like it's really got glass in it. Creating reflections takes care and thought.

Working with shiny surfaces can be challenging, but it's sure to make you a better artist.

9 Shiny surfaces

Introducing... Plastic Wrap

1 I photographed this jar sitting on a wooden surface. Just about any container would do: rotate a stock photo of a mug on its side for the same effect.

THE PLASTIC WRAP FILTER IS ONE of the most useful special effects Photoshop has to offer. Use it to make anything glisten – from beads of sweat on a dancer's forehead to visceral internal organs. Oh, and if you really want to, you can also use it to draw plastic wrapping.

The illustration above, for *MacUser* magazine, needed the figures to look as if they were encased in plastic. And, of course, I used Plastic Wrap to do this. But I also used it on the sitting figure itself, to make him more shiny; all the figures were modeled in Poser, and needed to look more plastic-like.

In this workthrough, we're going to use Plastic Wrap to create a syrup spill out of a jar. The same technique could be used to draw coffee, blood or anything that dribbles.

4 You'll find the Plastic Wrap filter in Filter > Filter Gallery, in the Artistic section. Drag the sliders until you get the effect you want.

Up until Photoshop CS6, you could find the Plastic Wrap filter in Filter > Artistic > Plastic Wrap. Now this section is hidden. To enable it, go to Preferences > Plug Ins and check Show All Filter Gallery Groups and Names.

7 Changing the color of the water turns it into different liquids. Here, I've used Hue/Saturation to darken it and add an orange tint – just right for our spilled syrup.

2 On a new layer, paint the spill in mid gray, with a hard edged brush. Try to imagine how the liquid would pour through the opening of the jar and lie on the table.

3 Use the Dodge and Burn tools to add some random shading to the layer. This is simply a matter of practice; you may have to adjust the shading and reapply the filter.

HOT TIP

Adding the shading in step 3 is a little tricky: you've really no idea of knowing how it's going to look until after the Plastic Wrap filter is applied. The trick is to be conservative with the Dodge and Burn tools, keeping the effect subtle. Only a small variation in tone is enough to make Plastic Wrap do its job.

5 Here's the result of applying the filter. If it doesn't look right, Undo and then fiddle with the shading, then use ⌘ F ctrl F to apply the Plastic Wrap filter again.

6 When we change the mode of the layer from Normal to Hard Light, all the gray disappears – leaving us with just the highlights and shadows. Perfect! Instant water!

8 To complete the effect, let's add some refraction. I've taken a copy of the background image, and applied the Wave filter to it to create a slight rippling effect.

9 The distorted layer is masked out everywhere except where it overlaps the syrup: this gives us a convincing distortion of the neck of the jar, which adds to the effect.

SHORTCUTS
MAC WIN BOTH

241

I'm forever blowing bubbles

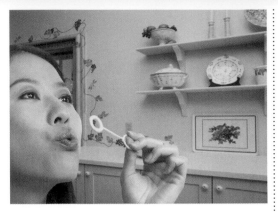

1 Begin by drawing a circle on a new layer: fill it with a mid-tone gray. Use the Burn tool to add a little shading. Apply the Plastic Wrap filter; then paint on some color, and finally add the outline of a window.

THERE ARE TWO TRICKS TO MAKING bubbles work. The first is to draw the bubble correctly in the first place; the second is to distort the view seen through them.

When bubbles touch, they form a flat disk at the plane of intersection. Tricky to draw, perhaps; but if you use the method shown here, this disk will appear automatically as you Spherize the view seen through them, also turning the flat window into a rounded view.

This was set as a Friday Challenge on the How to Cheat website, and produced some remarkable results. As always, several readers chose to take their bubble blowing in a different direction altogether...

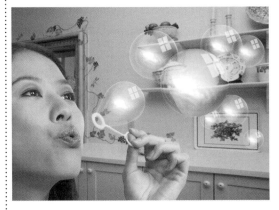

4 Load up the selection of one bubble by ⌘ *ctrl* clicking on its thumbnail (I've chosen the largest one), and press ⌘ *Shift* *C* *ctrl* *Shift* *C* to make a merged copy. With it still selected, Paste; the copy will appear in place. ⌘ *ctrl* click to select it again, and apply the Spherize filter at 100%.

THE FRIDAY CHALLENGE
www.howtocheatinphotoshop.com

Atomicfog

BabyBiker

Ben Mills

Ben

Big Vern

Dave.Cox

James

maiden

mguyer

Neal

Pauline

Pierre

2 When the bubble is placed in the scene, change the mode of its layer to Hard Light. All the gray will disappear, leaving us just with the highlights. If you can't see it clearly, increase the brightness of the bubble slightly.

3 Duplicate the bubble around the image, scaling it as you go to create different sizes. If you make a couple of the bubbles overlap you'll increase the realism of the scene. Remember to include one bursting out of the wand!

5 Repeat the process with each bubble in turn – load it as a selection, make a Merged Copy and then paste, load the selection once more, and use ⌘ F ctrl F to repeat the Spherize filter. Where they overlap, you'll get a convincing join – and the window will distort, too.

6 Let's add some more color. Load up one of the bubbles by holding ⌘ ctrl and clicking on its thumbnail; then hold ⌘ Shift ctrl Shift as you click on the other bubbles' thumbnails. Apply a Hue/Saturation Adjustment layer to the selection, and increase the saturation.

HOT TIP

In step 4, we distorted the bubble that's coming out of the wand to make it look as if it's being blown. If you have Photoshop CS2 or later, you can use Image Warp to do this easily; otherwise, you can distort it using the Liquify filter.

SHORTCUTS
MAC WIN BOTH

ek_101 Dirtdoctor23 Eggbox GKB Glen j.harvatt Michael Sinclair

eve Mac Chris Martin Tom Vicho Wayne Whaler

Water: moats and reflections

1 The first step is to draw the shape of the water on a new layer. We can follow the angle of the brickwork, and there's already a dark line indicating a previous water stain. Use the Lasso at first, then a hard Brush to wave the edges.

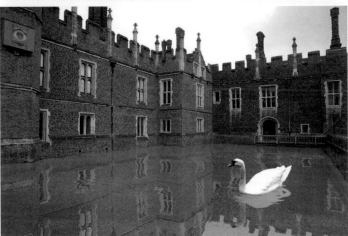

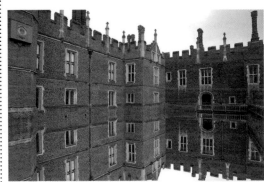

4 We can continue in this way until all the building sections have been cut to a new layer, flipped vertically and sheared so they fit the perspective. The trick is to make the reflected angles tend towards the same vanishing point.

FLOODING A SCENE WITH WATER IS always an impressive trick, and – even with a complex background like the empty moat at Hampton Court Palace – needn't be too difficult a task.

The only hard part here is creating the reflection of the buildings, since their irregular shape means we have to split them into multiple layers in order to get the job done.

This exercise was run as a Friday Challenge in the Reader Forum. You can check out the results at *tinyurl.com/HotChiPs-moat.*

7 To distort the water surface, first duplicate the reflection group, then merge its contents (⌘ E ctrl E). Apply the Wave filter with all the settings near their lowest point for the main distortion, then make elliptical selections and use the ZigZag filter to make the ripples.

2 Duplicate the background, and flip vertically. Select the rightmost building, and cut it to a new layer, using the Water layer as a Clipping Mask. It won't fit properly (left); we need to shear it so the base lines up (right).

3 Select the next chunk of building, and cut this to a new layer as well, then shear into shape. At this point, it makes more sense to put the new layers into a Group, with a Layer Mask that exactly matches the water layer.

5 With all the layers placed in a single group, we can lower the opacity of the whole group so we can see through it to the water layer beneath. An opacity of around 80% works well: the water isn't all that reflective.

6 Adding a floating surface element, such as this swan, makes more sense of the water as a real medium. To create the reflection, flip a copy of the swan vertically, and shear the back half down; place it in the reflection group.

8 The addition of a little algae helps us to make the water surface look real, and it's easy to draw. Set a soft brush to Dissolve mode, and paint in green at a low opacity – in this mode, this produces widely spaced dots. Use Gaussian Blur with a radius of 0.5 pixels to soften the result.

9 Finally, reduce the opacity of the base water level to around 80%, then add a new layer – set to Hard Light mode – to paint some color into the water. A mixture of blue and green, of course, works particularly well.

Making water from thin air

IN THE PREVIOUS TUTORIAL WE looked at how to flood a scene with water. Here, we'll take the process one step further: not only will we build the reflections in the pool, we'll also create the water surface from scratch.

The only difficult thing here is the complexity of the reflection: the image has to be broken into three parts for the reflected view to work correctly. Adding a ripple to the whole reflection, and creating the water surface, are easy in comparison.

1 Here's our initial picture: a boy sitting on the edge of a sandpit. The walls of the sandpit provide the perfect setting for the paddling pool which could well have been placed there instead.

4 We'll use this initial reflection to make just the wall of the pool, so select and delete the rest. It's a close fit, but not perfect: you'll need to select chunks of the wall and shear them downwards to follow the angle of the original.

5 Now duplicate the background again, flip it and place it behind the reflected wall layer (again, using the water as a clipping mask). Now we can slide it vertically, so we no longer see the playground surface. Much more convincing!

8 To create the water surface, first make a new document about twice the size of the one you're working on. Use the Clouds filter to fill it with random texture; then apply the Glass filter to make a detailed, rippled distortion that will simulate our water. Well, clouds are almost thin air.

9 Duplicate the water mask layer from step 2, then drag the texture we just made into the document, using that layer as a clipping mask. Use the Perspective mode of Free Transform (hold ⌘ *Shift* ⌥ / *ctrl* *Shift* *alt* as you drag a corner handle) to give the water surface a sense of depth.

2 Make a new layer, and paint the area to be occupied by the water. After you've blocked in the basic shape, go round the edges with a hard brush to ripple them slightly – and don't forget to leave some space round the ankles.

3 Now duplicate the background and flip it vertically; use the water layer as a clipping mask to limit its scope. The reflection as it stands is unconvincing: we shouldn't be able to see the surface of the playground from this angle.

6 The boy now needs to be isolated from the original, flipped vertically and placed on the reflected wall. You'll need a little masking to make him look as if he's actually sitting on the wall itself.

7 Make a new group (layer set) from all the reflected layers. Now duplicate the group, merge its contents into a single layer, and hide the original group. A small amount of the Ocean Ripple filter gives it the distortion we need.

10 The water surface looked too strong in the previous step, so reduce its opacity to around 30%. Adding a slight blue tint, using Color Balance or any of the other adjustment dialogs, helps to give the impression that it's reflecting a blue sky.

11 We could have stopped there – but let's take it one step further. Lowering the opacity of the merged reflection layer to 50% allows us to see through the reflection to the original sandpit below, adding an extra dimension of realism to the scene.

HOT TIP

Breaking the reflected view into its multiple planes can be a fiddly process, which is made more difficult with more complex views. I photographed this image with reflection in mind, knowing that the walls would provide a vertical element behind which I could hide the reflection of the view behind. It isn't always so easy! If you're going to attempt this technique with your own images, think about how the reflections will work while composing the scene in the camera.

SHORTCUTS
MAC **WIN** **BOTH**

247

Submerging in water

PLACING OBJECTS IN WATER IS NOT a difficult task – but it can take a bit of thought to make the effect look right. Duplicating the layer allows us to apply a Wave filter effect independently of the main car image, giving us extra flexibility.

I set this example as a Friday Challenge on the How to Cheat in Photoshop website, and you can see the results below. As usual, members' imagination takes over.

1 Rotate the car slightly to make it look less stable, as if it's sinking. The bottom part is painted out on a Layer Mask, using a hard-edged brush: add some up and down waviness to match the ripples on the water's surface. It's important to try to follow the contours of the car as you paint around them.

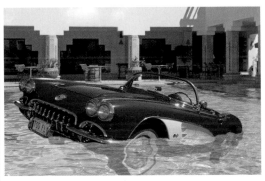

4 Switch to the main RGB layer (ie, off the Layer Mask) and use Filter > Distort > Wave to add some rippling to the submerged version of the car. Try low amounts of vertical distortion: we want mainly horizontal ripples. You only get a tiny preview, so some trial and error is required.

Andy L

Babybiker

Ben Mills

brewell

dave.cox

Deborah Morley

Josephine Harvatt

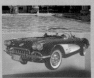
katew

maiden

mariong

mguyer

michael sinclair

2 To make the submerged section, we could just lower the transparency of the mask, allowing the car to show through partially. But that wouldn't allow us to apply a distortion easily. Instead, duplicate the car layer. Click on the Layer Mask in the Layers panel, and use ⌘ I / ctrl I to invert it. The full image will now look just like the original.

3 When we reduce the opacity of this layer to around 30%, we can see through it – giving the impression of it being seen through the water. So far, it's the equivalent of simply painting the original mask with a low opacity. The opacity we use depends on the job in hand, so feel free to vary it as required.

HOT TIP

The car I originally supplied as a Friday Challenge was photographed from an extreme angle – far too strong for this job. To make it work convincingly, it was necessary to adjust the angle using Free Transform first, to remove some of the exaggerated perspective.

5 One useful trick is to add a little turbulence to the water surface. On a new layer, use a small brush with White as the foreground color, and paint a thin line (don't be too accurate) matching the top edge of the mask.

6 Make a shadow beneath the car using a Curves Adjustment Layer. Load up the distorted car as a selection, and delete this from the mask; then paint the effect out everywhere except in a dark spot directly below the car.

SHORTCUTS
MAC WIN BOTH

llen

Eva Roth

Gaoxiguo

Gerard

GKB

James

lick Curtain

Paul2007

srowden

The Mad Lep

tooquilos

vibeke

9 Shiny surfaces

Snow and icicles

1 To get started, draw the snow shape on a new layer. Use a hard-edged brush where the snow sits on the windowsill, and switch to a large, soft brush to paint the area where it drifts up the side of the wall.

4 Make a new layer, and paint the icicles using a midtone gray and a small, hard-edged brush. Try to make them look as drippy and natural as possible, and don't add too many of them!

7 To add a sprinkling of snow to the walls, choose a large, soft brush and set its mode to Dissolve. With white paint, and the brush set to a very low opacity, it's easy to apply this speckled effect with just a few strokes.

MAGAZINE DEADLINES BEING WHAT THEY ARE, people always want pictures of snow for their Christmas editions – but they need them in September. Every Photoshop artist should know how to add snow to a scene to give it that festive flavor; we'll see how to turn the rather dull photograph (top) into a yuletide experience. We're even going to throw in a few icicles for good measure.

Up until Photoshop CS6, you could find the Plastic Wrap filter in Filter > Artistic > Plastic Wrap. Now this section is hidden. To enable it, go to Preferences > Plug Ins and check Show All Filter Gallery Groups and Names.

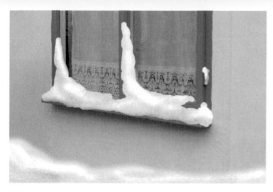

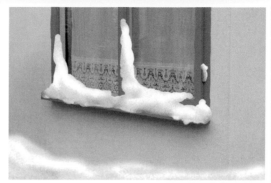

2 Add shading using Dodge and Burn, then add the texture. Begin with a little Gaussian Noise and then, to soften the effect, lock the transparency of the snow layer and use Gaussian Blur to smooth it slightly.

3 There are several ways of adding color: in this instance, it's probably easiest to use Color Balance to up the blue and cyan content slightly. Don't make it too strong – we only want a hint of the color effect.

5 We're going to treat the icicles with Plastic Wrap (what else?), so first we need to add some shading using Dodge and Burn. This can be done in a fairly random way; there's no need to simulate accurate shadow placement.

6 Apply the Plastic Wrap filter as before, erase the tops of the icicles so they merge into the snow. Add a little color, and change the layer mode to Hard Light for transparency, then duplicate to make the shadow behind it.

8 The snow we just drew looked rather harsh, so once again we can use Gaussian Blur to soften it. Don't check the Lock Transparency box this time, though, as we want to blur those edges slightly.

9 As a final step, add some color to the walls for a wintry feel. To get a good contrast inside the window, make a new layer from the window and increase the contrast, adding a yellowish hue for that warm interior glow.

HOT TIP

It's easy to get carried away with too much Dodging and Burning, too strong a color and too much snow overall. The key to making this effect work is subtlety; always try to use the minimum possible to get the effect you want, and the result will be that much more convincing.

SHORTCUTS
MAC WIN BOTH

Making it rain

1 Begin by selecting just the buildings - including the base of that traffic cone. Make a new layer from the selection, and flip it vertically to make the basis of the reflection.

WATER TAKES MANY FORMS. We've looked at ice, snow and flooding; here we'll turn this scene into a rainy day, adding reflective puddles as well as the rain itself.

Whether or not you want to add rain to your images, creating reflections in surface water is a task that should be within the scope of any Photoshop artist.

This was originally a Friday Challenge on the How to Cheat website: there were so many good entries, it would do them an injustice to squeeze them into the tiny space available here. Go online and check them out for yourself – there are some especially good animations to look out for.

4 Now make a layer mask for the reflection. Select the sidewalk, and darken the mask to lower the opacity, making this surface look damp; then paint out the high points in the road, as these will be above the water surface.

7 We need to make that noise look like rain, and to do this simply apply the Motion Blur filter to it. Increase the contrast, if you like, until it looks right.

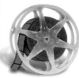

2 When we drag the reflection into place, we need to shear it to follow the base line of the buildings. Hold ⌘ ctrl as you drag a side handle in Free Transform mode.

3 The reflection was leaning back slightly, so shear it horizontally a little to make the verticals line up. Lower the transparency of this layer to around 50%.

HOT TIP

There's a trick to getting the reflection right in step 3. We can assume that the walls and doors are exactly vertical, and that the water surface is horizontal. So the reflections will go directly down, following the line set by the vertical elements (the sides of the doors, the divides in the walls, and so on). Once the angles are right, the whole image will look more convincing.

5 To add some rippling, first apply the Ocean Ripple filter to the entire reflection, using low settings. Then make a series of elliptical selections, applying the ZigZag filter to each one to make individual ripples.

6 Now for the rain. We'll begin by making a new layer set to Hard Light mode, filled with mid gray. Use Gaussian Noise to make the texture; then enlarge a quarter of the image area so it fills the whole space with a bigger texture.

8 Let's add a little mist. On a new layer, run the Clouds filter; set the layer mode to Screen, and all the black will disappear. Paint out the bottom area on a layer mask.

9 Finally, I've added a figure (with reflection) as well as a Curves adjustment layer to increase the contrast. And don't forget to turn a couple of lights on in those windows.

SHORTCUTS
MAC WIN BOTH

9 Shiny surfaces

A cool glass of water

GLASS IS ONE OF the hardest objects you can photograph, as any commercial photographer will tell you. Stylists will spend hours combining plastic ice cubes with piped-in carbon dioxide to get effects such as this – they can't use real ice, which would quickly melt under studio lighting conditions.

Fortunately, there is an easier way. We begin with a straightforward digital image of a glass of water, which has been photographed on a curved sheet of white paper so there was no crease visible where the background joined the base.

Up until Photoshop CS6, you could find the Plastic Wrap filter in Filter > Artistic > Plastic Wrap. Now this section is hidden. To enable it, go to Preferences > Plug Ins and check Show All Filter Gallery Groups and Names.

1 We begin by drawing the outline of our first ice cube on a new layer. Use a hard-edged brush and paint with a midtone gray (we'll need to use this color when we change the layer mode later). Aim for an approximation of a rough cube viewed from an angle.

2 Now add a little light and shade using the Dodge and Burn tools. Aim to place a blob of light in the center of what will become each face of the cube. Subtlety is the keyword here: keep the strokes very pale and don't be tempted to overdo it.

6 We could draw the bubbles one at a time, but it's a lot easier to let the brush do all the work. Select a hard-edged brush and open the Brushes panel: now set the spacing to a large figure – we've used 500%. Don't worry about 'corrupting' your brushes, since these settings will be forgotten as soon as a different brush is selected from the Brushes panel.

7 Using white paint, draw wiggly lines on a new layer to create the bubbles. The spacing we just set will create strings of dots, rather than solid lines. Now reduce the brush size, and paint smaller bubbles as well: these should be placed particularly at the edges of the glass, to give an impression of the bubbles falling away in perspective.

3 Now apply the Plastic Wrap filter, as described earlier in this chapter. If you've applied the Dodge and Burn correctly, the filter should now form the shape of three visible faces of our ice cube. If it doesn't look convincing, undo and adjust the shading before applying the filter again.

4 The Plastic Wrap filter can frequently leave an untreated edge around an object, as seen in the previous step. Rather than trying to correct it, it's far easier to delete that edge. Hold ⌘ *ctrl* and click on the ice cube layer's name, then contract the selection, inverse and delete.

5 Now change the layer mode to Hard Light to make the ice cube shiny and semi-transparent. Moved to the top of the glass, a layer mask can be used to hide the region on the surface where it isn't poking through. The second ice cube is simply a duplicate of the first.

8 To make those strings of dots look three-dimensional, use the Emboss section of Layer Styles to give them some automatic roundness. (You didn't seriously think we were going to shade each bubble individually, did you?) You'll need to set a very small offset to avoid the bubbles looking too fuzzy, but experiment with the settings and you'll get a good result.

9 Now to give those bubbles some transparency. Begin by changing their layer mode to Hard Light once again. In this mode, midtones become invisible, while the highlights and shadows remain; so we need to lower the brightness of the bubbles so that the pure white we drew approaches a midtone gray. Any of the adjustment dialogs can be used to do this.

10 Finally, adjust the color of the glass to make it bluer, since the original indoor lighting looked far too brown. The shadow is created by hiding the background layer, performing Select All and taking a Merged Copy (*Shift* ⌘ *C* *Shift* *ctrl* *C*) of the image. This is then pasted behind the glass, desaturated, and knocked back using a gradient on a layer mask.

SHORTCUTS
MAC WIN BOTH

A massive block of ice

ICE

T HIS IS A TEST I SET AS A FRIDAY CHALLENGE ON the Reader Forum section of the How to Cheat in Photoshop website. Readers were given the basic text above, and invited to turn it into a block of ice. There were many good entries, but sadly there isn't room to show them here: if you're interested, visit the website and check out Challenge 290, posted on 3 March 2010.

Most of the entries managed to get the ice to look suitably icy. The only thing missing from many of them was the refracted view seen through the ice – and this is essential to give the material real substance.

We could have built this ice block as a 3D object, but it's instructive to see how this kind of three-dimensional lettering can easily be constructed directly, without using any of the capabilities of the Extended edition.

1 The first step is to round off the corners of the lettering, using the Refine Edge technique shown on page 22. This is essential: real ice wouldn't have the hard corners of the original lettering. Then use Free Transform to distort it into perspective.

4 Merge all the layers together, then lock the transparency (the ⬛ key is a shortcut for this). Now that the edges can't become fuzzy, we can use Gaussian Blur to soften the interior joins for a more natural appearance.

7 Ice isn't made of glass. Impurities and air bubbles inside give it a cloudy consistency. On a new layer, choose a soft edged brush set to Dissolve mode, and paint a little white inside the object (left); then use Gaussian Blur to soften it (right), producing this mottled look.

8 Now for the background. Given the view of our ice block, we need a low view, with plenty of ground to work with. Change the mode of the ice layer to Hard Light, so we can see the view through it, and tint it to match the colors of the background.

2 Duplicate the layer, and place the copy behind – I've darkened it so we can see it better. Using a hard-edged brush, draw in joins between the duplicate and the original, to make the lettering look truly three-dimensional.

3 Make another copy of the duplicated layer, and move it to the front; set the mode to Hard Light, and lower the opacity. This creates the sense of the lettering as a transparent object, so we can see the rear face.

5 Add a little random shading using the Dodge and Burn tools. There's no need to attempt realism here: all we're doing is creating a texture for the Plastic Wrap filter to work on in the following stage.

6 Use the Plastic Wrap filter to add shine and gloss to the artwork. If it doesn't look right, then Undo, adjust the Dodge and Burn shading, and use ⌘ F ctrl F to run Plastic Wrap again.

HOT TIP

While the ice works reasonably well on its own, it's only when we add the background that it starts to make sense as a physical object. I added the background as a final stage, but it would be easier to make the perspective work if we started with the background, and distorted the lettering to fit the background view.

9 Hide the background, and save the document with just the ice layers visible. Then reveal the background and duplicate it; use the Displace filter on the copy to distort the view seen through the block (see page 412). The whole background will shift, so delete the area outside the ice.

10 Add a little Gaussian Blur to the refracted view, and lower the contrast slightly. Make a new group from all the ice layers, and add a Layer Mask to blend it into the snow, then paint on a few extra highlights for added realism. And don't forget to add a shadow!

SHORTCUTS
MAC WIN BOTH

Getting the glazing bug

GLAZING EFFECTS ARE EASY TO create, and make the difference between an object looking like it's in a box and looking like it's inside a picture frame. The bug I've used here is in a three-dimensional box, but the technique works equally well for flat pictures in frames – or for windows, museum cases and other glazed surfaces.

Here, I've taken this bug box and added three different glazing effects to it, from simple glass to rippled plastic. The inset pictures show each effect in isolation against a black background, so it's easy to see how it works without the distraction of the main image getting in the way.

1 The simplest way to create a glass effect is simply to paint one on. Create a new layer behind the frame, and use a large soft-edged brush to add white bands. Set the opacity of the brush low – 10% or 20% – and draw

a series of diagonal white strokes. This can be a very subtle effect, and is most noticeable at the edges (where the glass meets the frame) rather than in the middle of the image. Build up the strokes as you go until the effect works. This is one of those occasions when a pressure-sensitive graphics tablet really comes into its own. The glass layer is shown here (inset), although obviously it makes more sense to draw it while viewing the full image.

Up until Photoshop CS6, you could find the Plastic Wrap filter in Filter > Artistic > Plastic Wrap. Now this section is hidden. To enable it, go to Preferences > Plug Ins and check Show All Filter Gallery Groups and Names.

2 To make the glass more convincing, consider adding a background image. Here, this shot of a room (inset) has been distorted slightly using the Wave filter: without the distortion it would look too flat and rigid. The opacity of this layer was then reduced to 10% so it was barely visible – after all, you don't want it to swamp the main image. The white bands used in the previous example were added over the top, their opacity reduced to 50%.

Any background image can be used; the choice depends largely on the supposed location of the object in question. For outdoor scenes, such as looking in through a window, a cloud reflection is particularly effective. Remember to keep the opacity low; if necessary, increase the contrast of the reflected image to make it more dramatic.

3 This version uses the Plastic Wrap filter to make the bug look like it's encased in polythene. First, a new layer was created and its mode set to Hard Light: this was filled with 50% gray, which is transparent in Hard Light mode. The brushstrokes (inset, top) were painted on using the Dodge and Burn tools to add highlight and shading to the image; the Plastic Wrap filter was applied (inset, bottom) to show the full effect. In cases like this, it's worth applying the filter frequently as you paint to check the effect, which can be unpredictable; Undo after each time to carry on adjusting the background.

HOT TIP

Experiment with different layer mode settings – Hard Light, Screen and Overlay in particular – to see the different effects they have on reflected images. Often they can serve to reduce the clutter and intrusion of a reflection, while maintaining its strength.

SHORTCUTS
MAC WIN BOTH

Glass: refraction

1 In this simple montage the glass vase, the table and the background are on three separate layers. The task is to make the background visible through the vase.

2 Begin by loading up the area taken up by the vase, by holding ⌘ *ctrl* and clicking on its thumbnail in the Layers panel. Then use the Elliptical Marquee tool, holding down ⌘ ⌥ *ctrl alt* to limit the area to just the bowl itself.

GLASS OBJECTS NOT only reflect what's around them, they also refract the view behind them. This refraction is easy to achieve; the trick to making the montage look real is to bring back the reflections in the original photograph so that they sit on top of the refracted image.

 In this workthrough, we'll make this photograph of a glass vase look as if it's sitting within the scene, rather than simply stuck on top of it.

6 Now for the tricky bit – adding back the reflections from the original vase. Duplicate the vase layer, and delete the layer mask (without applying it). It will completely obscure the distorted background. Now choose Layer > Layer Style > Blending Options and drag the small black triangle under the This Layer slider (in the Blend If section) to the right. After a certain point, the vase will begin to turn transparent as all pixels darker than the position specified disappear.

3 Now hide the bowl layer, switch to the background and make a new layer from the selection using ⌘ J ctrl J.

4 Reselect the new layer by ⌘ ctrl clicking on its thumbnail in the Layers panel, and use the Spherize filter to create the refracted view. (If the bowl had been full of water, you'd need to flip this vertically to simulate the solid lens refraction.)

5 Turn on the vase layer so it's visible again, and create a layer mask. Using a large soft-edged brush, paint out the interior of the bowl so that the background becomes visible.

HOT TIP

Spherizing works well with spherical objects, as you'd expect. But if you want to distort the view seen through a cylinder, such as a glass wine bottle, you can still use the Spherize filter; this time, though, change the mode of the filter from Normal to Horizontal Only in the filter's dialog box.

7 Dragging the slider produces a hard cutoff as pixels darker than (in this case) 173 are hidden. That black slider is actually two sliders pinned together: to split them, hold down ⌥ alt and drag on the right half of the slider. When this is pulled all the way over to the right, any pixels whose brightness values are higher than 243 (in this instance) are fully visible; those pixels whose brightness values lie between the two sliders fade gradually from fully opaque to fully transparent.

Using Blending Options in this way to hide and show areas of a layer selectively is an extremely powerful tool: find out more about how it works in Chapter 3, Hiding and Showing.

As a final touch, the refracted background seen through the vase has been given a blue-green tint using the Color Balance dialog; I also painted out some of the stem on the layer mask to make it partially transparent.

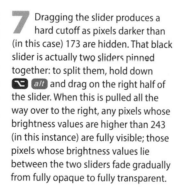

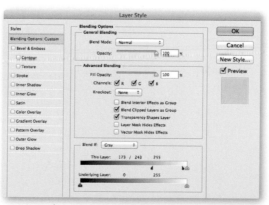

SHORTCUTS
MAC WIN BOTH

Combining reflections

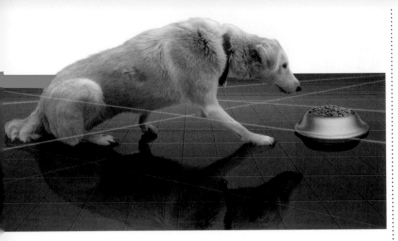

1 I cut out the dog using the Quick Selection Tool and the Refine Edge dialog (see page 20); I then used Puppet Warp (see page 56) to bend its head so that it was looking down at the bowl, rather than up as in the original.

A DOG STALKS ITS BOWL, IN THE manner of a laser-dodging Mission Impossible-style thief stealing a diamond. This was a commission from *Reader's Digest* magazine, and I decided to add the reflective floor to make the whole thing look more high-tech and more appealing.

Creating this kind of reflection involves more than just flipping a layer vertically, as we'll see: objects often need to be broken down into their constituent parts.

The first step here was to find the right image of a dog, and then to cut it out and make it fit the space. The dog I used in this tutorial is shown below.

4 I created the laser on a new layer, by drawing a straight line and using Layer Styles to add both an Inner Glow and an Outer Glow to it. I then duplicated this around the image, using Layer Masks to tuck it under the dog's legs.

7 Move the rear paw in front of the flipped dog, and the front leg behind it, using a soft Eraser to blend them both in as necessary. With just a bit of manipulation it's easy to place them so that they line up perfectly: the aim is to make the reflected paws sit neatly beneath the originals.

2 I've used this floor many times before: it's one I drew years ago, and is construted from a regular grid pattern, distorted in perspective and placed over a graduated blue background. It takes reflections very well.

3 Although I could have found a photograph of a bowl, I wanted a high-tech one made of steel – and it was far easier to use Photoshop's 3D modeling capabilities to draw one from scratch. The dogfood is real.

In step 4, after drawing in the lasers, I made a new Hard Light layer using the dog as a Clipping Mask. I painted on here in red, to give the impression that the lasers were casting a red light onto the dog's body and mouth.

5 Now for the reflection. The first step is to duplicate the dog layer, and flip it vertically. But note how it doesn't work well: the front and back paws are too high in the composition, and need to be adjusted.

6 Select the paws and copy them to a new layer – actually, to new layers, so they can be manipulated independently – then use a Layer Mask to paint out the original leg and paws on the reflected dog.

Breaking objects apart in order to reconfigure them to make good reflections can be a very fiddly task. But if you're working with a dark background such as this, it's very forgiving: small errors will be unnoticed in the final mix.

8 Now for the bowl. Because it's viewed from above, a simple vertical flip won't do the job here.

9 Duplicate the bowl layer. Then move the copy beneath the original, and drag it down a short way.

10 Take another copy of the bowl, flip it vertically, and move it behind the previous copy.

11 Lock the layer transparency, and paint in grays sampled from the original bowl above.

12 The next step is to turn all those flipped elements into a reflection. Select all the reflected layers, and choose Layer > New > Group from Layers. Now select the Group, and change its Layer Mode from Normal to Multiply, using the pop-up menu at the top of the Layers Panel.

By making a Group from them first, the entire assembly is changed to Multiply. If we simply changed each layer's mode to Multiply, then we'd be able to see through each one to the layer beneath it, which would look unconvincing.

The laser reflection is created in a similar way: first duplicate and flip each laser layer, and move it into place. Put them into a Group, and change the mode to Hard Light.

Complex reflections

SOME REFLECTIONS ARE AS SIMPLE as flipping an object vertically or horizontally: a man's profile looking in a mirror, for example, would suit this technique. Other reflections don't fall into place so easily.

In this example, we're going to create a reflection of the digital camera as if it's standing on a somewhat reflective surface. The procedure is made more complicated by the fact that we're looking down on the camera, resulting in a tricky three-point perspective viewpoint: not only is it going away from us left to right and front to back, it's also receding top to bottom.

The technique we'll use is a little surprising, because we're not going to flip the camera at all to create the reflection: instead, we're going to translate it down the lines of perspective, through the imagined surface.

1 Begin by taking a copy of the camera, and moving the copied layer behind. Now use Free Transform to shrink the copy so that the sides form a continuous straight line down the original camera and through the copy. A small amount of distortion is needed to achieve this.

4 We now need to get rid of the original flash and other elements that shouldn't show up on the reflection. The easiest way to do this is to make a new 'patch' layer, and use the Clone tool set to Sample All Layers. This way, we can keep the cover-ups on their own layer for convenience.

2 The lens is in the wrong place: it's sited lower than half way down the face of the camera, so in the 'reflection' it looks too high. Using the Pen tool, we can select just the lens in the reflection and copy it to a new layer. It then needs to be dragged up to the right optical placement.

3 The old lens on the reflection can be removed with the Clone tool and a little Dodge and Burn. The new lens also needs its highlights to be removed, by copying and rotating a section of it; and we can also copy and distort the reflected elements such as the flash and camera name.

HOT TIP

This technique works well for all kinds of symmetrical objects such as furniture, computer equipment, and technology of all kinds: try reflecting a chest of drawers in a vertical mirror, for example. Lowering the opacity of the finished reflection helps to conceal any vagaries or inaccuracies that may crop up in the final mix.

5 We need to lower the opacity of the reflections as a whole. The trick here is to make them into a new Layer Group, and then to lower the opacity of the group. Remember, you can change the opacity of a layer or group by pressing the number keys 1 to 0 for 10% increments.

6 The reflection looks more convincing if it fades away. Create a layer mask for the reflection set, and use the Gradient tool set to Black-White. Drag it along the central vertical axis of the camera; then adjust the resulting mask with Brightness & Contrast until the effect looks right.

SHORTCUTS

A bridge too far

1 Draw half the bridge on a new layer using the Pen tool. Make it into a selection, and fill with gray.

2 Draw the top and side of the bridge half as separate layers, and tint so they stand out from the side.

R EFLECTIONS CAN CAUSE THE MOST problems for Photoshop artists, as this Friday Challenge example showed. Here, the task was to build a bridge across the river so the boy could get to the girl. We'll only take the time to build a basic bridge; it's the reflection that interests us here.

6 Put all the bridge layers into a group, and add a layer mask to blend it into the grass.

7 Take a copy of the right side of the bridge (just the side – not the top or front) and flip the duplicate layer vertically. This is the first step in making the reflection.

10 Ripple it with the Wave filter, with a very short wavelength and the vertical scale set to zero.

11 Lowering the opacity merely shows the existing reflection through the bridge; this won't do.

Ben Mills

brewell

china

dave.cox

Deborah Morley

Einstein D Kid

Jota120

KateW

Les Moore

mguyer

Michael Sinclair

Nick Curtain

3 Duplicate the bridge half to make the other side, distorting all but the post so it recedes in perspective.

4 Add a base as a new layer, with a little shading to make it stand out from the bridge sides.

5 Add a wood texture, in Hard Light mode, using each of the sections of the bridge as a Clipping Mask.

HOT TIP

The key to making this reflection work is recognizing that lowering the transparency will simply allow us to see the reflected trees through it – which could never happen. By cloning the water texture on top, we're able to adjust the apparent density of the bridge reflection with much greater ease.

8 Enter Free Transform, and hold ⌘ *ctrl* as you drag a side handle to shear the bridge copy vertically. Once it aligns with the base of the original bridge, the reflection will be in the correct position.

9 Duplicate the side to make the other side of the reflection, then fill in the gap between the two with the same wood texture. Darken it considerably – the only light that can reach it is reflected from the water surface.

12 Rather than lowering the opacity of the bridge reflection, make a new layer, using the reflection as a Clipping Mask, and clone some of the water texture over it.

13 When we now lower the opacity of the cloned water, and reduce its saturation slightly, we get a far more convincing reflection: the bridge now ripples correctly.

SHORTCUTS
MAC WIN BOTH

Emma Gaoxiguo Gerard GKB Horonggo James

Powerslave Sophie Tom Tooquilos Vibeke Vicho

Shiny surfaces

Putting things in bottles

THE MONTAGE ABOVE shows noted art collector Charles Saatchi in one of the Damien Hirst boxes that make up part of his collection, and was commissioned by the *Sunday Times Magazine*.

Putting things in glass boxes, jars and bottles is a fairly straightforward technique: the trick lies in reproducing the surface of the glass, complete with its reflections and refraction, to make it appear as if the object in question is really sitting inside it. Here, we'll look at the procedure involved.

1 Our glass bottle was originally a much taller and thinner object. It was simply scaled using Free Transform to make it fit the shape of the object we want to place inside it. Most containers are as adaptable as this one: everything scales in proportion, so the end result still looks plausible.

2 Since the bottle was too dark for our purposes, it had to be brightened up – I used the Curves dialog, but Brightness/Contrast would have done the job as well. Some of that strong green hue was knocked out with Hue/Saturation.

6 To make the brain look like it's floating, we need a medium for it to float in. On a new layer, draw a shape that fits the sides and bottom of the bottle, remembering to draw the surface in perspective, and fill with the color of your choice. The top surface is brightened with the Curves dialog.

7 Changing the mode of this layer, as well, to Hard Light not only makes it look as if it's inside the bottle, but makes the brain look much more like it's floating in a supportive liquid. I've chosen to leave part of the brain sticking out to accentuate the overall effect.

BOTTLE IMAGE: **HEMERA PHOTO-OBJECTS**

3 Now for our brain (well, what else would you expect me to stick in a bottle). Placed on top of the bottle, it looks totally unrealistic; there's no sense here that it lives inside the glass, and looks as if it's sitting in front of it (which it is).

4 To make the ensemble more convincing, we'll begin by duplicating the bottle. Bring this copy to the top of the layer stack, and knock all the color out by desaturating it using ⌘ Shift U ctrl Shift U. As it stands, we can't see through it.

5 Easily fixed: we simply change the mode of the layer from Normal to Hard Light, and we can see through it. Already, the brain is looking like it's inside. The new Hard Light layer has also affected the rest of the bottle, but we can sort that out later.

8 To make the surface of the brain stick out, add a new layer mask to the liquid layer and paint around the contours of the brain so it looks as though it's poking out through the surface. Use a fairly hard-edged brush to get the most realistic effect.

9 All very well so far – but we need to remember that the liquid will distort as well as color the object inside it. Here, I've duplicated the brain and applied a horizontal-only Spherize to it, then added a layer mask to the distorted version so that it only shows up where it's beneath the liquid.

10 Finally, we can apply the original Hard Light bottle layer just to the brain. But there are two versions of the brain, so we can't just group them; instead, we need to make a layer mask. See the Hot Tip for a good way of making a layer mask to match multiple layers.

Glass: putting it all together

OW THAT WE'VE LOOKED AT different ways of rendering glass, let's finish off this chapter by putting several of those elements together. Starting off with the simple montage above, we'll use the techniques covered in this chapter to glaze just about everything in sight.

To begin with, the bottle is only a shaped outline: we'll create this (as well as the rest of the glass) directly in Photoshop. The end result, on the opposite page, shows off our glazing efforts to their best advantage.

1 The first step is to glaze the window. This is achieved using the techniques discussed on earlier in this chapter: first, a cloudscape is placed behind the window frame and set to 40% opacity, then, on a new layer, diagonal white brushstrokes are added to brighten the edges of the glazing. This technique is clearly a lot simpler if the window frame and the room interior are on separate layers.

The outline of the bottle is drawn with the Pen tool, and filled with mid gray.

Shading is added using Dodge and Burn tools to simulate lighting.

2 The bottle was drawn using the Plastic Wrap technique explained at the beginning of this chapter; the refractive effect was created using the method shown in the section Glass: Refraction. Because this bottle is not spherical, the Spherizing of the background was performed in two stages – one for the neck, and one for the bowl. The steps used to draw the bottle are outlined below.

3 The table was drawn directly in Photoshop, using the Dodge and Burn tools to create the highlights. To make the surface transparent, that section was cut to a new layer and its opacity reduced. The reflections of the bottle and window in the table used the techniques described in the section on glazing; the reflection in the greenhouse needed perspective distortion to achieve the correct angles.

HOT TIP

You can always photograph a bottle or glass rather than drawing it from scratch. The choice of background is critical: you need something bright enough for the glass to be visible, but must make sure the lighting doesn't cast shadows on it. It's also important to avoid reflections in the surface, unless you want to end up in your own montages.

Plastic Wrap adds the glass effect; with nothing reflected, it's unconvincing.

Increasing the contrast helps; the green color is added afterwards.

With the layer mask painted in, the refracted background becomes visible.

The original bottle is copied over the top, and Blending Options applied.

SHORTCUTS
MAC WIN BOTH

A refracting glass case

THIS ILLUSTRATION WAS commissioned by a magazine to accompany a feature about art buying online. The idea was to split an iMac down the middle and place it in a formaldehyde-filled case, in the style of British artist Damien Hirst.

It's a tricky project, as slicing the computer in half takes a fair amount of time and fiddling; but the end result is an attractive image. The original iMac photo I used is shown below.

1 Start by slicing the screen in half, curving over at the top. The stand can also be cut half way along, on the right half.

2 Duplicate the bottom of the stand to make the left half. The upper part needs to be redrawn, matching the tones of the original.

6 I used the Pen tool to draw the outline of the case as several separate paths. This is just for a visual guide, for placing the sides later.

7 Draw the face as a frame with a square hole cut out of it, then distort using Free Transform to match the perspective of the guides.

11 Lowering the opacity of this layer allows us to see the computer through it – and changing the mode to Hard Light adds strength.

12 This photograph of a room has strong verticals and geometric shapes: it's the ideal image to make our reflection.

3 Draw the interior in gray on a new layer (left), then duplicate a smaller version and fill with darker gray (right) to make the interior.

4 Add any pictures of circuit boards, using the smaller interior layer as a clipping mask; paint a couple of stripes to make the back of the screen.

5 Cut the keyboard in half, following the contours of the keys; then draw the interior of the keyboard as seen on the left side.

CASE STUDY

HOT TI

For greater realism, I could have enlarged the rear of the case (in step 9) to create the effect of refraction through the front of the glass. But this just looked awkward; sometimes you have to ignore reality in order to create a stronger image.

8 The same frame can be duplicated to make the side, using Free Transform once more to squeeze it into the correct shape.

9 Duplicate the face and side to make the back and the other side – it's easy to use Free Transform to make them fit in perspective.

10 Make a new layer behind the front face, and fill with green – this will form the 'liquid' inside the case.

13 Reducing the opacity of the reflection layer to just 10% makes it work well: it's barely visible, but it makes the glass more tangible.

14 A copy of the iMac, reduced and slid left, is an easy way to make a reflection in the left of the glass. The opacity is also reduced here.

15 Take a Merged Copy of the side window, and paste it on top, using the side as a Clipping Mask; enlarge it to make the refracted view.

273

INTERLUDE

Photographing glass

GLASS OBJECTS ARE AMONG THE HARDEST materials to work with in Photoshop. But we can make them much easier to work with by photographing them in the right way.

When we're photographing a wine glass, for instance, we might imagine that the correct method would be to photograph it against a black background, increase the contrast, and then set the layer mode to Screen so all the background disappears. And in some cases this works – that's how I photographed the three glasses on the cover of this book.

But if you're not sure about the background you'll be working with, or if it has a lot of bright objects in it, this approach will produced washed-out results. Here's an alternative method: photograph the glass against a white background instead, and adjust the tones in the resulting image so that the white becomes a mid gray (1). The problem here is that by darkening the background, we also darken the glass –

and when we place the image on a new background we realize that the detail in our glass should be white, not black (2).

This simple – and perhaps surprising – solution is to invert the glass, so black becomes white and vice-versa (3). Now, our image should show its key detail in white against the gray background. When we change the layer mode to Hard Light the background disappears, leaving us with just the glass (4). We can now use the Dodge tool to brighten up the edges, and we can clone out any real highlights that have turned black (5). Add a distorted view through the glass, and the image is complete (6).

One word of advice: before you photograph glass, or indeed any object, clean it thoroughly first to save having to do this in Photoshop later. I once spent half an hour tidying up a shot of my computer keyboard in Photoshop, before realizing I could have cleaned the real thing in just five minutes.

10
Metal, wood and stone

THESE THREE BASIC MATERIALS make up much of the fabric of everyday life. We're surrounded by them, from cutlery to tombstones, from tables to coins. We may take them for granted, but when we want to recreate them in our montages we have to look at them with new eyes.

In this chapter we'll see how we can create metallic effects from scratch, using a variety of techniques – from Curves to Layer Styles – that will allow us to turn any object we like into gleaming steel, chrome or gold.

We'll also look at how we can use the Lighting Effects filter, which has undergone a major reconstruction in Photoshop CS6, to model all kinds of embossed surfaces. And we'll also take in making all sorts of objects out of wood, as well as methods for turning people into statues – and bringing statues to life.

Instant metal using Curves

1 Begin by opening the Curves dialog using ⌘ M ctrl M and click near the left-hand side of the diagonal line: drag vertically upwards to make this steep curve. The image will appear very washed out at this stage, but it's just the initial step – it will all make sense later.

THE SIMPLEST WAY TO CREATE AN instant metallic effect is to use the Curves dialog. Metal differs from non-reflective surfaces in that it reflects the light in unpredictable ways: the light and shade aren't simply created by a single light source, but vary across the surface of the object.

We can simulate the effect of metal by drawing a stepped curve that reproduces the way metal reflects the light. On the following pages we'll look in more detail at how to get the best out of this technique; here, we'll simply turn this dull plastic monitor into a chrome-plated version.

4 Click further along, and drag down to complete the second step of our staircase. Now the image is beginning to look far more shiny; but it still looks like it's made of plastic rather than metal.

2 Now click a little further along the curve, and drag downwards as shown in the graph. This will make the image very much darker and more contrasted. So far, we've created the first of what will become three peaks; we'll go on to build the other two to make the metallic effect work.

3 Now click again, further along the curve, and drag up again to make the high point for the next step. Once again the image will appear washed out: but the data is all still there, and we can continue to manipulate it.

Using the Curves dialog to create metallic effects in this way can have unwanted results – in particular, it can create hard, pixelated lines around regions of high contrast on the original object. To remove these, use a small History brush to paint back the original image where it looks too harsh.

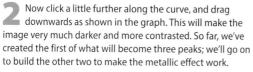

5 Click further along the curve once more, and drag upwards to make the high point for the final step. At this stage, we can begin to see the metallic effect taking shape, although the image still looks too bright.

6 Finally, click in the middle of the remaining part of the curve, and drag downwards. Now we've completed the effect, and that dull metal monitor looks like it's made of gleaming chrome.

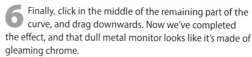

Metal with Adjustment Layers

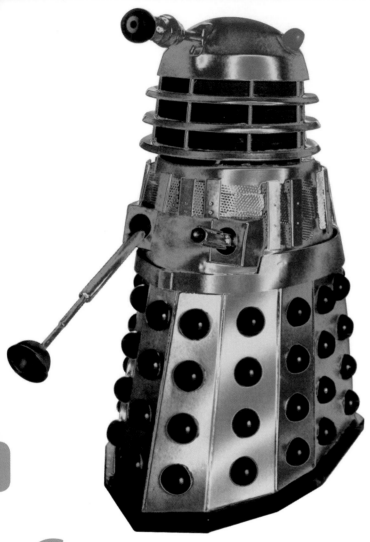

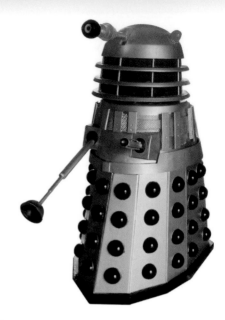

1 This original Dalek model has been painted using what the tin claimed was a metallic paint. But when it was photographed, the result looked dull and lifeless. We can use Curves again to bring the shininess back.

CREATING METALLIC EFFECTS USING THE CURVES technique described on the previous pages works fine, but gives us little control over the result. It's better to use an Adjustment Layer: not only can we mask and change the mode of the effect, we can always go back and change the shape of the curve at any time. We'll use this approach to make our plastic Dalek look more like the real thing.

Note: I'm indebted to Paul Smith, Art Editor of *Radio Times*, for pointing out that in earlier editions of this book I've had the Dalek the wrong way round. Oops!

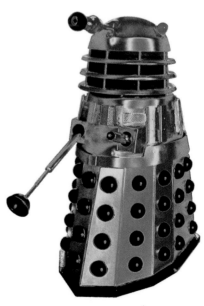

4 As expected, the Curves effect has produced some harsh pixelation. But because we applied it on an Adjustment Layer, we can modify the target layer to fix the problem. After locking the transparency of the Dalek using ▨, apply a small amount of Gaussian Blur (a 1-pixel radius maximum).

2 Create a new Curves Adjustment Layer by selecting it from the pop-up menu at the bottom of the Layers panel, and draw the same curve as we used on the previous pages. Here's the problem: the Curves effect has altered the color component as well, resulting in an ugly rainbow effect.

3 Because it's an Adjustment Layer, the problem is easily fixed. Simply change the layer mode (from the pop-up list at the top of the Layers panel) from Normal to Luminosity. Now, the Curves effect only affects the brightness and contrast of the underlying layer.

The edges of layers can often look highly pixelated when a stepped Curves effect is applied. To get rid of this unwanted noise, set the Adjustment Layer to use the target layer as a Clipping Mask, and most of the edge raggedness will disappear. Any extra noise can be painted out on the Adjustment Layer's mask.

5 Each Adjustment Layer comes with its own mask, which works precisely like a standard layer mask. We can use this to paint out the Curves effect on unwanted areas – the end of the suction cup, the orange light and the highlights in the black hemispheres on the Dalek's body.

6 The skirt still looked rather dull and lifeless. Easily remedied: we simply use the Burn tool to add a little shading to that area. Because we're looking through the Adjustment Layer, we can see the effect of the Curves as we paint with this tool.

Metal with Layer Styles

MAKING CONVINCING METAL text is often seen as a kind of holy grail among Photoshop artists. Here, we'll look at how to make metal with Layer Styles alone. The advantage of this method is that the text remains editable; and the style itself can easily be adapted to suit any purpose.

If this process seems a little long-winded, you can always cheat – after all, that's what this book is all about. I've included this style on the DVD that accompanies this book, so you can just load it up into your copy of Photoshop and start using it straight away.

1 Begin by creating your base layer – in this case, it's live text. Open the Layer Style dialog and add an Inner Bevel, sized to suit your artwork. I've also added a drop shadow for a more three-dimensional effect.

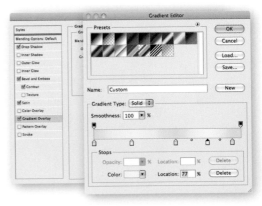

4 To give some sheen to the inside of the lettering, click the Satin tab and apply a bowl-like contour. You'll need to experiment with the distance and size to get the right combination, so just drag the sliders until it looks right.

5 To apply a gold color, we'll make a new gradient. Click on the Gradient Overlay section, and make a subtle gradient of alternating bars of light and dark yellow to complete our gold effect.

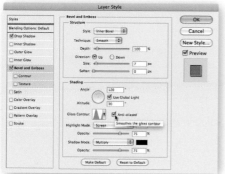

2 Now to liven it up. In the Shading section of Bevel and Emboss, click on the Gloss Contour icon and change it to a bumpy map such as this one, which adds sparkle to the lettering's bevel.

3 Next, we're going to add some reflection to those bevels. Click on the Contour section, and use the pop-up Contour icon to choose this sort of shape for our curve. That plastic image is beginning to look more like metal.

You'll find the metal style in the DVD folder for this chapter, called Cheat Metal.asl. Use Photoshop's Preset Manager to load this style, and it will appear in your Styles panel. It's preset for silver, as in step 6; to turn this to gold, uncheck the Color Overlay component in the Layers panel. Note that you'll almost certainly have to adjust the Bevel size, as in step 7, to suit the size and resolution of the illustration you're working on.

6 To turn the gold into silver, add a Color Overlay. Go to the blue section of the spectrum, and choose a gray with only the smallest hint of blue in it to avoid too much color creeping in.

7 Because we're working with live text, we can change the lettering or font as we need to. Here, I've also increased the size of the bevel to make the lettering look lumpier; the choice is up to you.

SHORTCUTS
MAC WIN BOTH

Turning silver into gold

TURNING SILVER INTO GOLD MAY not be precisely the medieval alchemist's dream – they were, of course, more concerned with creating gold from base metals – but it's an easy technique that anyone can master.

If you were painting, you might expect to add red and yellow to achieve a golden hue. But in the Curves dialog, we only have access to each of the three RGB channels – red, green and blue. You might not think there's any green in gold, but it's surprising how this is the color that makes the effect work so well: just one more example of the need to think laterally when working in Photoshop.

1 Begin by opening the Curves dialog, using ⌘ M ctrl M. Switch to the Red channel, either by choosing it from the pop-up list at the top of the panel, or by using ⌘ 1 ctrl 1. Now grab the midpoint of the straight line, right in the dead center of the graph, and drag up and to the left. The distance you drag depends on your image, but you should aim for something like the curve shown here.

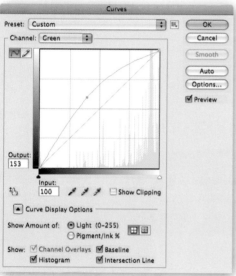

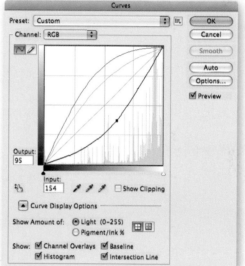

2 Now switch to the Green channel, either using the pop-up menu or with ⌘ 2 ctrl 2. Once again, grab the midpoint of the line and drag up and to the left, but not quite as far as with the Red channel. You'll be able to tell when the color looks right.

3 In the previous two steps, we brightened both the Red and Green channels – which meant brightening the image overall as well. Now we need to restore the depth of shading we had originally. Switch to the RGB (composite) view, using the menu or ⌘ ` ctrl `. Grab the midpoint again, and this time drag *down* and to the *right* to darken the whole image. And that's all there is to it!

HOT TIP

Gold isn't a single color, any more than silver is gold with all the color knocked out of it. As the examples at the bottom of the page show, different types of silver can produce very different results when turned to gold. Each object needs to be treated individually; the final stage, especially, will depend very much on the nature of the silver you started with.

SHORTCUTS
MAC WIN BOTH

285

Metal with Lighting Effects

THE LIGHTING EFFECTS FILTER IS A useful tool for adding light and shade to an image: simply point the spotlights where you want them and adjust the settings. But the hidden function of Lighting Effects is its ability to use Alpha channels as bump maps to simulate three-dimensional images.

An Alpha channel is an additional channel (in addition to Red, Green and Blue) that Photoshop uses to store selection data.

Lighting Effects has undergone a major overhaul in this version of Photoshop, now sporting a full-screen preview and direct Head-Up Display controls.

If you're using a version of Photoshop prior to CS6, then check out the PDF version of this page for your earlier versions of Photoshop – you'll find it in the Cut Pages folder on the accompanying DVD.

On the following pages we'll look in more detail at Lighting Effects, and see how filters can affect the end result.

1 Create a design like the coin I've made above left. Select All and make a Merged Copy (⌘ Shift C / ctrl Shift C), then open the Channels panel and make a new channel by clicking the icon at the bottom. Paste your coin in here, then use Gaussian Blur to soften it (around 2 pixels). Use ⌘ 2 / ctrl 2 to return to the RGB image, and make a new layer, matching the coin shape and filled with white. Use Filter > Render > Lighting Effects. You'll see something like the shot above.

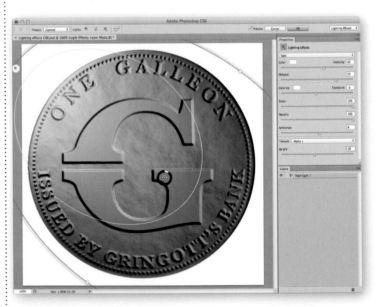

4 You should try to arrange the light so that the outer ellipse covers the whole of your coin. Now look at the settings: don't set the Hotspot too high, or the image will blow out; raise the Gloss and Metallic values for a shinier result; and drag the Height slider just a small amount for a dramatic effect: here, it's set at just -7 (so the black parts of the coin appear high).

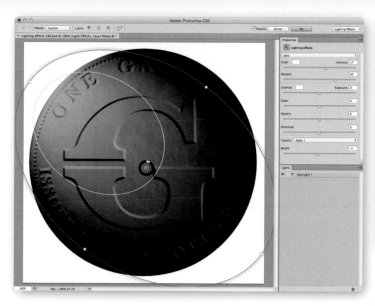

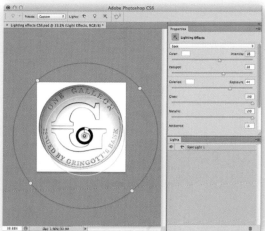

2 At first glance, Lighting Effects seems to be nothing special – just a spotlight cast on your layer. The secret comes from the pop-up next to the word Texture at the bottom. Choose the Alpha channel you created in step 1, and then drag the Height slider a little way left or right. Suddenly, the coin you drew will turn into a 3D object. If you drag the height slider to the left, then black areas on the coin design will appear high; drag it to the right, and white areas will appear high.

3 In order to light your coin clearly, you'll need to drag on the handles of the light, on the image, to both swing it around and set the radius of the light.

It's easy to find yourself in a situation where you simply can't reach the handles, as they're located off-screen. If this happens, then zoom out a little using ⌘ ⎯ ctrl ⎯ so that you can grab the handles more easily.

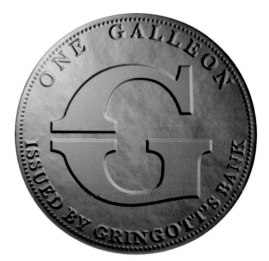

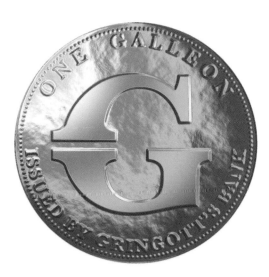

5 Here's the result after hitting OK. The coin certainly has depth, but it looks more like plastic than metal. That's OK: despite the Gloss and Metallic sliders, Lighting Effects does tend to produce plasticky results.

6 All that changes when we apply a Curves effect similar to that used at the beginning of this chapter. The familiar step shape produces a gleaming, shiny coin that truly looks three-dimensional.

HOT TIP

Lighting Effects only works on RGB images, so if you're working in CMYK you'll need to convert to RGB first. Even if you're creating a black and white illustration, you'll have to change it to RGB to use the filter, then change back to grayscale afterwards.

SHORTCUTS
MAC WIN BOTH

287

More on Lighting Effects

ALMOST ANY texture can be used as the basis for a Lighting Effects operation, as is shown here: Clouds and Noise are just two ways of generating natural-looking surfaces. Notice, as well, how the simple repeated screw heads shown in the final example produce an array of screws that are all lit slightly differently as their distance from the virtual light source varies.

The key to making artwork render well in Lighting Effects is to use just the right amount of blur on the Alpha channel that will be used as a texture map. So first, we'll look at how different amounts of blur affect the final appearance of the rendered artwork.

1 When no blur is added to the Alpha channel (above), the result after applying Lighting Effects (top) is harsh, with ragged, stepped edges.

2 Applying a 1-pixel radius Gaussian Blur to the Alpha channel softens the edges, and results in a far smoother image after Lighting Effects is applied.

6 The Clouds filter (above) produces a pleasingly random surface (top) when used as the basis of a Lighting Effects channel. It's a useful way to create an instant stone effect, which can be easily modified until it produces exactly the result you want.

7 Because the Alpha channel stores selections, we can press ⌥⌘4 alt ctrl 4 to load up the lighter areas for us (top). We can now recolor them, then inverse the selection and recolor the rest to create a more dynamic effect (above).

Looking for Lighting Effects on a Mac using CS5?

Lighting Effects is disabled in 64-bit mode on the Macintosh in Photoshop CS5. To use it, you first have to quit Photoshop. Select the Photoshop icon in the Finder, and choose Get Info from the File menu. Then check the box marked 'Open in 32-bit mode'. This will re-enable the plug-in when you relaunch Photoshop.

3 The greater the amount of blur, the more raised the result will be. Here, a 2-pixel blur results in a significantly taller object.

4 Increasing the blur to 4 pixels produces a result in which the edges thicken too much: this looks like it was cast from an old mold.

5 An 8-pixel blur is clearly a blur too far: Lighting Effects has trouble making sense of this, and the result is merely fuzzy.

8 Even the tiniest variations in shade can have dramatic effects. The 2% Gaussian Noise (above) is too faint to be seen clearly here; but the result (top) is a grainy, textured surface.

9 Increasing the Gaussian Noise amount to 20% produces a far more striking result: here, we've produced a rough, stony surface in just a few seconds using this technique.

10 The screws around this perimeter were created by dabbing a soft brush once, then drawing a diagonal line across it. Because the letter M is brighter than the background, it appears to be recessed rather than raised.

SHORTCUTS
MAC WIN BOTH

Spray-on rust and decay

IN EARLIER EDITIONS OF THIS BOOK, we saw how to make the sign above using Lighting Effects, and how to use a version of the Alpha channel with added Noise to make a paint-on rust effect. (If you want to read that tutorial, you'll find it on the DVD in the Cut Pages folder.)

Here, we'll look at how to make a better type of rust, lichen and decay that you can 'spray' onto the artwork using a Brush set to Dissolve mode, followed by a Bevel set in Layer Styles to add a three-dimensional quality to the decay and degradation.

Four different versions of the effect are shown here, all using slightly different settings. The result is a little over-the-top – I wouldn't necessarily recommend you apply all these techniques to the same piece of artwork. What's surprising, though, is that all the effects here are painted on new layers on top of the base artwork – which hasn't itself been touched at all.

1 Make a new layer, and choose a small Brush. Set the Brush mode to Dissolve (set this in the Options bar). Now, it will paint a spray of individual pixels. The lower the opacity of the brush, the more widely spaced the pixels; use about 40% opacity, and paint some brown streaks.

6 For the cutaway, paint in gray on another new layer. Use a higher Brush opacity, so that more of the interior is filled with dots.

7 This time, we want more Gaussian Blur – try a 3-pixel blur. This produces a softer result, as seen here, and fills in some of the holes.

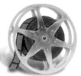

2 After you've finished painting your brush strokes, use the Gaussian Blur filter to add a 1-pixel blur to the whole layer.

3 Use the Layer Styles dialog to add an Inner Bevel to the layer. Use a Size of around 2px, and a Depth of around 180%.

4 To make the mold, make a new layer and, using the Brush still set to Dissolve, paint in light green at 20% opacity, then Blur as before.

5 Add another Inner Bevel, and this time use a large Depth – around 500%. Change the Technique to Chisel Soft for a lumpy effect.

HOT TIP

When placing elements such as rust, think where they're likely to be found. If this sign is hanging vertically, then rust will form in the places water gathers when it rains – dripping from the bottom of the letters, hanging on the underside of the triangle, and so on. The eaten-away enamel works well when it more or less follows the contour of the raised areas.

8 Apply an Inner Bevel again, with the Technique set to Smooth; add an Inner Shadow (left). Now check the Gloss Contour box and go to that section, and apply a Cove Shallow contour to make this eaten-away look (right).

9 Finally, make yet another layer and add an Inner Bevel to it, the Direction set to Down. When you paint in gray on this layer with a very small brush, you can make the scratches shown here. You can vary the depth of the scratches and adjust the layer opacity so they aren't too strong.

291

Photographing shiny objects

1 When you photograph a metallic or other shiny surface, the one thing you can't do is use a flash: the resulting glare would overwhelm the image. Instead, I dragged this trash can over to a window, holding the pedal down with my foot while I leant back and took the picture (memo: must invest in a decent house brick).

WHEN THE *GUARDIAN* RAN A feature about a lifelong socialist taking the decision to send their child to a private school, the cover image was a simple cutout of a boater – the kind of hat traditionally worn in selective girls' schools. The following week, they countered with a story by a journalist who had recently taken his child out of the private sector, and decided to illustrate it with an image of the same boater being tossed into a trash can.

Although this was in many ways an easy montage to create, the texture of the trash can was the hardest element to reproduce. Photographing shiny objects can be a test for even the most hardened photographers; there is a simpler method.

5 Getting rid of the reflection of the carpet in the lid involved a couple of stages. First, a new 'mask' layer was made, drawn with the Pen tool to fit exactly the shape of the inside of the lid (minus the reflection of the can itself). A copy of the blurred front was then clipped with this mask layer, and some Gaussian Blur applied to make the reflection less sharp.

2 Cutting the background out was an easy enough process using the Pen tool to draw a smooth path, and the image needed just a little brightening with Curves to lighten it up. But the reflection remained smeary, and showed my hallway and carpet all too clearly. For a perfect image, it was necessary to clean up all those distracting elements.

3 The solution was to take a section of the front of the can and make a new layer from it, and then apply Motion Blur to it. I then stretched the result until it was tall enough to cover the whole front of the can. By using the original as the basis for the blur, it was possible to keep the same color range as appeared in the rest of the object, so it would blend in well.

4 The blurred texture was moved into position, and a layer mask made so that it exactly fitted the front curve of the trash can. Because the can had been photographed slightly from above, it was necessary to apply a slight perspective transformation on the blur to make it taper towards the bottom. The result is a more convincing brushed metal effect.

HOT TIP

Rather than using Motion Blur to create the brushed metal effect, it would have been possible to either draw the surface from scratch, or use a photographed section of a shiny pole. But although the can's surface is, in theory, just black and white, there's actually a huge range of colors that define it. Using a blurred copy of the original is the best way to ensure that the color range matches the rest of the can.

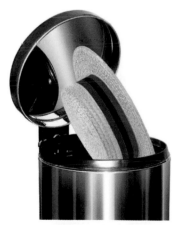

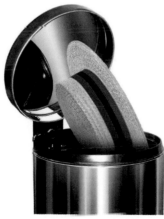

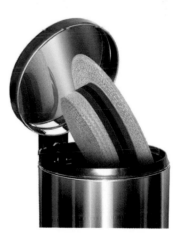

6 Placing the hat in the trash can was achieved by drawing a layer mask that exactly fitted the front of the can, up to the plastic rim. By clicking on the link between the hat and its mask in the Layers panel, the hat was separated from the mask, and so could be moved around independently.

7 Because the original hat had been photographed the right way up, the light naturally fell on it from above. Turned upside down, the top – previously the brightest part – now had to be darkened up. Rather than using the Burn tool, I made an elliptical selection of the top and used Curves to darken just this section until it looked convincing.

8 The reflection of the hat was added on top of a new mask, this time a copy of the entire inside of the lid. The hat was then masked where it would be hidden by the rim of the lid, and shading applied to it with the Burn tool. Finally, a third copy of the blurred front was placed above the reflected hat and grouped with the lid mask to dim the reflection slightly.

SHORTCUTS

Making a better impression

1 This may be an accurate representation of the Presidential Seal, but as it stands it's hardly a beautiful object in its own right. Let's take this flat artwork and make it a little more attractive by embossing it.

W E CAN USE THE TEXTURE OF A wooden surface as the base for any artwork, turning a two-dimensional design into one that looks as if it's been carved in wood. In the example above, I've used the complex outlines of this coat of arms to create a solid-looking object. The original design for this crest was in black and white, so the embossing has to do all the work.

The Seal of the President of the United States, by contrast, has no interest in its outline – it's simply a round disk. Unlike the crest, it does have the advantage of color to create more interest, and we can make use of this.

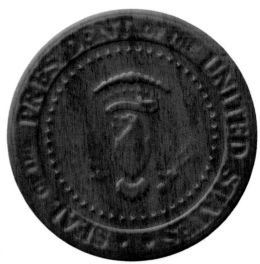

4 Now that the seal detail is in our Alpha channel, we can load it as a selection using ⌘ ⌥ 4 *ctrl alt* 4; the brighter areas will be more fully selected than the dark areas. Returning to the wooden disk, we can now make a new layer from that selection using ⌘ J *ctrl* J. This layer will appear with the bevel from the disk applied: as it stands, it's far too blobby.

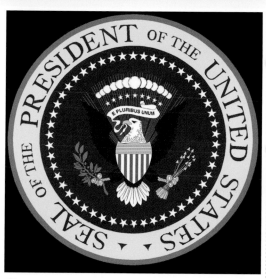

2 To begin, we'll take the same piece of wood as we used in the previous example. After stretching it so it covers the seal, hold ⌘ ctrl and click on the seal's name in the Layers panel to load up its selection; then inverse the selection using ⌘ Shift I ctrl Shift I and delete the outside. The bevel is applied using Layer Effects, with a 15-pixel bevel to give the disk a sense of three dimensionality.

3 Now we're going to turn the original seal into a selection. Copy it, then make a new Alpha channel by clicking on the New icon at the bottom of the Channels panel; then paste the copy in place, where it will appear in grayscale. This can now be used as a workable selection.

5 Double-click the layer effect in the Layers panel to open the dialog, and change the numbers. Here I've increased the depth from the default 100% to 200% to make it stronger; but I've also reduced the bevel size to just three pixels, so that the detail remains crisp. Some of the detail has failed to appear after the selection process, such as the wings of the eagle; but the next step will fix that.

6 Finally, move the original seal layer to the top. We need to change its layer mode so that the wood and beveling show through. Once again, we have a choice of layer modes open to us: although Overlay worked on the example on the previous page, it's too strong here. Instead, I've opted for Soft Light, which brings back much of the original color while retaining the subdued sense of stained wood.

SHORTCUTS
MAC WIN BOTH

Timber floors with varnish

1 To turn this piece of wood into a floor, the first step is to mark out the planks. It's easiest to draw a rectangular selection in QuickMask and fill it, then copy it across: that way you can be sure they're all the same size.

2 Make a new layer from the selection. I've used the Bevel and Emboss section of Layer Styles to add the shading lines. Be sure to keep the Highlight value fairly low, or you'll find it too glaring when the floor is finished.

I HAVE A CONFESSION TO make: I only have one piece of wood. At least, there's only one piece I tend to use for all my wooden needs: it's this image of the back of an old pencil box I scanned in 1989. You can still see the screw holes that held the base to the sides – it wasn't even a particularly sophisticated pencil box. The point is, though, that you really don't need a lumber yard full of different types of wood; as long as the piece you're using has a strong enough grain, it can be put to most purposes fairly well.

6 Adding the nails is optional, but can help with the sense of flooring. On a new layer, make a small circular selection, fill with a mid gray and add a little shading to it; then duplicate three times (you can see the nails on the fifth plank from the left).

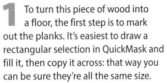

7 Copy that group of nails to all the other wood joins by holding ⌥ *alt* as you drag with the Move tool. Be sure to hold the mouse down within the nail area before dragging, or you'll create a new layer each time you drag. Finally, merge all the layers.

3 Now inverse the selection, and make a new layer from the wood base: apply the same beveling by dragging the layer effect from the previous layer onto this one. Finally, flip the new layer vertically so the grain lines don't match up.

4 Split one set of floorboards into irregular lengths by making rectangular selections, and make another new layer using ⌘ J / ctrl J; the bevel will automatically be applied to the new layer.

5 Repeat the process for the other set of planks, and adjust the brightness of both to make more irregularity in the planks.

HOT TIP

Applying a perspective distortion to the wood necessarily makes it narrower at the top than at the bottom. If your target image is wider than the original wood flooring, duplicate the layer and move it horizontally so the two overlap by about half an inch; then make a layer mask to blur the join lines and merge the two layers to make a floor that's nearly twice as wide.

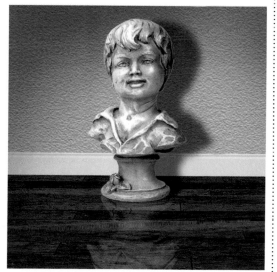

8 Your floor is now ready to be inserted in whatever document you want. Use Free Transform to make it fit the space: hold down ⌘ ⌥ Shift / ctrl alt Shift while dragging one of the top corner handles to create the perspective distortion. A floor like this can be made to fit in just about any space you want to fill. This wall, incidentally, was easily made using the Texturizer filter.

9 With the shading in place, the floor looks very much more realistic. Applying the varnish is far less messy than working with the real thing: simply make a reflected copy of whatever object you're placing on the floor, and set its Layer mode to Soft Light for that glossy appearance. For more on how to achieve this effect, see the reflection sections in Chapter 9, Shiny surfaces.

SHORTCUTS
MAC WIN BOTH

Recycling old wood

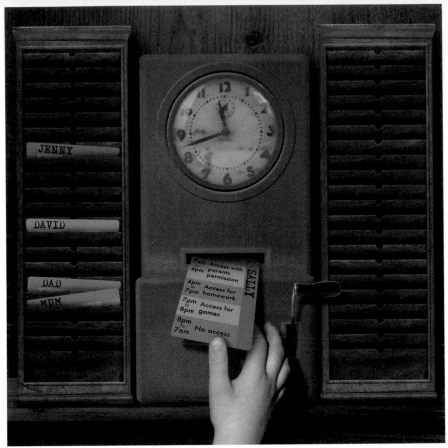

1 This was the unlikely starting point: a stock shot of a microscope cabinet. It already had the top and bottom structural bars, and the surface was nicely scarred and pitted.

THE ILLUSTRATION ABOVE, DRAWN for *Computer Active* magazine, represents an old-fashioned time clock of the sort once found in factories, with members of a family clocking in. The article was something about sharing computer and internet time.

The trouble was, no images of time clocks were readily available. I built the clock itself from a section of an old adding machine, with a real clockface inserted. Of more interest here, though, are the card slots at either side. They had to look convincingly old and used – and they had to look real, for this image was to be used across a page and a third.

5 For the first card holder, begin by drawing a rectangle with a semicircle cut out on a new layer, and fill with white (top). Add shading so it's lighter at the top, fading to gray (bottom). Most of this card will be hidden on all but the lower layer.

2 I used Free Transform to distort the face of the box to fit the rectangular, head-on view I needed for this image. In this version, I've compressed it to fit on the page better.

3 To make the dark interior, make a rectangular section into a new layer, and darken it. Here, I've also flipped it horizontally so that the grain doesn't match up with the original.

4 Select another rectangle on the original box, then hold ⌥ *alt* to deselect a smaller rectangle within. Make a new layer from it, and use Layer Styles to add the bevel effect.

CASE STUDY

HOT TIP

It's the texture of this old piece of wood that makes this illustration work. But wood like this often has unwanted elements: in this case, there was a lock on the original cabinet that needed to be removed. The Healing Brush Tool was the easiest way of removing this quickly and effectively.

6 Load up the layer as a selection, then nudge it down a couple of pixels, inverse the selection and brighten to get a bevel effect on the top edge (top). Copy a section of wood above, using the card as a Clipping Mask, and set its mode to Multiply.

7 Duplicate the card with the wood overlay to make each card holder. Here, I've offset the wood above each gray shaded holder so that the pieces are not all identical – this would destroy the effect. To do this, I used an oversized piece of wood in step 6.

8 At the end of the last step, the card holders looked as if they were flat up against the face of the cabinet – and I needed to make them look recessed, sloping back at an angle. Some shadow at the sides, painted on a new layer, helped this effect.

SHORTCUTS
MAC **WIN** **BOTH**

Making statues from life

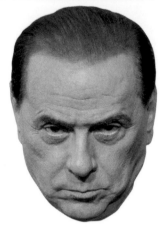

1 For a man so keen on publicity, it's surprising that there are few images of him generally available on the internet. I found this perfect pose – broody and sullen – but it was a low resolution image. When enlarged, it showed a lot of degradation.

2 Lock the transparency of the head layer, then use the Blur tool to smoothe over all the skin. We can also use the Smudge tool to smoothe it further, removing all the original skin texture and leaving just the shading.

WHEN ITALIAN NEWS MAGAZINE *Internazionale* wanted to highlight Silvio Berlusconi's lust for power, they decided to produce a cover showing him as a Roman emperor. Of course, this meant turning him to stone – would I oblige?

Delighted to help out. Turning people into statues is a tricky but very enjoyable exercise, and it requires a good understanding of the difference between skin and stone as textures – in particular, the way stone has none of the color variation we find in a typical face, and the fact that we can't keep eyes and hair as dark as they are in the original person.

6 I found this body of a Roman emperor through a web search. The original had a very detailed texture, but I knew I'd want to add my own texture later; so I used the Smudge tool to smear all the texture in the body, producing a much softer version that matched the texture of the head. In the version on the DVD, I've already done this for you.

3 We need to lose those dark eyes: there's no tinting in a stone statue. Make a new layer, and paint out the eyes with a gray sampled from the skin. Here, I've also painted over the deep shadows in the face to tone them down a little.

4 Select the hair, and make a new layer from it; then use the Curves dialog to raise the shadows, producing a much paler, washed-out version of the original.

5 Use the Dodge and Burn tools to paint alternate light and dark strokes through the hair, following the line of the head; then use the Smudge tool to blend these together for a more organic, stone-like appearance.

Berlusconi has fine, wispy hair that's impossible to reproduce in stone – which may be why Roman emperors are shown with such full, thick heads of hair. Alternatively, the reason could be that the sculptors simply didn't want to be executed for making their emperors appear balding.

7 Nothing says 'marble' quite as much as a genuine piece of marble. Place the texture (it's in the Photoshop file on the DVD) so it covers the whole body and head. Then, load up the head and body as selections, then make a Layer Mask for the marble layer that matches the selection. Change the mode of the layer to Multiply, so we can see the figure through it.

8 The marble effect in the previous step is just too strong, and swamps the original. We could simply lower the opacity of the layer, but here's a better method. Hide the marble layer, and make a Merged Copy of the head and body layers (load them as selections, and use ⌘ Shift C / ctrl Shift C). Then place this above the marble layer, and change the mode of the new layer to Hard Light.

Bringing statues to life

1 Our statue is of an unknown benefactor outside a church. He's been a perch for pigeons for too long: let's bring back some of his dignity.

2 The first step is to add some basic color to the model, using the swatch we implemented in Coloring Black and White Images, page 232.

ON THE PREVIOUS pages we looked at how to turn a photograph into a statue. Here, we'll reverse that process: starting with a stone model, we'll look at how to bring it to life.

The technique is similar in many ways to that used to color black and white photographs. But because the stone original is smooth, we'll also need to add some of those blemishes that make people human.

This was originally posted as a Friday Challenge on the How to Cheat website: the results are shown below.

6 Another application of the Beards and Stubble technique, this time very subtly – to add some slight stubble beneath the chin. It's barely perceptible, but makes a difference.

7 More shading: on a new layer, we add liver spots to the temples, wrinkles on the forehead and some extra shading beneath the chin and on the chest hair area.

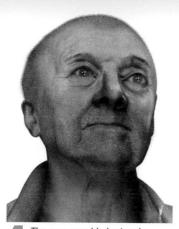

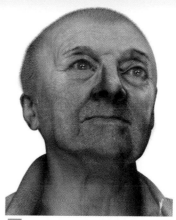

3 The hair and beard are both added using the Beards and Stubble technique described onpage 214. The beard itself is given a very low opacity.

4 The eyes are added using the technique shown on page 222. The edges of the irises have been softened slightly with Gaussian Blur.

5 Fine lines are drawn on the cheeks and nose on a new layer using a tiny brush at a very low opacity, to simulate the effect of broken veins.

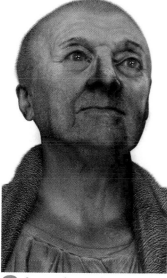

8 On a new layer, make a rectangular selection and fill it, then apply the Texturizer filter to it with Burlap. This is duplicated, and distorted to make the clothing.

9 The shirt is selected, copied to a new layer and desaturated and brightened. It's not bad – but it's lacking in texture, and looks too artificial.

10 As a final step, we can take another copy of the texture we created in step 8, and add it to the shirt layer on Multiply mode at a very low opacity.

HOT TIP

Subtlety is a key element here: it's easy to go too far when adding veins, liver spots, stubble and so on. The trick is to work on a new layer for each element, painting the features in harder than you'd like them; the layers can then be reduced in opacity, and in some instances blurred, to make the overall effect more convincing.

mguyer

mikewheattie

mr.pbody

neal

paul2005

pauline

slim

stefan

Storm

Tom

Whaler

303

Carving words in stone

1 This piece of stone is nicely mossy at the bottom, and will do perfectly as the basis for our grave. I tend to carry my digital camera with me whenever I'm likely to stumble upon an interesting building or texture.

THIS ILLUSTRATION WAS FOR THE cover of the *Independent* newspaper. The shape of the plinth and the cutout text were modeled in Adobe Illustrator, and the stone texture wrapped around both. With CS6, of course, I could easily have created the text using the 3D extrusion tools.

Carving text in stone is now easier than ever, thanks to the Emboss feature in Layer Styles. Here, we'll look at how to make a gravestone from scratch, in a few simple steps.

4 After creating your text, render it into a layer and then distort it using Free Transform to match the perspective of the tombstone. This text is loaded as a selection by ⌘ *ctrl* clicking on its name in the Layers panel, and the selection made into a new layer from the stone layer.

2 Because we want this grave to be somewhat rough around the edges, draw the outline using the Lasso tool to get the unevenness that couldn't easily be achieved with the Pen tool. This selection can then be made into a new layer using ⌘ J ctrl J.

3 The same selection is copied from a different part of the original stone material, and offset to make the edge. Shading can be added using the Dodge and Burn tools, making it darker on the undersides of the edge, and lighter on the upper faces.

5 After darkening the stone lettering slightly to make it stand out better, use Layer Styles to create the carved effect. Use Emboss rather than Bevel for this, as it makes a more convincing carved effect; remember to set the position to be Down rather than Up, so it's lit from above.

6 When the background is added, it's simply a matter of blending the stone into its surroundings. Darken the edge slightly, and add a shadow on the grass behind it; the grass is brought in front of the base of the stone using the technique described in Chapter 3, Hiding and showing.

HOT TIP

Choose an appropriate typeface for your lettering to make the whole effect more convincing. Sans serif lettering is virtually never used on graves, for good reason: it's the serifs that are carved first, and which prevent the stone from splitting as the thick letters are incised. This is, in fact, the reason why the ancients invented serif lettering in the first place.

SHORTCUTS
MAC WIN BOTH

A grave business

1 The first step is to draw the grave. I find it easiest to paint it in using QuickMask, to avoid straight lines at the edges. The perspective is tricky; it's just a question of doing what looks right. Make a new layer from the selection.

A READER POSED THIS QUESTION on the Reader Forum section of the website: How do I dig a hole in the ground that looks convincing? Never one to pass up a good idea, especially if it's handed to me on a plate, I made it into the week's Friday Challenge, the results of which are shown below.

It's not a difficult task, but there are some useful tips that will help you to make the effect more convincing. This is the image contestants were given to start with – it's the same gravestone we carved on the previous page. Here's how it's done.

4 The shading makes all the difference. Use the Burn tool to darken the bottom of the hole; some vertical streaks make it look more dug. Finally, darken a thin rim around the top, beneath the lip of the grass.

David Asch

Dezolat0r

Chris Pucci

"LIKE A BUS OUT OF HULL I'LL BE GONE WHEN THE MONEY COMES…"

maiden

julie

2 Lock the transparency and then choose two different browns for the foreground and background colors. Now apply the Clouds filter, holding ⌥ *alt* to produce a tighter effect: keep pressing ⌘F *ctrl*F until it looks good.

3 The Clouds filter gave us some useful lumpiness, but not enough detail. To add an earthy appearance, add some monochrome Gaussian Noise, then blur it slightly with the Gaussian Blur filter.

HOT TIP

In step 5, we made a layer mask to bring the grass over the edge of the grave. The front two edges of that layer mask can be applied to any other layers for objects you want coming out of the grave: it's better than simply using the grave itself as a clipping mask, since we want any skeletons, ghouls (or even buses) to be able to stick out over the top.

5 The real key to making this effect work is making the grass overhang the edge of the grave. This is easy: it's done in exactly the same way as we brought the grass over the couple in Layer Masks 2, in Chapter 3.

6 After that, it's up to you. For a night setting, choose a suitable sky and darken the grass using Curves – add a touch of blue for a night-lit effect. The mist here is simply painted on at low opacity using a soft-edged brush.

ha atomicfog Paul McFadden Glen BobbyJo

SHORTCUTS
MAC **WIN** **BOTH**

The point of illustration

BRIEFS FOR ILLUSTRATIONS come in three basic varieties. There are art editors who will send you the copy for the article in question, and wait for you to come up with a visual idea to accompany it. There are art editors who will work out the idea on their own, get it passed by the editor, and sometimes even supply a rough sketch of what they want. And finally there are editors themselves, who will insist on the first idea that pops into their heads and expect it to be turned into a work of art.

I have nothing against newspaper editors. Many of them are charming individuals who are great conversationalists and probably make outstanding contributions to society. But they frequently lack the ability to think in visual terms. One of the illustrations I'm frequently asked to create is a montage showing a politician taking money out of someone's pocket (this usually happens around budget time). I pause, take a deep breath and explain patiently that the problem is that newsprint technology has yet to embrace animation. There's no difference, in a still image, between a politician taking money out of someone's pocket and putting money into it. This has to be explained with great tact, of course, since ultimately these are the people who pay for my children's designer footwear.

It comes down to a question of what's desirable, what's visually interesting and what's humanly possible. The purpose of an illustration in a magazine or newspaper is to draw the reader into the piece and to make them want to read the article to which it's attached. It should express the sense of the article without giving away the punchline, and without prejudging the issue (that's best left to the journalist who wrote the story). An illustration in a printed publication is not a work of art; it's an advertisement for the story, and its job is to sell the story to the reader. Sometimes – at the best of times – it can be a work overflowing with artistic integrity and perfect composition. But if it doesn't relate to the story in question (and make that story seem interesting) then it's failed to do its job.

Those taking up photomontage for the first time frequently fall into the trap of piling on evocative imagery in the hope that the result will be poignant. I've

seen student artwork that incorporates a baby, a flaming pile of dollar bills, a nuclear explosion and a McDonald's wrapper within one image. Look, they say, all human life is here: it must mean something. But this is the visual equivalent of Tchaikovsky's 1812 overture with added reverb and a drum'n'bass backing: the cacophony simply prevents us from seeing the meaning.

Labeling, above all, is to be avoided at all costs. The days when you could depict Uncle Sam wearing a hat with Government printed on it rowing a boat labeled Economy while tipping out a handful of urchins labeled Unemployed rightfully died out in the early 19th Century – and yet illustrators are still asked to label their artwork today. I nearly always refuse, unless the wording can be incorporated into the image in a meaningful way. The destruction of a building bearing the sign Internet Hotel seems, to me, to be a reasonable request; the sinking of a boat labeled Fair Deal does not.

When you execute an original idea successfully, you can confidently expect to be asked to reproduce it within a few months. I've drawn cakes for the 20th birthday of Channel 4, the 10th birthday of Sky television, the carving up of Channel 4, the first birthday of satellite channel E4, and the 50th birthday of ITV – all for the same newspaper. I've blown up computers, telephones, televisions and video recorders, and I've tattered the flags of at least half a dozen of the world's top blue-chip companies. And I've completely lost count of the number of company logos I've pasted onto the backs of poker cards.

The hard part is keeping each new version as fresh as the first. I've often made the mistake of assuming that readers will find the repetition of the same idea tedious: but it is a folly, for the stark truth is that readers of publications cast barely a glance at the image that an illustrator has sweated blood over. Illustration, for the most part, is simply the ephemeral wrapping that's discarded once it's done its job of selling what's inside.

11
Paper and fabric

IN THE PREVIOUS CHAPTER we looked at substances whose common factor was that they were hard. Here, we'll see how to work with textures that have precisely the opposite characteristics.

Paper and fabric both distort. They can be crumpled, folded, torn, twisted, rippled, and put through as many different types of transformations as you can imagine. To show a sheet of newspaper as a purely flat surface may display the design, but it does nothing to get across the essence of the newspaper itself: its pliability, its tendency to tear, the difficulty of keeping it straight.

It's not difficult to crumple a sheet of paper, or to wave a flag, or even to curl a banknote so it looks like it's flying through the air. But when we do so, we bring an added realism to drawn or scanned artwork, making it appear that little bit more like the real thing.

How to make a load of money

1 This 50 Euro banknote is a flat, scanned object. These days, Photoshop prevents us from scanning banknotes: even if we take a photograph of one with a digital camera and then try to import it, Photoshop will prevent us from opening the image. Fraud is harder than it used to be!

THE ILLUSTRATION ABOVE, FOR THE *Sunday Telegraph*, is a simple enough concept – a couple navigating a sea of debt. If I'd had to draw each of those bills individually, I'd probably still be drawing them now.

We can use Photoshop's Image Warp tool to take a single flat piece of artwork and distort it so it appears to be a real, three-dimensional object, and create multiple views of the same item to create a lot of variation.

In early editions of this book I described how to do this using the Shear filter, which is how we used to have to work before Photoshop CS3 brought us Image Warp. It's altogether a much better way to get the results we need.

4 We can drag the handle up as well as down, to create a note that waves in the opposite direction – a quick way of building an instant, different view of the object.

7 With the basic distortion added, we can now choose to view our banknote from any perspective. Simply using Free Transform to squeeze it vertically and rotate it a little gives us a much flatter view of the note.

2 To make the note look more three-dimensional, use ⌘ T ctrl T to enter Free Transform, then press the Image Warp button on the Options bar. From the pop-up menu, select Flag as the warp preset.

3 The default distortion is far too strong. We can modify the amount by grabbing the only control handle for this warp method, and dragging it down until we get a more realistic view of the note.

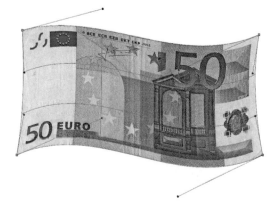

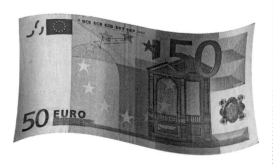

5 The sides look too straight and unnatural with just the Flag distortion. Change the method from Flag to Custom, again using the pop-up menu, and we can grab the corners and handles and apply a more natural distortion.

6 Hit *Enter* to apply the distortion. Adding shading using the Burn tool, set to Highlights, instantly makes the distorted note look much more like a real object. Add shading to the valleys, rather than the hills, for added realism.

8 We can easily distort that single note further, simply using Free Transform. If you're building a pile of notes, adding shadows to all but the topmost note using the Burn tool will make them look much more real.

9 Although we can distort the note to a very high degree, the one thing we can't do is to flip it horizontally or vertically. This is exactly the sort of error that will get noticed – try not to fall into the trap!

SHORTCUTS
MAC WIN BOTH

Judging a book by its cover

IF YOU WANT YOUR BOOK COVERS TO look old and tattered, as in the illustration for the *Independent*, above, then your best bet is to take an old paperback and photograph it. For this image, I ripped off the cover, leaving just the blank flyleaf: that way, I was able to place my new cover on top while allowing the creasing of the flyleaf to add texture to it.

Clean, pristine hardback books, on the other hand, are hard objects to photograph. Apart from the problem of getting the right angle, the close trimming of the paper makes it look like a solid block rather than individual pages: old, slightly worn books work very much better.

In previous editions of this book we looked at how to create the whole book from scratch for a cleaner, newer look. You'll find that version of the tutorial on the DVD.

1 Begin by photographing your book. Sadly, books aren't printed with blank covers, which would be convenient. But there's a simple solution: take the jacket off a hardback book, and turn it inside out. Put it back on the book, and you have a perfect white cover to photograph.

4 Place the new Smart Object cover above the cover we made in step 2, and use ⌘ ⌥ G *ctrl alt G* to use this as a clipping mask. Use Free Transform to distort the new cover to fit this shape: make the cover slightly larger, so it overlaps the photographed cover by a little way.

2 Isolate the cover from the rest of the book, and make a new layer from it. We'll need this to fit our drawn cover onto later, and we'll also need a copy of it to add some texture to the cover.

3 Create your cover head-on, to the right proportions. When you've finished, select all the cover layers and choose Convert to Smart Object from the pop-up menu in the Layers panel (there's more about Smart Objects on page 400). Now we can work with it as if it were a single layer.

HOT TIP

If you have a version of Photoshop prior to CS4, you'll find that Free Transform won't allow you to distort the Smart Object in step 4. If you're working with Photoshop prior to version CS2, you won't have Smart Objects at all. The solution in both cases is to make a new group from your cover elements, then duplicate the group (so you'll still have the original if you need it), merge the layers and then work with the cover as a single flattened layer.

5 Make a copy of the duplicated, photographed cover, and place it on top. Set the mode to Hard Light, and Desaturate using ⌘ Shift U / ctrl Shift U: use Curves to adjust the brightness so it adds some texture to our new cover without swamping it completely.

6 Select the visible portion of the jacket that fits around the back cover of the book, and make a new layer from it. This step's optional, but can look impressive: copying background elements from the drawn cover onto here makes it look like a convincing wraparound.

SHORTCUTS
MAC **WIN** **BOTH**

Paper: folding and crumpling

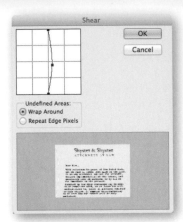

W HEN ART EDITORS are stuck for a visual idea, they fall back on a piece of paper with the concept written on it. An executive might hold a paper entitled Restructuring Proposal; a real estate agent might wield one with the word Contract emblazoned on it in red ink.

Whatever the wording on the paper, the last thing you want to do is to leave it as a flat sheet. Simply distorting it into perspective is rarely sufficient: this is paper, after all, and not a sheet of plastic; it bends, creases and deforms as it's handled.

Here, we'll look at a couple of different paper treatments: a simple fold, and the crumpled effect seen on a piece of paper that's been stuffed in a back pocket for too long.

1 Here's the business letter we'll use in both our examples. If you're going to use a letter, you'll obviously need some text on it. It doesn't usually matter what this is, as long as it doesn't begin Lorem Ipsum: readers may not recognize the fake Latin text, but the person who commissioned you will.

2 Select just the top half of the letter and apply Filter > Distort > Shear. Click just below the midpoint, and drag to the right to bend the paper. When working on the top half of the paper, be sure not to move the anchor point at the bottom of the dialog box or the two halves will no longer match up.

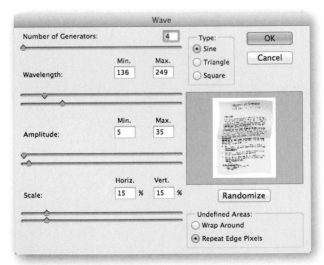

6 To begin the Crumple effect, we'll use the Wave filter to distort the basic letter. This can be a confusing filter at first glance, because there appear to be so many variables: but it's quite controllable. The number of Generators determines the different number of waves; set to 1, the effect will be too regular and phoney. Because we

want long, sweeping curves, raise the Wavelength levels: the higher the levels, the greater the length of each wave. You can use the Amplitude sliders to determine the wave height, but you'll get far more control by simply lowering the horizontal and vertical scale to make the wave effect less extreme.

3 After applying the filter, leave the top half of the paper selected and use the Burn tool with a large, soft-edged brush to add gentle shading above the crease line. Add a little more where the paper turns away at the top to give the impression of it bending over away from us.

4 Now select the bottom half of the paper, and apply the Shear filter again. You'll need to click the Defaults button to reset the tool to a vertical line; you can then add whatever distortions you want.

5 Now, with the bottom half distorted as well, add some shading to that half of the paper, again without deselecting it. You can also add a little shading elsewhere on the paper to give the sense of a gentle ripple.

HOT TIP

Although real paper tends to be white, you'll have a hard time working on it if you leave it pure white. Lower the white point of your paper using Curves or Levels to just take the edge off the brightness, and you'll find it far easier to see what you're doing. You can always paint highlights back in later if you need to.

It would have been possible to perform these distortions using Image Warp instead. But Shear is actually easier for this kind of bend; Image Warp can sometimes be just too powerful.

7 Now use the Lasso tool to make irregular vertical selections. Don't make the lines dead straight: hold the `⌥` `alt` key and click points at intervals along the letter to make the tool draw straight selection lines between each point you click.

8 Now use a large, soft brush with the Burn tool to add the shading. Keep the brush on the deselected side of the selection line, so that only the edge of the brush has an effect on the paper. Don't paint exactly along the lines, but fade off away from the edges for an altogether more realistic appearance.

9 Now deselect, and use the Lasso tool once more to make a series of horizontal selections. Use the Burn tool once more to add the new shading within the selected area, once again being careful not to overdo the effect.

SHORTCUTS

MAC WIN BOTH

Folds and wrinkles

F ABRIC NEVER HANGS STRAIGHT. IT'S the folds, creases and wrinkles that give it its distinctive quality. But it's an appearance that's surprisingly easy to reproduce in Photoshop.

Glancing at the composite image above, commissioned by the *Sunday Telegraph*, you might think that the lettering had been distorted using some complex system to make it follow the fold lines in the checkbook. In fact, the illusion of creased text and a crumpled book is created entirely by the play of light and shade across it.

Here, we'll look at how to paint folds and creases into fabric to make it look like it's hanging down, using just the Dodge and Burn tools to create the effect.

1 The lettering was created on a rectangular banner, and the text layers were merged into it. This banner can be curved slightly either using the Shear filter, or with Image Warp if you have Photoshop CS2. The version on the CD is already curved into this shape for you.

4 Now for the shading. Use the Burn tool, and choose a medium sized, soft-edged brush. Lower the opacity to between 20% and 40% so the effect isn't too strong, and paint a shallow curve running from corner to corner, dipping into the banner.

7 Hold the ⌥ *alt* key again to use the Dodge tool, and paint another highlight above that second shadow. It may take a few attempts before you're able to paint the Dodge strokes in the right way; if you make a mistake, just Undo and try it again.

2 To add the texture, use the Texturizer filter with the Canvas setting. It's a simple way to make smooth, flat artwork look more natural. Any grayscale document can be used to generate the textures used by this filter, so you can define your own easily.

3 The result of the Texturizer filter is too strong, so we'll reduce it. Rather than going through the dialog again, there's a simpler way: after applying this filter, use the Fade command (⌘ Shift F ctrl Shift F) to reduce the opacity. Here, it's been taken down to 30% of its original strength.

5 Now hold the ⌥ alt key to get the Dodge tool and paint a parallel curve directly above the one you just drew. This will brighten the artwork, where the Burn tool darkened it: used together, the effect will be of a highlight above and a shadow below the fold.

6 Using the Burn tool again, paint a second curve below the first, again running roughly from corner to corner. It helps to use a pressure-sensitive graphics tablet for a job like this, but it can be done with the mouse – just use a lower opacity and build up each shadow and highlight in stages.

HOT TIP

Using the Texturizer filter to add the canvas texture to fabric can result in a blocky, repetitive tiled pattern. If you have a digital camera, it's worth instead photographing a piece of real canvas (the back of an oil painting works well) and then simply overlay that on top of your artwork using Hard Light or Multiply mode, at a low opacity.

8 Continue in the same fashion until you've made a series of curves running right to the bottom of the banner. The flat artwork we started with now looks more like a piece of fabric that's hanging from its corners.

9 To finish off, add more folds in the corners of the banner. These won't reach right to the corners, but follow the same lines to make the edges of the banner look more realistic. Now's also a good time to strengthen those highlights and shadows that don't show up well enough.

SHORTCUTS
MAC WIN BOTH

Ripping and tearing

1 The initial poster was created using text distortion to bend the lettering; the figure was stylized using the Watercolor filter. As it stands, it's a brash image that looks nothing like a real poster.

T HE POSTERS IN THE ILLUSTRATION above, created for *.net* magazine, needed just a little distressing to make them look more realistic. Here, we'll take the process several steps further to turn this flat, artificial poster into something that looks as if it's been hanging around on the wall for a long time.

In most cases, you wouldn't want to add this much destruction to a single poster – I've gone to rather extreme lengths to illustrate the techniques involved. Often, only the smallest amount of shading is required to make a poster convincing: in the illustration above, the Internet Toasters billboard has been shaded in vertical strips to make it look as if it has been pieced together. The single turned down corner accentuates the sense of it being made from several sheets.

4 The corner is folded down by first masking the corner of the poster – a layer clipping path does the job without interfering with the layer mask. Now, on a new layer, draw the outline of the fold. Fill with a neutral color, and add a little shading with Dodge and Burn; then apply the Plastic Wrap filter to give the impression of sticky glue.

2 The first step is to create the tears. Make a layer mask for the poster layer, and make ragged selections using the Lasso tool. If you set the background color to black, you'll be able to remove chunks of poster simply by pressing *Backspace*. Because we're working on a mask, we can always undo any deletions that seem inappropriate later.

3 Simply removing pieces of poster isn't enough. We need to show the torn paper around each rip. Make a new layer, grouped with the poster layer, and paint on it using a small, hard-edged brush to trace roughly around each tear. It's important not to try to be too precise here: the rougher the painting, the more convincing the effect.

Using a layer mask to create the tears, rather than simply deleting holes from the poster, meant it was always possible to reconstitute the original at a later time. This is a key principle: try not to make irrevocable changes to your artwork unless you're sure you want them. Before adding the folds and creases in step 5, I duplicated the poster layer so I'd have an earlier version to return to if needed.

5 The folds and creases are added using Dodge and Burn, using the same technique outlined on the previous pages: first add a dark shadow using the Burn tool, then hold the ⌥ *alt* key (to temporarily access the Dodge tool) and paint above it to add the highlight. The lettering, which previously appeared flat, now looks rippled.

6 The lighting is added by making a new layer set to Hard Light mode, and filled with a neutral gray (it's an option when creating a Hard Light layer). Lighting Effects then adds both light and shade transparently through the layer. The drop shadow and the slight remains of old glue on the wall are both added as separate layers.

SHORTCUTS
MAC WIN BOTH

Simulating old photographs

1 This photograph of film director Martin Scorsese is an ideal candidate for being turned into a snapshot. But we need to make it a more photo-like shape first.

2 Delete all but a photo-shaped portion of the layer. Then select a smaller rectangle within that – our image area; inverse the selection, and fill the area outside it with light gray.

THE STACK OF photographs above was for a feature in the *Guardian* about life 20 years ago. The main image was originally in black and white, and needed recoloring.

Creating the effect of a stack of snapshots involved two processes: adding creases and wrinkles to the images, to make them look as if they'd been lying around in someone's attic for years; and adding shadows, to give the impression of a pile of curled photos.

These are two separate techniques, and they're both detailed here. First, we'll look at how to create a snapshot effect from a flat image; then we'll see how to add folds and wrinkles to make an old photograph look even older.

3 Load up the selection of the photo layer, and apply some feathering to it – around 8 pixels or so. Now make a new layer, and fill this selection with black to make the shadow.

4 Move the shadow layer beneath the photo layer, and lower its opacity to around 60%. If you're placing it on a dark background, you may want a stronger shadow.

5 Now use Image Warp (CS2 and above only) to curl the corners of the photo up slightly. Because we created the shadow based on the flat photo, it remains straight – and this is what makes this technique convincing.

6 Finally, use Dodge and Burn to add a little highlight and shadow to the frame. Because we initially filled the frame with light gray, rather than white, we can be sure it will show up against a white background.

1 This photograph of an old Western saloon looks far too crisp. We can age it by a hundred years by adding some texture on top.

2 This texture is the inside cover of an old paperback book, which has yellowed naturally with age; some of the creases are natural wear and tear, and some were added.

3 The building is made into a clipping mask with the texture layer, so that it only shows up where the two coincide. The mode is then set to Hard Light, which allows a little of the texture and color to show through.

4 Now to add some more texture. Duplicate the original texture layer and bring it to the front. Set the mode of this new texture layer to Hard Light as well, so we can see through it to the photograph beneath.

5 All we want from this second texture layer is the folds and wrinkles, and none of the color. So begin by desaturating it using ⌘ *Shift* U *ctrl* *Shift* U, which knocks all the color out of it. Now use Brightness and Contrast to boost its strength.

6 Now for the border. Hold ⌘ *ctrl* and click on the texture layer's thumbnail to load it as a selection. Contract that selection by say, 16 pixels, inverse the selection and make a new layer above the texture; fill this with white, and set its layer mode to Hard Light.

Smudge painting fabric

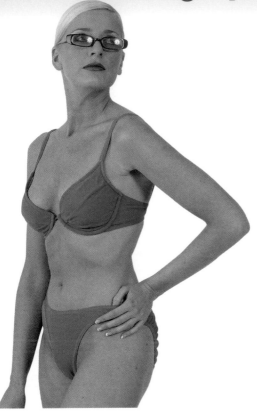

1 Draw the basic dress on a new layer. It's easiest to do this with the Pen tool, but you can always touch it up with the Brush afterwards.

2 Use the Burn tool to add shading round the edge, under the breasts and hand. Lock the Transparency so the Smudge tool doesn't go over the edge.

WE'VE LOOKED AT WAYS OF creating a fabric effect using the Dodge and Burn tools. But for more detailed work, nothing beats the Smudge tool for precise creation of folds and wrinkles.

We'll start with an image of a woman in a swimsuit, paint a dress shape on her, and then go on to build up the shading in detail until we achieve a realistic, compelling impression of a satin dress. I've included the dress shape in the version of this file on the DVD.

6 Continue to use the temporary 'Smudge Painting' technique, using both white and black. Make an extra deep fold for the thumb tip to tuck into.

7 Reduce the size of the Smudge tool, and then use it to smear intricate folds and wrinkles. It takes a while to get a decent effect: don't rush it!

THE FRIDAY CHALLENGE

Ant Snell

Nick Curtain

GKB

Ben Mills

Luis

Sophie

Artwel

tooquilos

Puffin31939

brewell

jota120

Garfield72

B Bentzen

Jimbean

joesala

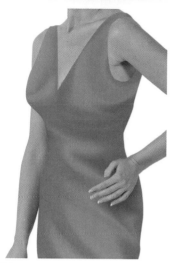

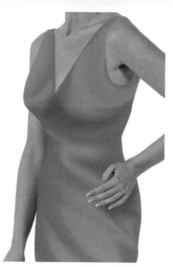

As always, it's best to work with a mid-tone gray as the base of the shading operation. That's because you don't want a color component to confuse matters at this stage: add the color afterwards, when the shading is finished.

3 Smudge the shadows into folds. Use a soft-edged brush, with a Strength of about 70% if you have a tablet, 30% if you use a mouse.

4 Set the foreground color to black, then hold ⌥ alt as you dab between the breasts to enable 'Smudge Painting', adding a blob of black.

5 Release the ⌥ alt key, and smudge the black blob to smear the shadow beneath the breasts and up the neckline, making it better defined.

Duplicate the dress layer every now and then, so you've always got a version you can return to if the Smudge operation goes horribly wrong.

SHORTCUTS
MAC WIN BOTH

8 To color the dress, use a new Adjustment Layer using either Curves or Hue/Saturation. Be careful not to choose an artificially bright color.

9 Duplicate the dress and set it to Hard Light mode for crispness. Finally, make a new layer to paint shadows on the skin for added realism.

Making custom fibers

T HE FIBERS FILTER IS A SLIGHTLY
curious one: its sole purpose is to create
natural-looking textures. In fact, it's fairly
versatile despite the fact that there are only two
controls. Here are some ideas on how to make
the most of this filter, using different settings to
generate a range of results.

1 Starting with
the basic
black outline,
above, we can
use the Fibers
filter to turn it
into a reasonably
convincing
curtain. Set the
foreground and
background
colors to red and
black, and use
a low Variance
setting combined
with a medium
Strength setting.

2 Now for
the floor.
To simulate a
woodgrain effect,
we begin by
selecting dark and
light browns as
our foreground
and background
colors. To make
the grain strong,
we now want a
high Strength
setting to increase
the contrast, with
a medium setting
for the Variance.

3 Now for the sign. This board is a flat, featureless object that looks entirely artificial. Using default black and white as our foreground and background colors, we combine a medium Variance with a very low Strength setting to get a lumpy effect.

4 Applying the filter to the sign board made the whole thing disappear beneath the strong texture. So before doing anything else, immediately press ⌘ Shift F ctrl Shift F to bring up the Fade dialog: here, we can change the mode of the filter to Color Burn for a distressed effect.

5 All we need to do to complete the picture is to set the board in perspective and add an edge to it (see the technique in Chapter 10) and place shadows both behind the board and beneath the curtain.

SHORTCUTS
MAC WIN BOTH

327

Ribbon and tape

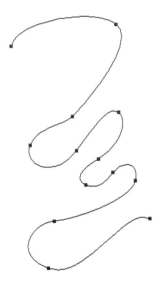

1 Begin by drawing a path using the Pen tool. Keep the curves smooth, avoiding tight turns and corners. When you've finished, save the path and duplicate it before continuing – we'll need this half of it later.

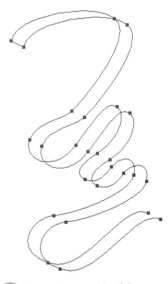

2 Now make a second path by selecting the original, and holding ⌥ *alt* as you offset it. Join the two starting points to make the two paths into one (holding ⌥ *alt* again, this time to force a corner at the join).

THE ILLUSTRATION above is part of a much larger montage for *.net* magazine about online stalkers. Dozens of photographs had to be fixed to the wall; shading on each one helped it look like it sat in place. The tape across the corner of some of the photos helped fix them to the wall in the reader's eye.

Ribbons can be used for a variety of purposes – from festooning partygoers to wrapping birthday presents. They're easier to draw than you might think; the trick is all in duplicating the Pen path.

1 We're going to fix this photograph to the wall using sticky tape. Begin by tracing the outline with the Lasso tool, holding ⌥ *alt* to draw the straight lines between the sides. Keep these sides parallel!

2 We don't need to make this tape solid, since it's made of translucent plastic. Let's fill the selected area with 50% gray. (It would also be possible to fill with solid gray, then reduce the layer opacity.)

3 Turn the path into a selection by pressing ⌘ Enter ctrl Enter . The ribbon will have some bumps where the paths crossed; these need filling by just painting across them. Dodge and Burn add some basic random shading.

4 We now need to add shading in the hollows. Activate the original path and turn it into a selection: nudge the selection down, and you'll find that the areas beneath the folds are selected ready for Dodge and Burn.

5 All that's needed now is a bit of color. The Hue/Saturation dialog, set to Colorize, is one of the best ways to add dense color to a gray image.

3 Now add a little random shading, once again using Dodge and Burn. This is only a preliminary stage before we apply the Plastic Wrap filter. I've shown the tape isolated as well at the side, for extra clarity.

4 The Plastic Wrap filter makes that shading look convincingly like reflective plastic. This useful filter is covered in more depth in Chapter 9, Shiny surfaces. Change the layer mode to Hard Light to make it transparent.

5 Now color is added using Color Balance, which I find useful for subtle color effects; a lot of yellow and a little red does the trick. Brightness and contrast are increased slightly to make the tape shinier.

INTERLUDE

Upgrade and replace

THE FIRST COMPUTER I ever bought was a Sinclair ZX Spectrum, which I purchased in 1982. It was a state-of-the-art machine, and I remember debating whether to choose the 16K version or opt for the massive 48K model. After much soul searching, I chose the 48K version: after all, I reasoned, this one was future-proof. Today, that computing power would barely run a singing greetings card.

The classified ads columns of newspapers and the listings in eBay are littered with advertisements from readers who have decided it's time to upgrade their equipment, and want to recoup the cost of their original purchase. Frequently, the prices demanded are well in excess of the aged computer's true value: often, readers will ask for more than it would cost to buy a new machine that offers twice as much power.

Their reasoning runs as follows: I bought this computer three years ago, and now it's obsolete thanks to the software developers, in league with the Devil, who have upped the requirements for their new versions so much that they won't run on my old machine. And I'm damned if I'm going to shell out that much money simply to run Photoshop CS6, so I want my money back before I commit myself to buying a new computer.

It's a fallacious argument, for several reasons. The first is that there's nothing wrong with their old computer. It will still run the software they used on it when they bought it, it will still access the internet and it will still enable them to do their job in the same way as they have for the last three years. If they want to take advantage of the tempting features the latest software versions have to offer, then they'll need compatible hardware; otherwise, they can just stick with the software they already have.

You can't blame software for needing a higher specified operating platform each time it brings new functionality: if this wasn't the case, we'd still be editing images one black and white pixel at a time on our Spectrums. The demands made by Photoshop are colossal in terms of processing power, disk access and chip speed; only the most diehard Luddite would advocate the withdrawal of new

features simply in order to ensure compatibility with antique equipment.

But the main problem I have with those who complain about the cost of upgrading is that they rarely take into account how much work their computer has done for them in the intervening period. My Mac enables me to do all my illustration work, as well as letting me do my accounts, watch DVDs and play *Call of Duty*, for a relatively tiny cost compared with the revenue I generate from it. At the end of its three-year lifespan I reckon it now owes me nothing. In return, I'll get a computer that's more than twice as fast, with a hard disk vast enough to hold the sum total of human knowledge in the 21st Century. A couple of weeks ago I bought a top-of-the-range 27-inch iMac, which cost around half what I'd paid for my now obsolete Mac Pro a few years ago.

I now consider the ownership of my computer to be more like a rental than an outright purchase. I need to top up my payments every few years, in return for which I get a pristine new piece of technology that has none of the grouchiness my old computer had acquired, and offers blistering speed in return. And I even have the opportunity to pass my old machine on to an aged relative or impecunious acquaintance – or, failing that, to convert it into a state-of-the-art fishtank. And I only resent the cost of the new one for a week or two.

12
The third dimension

The image opposite was created from the single Photoshop path on the right. The whole process took under ten minutes. Granted, it's not a work of art that's going to set the world on fire, but it does show just how far Photoshop's 3D modeling capabilities have come in the last few versions of the program. 3D modeling in Photoshop is not just an idle dream, but a very real and viable option.

The 3D capability is only provided in the Extended version of Photoshop, which means many readers of this book will miss out on this exciting new technology. But we start this chapter with a look at how to simulate the third dimension, using tools that have been present in Photoshop right from the very beginning. All it takes is a little imagination and a conviction that anything you can imagine, you can create in Photoshop.

Adding depth to flat artwork

ONE OF THE MOST common tasks the photomontage artist has to contend with is changing the viewpoint of an original photograph. Sometimes you can get away with simply rotating an object to make it fit in the scene; usually, it's a little more complicated.

The problem comes when an object has been photographed head-on, and you want to view it from an angle. Not all objects lend themselves to the kind of three-dimensional amendments shown here, but the principle used on these pages can be applied to a wide variety of source images.

1 This guitar has been photographed directly from the front, in common with many objects sourced from stock photography collections. In real life, you'd hardly ever see an object in this position: and placing it in a montage will always look flat and unconvincing.

2 The simplest way to change its perspective is to use Free Transform, holding ⌘ ⌥ *Shift* *ctrl* *alt* *Shift* while dragging one of the corner handles to get a perspective distortion. The problem is immediately clear: there's no side to this guitar.

1 This old coin has been photographed directly from above; with close-up photography, an angled view would have made it difficult to keep the entire coin in focus. But we can create any view of this object we like with just a few actions.

2 The first step is to use Free Transform to squeeze the coin vertically: if you hold ⌥ *alt* then it will squeeze towards its center. You may wish to add perspective distortion as well, but it isn't really necessary.

3 Then select the coin by holding ⌘ *ctrl* and clicking on its thumbnail in the Layers panel. Using the Move tool, hold ⌥ *alt* as you nudge this selection up one pixel at a time using the Arrow keys, and you'll create this milled edge as you go.

3 The side is best drawn with the Pen tool on a new layer, although you could also use the outline of the guitar as a starting point to get the curves correct. Here, the shape has simply been filled with a flat color to see if the perspective works.

4 A section of the guitar front is copied, duplicated and then flipped vertically to make a seamless tile. This is then used to fill the new side by clipping it with the side layer and repeating the pattern until it fills the space.

5 The key to realism lies, as ever, in the shading. The Burn tool has been set to Midtones to add the shadows – setting it to Highlights would have a more extreme effect, but would lose the warmth of the wood. Start slowly, and build up the shading.

HOT TIP

Boxy objects such as computer CPUs are easy to transform, even if photographed head-on. Simply copy a plain portion of the front of the unit, and distort it to form the side and top (if required). Adding appropriate shading means you can get away with a lot with little effort.

4 That milled edge is perhaps a little too strong. To fix it, use *Shift* ⌘ *I* *Shift* *ctrl* *I* to invert the selection and make a new layer from the edge. Preserve transparency with *I* and fill with a color picked from the coin itself.

5 Now use the Dodge and Burn tools to add highlight and shadow to this new edge, using thin vertical strokes to create the illusion of light reflecting off the edge.

6 Since this was created on a new layer, we can simply lower its opacity to allow the 'original' milled edge to show through underneath.

SHORTCUTS
MAC WIN BOTH

An open and shut case

A TRICK THAT EVERY PHOTOMONTAGE ARTIST needs to learn is how to make photographed objects do what he or she wants them to do – which means ignoring the perspective of the original image and adapting it to suit the needs of the job in hand.

The ability to open a closed door is a technique that every Photoshop professional should be able to achieve. Opening the drawer of the filing cabinet in our second example takes a keener eye, since it's important to match the rather distorted view present in the original photograph. But in Photoshop, if it looks right then it is right: you just have to trust your eye.

1 This door has been photographed closed, but opening it is simple. To begin, use the rectangular selection tool **M** to draw a rectangle that includes just the door itself, and not the frame. Cut this to a new layer using *Shift* ⌘ **J** *Shift* *ctrl* **J**.

1 The technique used to open the bottom drawer of this filing cabinet can equally well be applied to a wide range of tasks. Unlike the door, above, the drawer front doesn't hinge, so we can't use the perspective distortion in the same way.

2 Select the drawer front, and make it into a new layer using ⌘ **J** *ctrl* **J**. It needs enlarging slightly, since it will be nearer to us; and a small amount of perspective distortion is required to match the extreme angle of the original.

3 Now reload the original selection by selecting the path and pressing *Enter* (the advantage of having created a Pen path) and make a new layer for the inside of the cabinet. Fill it with a dark gray, and add shading using the Burn tool to give the sense of depth.

2 Now use Free Transform ⌘ T ctrl T to distort the door to its new position. If you hold ⌘ ⌥ Shift ctrl alt Shift while dragging a corner handle you'll get a true perspective distortion; use the center handles to make the door narrower.

3 The thickness of the door is easy to make: draw a rectangular selection that includes part of the front edge of the door (but not the handle), make a new layer from it and flip it horizontally. Drag it into place, and then just darken it up.

4 The doorknob didn't take well to its perspective distortion, but it's easy to make an elliptical selection of the knob and distort it back to its correct shape. Since the door is a separate layer, darkening the interior on the layer below is child's play.

When you use perspective distortion to open a door, you'll also need to reduce the width of the door to match: the more open it is (and the stronger the distortion), the narrower it will have to be. There's no solid rule for how to do this – just make sure it looks right.

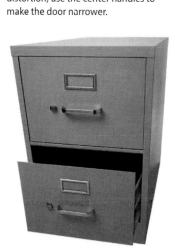
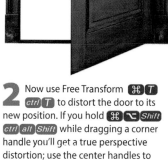
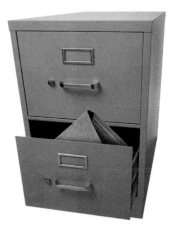

4 The drawer side is drawn on a new layer placed behind the drawer front by simply outlining it with the Lasso and filling with a mid gray. The three ribs are then drawn by selecting with the Lasso, and the areas between darkened with the Burn tool.

5 Once an object is placed in the drawer, the whole scene begins to make more sense. You need to choose objects to fill the cabinet that have a similar perspective; filling it with objects photographed head-on will look unconvincing.

6 The final stage is to add the shading – behind the folder in the drawer, and beneath the drawer itself. Make a new layer, grouped with the base cabinet layer, and paint on this using a soft-edged brush with black paint set to around 40%.

Flipping makes sense

W E'VE LOOKED IN THIS CHAPTER at ways of opening doors, drawers and other objects. Sometimes, though, we find the technique just looks wrong – and it can be hard to put our finger on exactly why.

In this example, we'll open the left-hand door of this bookcase cupboard. Unusually, we'll make it open inwards rather than outwards, to demonstrate the technique more clearly: if the logic of the situation baffles you, then you might imagine that the cupboard is a secret portal to a distant fantasy land (or just that the carpenter fitted the door the wrong way around).

1 Start by selecting the door and copying it to a new layer, exactly as we did earlier in this chapter; make a new door-shaped layer beneath it, filled with black, to represent the interior of the cupboard. Then distort the door in perspective. What's gone wrong? Why doesn't it work?

4 We need to bring that doorknob back, of course, which means copying it from the original door, pasting it on top, and then flipping it horizontally. But now the shadow will be on the wrong side of it: so erase the shadow, and paste it again behind the knob so it faces the right way.

2 Apart from the obvious issue with the door handle, the problem is the molding. In the original, we could see the left edge of the molding clearly, but the right edge was facing away from us. Now, the opposite is true. So select just the molding, flip it horizontally and distort it to fit the shape.

3 We can blend the molding into the door by making a Layer Mask for it, and painting with a small brush to create a soft transition at the edges. Then, on a new layer, we can use the Clone tool to remove the original doorknob, both the flipped and the flipped-again versions.

5 To accentuate the sense of the door disappearing into the gloom, we need to bring just a little of that gloom forwards. The easiest way to do this is to make a new layer, using the door as a Clipping Mask, and paint in black on here with a very large brush at a very low opacity.

6 Finally, don't forget those touches of detail. Because the door opens inwards, we need to be able to see the thickness of it in the edge facing us. Create this on a new layer in front of the door, painting out the top and bottom in black so there's a tiny gap parallel to the front edge.

Opening the hamper

WHEN SEARCHING FOR IMAGES, very often we'll come across a photograph that almost meets our needs. Many such pictures can be adapted to suit our purpose without much effort.

This image of a closed hamper is a good example. We want a picture of an open hamper – but this is the closest we could find. Rather than continuing to look for the perfect shot, we can make good use of the resources available. This image includes all the elements we need to open the lid; all we have to do is to rearrange the constituent parts.

1 Begin by making a layer mask to hide the hamper lid. It's worth paying a little attention to the way the rolls of bamboo appear on the upper edges: the best solution is to hide the top edge with a straight line, then paint it back in lump by lump with a hard-edged brush.

4 We can repeat the process for the remaining side of the hamper. To make the inner corner more convincing, I've used the Smudge tool here to pull out individual strands of bamboo and knit them into the corner post. It only takes a few seconds, and it's worth the effort.

2 The front side has a handle on it, which we could remove with the Clone tool: but it's easier to use the handle-free right side. Duplicate the side to a new layer, move it behind the composition, and distort using Free Transform so it fits into the space.

3 The bamboo on the upper edge of this side is pointing in the wrong direction. We could have flipped the whole side horizontally, but this would have meant losing the tidy left edge, which will make a good join. Instead, we can take a copy of the original top bar, and flip and rotate it to fit.

5 To make the lid, first disable the layer mask on the original hamper (hold *Shift* as you click on the layer thumbnail) and select the lid. Use ⌘ *J* / *ctrl J* to make a new layer from this lid, then enable the layer mask again. The lid is distorted into its new position with Free Transform.

6 The final process is to add some shading inside the hamper. ⌘ *ctrl* click on one interior side's thumbnail to load its pixels, then ⌘ *Shift* / *ctrl Shift* click on the other to add it to the selection. When you now paint the shadow, the holes will be retained. Don't forget to add a strap!

Matching existing perspective

1 This shuttered shopfront is an ideal surface on which to place our sign. Not only does it have strong perspective lines, which will allow us to place the text accurately, it also includes a good bumpy texture that will make the finished result more convincing.

I N THIS ILLUSTRATION FOR THE *Sunday Telegraph*, I aligned some of the elements with the perspective of the shutters. But the large Closed sign was placed at a deliberately skewed angle, to make it look as if it had been pasted on in a hurry. The sign still had to appear in perspective, but this was achieved by eye using Free Transform. (See Folds and Wrinkles in Chapter 11 for tips on shading the paper sign.)

In this workthrough, we'll look at how to make a shop sign that looks like it was photographed with the original shop.

4 Select Free Transform (or press ⌘ T ctrl T). Hold ⌘ ctrl and grab a corner, then hold *Shift* as well after beginning to drag to constrain the movement to vertical. Align the top and bottom handles so that they line up with the ribs on the shutter.

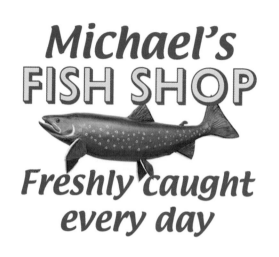

2 The sign consists of four elements: the three sets of words, and the fish. Although it would have been possible to create all the text in a single block, you get far more control over size and spacing when they're kept as separate chunks of text.

3 Select all the sign elements, and choose Convert to Smart Object from the pop-out menu on the Layers panel. This will allow the entire set to be distorted as if it were a single object – but we can still edit the text later if we need to. (See page 400 for more on Smart Objects.)

HOT TIP

In step 4, we use Free Transform to distort the Smart Object created in the previous step. If you're using Photoshop CS3 or earlier, you won't be able to drag the corner handles in this way: the best solution is to duplicate the Smart Object and turn it into a regular layer, so you can apply the transformation to it.

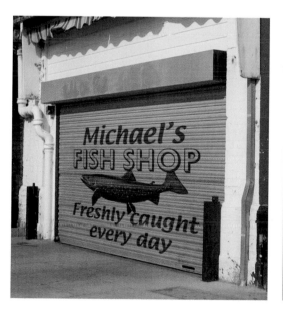

5 The previous step got the sign into perspective, but it didn't look as if it was part of the image. Changing the layer mode to Multiply (use the menu at the top of the Layers panel) allows the original texture to show through, which looks far more convincing.

6 Placing the figure in front of the sign achieves two things: first, it adds a human element to the image; and second, by obscuring a tiny part of the sign it makes the sign look far more integrated into the final image.

SHORTCUTS
MAC WIN BOTH

Building boxes

1 When preparing your flat artwork, remember that in most cases you'll be seeing the side of the box as well as the front, so you'll need to draw that as well. Keep a consistent color scheme on the side, and reuse some of the original artwork such as the Choco Flakes logo.

DRAWING BOXES IS EASY – IT'S simply a matter of distorting flat artwork using Free Transform, and adding a few finishing touches. The illustration above, for *ES Magazine*, was made slightly more complex by the fact that the box had a window in it, which meant drawing the polythene (see Chapter 9, Shiny surfaces) and giving the inside of the lid a little thickness (using the techniques described earlier in this chapter). But the principles are exactly the same as with the breakfast cereal box used to demonstrate the process on these pages.

4 Darken the side of the box to make it stand out from the front. Then add some shading to the entire artwork using the Burn tool: a small amount of shadow helps it to look more like a real object and less like distorted flat artwork.

2 Create a merged copy so that you've got all the elements in one layer – that is, one for the front and one for the side. Then simply distort the front using Free Transform, holding ⌘ Shift ⌥ ctrl Shift alt and dragging a corner handle to make the perspective.

3 Now simply repeat the process for the side layer. If you only distorted the front of the box on the left-hand side, the side layer will still be the correct height and can be distorted in the opposite direction to make the box appear three-dimensional.

HOT TIP

In step 2, we could have created a Smart Object from the box front elements, rather than merging copies of the layers. But that would prevent us adding the shading in steps 4 and 5 – although we could, of course, create a Hard Light layer on which to add the shading instead.

5 Since this box is made of cardboard, you won't get a perfectly sharp edge where it bends around the corner. Here, I've selected a couple of pixels down the left-hand edge of the side and brightened that strip up to give the impression of the cardboard bending.

6 What makes an illustration like this work are the elements that break out of the planes, such as the spout on the right. And where would any self-respecting cereal be without a plastic toy? The wrap for this was created using Plastic Wrap – see Chapter 9 for how to do this.

SHORTCUTS

MAC WIN BOTH

Displacement maps 1

WHEN A DESIGN APPEARS ON A three-dimensional surface, it needs to take on the shape and form of that surface. The most effective way to do this is by using a Displacement Map.

The approach is similar to that used for creating texture channels for the Lighting Effects filter, as seen in Chapter 10. But rather than making the maps from scratch, we're going to simulate the bumpy effect of natural surfaces by using those surfaces themselves. Like texture channels, Displacement Maps use light and dark information in the image to distort the picture. By overlaying an image distorted with a Displacement Map with the source image from that map, we can create a convincing three-dimensional effect. Let's see what happens when we combine the two images above.

1 Simply placing one layer above the other does nothing to convince the viewer of the validity of the scene. There's no interaction between the two layers, and no sense that the lettering and the fence are co-existing in the same space.

4 Select the text layer, and choose Displace from the Distort section of the Filter menu. You'll be asked for a scale: try 50 for both horizontal and vertical initially. When you press OK, you're asked for a Displacement Map: choose the one we saved in the previous step.

7 Open the Displacement Map file once more, and try some Gaussian Blur to smooth out the hard edges in the fence. The aim is to get rid of minor variations in the texture of the wood, without losing those knots and strong horizontal lines that define it.

2 One way of making the text look like it's been painted onto the fence is to set the layer mode to Hard Light, and to reduce the opacity to, say, 70%. But it's far too neat a result: we can see the fence through the text, yet we don't get the impression it's really part of it.

3 Let's make a Displacement Map from the fence. First, duplicate the fence layer, and desaturate it using ⌘ Shift U ctrl Shift U. Now copy this layer to a new grayscale document, and save it as a PSD file – this is the format Photoshop will need in the next step.

HOT TIP

Having trouble reading the Displacement Maps? Go to Edit > Preferences > File Handling and change the Maximize PSD and PSB File Compatibility setting from 'Never' to 'Always'. This will enable Photoshop to read documents with more than one layer as Displacement Maps. Thanks to forum member Rufus for this handy tip!

5 Now, the layer is distorted by that Displacement Map. Light areas distort the image up and to the right: dark areas move it down and to the left. With the layer still set to Hard Light at 70% opacity, the texture of the wood shows through the text.

6 The trouble is that the light and shade values have been taken too literally. Every slight nuance of shading is reproduced perfectly: the result is rather too ragged to be truly convincing. Undo the filter step, and we'll try again after making a few changes.

8 The amount of blur you apply depends on the image in question. Here, we've used just enough to soften the wood effect. Now save this Displacement Map, with a different name in case you want to return to the original, and run the Displace filter once again.

9 This time, the results are far more convincing. That raggedness around the edge of the lettering has gone completely, leaving a much smoother paint job; but the gaps between the wood slats now cause the text to be distorted through them, as if the lettering were really painted there.

Displacement maps 2

ISPLACEMENT MAPS CAN BE USED for placing many kinds of design onto many different surfaces. Here, we're going to apply the technique to a Union Jack flag, to produce two very different effects.

The map by itself isn't enough: it's important to decide how much of the original texture layer is shown, and in what way it should interact with the design layer. In the previous example, we set the text layer to Hard Light mode to allow the texture to be seen through it. But here, as we'll see, this isn't always the best technique when multi-colored designs are involved.

Displacement Maps can create the illusion of rough stone or smooth silk, depending on the application – and, to a large extent, the success of the project depends on the amount of Gaussian Blur used on the Map itself.

1 We'll start by mapping our flag onto this rough brick wall. The wall itself has a lot of texture in it, and will be the perfect base for accepting a design. We don't want the color of the wall to show through, though: it needs to be entirely painted over by the flag.

4 Duplicate the wall to a new document, as before, then apply Gaussian Blur once again and save it as a PSD document to be used as our Displacement Map. Once again, we need the blurring to prevent every tiny variation in shading causing fiddly distortions to the flag.

7 We're going to use exactly the same technique, but this time we'll map the flag using a photograph of some crumpled silk rather than the wall. Because this silk has a detailed texture, we need to blur it enough to hide that detail: it's only the folds that we want to retain.

2 Let's begin by changing the mode of the flag layer to Hard Light. It's not nearly as convincing as the text layer on the previous page: and however much we experiment with the opacity settings, we're never going to get the showthrough to look as we want it.

3 Instead, duplicate the brick wall layer, and desaturate it using ⌘ Shift U ctrl Shift U. Now, when we move this layer above the flag and change its mode to Hard Light, we can see a huge improvement: even without distorting the flag, the wall texture has a tremendous effect.

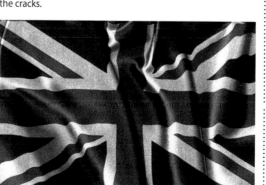

5 When we now use the Displace filter on the flag, it has a dramatic effect. Here, I've hidden the duplicated brick wall layer so we can see exactly what the filter has done to the flag. Although the distortions look random, they line up precisely with the wall.

6 Combining the displaced flag with the duplicated Hard Light brick wall layer produces this dramatic result. Look how the flag really does appear to have been painted on the wall, following the dripping mortar lines and disappearing into the cracks.

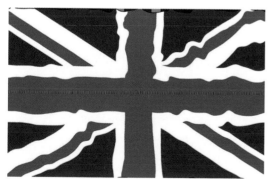

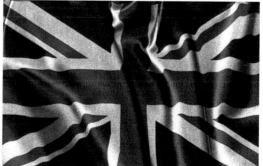

8 Here's the flag, as distorted using that piece of silk as a Displacement Map. Compared to the brick wall effect, above, the displacement is much more subtle: but this very much smoother distortion is exactly what we need to blend these two layers together.

9 And here's the result of combining that displaced flag with, once again, a copy of the silk layer set to Hard Light mode. The flag really appears to be wrinkling now, with the underlying folds in the silk producing a thoroughly convincing fabric effect.

Drawing pipes and cables

W HETHER IT'S MICROPHONE
cables, sewage pipes or chrome
cylinders, it's fairly easy to create any kind of
tubular object directly in Photoshop.

Cables are drawn using the technique of
applying a brush stroke to a Pen-drawn path: as
long as the path is visible, any of the painting
tools can be easily made to run a smooth
stroke along it.

Pipes can be created at any length. Since
the shading is applied evenly along the pipe
by holding the Shift key as you paint with
the Dodge and Burn tools, it's then easy to
stretch them to any length you want simply by
selecting half the pipe and dragging a copy
where you want it to go.

Bending pipes around curves is another
issue entirely, and the final step here shows a
simple way to achieve this effect.

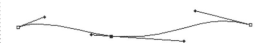

1 Drawing cables and wires is easier than you might think. Start by using the Pen tool to draw a Bézier curve that follows the line you wish the cable to take.

4 By nudging vertically and inversing the selection, only the feathered bottom half of the cable is selected. We can now use Brightness and Contrast to darken the edge.

1 Begin your pipe by drawing a simple rectangle with the Marquee tool, and filling it with a mid-tone gray (you can always add color later).

4 With the ⌥ *alt* key still held down, drag the ellipse to the other end: hold the *Shift* key after dragging to move it horizontally only.

6 With the Marquee tool selected, nudge the selection a couple of pixels to the right and fill with the same mid gray. The bright rim looks better than a hard edge.

8 Draw a new selection with the Elliptical Marquee that's smaller than the original one, and add shading to make the inside of the pipe – darker at the top and on the left.

2 Now, with the Pen path still selected, switch to the Brush tool and choose a hard-edged brush of the right diameter – here, a 9-pixel brush was used. Now hit the **Return** key, and the path will be stroked with that brush.

3 Next, load up the pixels in the cable layer by holding **⌘** **ctrl** as you click on the layer's name. Feather the selection (a 3-pixel feather used here), and, with the Marquee tool selected, nudge the selection up 3 pixels.

5 Now nudge the selection down twice as many pixels as you nudged it up (that makes 6, in this instance) and brighten up the top half in the same way.

6 After coloring the cable, it's time for the shadow. Modify your original path so that parts of the cable rise up from the floor, then stroke the path with a soft-edged brush.

When using shading techniques such as those shown here, it's always better to work with gray objects rather than colored ones: shading can affect the color as well as the luminance of an image. When the shading is exactly how you want it, you can put the color in using Color Balance, Curves or your favorite tool.

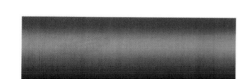

2 Using the Dodge and Burn tools set to Highlights, hold the **Shift** key to constrain the motion to horizontal, as you drag from end to end of the rectangle.

3 Now use the Elliptical Marquee tool to select an ellipse in the center of the pipe. Hold **⌥** **alt** to make a copy as you drag it to the left to form the end of the pipe.

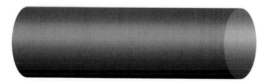

5 Now brighten up the selected end of the pipe, using Brightness and Contrast or Curves. It's brighter than we need, but this will just form the rim around the edge.

7 With the end cap still selected, add some more shading using the Burn tool. Bear the lighting position in mind: we want more shadow at the bottom right than at the top.

9 By applying a step effect using the Curves dialog, we can make this pipe look more metallic. See Chapter 10 for details on how to achieve this effect.

10 To bend the pipe into a curve, make a square selection around it and use the Polar Coordinates filter (Rectangular to Polar) to distort it. If the pipe is positioned at the top of the square selection, the result will be a very tight curve; if it's positioned in the center, you'll get a larger curve. Make sure the initial selection is square or the curve will be distorted. You can now take a section of this curved pipe to join two straight pieces together.

3D layers: getting started

A

3D LAYERS ARE ONE of the most significant features of Photoshop CS6 – but you will need to have the Extended Edition (read: more expensive) in order to use it.

3D started inauspiciously in Photoshop, with the ability to import models and rotate and scale them. Then came the ability to create 3D objects from scratch; now, Photoshop offers a sophisticated and powerful 3D modeling environment that combines greater ease of use with greater editability.

Here's a quick introduction to the processes involved in creating and manipulating a 3D object. To begin, just use the Type tool to create some regular text.

If you're using Photoshop CS4 or CS5, the method is quite different. See the Repoussé examples in the Cut Pages folder on the DVD for the techniques.

1 Create some text, and choose 3D > New 3D Extrusion from Selected Layer. In an instant, the text will be turned into a three-dimensional object. This is the default view, showing the Ground Plane and the Secondary View. You can use this to see the object from a different angle.

Using the head-up display

With Photoshop CS6, you can drag directly on an object to move and rotate it. Where you click determines what you can do; helpful text hints appear to explain what's possible in each situation.

3 Drag on any face to slide the object on a plane. Here, we can slide it back and forth along the Z axis.

4 Position the cursor over an edge to rotate around that axis. Here we're rotating around the Y axis.

Using the 3D controller

As well as dragging directly on the object, you can use the 3D Controller to manipulate it. It's often easier to do it this way, as it's always accessible.

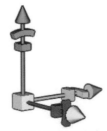

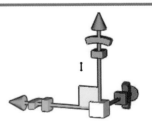

8 Drag a cone on the end of an axis indicator to move the object in that direction (it will light up yellow).

9 Drag near the center box to move an object in that plane. Again, a yellow highlight will appear.

2 If you click and drag on the background, you'll rotate the entire 3D scene. Normally, we'll want to leave the Ground Plane where it is, and just work on the model, as we'll see in the next step.

You may find the Ground Plane and the Secondary View rather distracting, in which case you can hide them using the View > Extras menu (it's worth setting up keyboard shortcuts to turn them on and off).

For most of these 3D tutorials, the Ground Plane has been hidden so you can see the model more clearly.

HOT TIP

The Properties panel (left) is the main control panel for 3D objects. Click each button at the top to change different aspects of the model.

In the first section, Mesh, you can choose whether or not your object casts shadows, and whether it receives shadows cast by other objects in the scene.

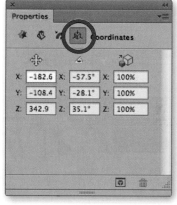

5 Drag on an edge to slide the object on a plane. Here, we're sliding it up and down on the ZX plane (the Y axis).

6 Drag *outside* the object to rotate it freely in 3D space. This rotates without constraining to any axis.

7 If you get lost, click the Coordinates button in the Properties panel, and set the positions and angles back to 0.

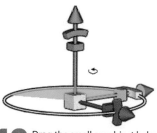

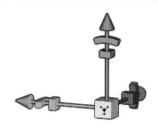

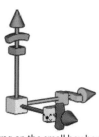

10 Drag the small arc object below the cone to rotate in that plane. A ring shows the rotation angle.

11 Drag on the center box to scale the entire model uniformly, from the center.

12 Drag on the small box beneath the rotation arc to scale the model just along that axis.

353

3D layers: reshaping

PHOTOSHOP CS5 brought us Repoussé, a way of manipulating the shape of 3D objects through a dedicated dialog.

With CS6, Repoussé has disappeared entirely. Instead, we're given a head-up display of all the controls, and work directly on the model.

For those who like entering numbers, though, the new Properties panel presents all the information at a glance.

1 Click on your object with the Move tool so that the 3D model rather than the whole scene is active (it will have a yellow box around it). Press **V**, and the head-up display appears.

In the center is a double-headed arrow icon. This is the Extrude control. Click and drag up and down on this to change the depth of the object, from front to back.

2 Move the cursor outside the Extrude control, and an outer box becomes highlighted. This is the Taper control. Drag left and right here to increase or decrease the amount of taper – the degree to which the object gets smaller or larger as it recedes away from you (in other words, along the Z axis).

If you're using Photoshop CS4 or CS5, the method is quite different. See the Repoussé examples in the Cut Pages folder on the DVD for the techniques.

5 Press **V** once more to bring up the Bevel and Inflate controls. Inflation is on the right, and it puffs up the front face of the object.

Drag on the orange Inflate icon to increase the amount of inflation; drag on the quarter-circle above and to the right of the icon to increase the angle of the inflation edge, up to a maximum 90°.

6 The icon on the left controls the Bevel. This is the chamfered edge between the sides and the face of the object.

Drag on the orange icon to increase the width of the bevel; drag on the quarter-circle above and to the left of it to change the bevel angle. Note that this will also change the height of the bevel.

3 Immediately outside the Taper control is the Bend control. This, as the name implies, curves the object away from the front edge.

Unlike Extrude and Taper, Bend has two separate dimensions: drag it left or right to bend the object in that direction, and up or down to bend it vertically. The best way of understanding how this control works is simply to try it.

4 Outside the Bend control is an outer ring. This is the Twist control, and it sets the amount to which the object twists along the Z axis. Because twisting is a rotational activity, this control is in the form of a ring: drag around this ring to increase the amount of twist. You can drag past 360°, to make the effect of a screw.

7 You can choose custom bevels by clicking on the Contour icon in the Properties Panel (with the Cap section selected at the top of the panel). A pop-up display, similar to that seen in Layer Styles, appears. You can also click on any one to adjust it manually.

HOT TIP

The Properties panel (left) contains all the numerical values for the distortions you apply. If you prefer, you can adjust the sliders, or enter numbers, in this panel. Just make sure you're in the Deform section for Extrude, Twist, Taper and Bend, and in the Cap section for Inflate and Bevel – use the icons at the top of the panel to switch between them.

SHORTCUTS
MAC WIN BOTH

355

3D layers: texture and more

WE'VE SEEN HOW we can create 3D text objects, and adjust both their position and their shape. Here, we'll look at how to change the lighting on an object – which affects the shadow as well, of course – as well as looking at applying textures.

We'll also see how the remarkable new 3D engine in Photoshop CS6 allows us to edit the text after we've created it.

If you're using Photoshop CS4 or CS5, the method is quite different. See the Repoussé examples in the Cut Pages folder on the DVD for the techniques.

1 Click the tiny Light icon near the edge of the canvas to activate the Lighting control. It appears as a shaded ball with a pin sticking out of it. The pin indicates the direction the light is coming from: drag to move it around the object, and see how the shadow moves with it.

2 You can add extra lights in the Light section of the 3D panel, and vary their intensity using the straightforward controls. If you don't want your objects to either cast shadows or receive those cast by other objects, turn off the feature using the checkbox in the Properties panel.

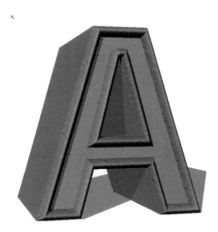

5 Here's the model with the Orange Peel texture applied just to the Bevel. You can see that the sides (the Extrusion Material) and the face (the Inflation Material) are both just the original color, and have had no texture applied yet.

6 The ability to apply textures to different parts of the object means that we can create rich, complex-looking extrusions. We can also use our own textures: double-click any of them in the Layers panel to open them in a new window, and paste your chosen texture in. When you Save the .psb window, you'll see it on your model.

3 To apply textures, first click the Materials button in the 3D panel to switch to that section. Select the part you want to apply the texture to – the diagram above shows which name relates to each part of the object.

4 Double-click each material in the 3D panel to open the Materials in the Properties panel. Click the sample to pop up a scrolling list of all that's available. You can also download more textures from the Adobe website.

7 At the bottom of the Properties panel, in the Text section (see step 2) you'll see three buttons. Clicking the Text swatch allows you to change the color of the text; click the Character Panel button to change the font, as seen above.

But you can also rewrite the text itself. Click the Edit Source button to open the text in a new .psb window, as seen on the left. When you Save this window, the text will appear on your object.

HOT TIP

At any point in the construction of your model, you can choose 3D > Render and Photoshop will take several passes to smoothe out the edges and shadows. You can interrupt the process at any stage just by clicking. If you make a selection first, Photoshop will render just that area – very useful to quickly get an idea of how the finished artwork will look.

SHORTCUTS
MAC WIN BOTH

357

3D layers: revolution

1 Start by drawing your outline on a new, empty layer. It has to be a closed path – Photoshop can't work with open paths. Choose 3D > New 3D Extrusion from Selected Path, and it will be turned into the extruded shape seen here. Make sure you have the Properties panel open.

ON THE PREVIOUS PAGES, WE looked at how to extrude text to make a basic 3D object. But extrusion is only one method of turning an outline into 3D. Here. we'll look at how to take a Pen path and revolve it as if it had been turned on a lathe.

In the previous edition of this book, I recommended painting the outline on a new layer with the Brush tool. You can still do it that way, but with Photoshop CS6 the Pen tool produces much better results – not least, because it allows you to edit the shape of the curves after you've drawn them, which gives tremendous extra flexibility.

4 We can now modify the thickness of the model. Dragging the Extrusion Depth at this point will move the outline edge further away from the Deformation Axis, making it wider.

If you're using Photoshop CS4 or CS5, the method is quite different. See the Repoussé examples in the Cut Pages folder on the DVD for the techniques.

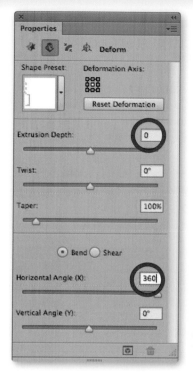

2 We want to revolve, rather than extrude. Drag the Extrusion Depth to zero, and the Horizontal Angle to the maximum 360°.

3 So far, it has revolved around the center. Click the Deformation Axis marker on the right edge to correct it.

HOT TIP

If you don't want your object to cast a shadow, uncheck the Cast Shadow box in the Mesh section of the Properties panel (this checkbox is visible in step 4).

The distortions we looked at on the previous page – Taper and Twist – can still be applied to a revolved object. But the Bevel and Inflate controls will now have no effect, since there's no longer a flat surface for them to work on.

5 If you click the Edit Source button on the Properties panel, the path will open a new window. You can change the path as much as you like; each time you Save this new document, the 3D object will be reshaped to match the drawn outline.

6 While you're working on a 3D model, it will be shown in a bounding box, as shown above. To view just the model, select a different layer or choose ⌘ H ctrl H to hide it.

SHORTCUTS
MAC WIN BOTH

3D layers: inflation

WE'VE LOOKED BRIEFLY AT HOW we can inflate the front face of an extruded object. But inflation has far more to offer than this: it's capable of turning flat photographs into true three-dimensional forms that can be manipulated and viewed from any angle. Making 3D models was never as easy as this – and the results can be staggering. We'll see how both a cutout shot of a beetle and a simple view of a donut can be turned into stunning objects.

If you're using Photoshop CS4 or CS5, the method is quite different. See the Repoussé examples in the Cut Pages folder on the DVD for the techniques.

1 You can turn the beetle photograph into a 3D object in the usual way, using 3D > New 3D Extrusion from Selected Layer.

It comes out as seen above. It helps to spin it around, as seen on the right, to see what's going on better.

5 You can now drag the Inflate button some more, to pump more air into the beetle. As you drag, you can see it taking shape.

Inflatable donuts

7 This is the donut image we're starting with. It has had no special treatment, other than to cut the background out so it's on its own layer: this is an absolutely standard photograph of a donut.

8 As before, make the donut into a 3D object, then set the Extrusion depth to 0. It doesn't need to be exact, so you can drag the button if you like.

9 Follow the same procedure as before, setting the Inflate angle to 90° and dragging the Inflate button to pump up the donut.

3 Click on the object and press **V** until the Bevel and Inflate buttons appear. Drag up on the Inflate button to blow air into the beetle.

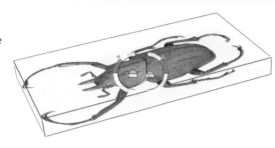

2 We first need to set the Extrusion to zero. Although we can do this by dragging on the Extrude button in the head-up display, it's hard to hit zero exactly – far easier to drag the slider in the Properties panel.

4 The Inflate angle starts off at 45°, which is too flat. Drag the arc to change this to 90°.

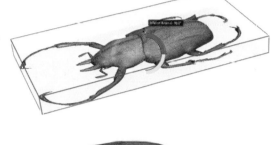

HOT TIP

Not all cutout objects can be turned into 3D models in as obliging a way as those shown here. But it's worth experimenting with all sorts of cutouts – partly to see what works and what doesn't, and partly for the sheer fun of seeing what happens when you pump air into a flat form.

6 Here's the result: a fully three-dimensional beetle, which we can spin around and place at any angle in our scene.

10 We need to inflate both sides. Open the Properties panel, and change the Sides pop-up to show Front and Back.

11 Not only does Photoshop now inflate the back side of the donut, but it does so using a mirror of the texture it used on the front. The result is that we've turned that flat photograph into a true 3D donut, which we can view from any angle. Now that really is magic.

3D layers: scene integration

ONE OF THE GREAT NEW FEATURES in Photoshop CS6 is how much easier it is to integrate a 3D model into a scene. Whether it's a model drawn directly in Photoshop, as we've done here, or a model imported from a file, we can now make our objects look as if they truly belong in the background picture.

The key to it is using the Vanishing Point filter (see page 152) to define the ground grid for the image. Here, it's easy to define a Vanishing Point grid, since the floor is made up of rectilinear tiles: all we have to do is trace round an obviously square area and then stretch the grid in all directions to fill the floor.

In the version of this file on the DVD, I've already drawn the grid for you, and created the 3D model. You can, if you like, recreate the model using the path saved within the file.

1 This oversized pepperpot started life as a simple Path outline, drawn on a new layer (left). Choosing 3D > New Extrusion from Selected Path produced a standard extrusion, which was then turned into a lathed object (see page 358).

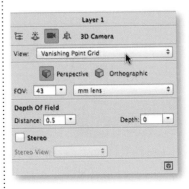

4 Now for the clever part. Click with the Move tool **V** on the grid, and click the Camera icon; choose Vanishing Point Grid as the view, and this will now be set as the Ground Plane. Choose 3D > Snap Object to Ground Plane to drop the pepperpot to the floor.

You may find the object changes size when it's dropped to the floor, in which case it will need to be resized. But since resizing takes place from the center, it will need snapping to the ground plane once again.

Once it's set up as you want it, you should hide the Ground Plane (found in View > Extras).

5 By default, objects are created with no texture. You need to **ctrl**-CLICK / RIGHT-CLICK on the object to pop up this panel, and choose the Texture icon on the top left. Choose one of the built-in textures from the pop-up list, or click the folder icon next to Diffuse and pick any texture on your hard disk.

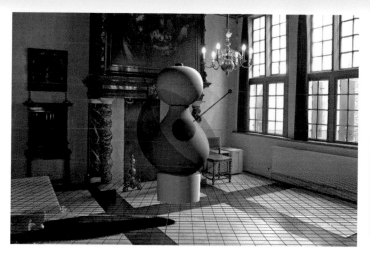

2 By default, all new 3D objects in Photoshop come with shadows. If you *Shift*-click on a shadow, it will pop up the Light controller: it's now easy to drag this so that the light comes from the direction of the window.

3 The window light on its own is a little harsh. Adding a new Point light, at a low opacity, fills in the shadows.

HOT TIP

Rendering takes time. But you don't have to do it all in one go: make any rectangular selection to perform a test render of just a small area.

6 There's more we can do to enhance the effect. In the Environment pane, lower the opacity of the shadows (100% is just too strong). The softness of the shadows is controlled in the Lights tab. We can also choose to add reflections: I've chosen an opacity of 31%, with a roughness of 12%.

7 And here's the result. The pepperpot is lit from the direction of the window, with a little light spilling onto it from the back of the room. Even at this stage, we could edit the shape of the pepperpot if we needed to.

Look at the extra element we just added. The shadow starts off crisp at the base of the pepperpot, then gets softer as it recedes with distance; the reflection, with that 12% roughness, dissipates with distance from the object.

SHORTCUTS
MAC WIN BOTH

3D layers with Vanishing Point

WE LOOKED AT VANISHING POINT earlier in this book, and we saw how it could be used to clone and paste artwork in perspective within a scene.

But there's another side to Vanishing Point, and that's its ability to create a 3D model using the grid we define. The system isn't perfect, and it certainly works best with rectangular, boxy objects: but it's fun to play around with, and could have some serious uses.

In this example we'll use this photograph of an old leather-bound book, above, and turn it into a model.

1 Use ⌘ ⌥ V / ctrl alt V to enter the Vanishing Point dialog. Begin by clicking the four corners of the front cover of the book, as this is the clearest rectangle in the photograph.

2 Click and drag on the center right handle to 'tear off' a new plane. Drag until this fills the tall cut page side of the book. You may need to adjust the corners to fit perfectly.

6 We can rotate the book by dragging with the Move Tool (CS6) or the 3D Tool (CS5 and earlier), moving it into just about any position that shows the three faces – the cover and the two cut paper sides – that were present in the original photograph. As long as we make relatively minor changes from the original viewpoint, the book will rotate smoothly and will still look like a real book.

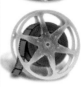

3 Tear off another plane by dragging on the top center handle of this new side, to match the top of the book. Drag until it meets the corner at the back of the book.

4 From the tiny pop-up menu at the top left of the dialog window, choose Return 3D Layer to Photoshop. Now hit OK to leave the Vanishing Point dialog.

5 The result is a new layer that looks almost exactly like the photograph of the book we started with. When we switch to the 3D Tool *K*, we can see it's really a 3D object.

Even though this book is basically a rectangular box, its irregularities still mean it doesn't make a perfect 3D model. The best images to work with are of true, squared-up boxes, such as software boxes and other packaging: try it with a photograph of a carton of washing powder, for instance, and you'll be impressed by the results.

7 When we place the book onto a background, though, we can see the first problem: because the edges of the original weren't perfectly squared-up, some of the white background has been included in the model. One way to get rid of this would be to rasterize the model after it has been rotated to the angle we want it, then select the white and delete it; or use Advanced Blending to hide the white.

8 When we turn the book around, we can see what a sham it really is. Like a stage prop, all we have is the three sides we started with: inside, it's just hollow.

Image-based lighting

PHOTOSHOP HAS made a huge leap forward in its handling of 3D objects, particularly in the key area of the final render. One of the key enhancements is the use of Image-Based Lighting (IBL), which uses an image of your choice that can tint and be reflected in the rendered model.

This 3D model of a Grumman F9F-5 Panther has been modeled by Forum regular Gordon Bain, who has generously agreed to let me include it on the DVD with this edition. We'll look at how to apply a few advanced techniques to the plane to make it come to life.

Rather than place it in the sky, I've located our plane underwater, gently settling down onto the ocean bed.

This is as close as Photoshop gets to real 3D modeling. If you find it all just too daunting, I quite understand and won't hold it against you.

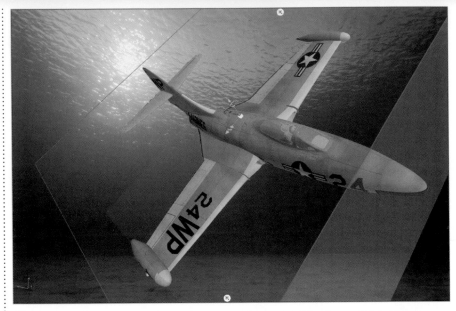

1 This file consists of two elements: the underwater background, and the plane model. As it's a 3D model, we can position our plane in any pose we like, using the 3D axis indicator and other positioning tools as described earlier in this chapter. It's probably easiest to hide the Ground Plane.

3 Double-click the Environment button at the top of the 3D panel (above the lights), to open the Properties panel. Select All and Copy the Background layer in the document. Check the IBL tickbox, and click the New icon next to it: Paste the copied background into the IBL file, and Save it. The image will now appear much darker (but this is temporary).

2 In the 3D panel, turn off one of the Infinite Lights and use the handle to turn the other so it's facing towards the sun. Double-click the light to open the Properties panel: here, check the Shadow box, so the light casts a shadow, and choose a Softness value of around 40%.

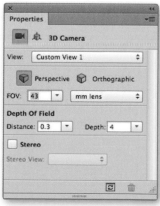

HOT TIP

If you find this rendering technique is just too much like hard work, you can always simulate the effect with an Adjustment Layer.

4 The Image-Based Lighting will tint the plane – but we need to give it some depth. Click on the Camera icon in the Properties panel, and set some Depth of Field values – I've chosen a distance of 0.3, and a depth of 4. This gives the impression of the plane fading off with distance, accentuated by the refraction of the water. Click the Render button at the bottom of the Properties panel, and go and have a cup of coffee while it renders. To make the scene more convincing, I've also applied some Gaussian Blur to the background to push it out of focus as well.

Reality overload

REALITY IS ALL VERY WELL, but it can be a little dull. Photoshop gives us the opportunity to make real life more exciting, more vivid and more dynamic. Throughout this book I've concentrated on techniques for making images look as realistic as possible; but we shouldn't let our desire for realism get in the way of a good picture.

We instinctively know when something looks plausible, and when it doesn't. We've all seen old films showing flying cars, rockets and men falling out of airplanes, and have sensed that the real thing wouldn't look that way. But how do we know what the real thing would look like? Most of us have never seen a rocket from space, or someone falling from a plane. It's likely that the 'real thing', when filmed, wouldn't look convincing either: in many cases, creating a plausible image is more important than one that adheres rigidly to the confines of reality.

Often, the way we remember an object or scene is of more importance than the prosaic reality. Let's say you wanted to draw a time bomb, to be incorporated in a montage. You could spend hours researching bomb construction on the internet, and end up with a dull, colorless device that readers would find hard to interpret. Or you could simply draw two orange sticks attached by curly wires to an analog alarm clock, and you'd have an instantly recognizable image.

Let's take a different example. You're creating a montage of the President of the United States at his desk in the Oval Office. Without suitable reference material, you must rely on your memory – and the collective memory of your readers – to make the picture work. So you assemble a large desk, a high-backed chair, and a window with flags hanging either side of it. But what of the view through the window? It's likely that, should the President turn in his swivel chair, he'll gaze out over a dull stretch of White House lawn. For the reader, though, such a scene wouldn't help to place the location. If you instead opt for a view of another government building, perhaps with a glimpse of a dark-suited man in black sunglasses with a curly wire over his ear, you'll give the reader many more clues to where your scene is located.

Cartoons, both in print and in animation, have educated us to recognize a host of artificial visual devices designed to accentuate the action. So we'll always see a puff of smoke as Road Runner suddenly takes off for the hills; and we're so used to seeing characters carry on running in mid-air as they leave a cliff top (before suddenly plunging to their doom when they realize their predicament) that we don't think twice about the logic. In printed cartoons, we've come to interpret a series of wavy lines behind a running figure as indicating speed, and straight lines emanating from a central point as a sign of explosive activity.

These metaphors have become so much part of the public consciousness that we can adapt them for use in photomontage. The result will tend towards illustration, and few readers would be fooled into thinking these were actual photographs: but, sensitively used, the cartoonist's techniques can add life to an otherwise static composition.

In real life, explosions are scenes of chaos and confusion, usually so wreathed in smoke that you can't see what's going on. In Photoshop, we can start with the elements of the destruction and add fire, smoke and sparks to illuminate the scene; we're not so concerned with recreating the effect of a real explosion as we are with communicating to the reader that an explosion is taking place. Which means dipping into the collective subconscious to retrieve the sense of exploding material we've gathered from action movies.

If what you want to do is fool your public into thinking they're looking at a real photograph, then none of these techniques will apply. But if your aim is to create an illustration that's entertaining and that tells a story, then don't let the constraints of reality get in the way.

In the next chapter we'll look at a few ways of making reality just that little bit more exciting.

13

Hyper realism

As Photoshop artists, we're often asked to produce images of situations that would be impossible to photograph – a planet exploding, a politician melting down, or, as opposite, city landmarks as they might appear years after all the people had disappeared.

We have to produce these images armed with nothing more than Photoshop and our imaginations. But in cases like this it's really not important exactly how a scene would look in real life; what matters is how well you can get the point across.

The same applies to many other forms of montage. We're telling a story, not cataloging forensic evidence, and the truth is less important than producing a compelling and intriguing image.

In this chapter we'll look at several ways of creating powerful, sometimes cartoony image effects that can add a sense of life and energy to our montages. Often, we're enhancing reality, rather than merely reproducing it. Where you use these effects is up to you.

The need for speed

THE SIMPLE MONTAGE above consists of just two elements: the car and the background. It's a pretty car on an attractive beach, so why doesn't it look better than this? Because the image is static. It has no sense of movement.

We can bring some excitement into this image by adding a little Motion Blur – along with a couple of other useful techniques, such as blurring the wheels and adding a shadow.

We'll start, though, by fixing those reflections.

1 The car was photographed surrounded by exotic buildings, all of which are reflected in the paintwork. Make a new layer, using the car as a clipping mask, and use the Clone tool to patch the buildings – it doesn't need to be perfect.

5 Move that spinning hub back on top of the wheel you copied it from, and use Free Transform once again to distort it back to its original elliptical shape. Repeat the process with the other wheel, or just copy this hub on top of it.

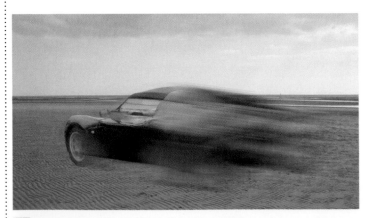

7 The great thing about applying filters to Smart Objects is that a Layer Mask is automatically attached to the filter. This means we can paint in black on it – not to hide the layer, but to hide the filter effect selectively.

2 The next step is to spin those wheels. Use the Elliptical Marquee to select one wheel hub, and copy it to a new layer.

3 Use Free Transform to stretch the hub horizontally, so that its shape is nearer circular than elliptical.

4 Load the hub as a selection by ⌘ ctrl clicking on its icon in the Layers Panel, then choose Filter > Blur > Radial Blur. Choose a Spin amount of around 40 to get the spinning effect.

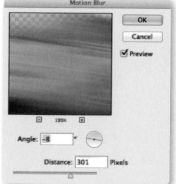

6 Select the car and both the wheel hub layers, and choose Layer > Smart Objects > Convert to Smart Object. All three layers will now appear as a single layer. Next, choose Filter > Blur > Motion Blur, and set an Angle that matches the angle of the car, and choose a Distance that you think looks good. I chose 300 pixels, or thereabouts.

8 As well as being able to paint the filter in and out on the mask, we can double-click the filter in the Layers Panel and adjust its settings. Here, I've changed the angle from -8° to -4°, and made the blur slightly shorter.

I've also added a Curves Adjustment Layer to brighten the whole image, painted a shadow layer beneath the car, and added a little blur to the background – again, after turning it into a Smart Object first.

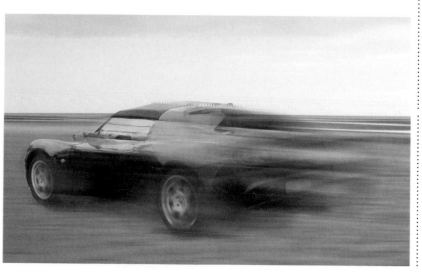

HOT TIP

The Motion Blur filter offers no preview within its dialog – instead, the blur is displayed on the whole image every time you make an adjustment. Radial Blur doesn't even offer that: you just have to take a guess and see what happens when you click the OK button.

SHORTCUTS
MAC WIN BOTH

Iris Blur: yes and no

1 Choose Filter > Blur > Iris Blur and this is what you'll see: an ellipse appears centered over your photograph. There's also a Panel, but frankly you rarely need to touch it.

P HOTOSHOP CS6 FEATURES THREE new Blur filters, found together at the top of the Filter > Blur menu. They're Field Blur, Iris Blur, and Tilt-Shift.

All three filters are designed to simulate depth-of-field effects. The Tilt-Shift technique is one that became briefly popular a couple of years ago, as it allowed landscape shots to look like model railways through innovative use of high and low blurring in the image. These days, though, it's seen as a rather hackneyed look.

The Iris Blur filter attempts to reproduce the effect of the subject of a photograph remaining sharp, while everything else is knocked out of focus. It's a good idea, but the problem is that it's limited to elliptical selections. Although the controls are well thought-out, the end result is never quite as good as it should be.

To contrast the new filter, we'll look at how to achieve a similar effect – and achieve it better – using the existing Gaussian Blur filter.

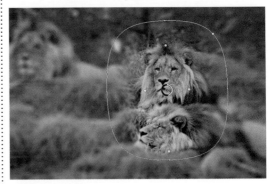

4 Dragging the four inner white dots marks the falloff between blurred and unblurred regions. You can also hold ⌥ *alt* as you drag the dots to move them independently. of each other.

Iris Blur: the manual

7 First, make the layer into a Smart Object (if it's a Background layer, you'll need to turn it into a real layer first). Choose Filter > Blur > Gaussian Blur and set as much blur as you want.

2 Drag the center dot to move the blur where you want it, and it will update in real time. You can also drag on the white/black circle in the center to set the amount of blur.

3 Dragging the handle in the upper right makes the ellipse more like a rounded rectangle: this is the only way to change the shape of the blur radius.

5 In this case, we want the lion in the upper left to be partly in focus as well. And the Iris Blur filter allows us to do this: click on the lion, and a second blur ellipse appears, which can be manipulated just like the first.

6 The problem is, lions aren't elliptical objects. Unless you work exclusively with eggs, Frisbees and hubcaps, you're going to find that however much you tweak the blur, it won't ever quite match the shape of your foreground object.

approach often produces better results

8 When you apply a filter to a Smart Object, it automatically appears with a mask built in. Painting on the mask with a soft-edged brush allows us to hide the blur effect from, in this case, the lions on the right.

9 By working with a brush set to a low opacity, we're able to customise the blur to look exactly as we want it – making it match the outline of the lions, and revealing just as much sharpness as we want. A much better solution.

HOT TIP

Although I've been somewhat dismissive of the Tilt-Shift filter, it's still fun to experiment with. Try it on any landscape shot, and see how by closing up the focus it produces a strong model effect. It won't win you any prizes for originality, but it is still an interesting and entertaining effect to play around with.

SHORTCUTS
MAC WIN BOTH

The hidden Bokeh effect

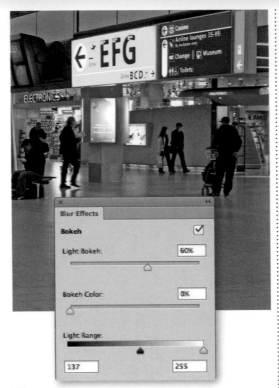

1 Duplicate the current layer, then use Filter > Blur > Field Blur, and set the Blur amount very small – about 2 pixels is all that's needed in order to get the Bokeh effect. In the Blur Effects panel, drag the Light Bokeh slider to the right until you can see a strong effect.

WE LOOKED AT THE NEW BLUR filters on the previous page, and saw how they weren't quite up to the job. But here's a different way of using them, making use of the Bokeh effect that's an option in all three filters – it's controlled by a separate panel.

In photography, the term Bokeh refers to the way lenses handle points of out-of-focus light. It's from the Japanese *boke-aji*, which means 'blur quality'.

Here, we're going to use the Field Blur filter, which simply adds an overall blur effect, and make use of the Bokeh component to produce a novel set of special effects.

4 Changing the mode of the blurred layer to Overlay is another option. This retains more crispness in the image: see how the letters EFG are much more defined than they were in the previous version.

2 The default Bokeh effect produces a strong white glow on all the brightest areas of the image, but we can make it more impressive: drag the Bokeh Color slider to the right to bring the color back into the glow.

3 The problem is that the only way we could achieve the glow was to blur everything – turn the blur off, and the glow disappears. One way to remedy the position is to change the mode of the blurred layer to Lighten: this retains some of the original sharpness beneath.

5 For a different approach, try changing the layer mode to Color Burn. This darkens the image considerably, of course, but it gives it a *Blade Runner*-like night time feel that's full of mystery and interest.

6 Fancy an instant neon effect that really is instant? Then try changing the layer mode to Difference. This produces a stark, highly stylised image that has the interesting effect of turning the lettering into outlines. Very graphic indeed.

HOT TIP

If you've settled on an effect that you want – the Difference mode, for example – then you can perform the operations in the reverse order. First duplicate the image and set the mode to Difference (everything will disappear, but don't worry about that, it's what Difference mode does).
Now run the Field Render filter, and you'll be able to see the final effect as you adjust the controls.

SHORTCUTS
MAC WIN BOTH

Cartoon distortions

WE DISCUSSED THE HUGELY POWERFUL
Image Warp feature in Chapter 2. There, we looked at
how to use it to make objects fit within a realistic environment.

Of course, realism is only one facet of this remarkable
tool's abilities; it's perhaps at its most effective when creating
distortions that take photomontage firmly into the area of
illustration. Here, we'll look at how to replicate a technique
commonly used by cartoonists to give the impression of speed
and energy.

It's a playful, frivolous approach to photomontage that won't
appeal to all users, and is certainly far removed from photo
realism. But it's fun, and the results speak for themselves.

1 Here's our starting image: a British double-decker bus
coming over the brow of a hill. The hill isn't the sort of road
you'd see in everyday life: that curve is too extreme for the
wheelbase of any real car. It's a cartoon hill, and the bus looks
too stiff in comparison. As always when using Image Warp, it's
best to convert it to a Smart Object first (see page 400).

4 Raising the handle in the previous step lifted the wheel
well, but the result is that the lower floor of the bus is too
condensed, making the whole thing look top heavy. We can
fix that by grabbing the top left center handle, in the middle
of the mesh, and dragging it upwards. The upper deck is now
more compressed than the lower, exaggerating the sense of
movement and giving the impression that we're viewing the
bus from slightly below.

5 Now let's look at the rear end, which at present is too
straight. Grab each right-hand corner handle in turn,
and drag it down and in to add some curvature to the back
of the bus, giving it a slight Spherized effect, as if it has been
photographed through a wide angle lens. This also gives the
illusion of the bus being closer to us than it really is.

2 Begin by entering Free Transform mode using *ctrl T* *⌘ T* as usual, and then press the Warp button on the Options bar to move to Image Warp. We'll start by ballooning out the front of the bus: drag both left corner handles (ringed here in yellow) so the bus distorts in the direction of travel.

3 The curved front helps to make the bus look more unreal, but we still have a way to go. Let's lift that front nearside wheel so that it raises itself off the ground a short way. Grab the handle closest to it, and drag it up to compress the area around the wheel.

HOT TIP

The difficult part of creating a cartoon distortion is, as is so often the case, knowing when to stop. You should aim for a final result that looks almost like a real photograph at first glance, but which on closer inspection proves to be impossible. Don't get too carried away: the image should look more or less plausible, as if the object we're distorting were made of rubber rather than metal.

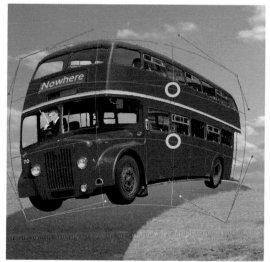

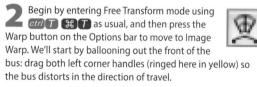

6 Time for some fine tuning on the interior. To make more of a curve on those side windows, grab the remaining two interior anchor points on the mesh and drag them up slightly, to accentuate the curve and make it match the curvature of the top and bottom of the bus. That's it for the distortion: you can now press *Enter* to leave Free Transform mode and return to the main artwork.

7 Normally, shadows beneath objects lying on the ground would be touching the object at each point of contact with the surface. But here we can take another tip from the cartoon illustrator's book: by painting in our shadow at a distance from the bus itself, we give the impression that it's leaping up in the air rather than proceeding sedately along the road – almost as if the effort of coming over the hill has sent the bus flying.

SHORTCUTS
MAC WIN BOTH

13 Hyper reality

Breaking glass

The original screen on this television has been replaced by a new layer, tinted blue and accented using the Dodge tool to make it more appealing. Since the days of black and white TV, we're used to screens looking bluish.

In the last step, we reduced the selection area to the original Lasso selection minus a thin border at the right edge. When we now exit QuickMask and delete, we're left with just the brightened edge of the glass to give some thickness to the broken edge.

BREAKING GLASS IN PHOTOSHOP HAS little to do with broken glass in real life, which tends to look dull and lifeless. We want to give the impression of serious damage, as in the illustration above for the *Independent*: the violence of the act must be more apparent than the actuality.

Here, we'll look at the process of smashing the glass on the front of a television screen: the glass will explode outwards to heighten the effect. In real life, of course, smashing a screen would cause the glass to implode inwards, to fill the vacuum inside the tube; but real life is sometimes too dull to reproduce.

On the following pages, we'll look at how to turn this broken screen into an explosion.

Nudge the selection down a couple of pixels (don't use the Move tool or you'll move the layer), and use the Brush tool set to Behind to add some thickness to the glass. There will be some awkward double spikes at the pointed ends; these can be removed using the Eraser.

2 Using the Lasso tool, select an irregular shape on the screen and brighten it up. If you hold ⌥ *alt* while clicking points on the screen you can draw straight selection lines between the points.

3 Enter QuickMask mode by pressing **Q** and select the red mask with the Magic Wand. Nudge the selection up and left a couple of pixels; then inverse the selection and delete, so only a fraction of the highlight remains.

5 On a new layer, draw individual shards of glass with the Lasso tool – simple triangles work best. Using a soft brush at around 50% opacity, paint some color from the screen into these shards, but don't fill them completely.

6 Don't deselect, but use the Dodge tool to brighten up those shards so that they look more reflective. Again, use the tool unevenly so that the pieces don't end up looking too uniform in appearance.

HOT TIP

If you don't see the broken screen highlighted in step 3, but see the inverse in red instead, it's because you've got your QuickMask settings set to default (Masked Areas). Double-click the QuickMask icon and change the settings to Selected Areas, which is easier to work with.

8 Duplicate the glass shards layer, and use Free Transform to shrink the new layer towards the centre of the screen (hold the ⌥ *alt* key as you drag a corner handle). Lower the opacity of this new layer to around 50% to give the impression of movement.

9 Make another duplicate of this layer, and reduce that in size even further – you can add a small degree of rotation as well if you wish. Reduce the opacity of this layer still further, to around 20%, to complete the explosive effect. Finally, paint a little smoke inside the screen.

Smashing things up 1

W HICH OF US HASN'T WANTED, AT some time or other, to take a sledgehammer to our computer when it freezes? Or to our television during an election broadcast? With Photoshop, it's easy to vent your anger without voiding your insurance.

The illustration above was for a *Sunday Telegraph* article about the collapse of housing prices. It's a straightforward metaphor, but added more interest than the usual shot of a row of For Sale signs.

The principles of breaking up technology apply equally well to televisions as to houses: it's a matter of making holes and then filling the gaps. Following on from the previous page, we'll look here at how to make a television explode.

1 Here's the same television we used before, placed against a black background. If you're going to use explosions and flying glass, the effect always works best against a dark background; explosions rarely show up well against white.

4 Now we can bring in the flying glass and broken screen from the previous page, rotating it to fit the new angle of the screen border. That's the basics of the television finished: all we need to do now is to add the elements that will make the destruction look more explosive.

2 Begin by selecting the front panel, then cut it to a new layer using *Shift* ⌘ *J* *Shift* *ctrl* *J* . It's now easy to distort it to a new position: although I've kept it close to the original, there's no reason why you shouldn't have it flying halfway across the room.

3 Repeat this process with the side, rotating it in the opposite direction. Add some shading with the Burn tool to give the effect of a shadow. You'll also need to draw the inside of the frame, on a new layer: simply fill the outline with a color picked from the TV, and shade it.

5 Fireworks make great explosions. This firework has been placed just in front of the rotated side, and the black background knocked out of it using the techniques described in Chapter 3. The back edge of the side was painted out on a layer mask so that the firework spilled out behind it.

6 The firework layer is duplicated to make a second explosion, and a bunch of other electronic material is added to give the impression of the guts of the TV flying out in disarray. Next time you upgrade your computer, remember to photograph the boards before throwing them away.

HOT TIP

In the introductory illustration (opposite), I had to build the interiors of the rooms visible where the brick wall had broken away. This was easily done by shading and distorting patches of wallpaper to match the existing perspective.

SHORTCUTS
MAC WIN BOTH

Smashing things up 2

ON THE PREVIOUS spread we looked at an explosion in the act of occurring, complete with sparks and flying glass. Here, we'll step forward in time to view the destruction after it's happened.

This piece of artwork for the *Sunday Telegraph* was for a story about the break-up of the telecommunications company Energis, graphically illustrated by a smashed telephone. It's a fiddly job, as each of the buttons on the handset needs to be isolated and distorted individually; but it simply takes a little patience to ensure that all the pieces fit where they belong.

Never having studied the interior of a telephone, I have no idea if they contain printed circuit boards or this sort of wiring. But this is artwork, not technical illustration; such niceties as factual accuracy need not concern us.

1 To begin with, I simply photographed a phone with the receiver off the hook. By placing it on its side, a small sense of chaos is already achieved. I chose a phone with the keypad in the receiver so that I'd have the base free on which to place the Energis logo afterwards.

4 The interiors of the base and the handset were drawn and filled with a flat color to fill the gaps where the tops had been broken off. This was simply a matter of inventing the new shapes using the Pen tool to draw the smoothly curved outlines.

7 The speaker is simply a loudspeaker from a stereo system, photographed and distorted to fit; the printed circuit board is actually a computer logic board cut to fit the interior of the phone.

8 Opposite is the finished illustration, with background and shading added. The Energis logo was taken from their website and redrawn, then distorted using the Shear tool; the shading was added using the Emboss feature in Layer Effects.

2 The first step was to separate the two halves of both the receiver and the handset, exactly as shown in the television example on the previous spread. While it would also have been possible to break the handset into shattered fragments, it adds to the sense of realism if the constituent parts remain intact. If you (or your children) have ever tried to break a telephone handset, you'll know how resilient they can be.

3 Each button was isolated using QuickMask, and then cut to a new layer using *Shift* ⌘ *J* *Shift* *ctrl* *J* . The button background was recreated, and then the buttons rearranged individually.

HOT TIP

Outlining the buttons was the trickiest part of this illustration. It would have taken too long using the Pen tool: instead, I entered QuickMask mode and used a hard-edged brush of the same diameter as the end of a button. Clicking at one end, then holding *Shift* and clicking at the other end, drew a smooth lozenge that exactly fitted the shape of each button. If you're using a graphics tablet, this method will only work if you have Pressure Sensitivity turned off.

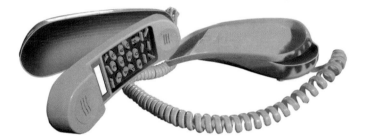

5 To make the interiors look more realistic, shading was added using the Burn tool to give a sense of depth and roundness. The horizontal ridges inside the back of the handset were added because the flat interior looked too dull without them.

6 The disk covering the mouthpiece was cut to a new layer, and both the disk and the hole given depth using the techniques described in Chapter 12.

energis

SHORTCUTS
MAC **WIN** **BOTH**

Magical realism

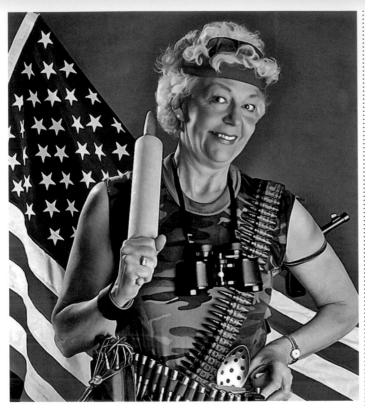

1 The initial image is of critical importance, of course. This montage has been put together from four images, to produce a somewhat cheesy Norman Rockwell scene that wouldn't be out of place in a 1940s magazine. But it suits our purpose perfectly. To begin, make a merged copy of all the layers in the document so we can work on them as one.

OCCASIONALLY WE'LL SEE AN image in a magazine or on a website that's clearly a photograph, but which appears larger than life. The colors are stronger, the detail is smoother, the whole thing appears to be a photograph created by a painter.

After the fifth edition of the book was officially finished, I had a request from a member of the Reader Forum asking how to achieve the technique. It wasn't something I'd looked at before, but I found I couldn't let it go – the results were just too intriguing to ignore.

The results of my experimentation are shown here. Feel free to modify any of these steps, or to add new ones of your own, to suit your own images.

4 Now for our old favorite, the Hard Light layer. Duplicate the existing layer, and desaturate using ⌘ Shift U ctrl Shift U (left). As it stands, the image is too strong; so open the Shadows/Highlights adjustment, and set both Shadow and Highlight values to 100% (right).

2 The first task is to use Filters > Stylize > Diffuse. Rather than using any of the standard settings, choose the Anisotropic option right at the bottom. This produces a soft, stylized version of the image, that's very smoothed out: all the fine detail has been removed here.

3 To crisp up the image, turn to the Unsharp Mask filter. Use a high setting for this one: I used an amount of 200% with a radius of 2 pixels, but with a Threshold value of 10 to prevent the image from becoming too over-sharpened. We can see how this has livened up the image.

HOT TIP

If you're using a version of Photoshop prior to CS4, you won't have the Vibrance adjustment mentioned in the final step. Instead, you can use a Hue/Saturation adjustment layer to boost the saturation. The result won't be quite as effective, but it will be a very close alternative.

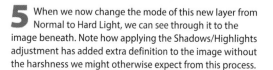

5 When we now change the mode of this new layer from Normal to Hard Light, we can see through it to the image beneath. Note how applying the Shadows/Highlights adjustment has added extra definition to the image without the harshness we might otherwise expect from this process.

6 Finally, add a Vibrance adjustment layer, setting the Vibrance value to 100%. This brings a richer color to the whole image. Note how stylized the final result is: that tree looks hand painted, and the boy and the cow have an almost tactile quality.

SHORTCUTS
MAC WIN BOTH

Zombie pensioners from hell

1 Here's our starting image: the head is a cheerful enough chap, placed on a raincoat body. The key thing here was the angle of the head, which let me see the open mouth clearly – all the better for drooling with.

WHEN THE *SUNDAY TELEGRAPH* wanted to illustrate a feature on pension fraud, they immediately thought of zombie pensioners. It's not as daft as it sounds: it turns out that some unscrupulous relatives are continuing to claim pensions for long-dead members of the family, so the idea of a gruesome grandad isn't so far-fetched after all.

Whether or not you want to turn your own ageing relatives into creatures from beyond the grave, the chances are you'll want to inflict a similar scourge on someone you know, even if it's only a politician (for example).

It's not difficult to do, but it is an awful lot of fun. Here's how I turned Mr Average Gray into a grisly grotesque. The only really surprising thing is not so much that a conservative newspaper should want to inflict this sort of imagery on their readers, but that I actually get paid for doing this stuff.

5 The eye sockets and teeth are taken from a Hemera Photo-Objects image of a skull, photographed from a similar angle to the head. The rest of the skull is then painted out on a Layer Mask.

2 The first step is the basic distortion. The mouth, nose, ear and eyes are all distorted using the Liquify filter; the hair is then messed up using the Smudge tool for a more wild effect.

3 Normally, over-sharpening an image results in too much degradation of the original. Which is exactly what we want here: roll on Unsharp Mask, with the settings far too high for conventional use.

4 The grime is painted on a new layer, set to Hard Light, using the head as a clipping mask. Here, we can add both shading and coloring, using a soft brush at low opacity. Don't paint directly on the head layer!

HOT TIP

The trick to making an image like this work lies largely in selecting the right original photograph. You need an open mouth, both to distort into a leer and to place rotten teeth into. If you don't have the right image, you can try opening a mouth by splitting it into two layers (upper and lower lips) and distorting each with Mesh Warp.

6 Irregular selections of the cheek are made using the Lasso tool. These are copied to a new layer with ⌘ J ctrl J and darkened slightly; a small bevel, added with Layer Styles, makes them slightly recessed.

7 The goo inside the face slashes, and that dribbling out of the mouth and down the chin onto the coat, are painted on a new layer, shaded and textured with the Plastic Wrap filter.

8 The coat is treated in much the same way, with irregular selections darkened and shaded; more goo all round with Plastic Wrap again, and a couple of nasty-looking spiders for good measure.

Working to a brief

SOME EDITORS know exactly what they want, some know roughly what they want, and some just want the space filled by whatever I can come up with. In all cases, it's a question of reading the feature that the illustration is to accompany – if it has been written yet – or, at least, reading a synopsis of the story. The question then becomes: how do I tell this story in the most economical, effective way?

Illustrations inside a newspaper or magazine provide visual interest on the page, and it's to be hoped that readers will have the time and inclination to explore them and examine them at leisure. These images have to relate to the story, of course, but since the readers will have the illustration in front of them while they're actually *reading* the text, we can assume they have a fair idea of what the piece is about. So the image can allude to the text, pulling out ideas and references within the story and adding a twist to it.

Cover illustrations are a different matter. They're not so much works of art as advertisements for the publication. The reader won't have any idea of what

The editor's
initial sketch

My rough, showing a
different viewpoint

the story is about, save for a teasing headline, so the illustration has to grab their attention: it must be simple, it must be direct, and it must get the point across as economically as possible. There's little room for extravagant embellishment. A cover has to be taken in at a glance.

The same often goes for illustrations that open a magazine spread. They have to tempt the reader, to give them enough visual stimulus to make them want to read the article. The example below right was for a *Reader's Digest* feature on placebos – the fake pills that nonetheless have a beneficial psychological effect on the patient. The idea was a simple one: a handful of pills made of glass, so it's clear that they contain nothing of medical benefit. Of course, there's no reason why the illustration can't be beautiful as well as informative, especially when the idea (this one came from the art editor) is as clean and impressive as this. The best illustrations are usually those that start with the simplest ideas.

Often, an editor will provide a rough sketch, and equally often, that rough will need to be reinterpreted. The image below is about Swiss gold, and was a cover for the Italian news magazine *Internazionale*. Below left is the editor's original sketch: a bar of chocolate with the word 'Svizzera' (Switzerland, in Italian) written on it. I realized that the text would be unreadable upside-down, and that the image would look more dynamic with some perspective; so I produced the quick rough of my version of the image in return. Once this was accepted, I could then go on to complete the finished artwork.

The finished cover illustration

Placebos: the pills that aren't pills

How to Cheat in

PHOTOSHOP CS6

14

Advanced techniques

YOU MAY BE THE MOST TALENTED Photoshop artist in the country. You may be overflowing with creative ideas, bursting to get them into print and share them with the world. But unless you can meet a tight deadline, you have no place in the frantic design studios of today's newspaper and magazine publishers.

The techniques described in this chapter differ from the rest of the book in that they're not, by and large, designed to produce spectacular artwork. Instead, they're a collection of tips for long-term Photoshop users who want to sharpen their skills.

The techniques here are 'advanced' only in the sense that they'll be of little interest to beginners. It doesn't mean they're hard to achieve!

Tricks with Layer Masks

1 This photograph of Kate Middleton, Duchess of Cambridge – and the future Queen of Great Britain – was shot against a black background. Which would normally be the perfect backdrop, but for the irritating fact that she's wearing a black polka-dot dress.

2 We can use the Quick Selection tool to select the black background as well as we're able to, and then Inverse the selection. But we can see the problem: chunks of her arm and hat are missing from the selection. No matter, we can work with this as it is.

WE'VE LOOKED AT LAYER MASKS earlier in this book, and seen how to create them and how to work with them. There are times, however, when images can be too tricky for a simple masking operation. In these cases, we need to think laterally and apply a range of different techniques in order to get the results we wish.

To work with Layer Masks effectively, it helps to be able to enable and disable them with a keystroke. To do this, go to Edit > Keyboard Shortcuts. In the dialog box, choose Application Menus in the Shortcuts For field, then scroll down to Enable/Disable Layer Mask. Click in the Shortcut field and type the shortcut you want to use. I use F2 for convenience.

Then press OK, and from now on each time you press F2 your Layer Mask will be alternately enabled and then disabled, allowing you to see the whole layer.

5 When you press F2 again, the Layer Mask will be enabled once more, and you can see where you've painted. Pressing F2 toggles the Mask on and off, allowing you to see and paint areas such as the brim of the hat. The key is that you can paint on a Mask even when it's hidden.

6 Once the edge has been successfully painted in, you can reveal the Layer Mask again and paint in the gaps with a hard brush. We've now got a much smoother, crisper outine that correctly follows the contours of the body. The problem now is: what do we do about the hair?

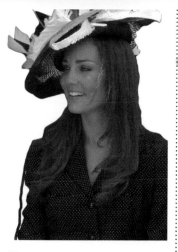

3 Open the Refine Edge dialog
(⌘ ⌥ R ctrl alt R) and view
the selection against white. It will look very fuzzy, because of the awkwardness of the selection, so raise the Smooth value to even out the kinks (I used a value of 15).

The trouble with this is that Smoothing results in a soft, feathered edge. To counter it, increase the Contrast: I used a value of 40% to tighten it up. Finally, output the result to a Layer Mask. You'll then see the rough cutout against the standard checkerboard background; I recommend adding a new, white layer behind it.

4 We have to paint the dress back in, but now there's a Layer Mask, we can't see where the edge really is. So press F2 (or whatever keystroke you defined) to disable the Layer Mask. Even though it's hidden, you can still paint on it; paint down the side of the arm on the Mask with a small, hard brush.

HOT TIP

Almost all Photoshop cutouts involve a variety of techniques, especially if they're images of people. We always have to balance wanting a crisp outline for the body with the need for a soft hair shape. By using Refine Edge twice, we can combine the two very different settings in a single mask.

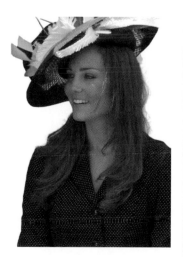

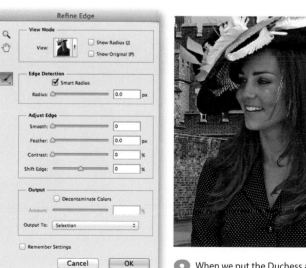

7 All the smoothing and added contrast we applied in step 3 made it impossible to select the hair with any degree of accuracy. But all is not lost: we can go back and do that now.

Load the Layer Mask as a selection by ⌘ ctrl clicking on its thumbnail in the Layers Panel, and open Refine Edge once more. Check the Smart Radius box, and drag the tool over the edge of the hair on both sides; then choose Output To Layer Mask. The Mask will be adapted to incorporate the softness of the hair.

8 When we put the Duchess against a different background, such as this royal palace, the result is wholly convincing. Here, I've added a duplicate of the Duchess layer at 50% opacity, desaturated and with a High Pass filter, to boost the contrast – see page 116 for details on how this works.

SHORTCUTS
MAC WIN BOTH

395

Front and back

SUPERMARKETS ARE BIG BUSINESS. Which means the financial pages of Sunday newspapers are full of them. Which means shopping baskets… aaargh!

Shopping baskets and shopping carts are a nightmare to work with. They're about the most fiddly object in the world to cut out, and you can't use standard erasing techniques such as the Background Eraser because there's so much white in the chrome bars. So, after years (literally) of cursing the things, I bit the bullet and spent a couple of hours laboriously cutting this basket from its background.

Then I went one step further: I separated the front two sides from the rest of the basket, and saved the result as a layered PSD file. Now, every time I need one, I can pull it straight out of the folder and fill it with groceries, supermarket managers or anything I like. And now I'm giving it to you, so you can fill it with your own groceries.

It's not just carts and baskets: plenty of other objects benefit from the front-and-back technique.

1 I use hands a lot in my work – holding pieces of paper, poles, placards, whatever. So my favorite hands are saved not as JPEG files with clipping paths, but as layered PSD files: the hand and fingers are copied to separate layers, one above the other, and linked so they both move together.

4 And so to the shopping basket. To begin, I created a new layer, filled with a strong color, behind the basket to see the cutout better. It was then a process of using the Brush tool, in QuickMask mode, to paint a line down each of the bars – click at one end, then hold **Shift** and click at the other.

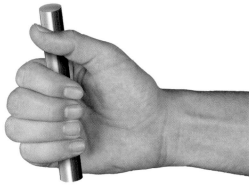

2 Now, every time I need a holding hand, I choose one from the right angle and drag it into my composition. When making this particular hand, I split the thumb and fingers into two separate layers. That way I can have it holding objects in front of or behind the thumb.

3 I can also use just the fingers by themselves to link two characters together. Here, although I photographed the man and woman at different times, I'm able to place them in the same scene by giving the impression he has his hand on her shoulder.

5 I then duplicated the basket and hid the original. Now, I made a Layer Mask and painted out everything except the front set of bars (and the front of the handles). This made the front half. The back half could remain at it was – still with the front bars present. No need to erase them.

6 Once again, the two layers were linked together and saved as a layered PSD document. Now it's an easy matter to drag whatever items I need between the two layers. Whatever I put in there looks convincingly as if it belongs in the basket – even if it's patently absurd.

Avoiding white outlines

MOST PHOTOSHOP USERS BUILD up their own libraries of images that they've photographed. If they're objects, then it makes sense to save them with a clipping path, so that they can be easily lifted from their background at a later date.

The trouble is that when objects are saved as cutout images, with no background, the act of turning a clipping path into a selection will, because of the anti-aliasing process involved, include a thin white border from outside the object within the selection.

This is not a difficult problem to deal with, and we discussed several methods of remedying the situation in Chapter 1. But wouldn't it be better if the problem didn't arise in the first place? Here's a simple solution that can save a lot of time later.

1 Here's a typical situation: a photograph of a statue in a dark corner of a museum. The statue's a fine piece of work, but all that background clutter is too distracting. It will have to go.

2 Drawing a path around fiddly objects like this is a tricky business, and it's not the sort of thing you'd want to do more than once. So we'll save the path we've drawn, to be retrieved later.

6 When we zoom in we can see a white fringe around the whole statue. This is exactly what we don't want: it makes the whole composition look ugly and unnatural.

7 The solution is to stop after the initial path is drawn. Rather than inversing and deleting straight away, turn the path into a selection and then expand that selection by one pixel.

3 Here's the standard procedure: make the path into a selection, inverse that selection and then press ⌥ Delete alt Delete to fill the outside with white. (I've assumed we're still working on the background layer.)

4 As with all cutout images, this one is saved as a JPEG to be worked on later. When we come back to it, we take that path and turn it into a selection, so that we can lift the statue from its white background.

5 This is a much better background: it makes the statue stand out, but its graphic nature doesn't detract from the image. When we look closely, though, it doesn't look right: is the outline as clean as we'd hoped?

HOT TIP

If you're still using dialogs to turn paths into selections, you're causing yourself extra work. Instead, click on the path name in the Paths panel, then press ⌘ Enter ctrl Enter. The selection will be made for you. Better still, write a Photoshop Action to do the whole job with a keystroke.

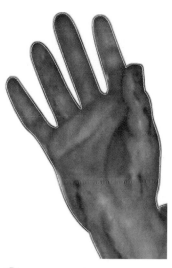

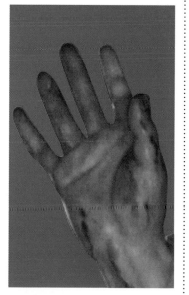

8 Here's how the expanded selection looks: there's now a fringe of background image, one pixel wide, all the way around the perimeter of the statue.

9 Now, inverse the selection and delete to fill with white as before. Note that the path itself hasn't changed – it's now one pixel inside the object perimeter.

10 The difference is that when we now make that path into a selection and place it onto a different background, there's no white edge. Problem solved!

SHORTCUTS
MAC WIN BOTH

Working with Smart Objects

1 The image we're going to use is shown on the left. Here, I've added two extra layers: a background that's larger than the image, to make the frame; and a brownish stained paper overlay, set to Hard Light mode, to add texture.

SMART OBJECTS ARE A RADICAL departure from the way we've treated Photoshop layers before. In the past, distorting a layer or group meant irrevocably changing it, and we could expect more degradation of the image each time we applied a further rotation or other transformation to it.

Now, we can group multiple layers together into new units that store the data for future reference (the layers are actually saved in their original state within the Photoshop file). This means that not only can we apply as many distortions as we like to layers without losing their integrity, we can also change the original Smart Object and then have that change reflected in each instance of it on the page.

Each Smart Object can contain many layers, although it appears to be just a single layer in the Layers panel. You can distort, transform, apply filters and scale a Smart Object as much as you like without ever damaging the original. The only thing you can't do is paint directly on it: to edit the contents, double-click it and it will open in a new window with all the layers intact.

Here, we'll look at how to put this innovative technology to work for us.

4 To make the shadow, first make a new layer behind the Smart Object. Hold ⌥ *alt* as you click the four corners with the Lasso tool, then fill with black. This is the trick to creating shadows of curled objects: if the shadow itself is straight-edged, it accentuates the curling even more.

7 The best thing about applying Smart Filters is that, like Adjustment Layers, they come with a Layer Mask attached. This means we can paint out the effect where we don't want it: so the center of the image can remain crisp, while only the front and rear edges are out of focus.

2 Select all three layers, and choose Layer > Smart Objects > Convert to Smart Object. This groups all the layers into, apparently, a single layer. We can now use Free Transform to apply a simple perspective distortion, holding ⌘ ctrl as we drag each corner to move it independently.

3 Without exiting Free Transform, press the Image Warp button on the Options Bar. This adds the familiar nine-segment grid overlay. By dragging the four corners up slightly, we're able to give a curling effect to the old photograph. Press Enter to apply the Free Transform operation.

HOT TIP

We can use Smart Objects throughout the Photoshop workflow. If we're distorting a layer with Image Warp or Puppet Warp, for instance, converting it to a Smart Object first will allow us to adjust the distortion at any point: selecting the distortion method will reveal the original grid, intact, just as we left it after the initial distortion.

5 Apply some Gaussian Blur to the shadow layer, and reduce its opacity so it looks more convincing. This layer isn't part of the Smart Object set, but will appear beneath it.

6 We can increase the realism by applying some Gaussian Blur to the Smart Object itself – simply choose it as normal from the Filter menu. It will behave as normal, except that it will appear in the Layers Panel as a Smart Filter, nested beneath the Smart Object layer.

We can also use Smart Objects if we're going to repeatedly scale or rotate a layer, as the original data is stored within the Smart Object.

8 This photograph of Alexander Fleming in his laboratory is the same proportions as the original photo. Double click the Smart Object and it will open as a separate .psb file; drag the Fleming photograph into it, and move it so it's aligned with the original photo.

9 All we have to do now is to press ⌘ S ctrl S to save the Smart Object file (or just close it, and hit OK when prompted to save it first). And this is the result: the original image is replaced by the new one, complete with both the distortion and the Smart Filter blur applied earlier.

SHORTCUTS
MAC WIN BOTH

Layer groups and layer comps

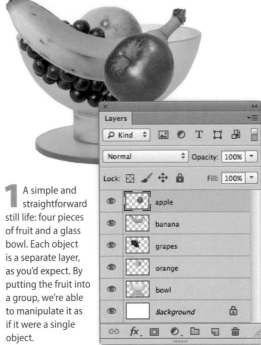

1 A simple and straightforward still life: four pieces of fruit and a glass bowl. Each object is a separate layer, as you'd expect. By putting the fruit into a group, we're able to manipulate it as if it were a single object.

WHEN WORKING WITH A LARGE number of layers, managing them becomes a tricky issue. Layer Groups help to organize multiple layers into logical folders, which makes navigation that much easier.

The illustration above, for the *Guardian*, is a complex arrangement of buildings and other objects. During its construction there were several alternatives open to me: by saving each as a different Layer Comp, I was able to switch quickly between them to see which worked better with the new image elements as they were added.

This tutorial isn't about special effects or techniques, but about better working practice.

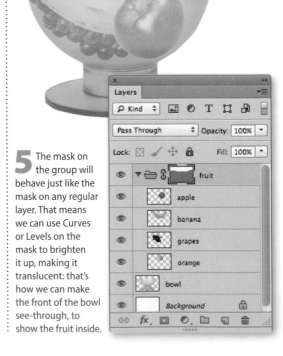

5 The mask on the group will behave just like the mask on any regular layer. That means we can use Curves or Levels on the mask to brighten it up, making it translucent: that's how we can make the front of the bowl see-through, to show the fruit inside.

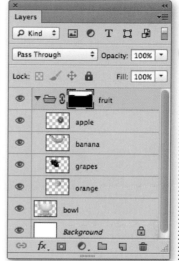

2 Select all the fruit layers – the easiest way is to select the top one, then hold **Shift** and select the bottom one. The shortcut for creating a group is **⌘ G** **ctrl G**. Initially, the group will be a closed folder.

3 Click the arrow next to the folder to pop the group open (right). Placing the layers into a group doesn't affect the appearance of the image, but it does make the composition more manageable.

4 In many ways, we can treat the group as if it were a single layer – for instance, we can add a Layer Mask to it. Here, the mask matches the shape of the front of the bowl, which hides all the fruit.

If you want to change the size or angle of a number of layers together in a large montage, it can help to make a group from them first, duplicate the group and then merge it into a single layer. Transforming this new layer will be far quicker than working on a large number of separate layers together: when you get the effect you want, you can always delete the new merged group and repeat the transformation on the group as a whole.

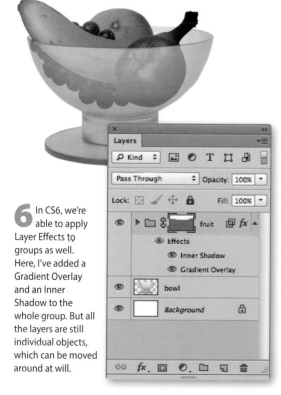

6 In CS6, we're able to apply Layer Effects to groups as well. Here, I've added a Gradient Overlay and an Inner Shadow to the whole group. But all the layers are still individual objects, which can be moved around at will.

7 Layer Comps are a way of storing a particular arrangement of layers. Click the New button at the bottom right to make a new comp, and choose whether you want to store the layers' position, visibility, layer styles, or all three. It's a very useful way to work with multiple arrangements: you can click the left and right arrows in the panel to cycle through the comps, so you can choose the one you want.

Watercolor with Filter Gallery

1 Here's our original image: Sandra Bullock, snapped at the Cannes Film Festival. I've already brightened the background so she stands out more.

PHOTOSHOP FILTERS ARE AN EASY and quick way to create a variety of special effects. But some techniques involve using multiple filters together: applying them one after the other would involve too much guesswork.

The Filter Gallery is much more than a convenient way to preview and choose filters. Its strength lies in the fact that multiple filters can be stacked on top of each other, allowing us to see the entire effect without committing to any one of them. We can adjust the sliders at any time, to vary the effect of each of the filters in the stack.

The Filter Gallery also allows us to change the order in which the filters are applied, by simply dragging them up and down in the list. This gives us tremendous flexibility, allowing us to fine-tune the final effect with ease.

Here, we'll combine multiple filters to turn a routine photograph into a watercolor effect.

4 To add a new filter to the stack, click the New Document icon below the list of filters. This will duplicate the current filter, so here's Diffuse Glow twice – clearly, a very overblown effect.

7 Because we chose Poster Edges after Diffuse Glow, it was applied on top of it. As well as changing the settings for each filter, we can also change the order in which they're applied: here, when we drag Diffuse Glow above Poster Edges, it's applied on top – for a softer result.

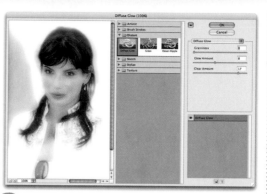

2 We'll begin by choosing Diffuse Glow from the Distort section. This adds an ethereal brightness, fading her shirt off into the background.

3 As it stands, the default settings include too much grain. We can reduce the grain amount to zero, and adjust the Glow and Clear settings until we get a vignette effect.

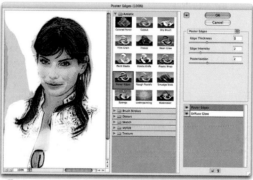

5 We can change this to any other filter in the set: let's choose Poster Edges from the Artistic section instead. These settings make her look like she has too much stubble, so we'll change the parameters.

6 By reducing the Edge Intensity and the Edge Thickness settings, we can soften the effect considerably. You don't need to get it right first time: the setting can always be adjusted later.

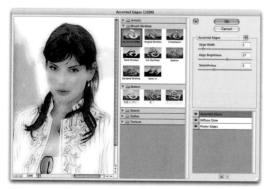

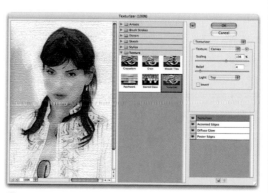

8 To smooth the image even further, we'll add a new filter - Accented Edges. This softens the skin tones, and removes all trace of the hard speckles caused by the Poster Edges filter. The image is now looking far more like it's really been painted by hand.

9 Finally, we can complete the watercolor effect by adding some texture: we'll add the Texturizer filter to the top of the filter stack, setting the scaling and relief amounts until we achieve the effect we want. All done within a single, editable filter environment!

HOT TIP

One drawback of the Filter Gallery is that it doesn't allow you to save favorite combinations of filters for later use. The best way around this is to start recording a new Action before you enter the Gallery; your settings will be preserved within the Action. If you then click to the left of the Filter Gallery item in the Action to set a 'stop' point, then running the Action will open the dialog with all the filters lined up for you.

SHORTCUTS
MAC WIN BOTH

Working with Shapes

THE SHAPES TOOL HAS undergone a major overhaul in Photoshop CS6, in that it now creates true vector layers – previously, it made color fill layers with vector clipping paths.

The difference is that we can now have open-ended strokes, and can apply colors, gradients and textures to those strokes; we can also use dotted and dashed lines.

You can no longer select the shape itself from the Options bar: this now has to be done from the tool pop-up.

Shapes layers are special layers created with the Shapes tool, and which are defined by paths. These paths can be edited with the Direct Selection tool (**A**) or with the Pen tool, holding **⌘** **ctrl** to access the Direct Selection tool temporarily.

1 A pop-up menu on the left of the Options bar sets whether you draw a Shape, a path or pixels. On the right is a typical Shape.

2 Choosing Path creates a Pen path, which can then be turned into a selection. It will be unfilled, as it isn't a Shape layer.

3 Choosing Pixels paints the selected shape directly onto the current layer. It can then be edited using the Brush or Eraser tools, but is no longer an editable shape.

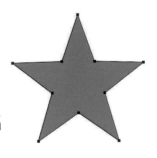
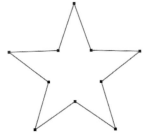

Fill and stroke

4 Both Fill (the interior of the shape) and Stroke (the border) can now have color, gradient or patterns applied to them, using the buttons at the top of the panel that pops up when you choose Fill or Stroke in the Options bar.

The leftmost icon at the top of this panel is None – especially useful when you want to apply a stroke to a shape without having it filled.

Fill and Stroke can be changed at any time, like Layer Effects, making it easy to experiment with different settings to see which works best in your artwork.

Using the Options bar

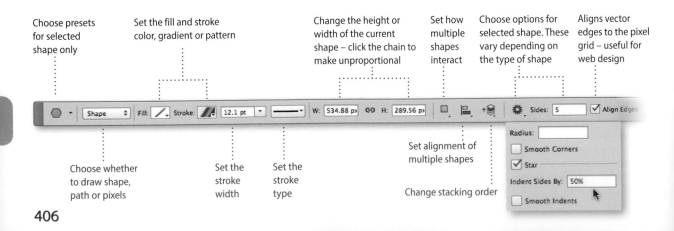

Choose presets for selected shape only

Set the fill and stroke color, gradient or pattern

Change the height or width of the current shape – click the chain to make unproportional

Set how multiple shapes interact

Choose options for selected shape. These vary depending on the type of shape

Aligns vector edges to the pixel grid – useful for web design

Choose whether to draw shape, path or pixels

Set the stroke width

Set the stroke type

Set alignment of multiple shapes

Change stacking order

5 Click the horizontal line showing the stroke type on the Options bar to pop up this dialog. Here you can choose a dotted or dashed stroke, and can set whether the stroke aligns to the inside, outside or center of the path; and whether both the ends and the corners are straight, chamfered or rounded.

HOT TIP

The useful thing about Shapes layers is that they can be scaled and reshaped (with the Pen tool) at will, without any pixel degradation. That's because they're PostScript outlines, rather than pixel-based layers, which means their fill and stroke are always based on the Pen paths.

When drawing multiple Shapes on a single layer, you can hold the standard modifier keys as used with selection tools to set whether they add to, subtract from or intersect with existing Shapes. See the movie on the DVD for more on how this works.

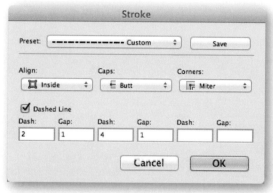

6 Click the More Options button at the bottom of the Stroke Options panel to open this dialog, which allows you to set the spacing on dashed strokes. You're allowed up to three different dashes and gaps in one stroke.

Manipulating shapes

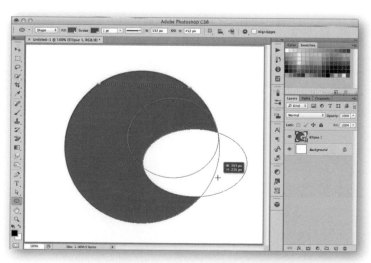

7 Any of the modifier keys you use with standard selection tools can also be used with the Shapes tool.

So hold ⌥ *alt* to subtract from an existing shape, hold *Shift* to add to the selection, and hold the Spacebar to move the selection around while you're still drawing it.

You can see how the process works in detail in the QuickTime movie on the DVD with this book.

SHORTCUTS
MAC WIN BOTH

14 Advanced techniques

Making tricky selections

1 I began this job by going into QuickMask mode (**Q**) and making a selection of one of the large coins, at the top, using the Elliptical Marquee tool, before using ⌥ *Backspace* *alt* *Backspace* to fill it with black.

SOMETIMES THE MOST SIMPLE, straightforward jobs – on the face of it – can turn out to be the most demanding. The trick is to find a shortcut, a way of completing the task with the minimum amount of pain.

The photograph above was taken for the *Guardian* newspaper. They'd asked the photographer to assemble a load of coins for placement on top of the cover elements. The trouble was, he took the instruction too seriously, and photographed the coins on an actual cover. With the inherent distortion, and the fact that the headline had not yet been written, it was clear that the coins would need to be lifted off this image and placed, in a separate layer, on a new cover.

But how to proceed with this one? Surely it wouldn't be necessary to outline every single coin with the Pen tool – that would take forever. As is often the case, five minutes' thought saved an hour's hard work.

4 There were only two sizes of coin in this image. Once all the 2p coins around the edge had been covered by the QuickMask overlay, it was a simple task to reduce the size of the selection so that it fit the 1p coins, and then drag copies to cover all edge instances of these coins.

2 Holding ⌥ *alt* to make a copy, I switched to the Move tool and dragged the filled outline to cover a new coin. This made an identical selection of a second coin, by simply copying the first.

3 It's necessary at this point to use ⌘ *Shift* *F* *ctrl* *Shift* *F* to change the mode to Multiply, to avoid white fringes where the selections overlap. Holding *alt* *ctrl*, I duplicated the selection to all the edge 2p coins.

5 With the edges complete, I selected all the interior regions with the Lasso tool, filling with black to complete the QuickMask selection. I then exited QuickMask, and made a new layer from the coins.

6 Because there was some distortion when the coins were photographed, they needed to be distorted slightly to fit on top of the imported PDF of the cover furniture. The final image was supplied as a TIFF file with transparency, so the headline could be placed behind the coins and shadow.

HOT TIP

It's most unlikely that you'll ever find yourself having to outline a load of coins. But the principle remains, whether you're trying to select a hundred golf balls from a bucket or a collection of marbles on a table. Once the first selection has been made, use that to replicate all the others.

In step 3 here, I used the Fade command to change the mode to Multiply. That's because the selection, being anti-aliased, would otherwise have included a white fringe – the 'transparent' background in QuickMask. This mode neatly avoids the problem.

SHORTCUTS
MAC WIN BOTH

Complex repair work

T HE TOWN OF GRAZ IN AUSTRIA IS A BEAUTIFUL
one, and would be all the more so were it not for the fact
that, every time you look up, your view is cluttered by a network
of tram lines. It's a tricky patching job, but taken bit by bit it
becomes less daunting.

I set this as an exercise one Friday on the *How to Cheat in
Photoshop* Reader Forum, and you can see the results below. As
you can tell, Forum members have active imaginations and are
rarely able to stick to the brief!

To illustrate the process I'll concentrate on just a part of
the image, rather than trying to show the whole thing – but the
techniques apply to the rest of the image as well.

1 The most obvious place to start is with the tramlines
themselves. We can make a new layer and use the Spot
Healing Brush, set to Content-Aware mode, to paint over them.
It's tricky painting in diagonal lines, though, so begin by using
the Pen tool to trace the middle of each thick tramline.

4 Make another new layer, and use the Clone tool to patch
over the ugly gray spotlights at the top of the walls, and
to correct any other minor errors. Use the cursor keys to nudge
each patch into its correct position.

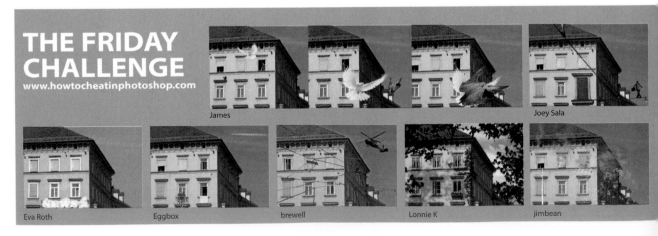

THE FRIDAY CHALLENGE
www.howtocheatinphotoshop.com

James

Joey Sala

Eva Roth

Eggbox

brewell

Lonnie K

jimbean

2 You'll remember that we can use the Brush tool, when a Pen path is selected, to paint along that path. We can do the same with the Spot Healing Brush. Select it, size it so it's just wider than the tramline and, with the path still selected, hit *Enter*. The tool will follow the path and erase the lines.

3 As ever, the Spot Healing Brush doesn't do a perfect job, but it gets us very close. Make another new layer and, using the Clone tool, clone over the errors. It can be hard to align the Clone tool precisely; by working on a new layer, it's easy to then move the patch as required.

5 That big lamp is the next beast to deal with. Make another new layer, and select it roughly with the Lasso tool. Switch to the Patch tool, choose its new Content-Aware mode, and drag to the equivalent blank piece of wall.

6 When patching the blinds, be sure not to repeat one blind exactly or the result will look false; choose different regions from each blind so they appear to be two different objects, rather than clones of the same blind.

HOT TIP

It may seem here as if we're creating far too many layers – effectively, one for each cloning operation. But this simply enables us to control the position of each patch with greater accuracy: if you're worried about the document getting too large, you can merge several layers together every now and then.

SHORTCUTS
MAC WIN BOTH

Deborah Morley Tissana Lago di Lecco Puffin 31939 J Marc P

Garfield 72 Nick Curtain GKB Stewart Scott Tooquilos

Distortion through glass

spy

spy

SKY TELEVISION IS THE SATELLITE BROADCASTER that covers the United Kingdom. For some time, its billboard advertising has featured a striking background image, with the Sky logo superimposed over it, apparently made of glass. I can't include the Sky logo in this book for copyright reasons, but I can approximate it with the word 'spy', set in a similar typeface.

This tutorial will incorporate several of the techniques we've covered earlier in the book – rounding selection corners, creating metallic text, changing layer modes, and working with displacement maps.

The good thing about this technique is that the background image can be swapped for a different one at any time: running the Displace filter again will produce the desired glassy effect. We're working with an architectural image, but we can swap it for the tiger seen below.

1 The first step is to round the corners of that logo, so it looks more like it could be made of glass – use the Refine Edge technique on page 22. Then fill the selection with 50% gray, on a new layer.

4 Make a new layer, filled with 50% gray. Load the logo layer as a selection, and use Select > Modify > Contract to shrink it. I've contracted it by 30 pixels, as I'm working on a high res image; you'll probably want to contract less.

7 Save the document with just those layers showing. Now reveal just the architecture layer, and choose Filter > Distort > Displace. When prompted for an image, navigate to the file you just saved, and use the settings shown here.

2 We can add a shiny, chrome effect to the logo using the metal technique described on page 282. Keep the middle clear, though, so avoid the Satin stage. Here's how it looks on an architectural background.

3 When we change the mode of the logo layer from Normal to Hard Light, we can see the building through it. I've brightened it very slightly, so it's lighter than 50% gray, to give it a glassier feel.

HOT TIP

The amount of displacement selected in step 7 depends on the background image. For the architecture shot, with its regular straight lines, I used a distortion of 20. But that didn't make enough of an impact with the tiger background: here, I changed the distortion amount to 50.

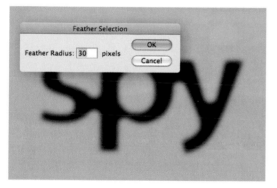

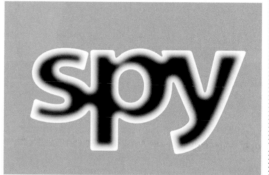

5 Now use Select > Modify > Feather to soften the selection by exactly the same pixel count used in the previous step: the feathering is now entirely inside the logo area. Make a new layer, and fill the selection with black.

6 Load the original (rounded) logo as a selection, and fill it with white on the 50% gray layer. This area outside the lettering will be seen as neutral when the background is displaced, and so won't be distorted at all.

8 This is how the background is distorted when the Displace filter is applied. When we add the logo back in, right, we can see how the distortion is applied only within the logo area – for a very glassy effect.

413

Complex strokes

1 Here's our basic lettering, with an added Emboss to give it a little more interest. This is live text, which means we can edit the wording or change the font at any point.

W E CAN USE LAYER STYLES TO add strokes to text and other objects. But what if we want more than one stroke? In the example above, for the *Sunday Telegraph* newspaper, the word 'Vitality' needed a white stroke outside the lettering, and then a blue stroke outside that. But how are we to do this, if Photoshop allows only one stroke per object?

The answer is to modify some of the other layer styles so that they behave like strokes themselves. Alternatively, as we'll see here, we can set up multi-color gradients to use as strokes – although it's harder to get a crisp result this way.

4 We can repeat this process with the Drop Shadow style, again setting the Spread value to 100, and changing the Blend Mode from Multiply to Normal. With a Size setting of 22 pixels, we can now see a third black stroke outside the red and yellow strokes.

7 We could achieve a similar effect using a Stroke alone, by setting the fill type to Gradient and the Style to Shape Burst, which bends the gradient to follow the perimeter of the layer. We can edit the gradient colors by clicking on it, and changing the colors as we like.

2 We'll start by adding a straightforward yellow outline, using the Stroke section of the Layer Styles dialog (you can access this using the 'fx' icon at the bottom of the Layers panel). In this instance I've used a 6 pixel wide stroke, set in bright yellow.

3 Move to the Outer Glow section of Layer Styles, and set the Spread value to 100 (which produces a solid 'glow'), the Blend Mode to Normal (as opposed to the default Screen) and the Opacity to 100. Change the color – I've used red – and increase the size: here, I've used a size of 14 pixels.

5 There are several ways in which we can customize the effect. For example, offsetting the Shadow position by a small amount – in this case, just 2 pixels – produces a far more three-dimensional appearance, as if the letters have some substance to them.

6 We can also use Inner Shadow and Inner Glow to add interior strokes, in the same way as we added the outer strokes. Here, though, I've left the Inner Shadow on its default setting, to produce a recessed appearance to the inner stroke.

8 The trouble with this method is that it's hard to create hard-edged strokes in this way. Gradients are designed so that the colors flow smoothly into each other, and it takes a fair amount of effort to make them behave like the hard strokes we used above.

9 One advantage of the Shape Burst stroke mode is that it follows the shape of the object, so we can create interesting outlines. Here, a black/white/black gradient has been used to make this pipeline effect, in which the pipe appears to wrap around the outside of the lettering.

HOT TIP

In step 3, we set the size of the Outer Glow to 14 pixels. This sounds huge, compared to the 6 pixel stroke we initially applied: but remember that this is measured from the edge of the lettering, so we have to subtract our initial 6 pixel value to get a true outer stroke size of 8 pixels. The same is true of the 22 pixel stroke added using the Drop Shadow style in step 4.

SHORTCUTS
MAC WIN BOTH

415

Custom brush design 1

1 The scan of a piece of ivy was the starting point here. To make it into a brush we first need to desaturate it (⌘ Shift U / ctrl Shift U) then, making sure we have a transparent background, draw a marquee selection around it. Choose Edit > Define Brush Preset to complete the task.

ALTHOUGH CREATING CUSTOM brushes might seem like the kind of job you dabble with once a year, it's not unusual to define a brush for a single specific job. For the illustration above for the *Independent*, for instance, I created this ivy brush as the only expedient way of covering the side of the house with rampant foliage.

In fact, it isn't hard to create these brushes, and once created they can be used over and over again. In this case, I've defined custom colors to go with the brush, so that I can retrieve my ivy painting kit with a single click on a panel.

5 Part of the success of this brush depends on setting the foreground and background colors correctly. The settings I used are shown above, but you may choose to vary this for a specific illustration. Also shown here is a sample of brushed ivy, using the colors we selected.

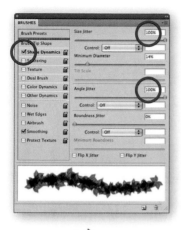

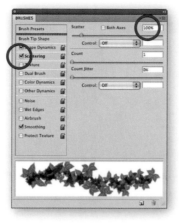

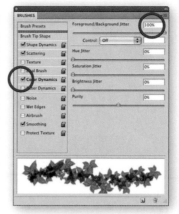

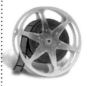

2 We need to make the brush flow. Open the Brushes panel and click on the Shape Dynamics section: set the Size and Angle jitter to 100%. I've shown a sample brushstroke above.

3 To bring some variation in, move to the Scattering pane and set a low Scatter value – enough so the ivy spreads around, but not so much that any leaves are fully detached.

4 Change to the Color Dynamics section, and set the Foreground/Background jitter to 100%. With our colors still at the default black and white, this is the result we get.

HOT TIP

Saving the brush by itself will save all the dynamics of the tip – but it won't save the colors as well. To do this, use the Tool Presets panel to create a new Brush preset based on this design: in the checkbox, tick the Include Color box, and the foreground and background colors will be stored for later retrieval.

6 When we paint the ivy onto a scene, always use a new layer – preferably, two or more. The brush can be sized using the square bracket keys, as normal; be sure to use a small size for the background, larger in the foreground. Pay special attention to the way ivy grows up surfaces.

7 Adding a Drop Shadow using Layer Styles is a simple process: here, I just accepted the default settings. But the difference it makes is tremendous: suddenly, the ivy comes to life, as the shadow lends it a three-dimensional quality that it didn't quite have before.

SHORTCUTS
MAC WIN BOTH

Custom brush design 2

THE SIMPLE MONTAGE ABOVE WAS easy to create. The letter R on a textured surface, set to Hard Light mode so we see the texture through it; a touch of Pillow Emboss, using Layer Styles, to make it appear to be an inset part of the fabric.

But it isn't complete yet. To make it more convincing, we need to add stitching all the way around. How do we do this? After several attempts at painting stitches by hand in jobs similar to this one, I realized there must be a better method.

Buried away in the Photoshop brush engine is a control that makes brushes follow the angle at which you're painting. And that's the key to making this brush stroke look like stitching.

1 Draw two circles (on a blank layer) for the stitch holes and soften with Gaussian Blur. Use a hard-edged brush to paint in a curved stitch – don't worry about accuracy or the slight stepping effect. Some shading with Dodge and Burn adds realism. Select it all with the Marquee tool, hide the background, and choose Edit > Define Brush Preset.

5 We can now reduce the size of the new brush (using the *[* key) and paint around the edge of the letter. Except it's a tricky, inaccurate process. So here's a better method: load up the letter as a selection, and choose Make Work Path from the Path panel pop-up menu.

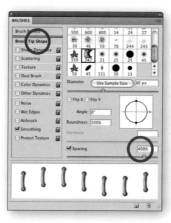

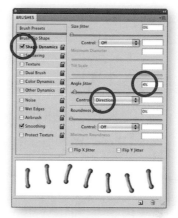

2 Open the Brushes panel, and choose the newly created brush tip. I've painted a sample stroke with this brush, above – having greatly reduced the size. At present, it's more or less a solid black line.

3 Switch to the Brush Tip Shape section, and increase the Spacing value – the default is 25%. I've used 400% for this brush; it all depends on the size and spacing of stitch that suits your design.

4 To make the brush follow the angle of the stroke, switch to the Shape Dynamics section and set the Angle Jitter control to Direction. Add around 5% Jitter for realism: this stops the strokes looking too regular.

6 With the newly created path visible, switch to the Brush tool and set the size and color you want, then press *Enter*. This strokes the active path with the current brush: note how the stitching follows the shape of the letter, with the slight inaccuracy we built in using the Jitter control.

7 For variation, try a mid-tone brown color when stroking the path, then use Curves to brighten the result. Adding a slight drop shadow using the Layer Style dialog adds an extra dimension to the image, giving it a slight lift from the surface of the material.

Natural media brushes

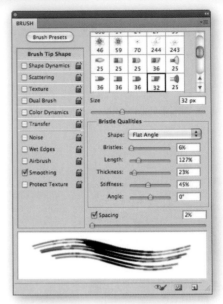

ADOBE RE-ENGINEERED THE brush engine in Photoshop CS5, producing a range of natural media brushes that simulate the experience of painting in watercolors.

This isn't Photoshop's attempt to take on Corel Painter: the brushes have none of the three-dimensional, oil paint quality of that powerful painting application. But we can use Photoshop's brushes both to create artistic work from scratch, and to modify existing images.

The ten new brushes can be used in standard mode or with the new Mixer Brush. Each comprises individual bristles that work as independent tips, producing multi-colored painting techniques previously unseen in Photoshop.

There's a lot to be said about the new brush technology: we only have space to scratch the surface here, giving an overall impression of the range of features available.

1 Ten new brush tips were introduced in Photoshop CS5, and examples are shown above left; they're shown next to the icons that appear in the Brush Presets panel. Each brush can be customized in the Brush panel, above, giving the user full control over the number of bristles, their length, thickness and stiffness.

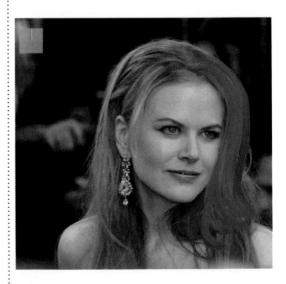

5 The Mixer Brush can be set to various modes between Dry and Wet. This is equivalent to adding more water to painting with watercolors: here, I've painted on the right side of Nicole Kidman's head with a Wet brush, which produces smeary strokes.

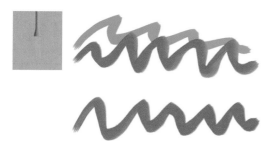

2 By far the most interesting aspect of the new brush engine is the Mixer Brush, a new tool nested beneath the Brush tool in the Tool panel. This shows a preview displaying the brush itself, which angles as we drag and rotate it (assuming you have a compatible graphics tablet).

3 The interesting part comes when we paint over an existing stroke. Here, I've changed the foreground color from green to orange: as I've painted from left to right, the brush picks up the green color and starts to paint with it.

4 When we now paint a new stroke with the brush – again from left to right – it paints with the green color still mixed in, which gradually disappears as the brush 'cleans' itself back to the original orange color.

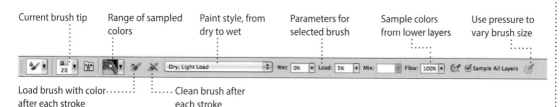

Current brush tip

Range of sampled colors

Paint style, from dry to wet

Parameters for selected brush

Sample colors from lower layers

Use pressure to vary brush size

Load brush with color after each stroke

Clean brush after each stroke

6 I've painted on the left side of the head here using a Dry brush, which reveals the individual strands much more clearly. There's a wide variation of brush types between wet and dry to choose from, with additional variants built in for each brush type.

7 We get interesting results when we use the Mixer Brush using a standard brush tip. Here, I've used the same sample I used on the Nicole Kidman image to produce this shaded pipe (top); sampling an area half brown and half black produces this strongly shaded tube (bottom).

Precise scale matching

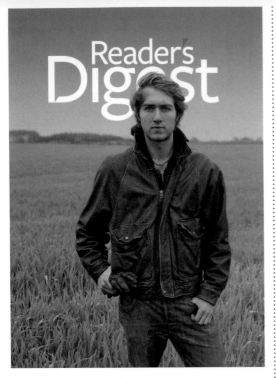

1 This is a screen shot of the cover, as laid out in Quark XPress by the designer. The image used here was a rough he'd put together to allow him to align the cover lines and the rest of the page furniture. As a screen shot, it was of course taken at 72 ppi.

2 When placed into the high res cover template, the mockup was clearly very much smaller. In order to position the image precisely against this logo, it would need enlarging to the right size.

ONE OF THE MOST basic Photoshop actions is scaling one image to match another. In cases where accuracy is required, we can't just rely on our eye to ensure a good result.

The image above, for the cover of *Reader's Digest*, needed some basic adjustment: the head had to be brought in front of the logo, a new sky inserted, and the field behind had to have graduated blur applied to knock it out of focus. First, though, all the elements had to be made the right size.

6 When the original photograph was brought in, it was again the wrong size for the cover. This time, the sizing was just as critical: it had to match all the carefully positioned cover lines.

7 A similar procedure here: first, I entered Free Transform mode, and then dragged the image (reduced to 50% opacity) so that the center of the right eye on the photograph matched the center of the eye on the mockup; I then dragged the center point marker so that it aligned with the two eyes.

3 A medium enlargement made the mockup large enough to work with. By changing its opacity to 50%, I could see through it to the template beneath. At this stage, the mockup is still in the middle of the Free Transform operation. The aim now was to get the logo in the mockup to match the size of the logo in the template.

4 To get the right size, I moved the mockup so that the top left corner of the letter D aligned precisely with the same corner on the letter D in the template. I then dragged the center point marker so it aligned with these superimposed corners.

5 With the center point pinned at the correct location, I was able to hold ⌥ *alt* and drag any of the four corner handles of the image to scale from the 'center' (still holding *Shift*, of course, to maintain the aspect ratio). This pinning of like points made it easy to scale the mockup so its logo matched the exact size of the logo in the template.

HOT TIP

When scaling from the center, you can drag any of the corner handles – it doesn't make any difference to the end result. This means you can choose a nearby handle so you don't have to zoom out of the image too far – the handle will be close to where you're working. Alternatively, choose a further handle for more precise control.

8 With the center point marker in place, I could now scale from the center (holding ⌥ *Shift* *alt* *Shift* as before) until the photograph was an approximate match for the mockup.

9 For greater accuracy, I took one more step. I changed the layer mode of the photograph to Difference, and the opacity to 100%. We can see some white fringing here, around the mouth and at the edge of the hair: this shows that the two images are not the same size.

10 When the photograph and the mockup are precisely aligned, there's no fringing and the figure appears as almost a solid black. That's because, in Difference mode, identical pixels cancel each other out to produce black. (The screen shots have been exaggerated here to make them clearer in print.)

SHORTCUTS

Background Eraser tricks

THE BACKGROUND ERASER IS A fantastic tool for removing dull backdrops from photographs. In Chapter 8 we looked at its use for removing the white background behind fuzzy hair; here, we'll show how it can be used effectively to take out a dull sky and replace it with a more interesting one.

Although it's undeniably powerful, the Background Eraser isn't perfect. Here are a few tips to help you to get the best out of it.

You'll find the Background Eraser hidden beneath the Eraser tool in the Toolbar – or press **Shift E** repeatedly to access it.

1 There are two steps you should always take before beginning to use the Background Eraser. First, double click the Background layer in the Layers panel to turn it into a regular layer; then open the History panel, and click next to the Make Layer step to pin the History at that point.

4 When we place a new background in the composition, we can see a couple of mistakes. The tool has erased the clock face, for instance, and the building lower right is partly transparent. Switch to the History Brush (**Y**) and, with a hard-edged brush, paint over these areas: the saved History data will be used to paint the elements back in.

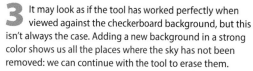

2 We can now go ahead and use the tool to erase all the sky. I recommend always setting the tool to Sample Once, so we don't inadvertently sample foreground colors; and set the mode to Discontiguous, so it will look (and erase) inside bounded areas such as the tree branches.

3 It may look as if the tool has worked perfectly when viewed against the checkerboard background, but this isn't always the case. Adding a new background in a strong color shows us all the places where the sky has not been removed: we can continue with the tool to erase them.

5 On close inspection, we can see some color fringing in the original photograph (left). This is caused by the high contrast between the dark branches and the bright sky. Lock the transparency of the original layer, and use a soft brush set to Color mode to paint the fringes in a color sampled from elsewhere in the branches.

6 As a final step, we can easily remove any stray pixels of the original sky that may remain. ⌘ ctrl click on the layer's thumbnail to load it as a selection, then use ⌘ Shift I ctrl Shift I to inverse the selection. Pressing Backspace now will remove those single-pixel aberrations (but make sure it doesn't take out twigs as well).

HOT TIP

Setting the History position right at the beginning is the key to working effectively with the Background Eraser. But it's important to do this after the background has been turned into a regular layer: otherwise, when you try to use the History brush later, you'll be told that the corresponding layer no longer exists in the document.

SHORTCUTS
MAC WIN BOTH

Making the most of Bridge

Store frequently used folders in the Favorites tab at the top so they can be accessed easily. Just drag a folder into this section to store it here; use contextual menus to remove it.

Step back and forth between recently used folders here, or click on the pop-up menu to view them all.

ADOBE BRIDGE IS THE FILE browser that allows us to preview, open and manipulate image files. It's much more than a simple open dialog: Bridge allows you to sort, classify and annotate your images with ease and precision.

Batch processing of images is also much easier with Bridge. Any Photoshop Action can be applied to a range of selected images – so if you find that all your digital camera pictures need the same adjustment and sharpening, it's easy to achieve this with a single click.

Adobe Bridge can save a lot of time when you've got a large number of images to sort through, and it's worth taking the trouble to learn what it can do.

A relatively new feature is the ability to enlarge a thumbnail to fill the screen by pressing the spacebar. We can move through the images one at a time in this way, using the cursor keys.

Bridge also includes a Browse mode, allowing us to look over a batch of images quickly and select those we want to keep and reject.

Photoshop also includes Mini Bridge, a cut-down version of Bridge that works as a panel within the main application.

Saving your images into subfolders makes them easier to browse: you can view your entire hard disk in this way, and even browse images on your digital camera card.

The Keyword feature in Bridge is a useful way to categorize images across several folders. It may take a while to specify the keywords, but it will save plenty of time later.

Click here to create a new folder. You can drag images between folders in Bridge to help you organize your files.

Rotate images taken with digital cameras using these buttons. Only the thumbnail will be rotated at first: but when the image is opened in Photoshop, it will be rotated as well.

The Compact Mode button minimizes the window to display just a small selection of thumbnails. It's really useful to be able to shrink Bridge down like this so you can drag items into other applications, and then push it back to full screen at other times.

Interiors

ADOBE MEDIA GALLERY 2.0 METADATA SC ESSENTIALS

Sort Manually

PREVIEW

You can filter images by star rating, or by label. This is a useful way of creating on-the-fly selections for a particular job: images can be assigned temporary labels, which are removed later.

CIMG0173.JPG CIMG0174.JPG

IMG_1055.JPG IMG_1058.JPG

IMG_1064.JPG IMG_1065.JPG

The Preview window shows the image as large as the window. You can also press the spacebar (CS4 and above) to enlarge an image to full screen.

Metadata can show you when an image was taken, what camera and settings were used, and so on. You can also write your own information into the custom fields.

IMG_1059.JPG

METADATA

f/5.0	1/40	2048 x 3072	
	---	2.65 MB	180 ppi
AWB	ISO 800	sRGB	RGB

File Properties

Filename	IMG_1059.JPG
Document Type	JPEG file
Date Created	06/03/2005, 11:33:10
Date File Modified	06/03/2005, 11:33:10
File Size	2.65 MB
Dimensions	2048 x 3072

IMG_1068.JPG IMG_1080.jpg

As well as the standard Thumbnail view, there are other ways of looking at your images. Filmstrip view shows thumbnails of all the images either below or next to each other, with the current one previewed much bigger: press the cursor keys to move around them.

Multiple images can be grouped into 'stacks' – handy if you have several different shots of the same subject.

Drag the slider to change the size of the thumbnails. Enlarging a set of thumbnails together can be much quicker than viewing them one at a time in the Preview pane.

Photoshop Actions

THE ACTIONS PANEL in Photoshop is a feature that most users tend to ignore, and when you look at the Actions shipped with the program it's hardly surprising. They allow you to perform such sequences as generating plastic-looking wood frames, creating dodgy reflections of type on water and filling the screen with molten lead. Which are hardly the sort of everyday tasks that make you want to explore the system further.

But Actions are capable of far more than building questionable special effects. At their basic level, Actions can be used simply to create keyboard shortcuts for tasks that would otherwise have you reaching for the menu bar.

In the examples here, we'll first look at how to create an Action from scratch. The effect of this one will be to delete a 1 pixel border around a selection – my preferred defringing method.

Next, we'll examine the steps that make up a more complex Action, explaining the purpose and function of each stage in the process.

1 First, make a selection in your Photoshop document. These keys have been selected using a previously saved clipping path.

2 Select New Action from the pop-up menu at the top right of the Actions panel. You need to choose a set in which to create the Action. Give the Action a name, and choose a keyboard shortcut; then hit the Record button.

3 The first step in this Action is to contract the selection by a single pixel. Choose Select>Modify>Contract and enter a value of 1 in the dialog that appears; press OK to apply the contraction.

4 Two more steps: inverse the selection using ⌘ *Shift* *I* ctrl *Shift* *I*, and then delete using the Backspace key.

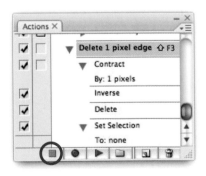

5 Finally, press the Stop button on the Actions panel (the square at far left on the bottom) and the Action will finish recording. Every step is now shown in the panel, and the Action can be played back on any image.

Anatomy of a complex Action

This is an Action I use several times a day, and it allows me to change the direction in which my subjects are looking. After I make a selection of a figure's eye region, the Action adds shading and color to a new layer, then opens a file named 'iris' and pastes it into the new eyeball, setting the mode to Multiply and using the eyeball as a clipping mask.

This is the name of the Action, together with the key command which activates it

The Action assumes I've already made a selection for the eyes; it makes a new layer called 'eyeball'

The foreground/background colors are set to default black and white

The foreground/background colors are swapped over

The selection is filled with white (foreground color)

A 'stop point' is placed here: this brings up a dialog asking for the feather amount. It depends on the size of the eyes in the image; the default is 8 pixels

The selection is then inversed

The colors are set to default black and white

The feathered outside of the eyeball is now filled with black, with transparency preserved so the effect remains within the eyeball area

The eyeball is deselected

A custom Color Balance setting is applied to add color to the shaded edges of the eyeball

The Action now opens a file called 'iris', located on my hard disk

The whole of the 'iris' file is selected and copied to the clipboard, and the file is closed

The 'eyeball' layer is loaded as a selection

A new layer is made to take the copied iris, with its mode set to Multiply so that the iris will take on the shading of the underlying layer

The iris, previously copied to the clipboard, is now pasted into the new layer

Finally, the iris uses the eye layer as a clipping mask

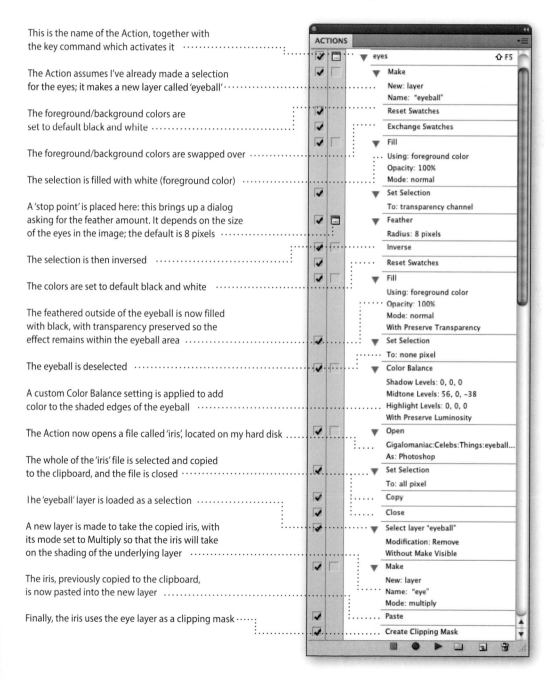

HOT TIP

After you've recorded your Action, you can inspect and edit each step of it through the Actions panel. You can even record extra steps or delete those you don't want.

If you have a number of images which need similar treatment, such as being resized to 600 pixels wide, then record an Action as you make the changes to the first image. You can then apply the Action to all the images in a folder directly from Bridge.

Some people recommend starting each Action recording with a Snapshot, which will store the state of the document at that time: handy, just in case it all goes horribly wrong!

SHORTCUTS
MAC WIN BOTH

Working with Camera Raw

1 When we double-click a Camera Raw (.crw) image in Bridge, it opens into Photoshop's Camera Raw import dialog. All the adjustments appear in this window.

4 If we move to the Lens Corrections pane, we can tell Photoshop what kind of lens we're using – and basic distortion will be corrected. Checking the Remove Chromatic Aberration box removes all color fringing automatically.

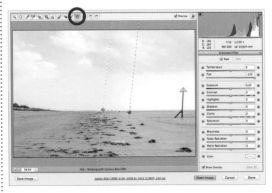

7 The Graduated filter allows us to position a set of effects which fade smoothly into view, like adding a gradient to an Adjustment Layer's mask. Set any value at first – here I've added a lot of Tint – so you can see the difference as you drag.

CAMERA RAW IS A FILE TYPE RECORDED ON digital SLR cameras, and one or two higher-end compacts. Rather than compressing the image into a JPEG file, it retains the full bit depth. Camera Raw files can be modified to a huge degree without loss of quality.

Photoshop has enhanced tools for dealing with Raw images, and they're all editable later: we can turn the top image into the lower one without irrevocably changing the file. The adjustments are different to what we're used to, though.

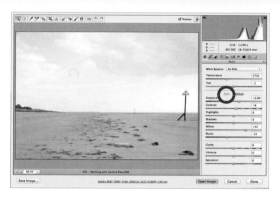

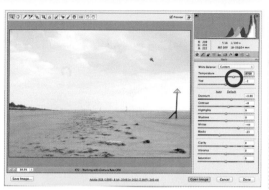

2 Clicking the Auto button is often a good first step when using Raw. It helps to a large degree, but it's nowhere near perfect yet.

3 We can warm up the scene by dragging the Temperature slider. Dragging it to the right increases the overall warmth of the image.

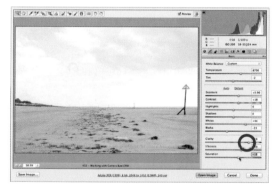

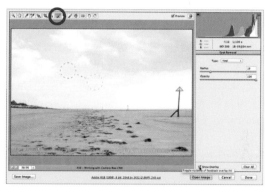

5 Back in the main adjustment pane, we can enhance the image by raising the Clarity slider, as well as boosting the Vibrance and Saturation settings. It's worth experimenting here, as nothing you do is irrevocable.

6 The Camera Raw dialog includes a Spot Removal tool. It always works on a circular area: drag to set the size of the circle, then move the 'copied from' region for a perfect blend. Here, we're adding a spot removal in the sky.

HOT TIP

Camera Raw files are typically around five times the size of their equivalent JPEG counterparts. That's because they hold 12 bits (or more) of information per RGB channel, as opposed to the 8-bit mode for JPEG files. This means we can adjust the tonal range to a much higher degree. They're definitely worth investing in an additional hard drive for.

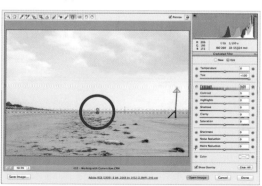

8 We want to apply a different treatment to the sky, so position the cursor just above the horizon and drag straight down – holding **Shift** will help to make it vertical, producing a gradient that runs along the horizon line.

9 With the gradient in place, we're now able to fix the sky. We can pull the Temperature setting back to where we started, and boost the Contrast and Clarity as well until the sky stands out strongly against the beach.

SHORTCUTS
MAC WIN BOTH

431

Portable shadows

W E OFTEN WORK WITH CUTOUT objects. But sometimes, an object will have been photographed with a particularly fine shadow. And why should we go to the trouble of painting our own in, when we can work with the real thing?

Here, we'll look at a couple of techniques for extracting a shadow from its background. First we'll see the simplest method, which works well when we're creating montages in Photoshop.

But frequently, we need to prepare cutout objects for other applications – InDesign or Quark XPress, for instance – or to export as a PNG file with transparency for incorporation into a web design. In these cases, we need to treat the shadow in a rather different way. But there is still a straightforward solution that produces a shadow with true transparency.

1 The first step is to duplicate the layer, and then cut out the object from both the background and the shadow. This royalty-free image comes with a clipping path, so it's an easy job; otherwise, it's not hard to use the Magic Wand to select the white and so extract the umbrella from it.

You should now have two layers in your document: the cutout and the original. I've added a third layer, filled with color, so that we can see what's going on with greater clarity. I recommend you do the same.

4 Select All and Copy the original image, and make a new Channel in the Channels panel. Paste into here. Go back to the RGB composite, and load the channel as a selection (⌘ ⌥ 6 ctrl alt 6).

2 Double-click the original background's thumbnail to make it into a regular layer. When you change the mode from Normal to Multiply, it duly shades the background – and the cutout version above remains solid.

3 So far, so good. We can use the two layers chained together in our Photoshop documents to form a realistic shadow that travels with the umbrella on top.

But when we hide that green background layer, the white returns. Even though the shadow layer mode is set to Multiply, with no background it just shows up as white; the same would be the case when we export the file as a TIFF or PNG file with transparency, for use in other applications.

HOT TIP

In order for this technique to work, the background has to be truly white. In the case of photo library cutouts, you can assume this to be the case; if you're using images you've photographed yourself, you'll need to turn it white. To do this, use the white point eyedropper sampler in either the Levels or the Curves dialog – see page 108 for how to do this.

5 Because selections stored as channels use white as the selected color and black as the deselected color, you'll need to inverse the selection (⌘ *Shift* *I* ctrl *Shift* *I*) so that the black part of the image is selected.

Next, make a new layer beneath the cutout umbrella layer. Use **D** to set the foreground/background colors to black and white, and then ⌥ *Backspace* alt *Backspace* to fill the selection with black.

6 When we reveal the cutout umbrella again, this is the result: a truly transparent shadow that we can take anywhere. To make a flattened PNG or TIFF file, you can merge the umbrella with its shadow and the transparency of the shadow will be retained.

SHORTCUTS
MAC WIN BOTH

Take a fresh look

IT'S AN UNFORTUNATE FACT OF LIFE that we rarely notice our mistakes until it's too late. It's not until after a job has been sent back and forth between artist and client a dozen times, converted to CMYK, sent off to the printer and then reproduced a hundred thousand times on glossy paper that we notice that one of our characters has three ears. Or that a stray leg is still visible where someone has been removed. Or that, as in my case, that the photograph of Humphrey Bogart on the cover of *How to Cheat in Photoshop CS3* has no left elbow. For a book about Photoshop, especially, this is an error that's as unforgivable as it is laughable.

So why does it happen? Why can't we spot the mistakes on screen, when they're so glaringly obvious the moment the image appears on paper?

The main reason is that we get used to the image we're working on. When we've built it up step by step, from dozens or even hundreds of pieces, we're too close to see the full picture. Even when we're not in danger of making mistakes, it can be hard to tell if an image is working properly: if the composition flows as it should, if it tells the story clearly and unambiguously.

There are several simple solutions to the problem. The simplest of all is to go out of the room, walk around in the fresh air or make a cup of coffee, and then come back in. The view of your monitor from the door will be significantly different to what you see when you're 18 inches away from it.

Traditionally, artists would turn their canvas upside-down to get a different view of it. It's a good way to check the composition: it's often easier to see the balance between light and shade, foreground and background, when you're looking at it purely in terms of shape and not reading each element. In Photoshop, we can turn an image upside down just by flipping it vertically. But we can also flip our image horizontally, in which case it still makes sense as an image – the characters, faces and trees are still the right way up, the sky is still at the top – but it can look completely different. Flipping the image enables us to see it with fresh eyes.

One of the best techniques is to leave the image overnight and come back to it in the morning, if your deadline allows. When I designed the cover of this edition of *How to Cheat in Photoshop CS6*, I took several days over it as it went through several different versions and approaches. I knew I wanted a large face, treated in some way, but it took a while to find the exact treatment that worked. The gap in the bottom left called for a hand, which was originally holding a gold coin; then the gold changed to glass, echoing the previous edition; and then it became a diamond, with an attention-grabbing light flare. The ability to look at your image freshly, and to be ruthless enough to discard anything that doesn't work, is essential.

I've checked the cover thoroughly, and so far I haven't found any mistakes. If you spot any, please be gentle when you point them out.

15

Print and the internet

Throughout this book we've been looking at how to get the best out of Photoshop, how to improve your workflow and how to make pictures that look beautiful.

But creating images that look stunning on your computer isn't enough. At some point, you need to break them out of the confines of your monitor and share them with the world – whether that's through the medium of print, or on the internet.

And that's where many people come unstuck. What is CMYK all about? How do you make files smaller without making the images smaller? And how on earth do people make those animations from Photoshop files? It's all a lot easier than you might think

Image size and resolution

IMAGE SIZE AND RESOLUTION HAVE long confused even the most Photoshop-savvy of digital artists. There's no mystery: different media have different requirements.

The 'resolution' of a photograph refers to the fineness of the image: in other words, the number of dots used to make it. Image resolution for printing purposes is talked about in 'dots per inch', shortened to dpi. One dot equates to one pixel – that is, one square of unique color that combines with the squares around it to make up the digital image. When working on a computer, this is usually referred to as 'pixels per inch' (ppi).

For images printed on paper, such as books, magazines and newspapers, the number of dots per inch required correlates directly with the quality of the paper. The better the paper, the less the ink spreads as the two come into contact, and so the finer the detail that can be reproduced.

Computer screens, traditionally, operate at 72dpi, although these days higher resolution screens are used for graphics work. There are no printing issues here: so anything destined for on-screen delivery, such as the internet, is created at 72dpi.

When you view an image in Photoshop at 'actual size', or 100%, it means that one pixel in the image exactly matches one physical pixel on your monitor. To see it at the size it will be printed, choose Print Size from the View menu. This reduces it on screen, and assumes that your monitor is set to display at 72dpi.

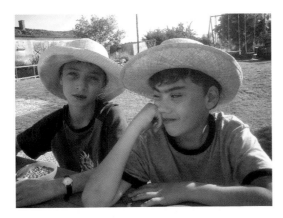

4 Here's a photograph taken with a 3.2 megapixel camera. The size of the image captured by this camera is 2048 x 1536 pixels: multiply those numbers together and you get 3,145,728, which is approximately 3.2 million pixels in total. It's from multiplying these dimensions together that digital cameras get their size rating.

5 If that image were printed in a newspaper at 200 dots per inch, it could be used up to a size of roughly 10 x 8 inches. That's easily big enough for the main front-page photograph of most newspapers. Because of the lower resolution requirements, coupled with their speed, many news photographers now use digital cameras.

300 pixels

<--- 300 pixels --->

200 pixels

<--- 200 pixels --->

72 pixels

<--- 72 pixels --->

1 This image has been scanned at 300dpi (dots per inch). The picture is exactly one inch square, which means it's 300 pixels wide by 300 pixels high. That makes a total of 90,000 individual pixels in this single square inch of paper.

A picture with this density of pixels is suitable for printing in high-quality magazines, which use 300dpi as their standard resolution. The higher the quality of paper, the finer the detail of photography that can be reproduced on it.

2 This picture has been scanned at 200dpi. Although 200 is two-thirds of 300, the image measures 200 pixels in each direction: this makes 40,000 pixels in all, which is less than half the 300dpi version.

This picture is suitable for printing in newspapers, which use coarse paper that doesn't take the ink as well and therefore require a larger, coarser dot screen. This resolution of image could be printed in glossy magazines, but the result would be too soft for demanding art directors.

3 This picture has been scanned at 72dpi. The picture is also one inch square. At 72 pixels wide by 72 pixels high, that makes a total of only 5184 pixels in this square inch of image.

This picture is suitable for publishing on the internet, since 72dpi is the standard 'screen' resolution. It's far too low for glossy magazines, and even newspapers: you can clearly see the squares that make up the image.

HOT TIP

All digital cameras will give you the option of capturing images at a lower resolution, so you can fit more images on the card. But while you can always crop large images, or make them smaller in Photoshop, you can't enlarge small images without losing quality. Always capture at the highest quality your camera will support: memory cards are cheaper than they've ever been, and there's no excuse for economizing on data you'll wish you'd kept later

6 If that same image were used in a glossy magazine, it could be used up to just under half a page in size before the art director started to complain about the resolution. That's assuming, of course, that the camera lens was up to the job for high-end reproduction – size isn't everything when it comes to glossy photography.

7 If used on a website, the same image could now be used at a size of nearly four square feet – although an image this size would take a while to download. It's a matter of happy coincidence that the shortcomings of computer screens match the download and storage requirements of the internet!

SHORTCUTS
MAC WIN BOTH

Working for print

PREPARING IMAGES FOR PRINT means working at a high resolution, as we've seen earlier in this chapter. But it also entails an understanding of the difference between RGB and CMYK color models.

For most of the time, you'll work in RGB even if your final output is destined for CMYK. It's quicker in operation – the files are three-quarters the size, for one thing, since they have one fewer channel – the dialogs are frequently more intuitive, and many of Photoshop's filters simply don't work in CMYK.

But the RGB color range, known as its 'gamut', is far wider than that of CMYK. Which means there's a huge range of colors you can create on screen which simply won't transfer onto paper.

Even if you're only printing work out on your own inkjet printer, you need to understand why some colors print fine, while others don't.

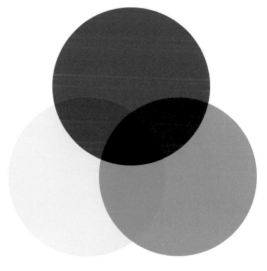

RGB Monitors display colors using Red, Green and Blue light. These are known as 'additive' colors, because the more light you add, the brighter the result: it's like shining torches on a sheet of paper in a dark room. You start with black, and each torch you turn on increases the overall light level.

Red and green added together make yellow; red and blue make magenta; blue and green make cyan. When all the colors are added together, the result is white.

You can see the effect of additive color clearly by creating red, green and blue shapes, and setting their layer mode to Screen, set against a black background. The file RGB.psd in the Chapter 15 folder on the DVD includes these three disks of color: try moving them around, and changing their opacity, to see how all the intermediate colors are made.

CMYK Printing inks create color in precisely the opposite way to monitors. Cyan, Magenta and Yellow inks (with a little Black for the shadows) are 'subtractive' colors: you start with a white sheet of paper, and the more ink you add, the darker the result.

Magenta and yellow added together make red; magenta and cyan make blue; yellow and cyan make green. When all the colors are added together, the result is black.

You can see the effect of subtractive color clearly by creating magenta, yellow and cyan shapes, and setting their layer mode to Multiply, set against a white background. The file CMYK.psd in the Chapter 15 folder on the DVD includes these three disks of color: as with the RGB file, try moving them around and changing their opacity, to see how all the intermediate colors are made.

If you are doing work for print that will be sent to a magazine, newspaper or other publication, then work in RGB – and send them your files in RGB. There's a good reason for this: creating effective CMYK files isn't simply a matter of choosing CMYK Color from the Mode menu.

Professional publications will go to great lengths to print test images, comparing them with the original files, before producing their own custom RGB to CMYK conversion. A lot depends on the type of paper used, the printing method – sheet-fed or web offset – as well as the specific printing machine used. If you convert the files to CMYK first, they won't be able to perform their custom conversion and the result will look muddy when printed.

When you do have to convert work to CMYK yourself, however, make sure you get as much advice as possible from your printer first.

A fan of floppy disks (remember them?) held in front of a colorful computer monitor. Rainbow gradients such as the one on the screen are easy to make, and they always look bright and colorful – on screen, at least.

It's when you try to get them off the screen that the problems start. The RGB version of this image looks quite different to the dull CMYK impression printed in this book. There's no way of showing the RGB original in print – that's the point of this exercise, after all – but you can compare the two by opening the file RGB Gamut.jpg, which you'll find in the Chapter 15 folder on the DVD.

One way of telling how your images will look when printed is to turn on Proof Colors mode (⌘ Y ctrl Y). This dulls colors that are out of gamut, giving a good impression of how their CMYK equivalents will look. Again, try this with the file RGB Gamut.jpg on the CD – you'll be astonished by the difference.

When working for CMYK, it's common practice to switch in and out of Proof Colors mode frequently, to check that the colors will work: any that look significantly different when proofed in this way will need to be changed.

Alternatively, you can turn on Gamut Warning mode using ⌘ Shift Y ctrl Shift Y. This turns all out-of-gamut colors to a flat gray, as shown here. It can be shocking to see how much of that bright color you'll lose!

Working for the web

THE IMAGE ABOVE IS 600 × 400 pixels, and has been saved at 72dpi for delivery on the internet. It includes a clipping path, which outlines the car – although we don't need this in the web version. Saved as a standard JPEG file directly from Photoshop, this results in a file size of 256K.

When you save JPEG images from Photoshop, you're trading quality against file size: the lower the quality, the smaller the file. If you're working for print, or simply to archive your own work, you should generally use a JPEG setting of at least 10, which gives the best compromise between size and quality. The maximum JPEG quality is 12.

Working for internet delivery, however, is a very different matter. Here, file size is all-important: you need to make the file as small as possible, even if that means trading off a little quality.

Photoshop's Save for Web feature, found under the File menu, discards all such unnecessary elements as paths to produce the smallest possible files. Choosing Save for Web opens the dialog shown here. At the top left are four tabs which allow you to view the original or the optimized image – that is, how

the image will look after it's compressed. You can also choose to view the two side by side or, as shown here, four views of the same file with different compression settings. This is perhaps the most useful view.

You have the option of saving as either a GIF (Graphic Interchange Format) or JPEG (Joint Photographers' Expert Group) file. In general, you should only use GIF files for animations, or if you need to include transparency in your image, as these tend to result in larger files at lower quality.

A rather confusing aspect is that the JPEG settings are shown here as being ranked out of 100, whereas they're shown in standard Photoshop Save dialogs as being ranked out of 12. But a quality setting of 60 in Save for Web will roughly equate to a setting of 6 in the standard Save dialog, so just divide by 10.

The advantage of this split view is that you can see exactly how each quality setting will affect your image. You can zoom and pan in any of the views, and they'll all be synchronized to match: choose to view the most detailed area of your image when saving in this way.

In the example shown here, we can bring the quality right down to 30 without too much degradation: and this drops the file size to 50K, which is far more suitable for our purpose.

Save for Web always saves a copy of the original image, rather than overwriting it. So you can always return to the original (assuming you've saved it normally) if your settings later prove to be insufficient.

This is the original image. Its size is shown as 703K – which means the size in 'real terms' while the file is open in Photoshop. This does not equate to the size when it's saved as a regular JPEG file.

This is the size the image would be if saved as a 256-color .gif file. At 195K this is far too big for web delivery: the GIF format isn't really suitable for such complex images.

The information shown here depends on whether you've selected GIF or JPEG as the file format: each has its own set of controls. The settings for GIF files are described more fully on the next page.

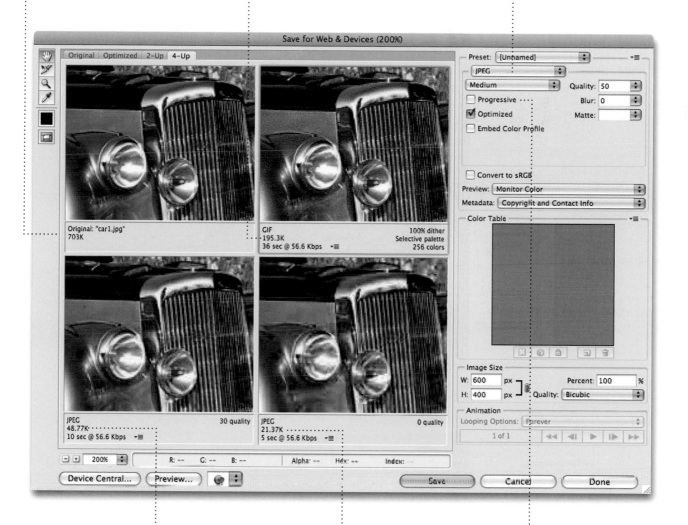

At a 'medium' quality JPEG file (which means a setting of 30) the image is still reasonably crisp and clear, but its size is reduced to under 50K. This is about the lowest we can reasonably get away with without the image looking ugly.

Here, just for the sake of comparison, the image has been reduced to its lowest quality setting of 0. This reduces the file size to just 21K. A lot of blockiness is now apparent, and the picture looks like it's been left out in the rain. You'd never normally use such a low quality setting.

A 'progressive' JPEG will load in stages, the resolution increasing with each pass. It's a good way of getting your images to appear more quickly, but can be annoying for the visitor.

Making it move

AS WELL AS BEING unsurpassed at creating still images, Photoshop can create animations – those animated GIFs that show short sequences of action, and which are often used for avatars.

Animations are made using the Timeline panel – choose it from the Window menu. Here, you can set timings for each frame, create new frames and play the animation.

You can move layers between frames, hide and show layers, but that's about it. You can't rotate or scale layers between frames: do so and the layer will be transformed through all the frames in your animation.

It may sound limiting, but take a look at the How to Cheat in Photoshop Reader Forum and you'll see just how masters of the art can create utterly convincing movement using just a small number of frames.

Here we'll look at the basics of creating an animation. Since you'll use File > Save for Web to save the animation as a GIF file, we'll also look at what settings you should use here.

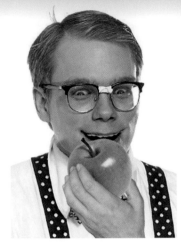

1 Preparation is the key to successful animation. This file contains seven layers: the man; his open mouth; his eyeball and iris; his hand separated into fingers and rear thumb; and the apple, with a Layer Mask that matches the shape of his upper lip, and is not linked to the layer.

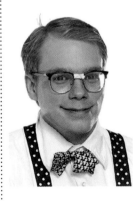

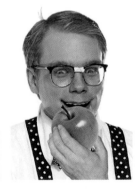

2 Start by moving the hand and apple layers down, off-screen – the open mouth layer can simply be hidden.

3 Click the New icon in the Timeline to make a new frame, then raise the hand and apple, and reveal the open mouth layer.

4 From the pop-up menu in the Timeline panel choose Tween, and add 3 frames. This places a smooth transition between the hand movement, and fades the mouth open gradually.

5 Add more frames, opening and closing the mouth and moving the hand and apple upwards. Because the mask on the apple layer isn't linked with the layer, the apple will disappear inside the man's mouth as it moves upwards.

6 Once the apple has gone into the mouth, hide its layer on a new frame and move the hand downwards. You can use as many frames as you like to get smooth motion: but the more frames there are, the larger the resulting file will be.

7 Here's the Timeline as it looks at the end. Frames 2, 3, and 4 are set to a timing of 0 seconds – as fast as possible, in other words – so the initial movement looks small. The first frame is set to 1 second, so there's a pause before it all runs again.

Save for Web: animated GIFs

Be sure to choose GIF rather than JPEG, or you won't see any animation (even if it's there in the original Photoshop document).

This menu selects the way colors are selected. Adaptive or Perceptual give good results, with fairly small file sizes.

This determines the 'dither' method, or how intermediate colors are displayed. Diffusion is generally the choice here, but try None for smaller files (and a more graphic appearance).

When you find a combination of settings that works well, save them as a preset.

The 'lossiness' is one factor that determines the file size. The higher this value, the worse your animation will look – but the smaller the file.

The fewer colors you use in your animation, the smaller the file size will be. Starting with 256 colors, you can reduce them in powers of 2 (64, 32 and so on).

When you use fewer colors, they need to be 'dithered', using noise patterns to give the impression of colors that aren't there. The higher the dither amount, the smaller the file.

The web snap is the degree to which the colors in your document match the 216 'web safe' colors.

445

Movie editing in Photoshop

I F YOU'D asked me a few years ago if we needed movie editing capabilities in Photoshop, I'd have said there was no point.

But today, all digital cameras can shoot video – and high end cameras can shoot very high quality video indeed. And now that video editing is supported in the standard edition of Photoshop, it makes sense to see what it can do.

1 Here's our starting position – a film of a glass on my kitchen table. After a couple of seconds my hand comes in and lifts the glass off the table and out of shot. It isn't Spielberg, but it's a useful starting point. The total length is just under 5 seconds.

2 The original movie was lit by daylight from the window, and the result is much too blue. We can add a Curves Adjustment Layer, just as we would with any other layer, and take the blue out. To focus the viewer's attention, make a new layer above the Video Group, and paint black around the edge with a soft brush.

5 The reason for creating the flame elements as Layer Effects is that these can be animated over time. Open the Timeline panel, if it isn't open already, and you'll see that each layer in your document appears here. Pop open the 'flame' layer controls, and click on the little watch next to the word Style. This means that changes will be recorded. Drag the time slider on a few frames, and change the amount of the Inner and Outer Glows; keep repeating this half a dozen times. The Layer Style settings will be recorded each time, indicated by a diamond icon in the timeline. The result is a flickering flame.

6 When the hand comes in, we need it to obscure the candle and flame. First, put them in a new group, add a Layer Mask, and check the watch icon in the Timeline for this layer. Paint a mask to match the shape of the thumb, then drag through the timeline, moving the mask every few frames so that it lines up with the position of the thumb.

7 When the glass is lifted off the table, the candle and flame have to move with it. Check the Position watch icon in the Timeline panel for the flame and the candle, as well as the candle's mask, and then move them all every few frames to line up with the glass position: each time, a new keyframe will be created, marking the position.

3 Let's make a candle to go inside the glass. We learned how to draw candles in earlier editions of this book – see The Romance of Candlelight in the Cut Pages folder on the DVD. To make it look like it's really inside the glass, add a Layer Mask to it and paint out around the highlights in the bottom of the glass.

4 Make a new layer, and draw the flame. Paint just a soft-edged orange blob for the main shape of the flame. Rather than painting the highlights, use Layer Effects to add an Inner Glow in pale yellow, and an Outer Glow in a similar orange to the flame color.

HOT TIP

Although we can move layers over time, we can't modify their shape, size or rotation. In step 6, it can be hard to make the mask line up with the thumb exactly. One solution is to apply a feather to the mask: when it has soft edges, it's much more forgiving.

How the Timeline Panel works

Click to jump to next/previous keyframe in layer

Click to make Photoshop record changes over time

Click to add a transition such as Fade

Yellow diamonds indicate keyframes for the selected layer – you can drag the keyframes markers to refine timing

Drag to scrub through whole movie

You can animate a layer's position, opacity and any attached Layer Styles – as well as the position and opacity of Layer Masks. You can add masks to movie layers as well as regular layers.

Although we haven't added text here, you can do so – and text distortions, in the form of warping, can be animated over time.

Unchecked watch icons mean any changes will affect the whole timeline

All the properties that can be animated are listed here

Drag to increase/ decrease the size of the Timeline view

Gray diamonds indicate keyframes on unselected layers

Click to add a new movie or soundtrack

WE'VE REACHED THE END OF THE BOOK, AND it's time to see how much you've learned. This self test section is a way to check that you've understood everything so far.

There are hints for each test, if you need them, in the Read Me file in the Test Yourself folder on the DVD – and that's where you'll find the source files, too. If you get stuck, visit the Reader Forum section of www.howtocheatinphotoshop.com where you'll find plenty of tips and advice.

For more tests, check out the weekly Friday Challenge section of the Reader Forum.

7: PACK UP SMOKING

One cigar – but I want a whole box full of them. All placed inside the box, please. File: **Cigars.psd**

8: SAND BLASTING

A bucket and spade at the seaside. Can you make them sit in the sand? File: **Seaside.psd**

9: ROOM WITH A VIEW

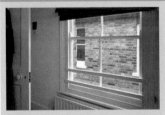

There's a great view through this window – or there would be, if that other house wasn't in the way. Can you fix it? File: **View.psd**

1: REBUILD THE WHEEL

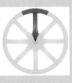

The ghosted image shows a complete wheel, but we've only got one whole spoke and section of rim. Reconstruct the entire wheel. File: **Wheel.psd**

2: CHANGING COLORS

Joe liked yellow when I got him the sweatshirt – but now he'd prefer blue. Can you give him the color he wants? File: **Sweatshirt.psd**

3: FIRE HAZARD

Your mission: to put the firework behind the trees, without any painting tools. File: **Fireworks.psd**

4: HANDIWORK

Can you make this mismatched pair of hands look like they both belong to the same body? File: **Hands.psd**

5: SPIN CYCLE

This old bicycle is in need of repair. Can you build a wheel to replace the missing one? File: **Bike.psd**

6: SNAKES & LADDERS

A snake. A couple of ladders. Weave the snake through the ladders so it looks realistic. File: **Snakes.psd**

10: STREET SCENE

Can you resize all the people in this scene so that they're all located in the same street? File: **Street.psd**

11: DOUBLING BOXES

I'd like this box to be twice as wide, with two doors. I'd also like it arranged so both keyholes are together in the center. File: **Box.psd**

12: BANK JOB

The bank nearest to us has expanded, and wants to take over the two shops next door. Extend it, while retaining its corporate identity. File: **Bank.psd**

13: SHADOW DUTY

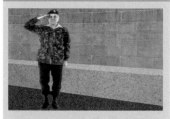

This soldier needs a shadow on the wall. But there's a bench in the way… File: **Shadows.psd**

14: FRUIT BOWL

A couple of apples in a bowl. Well, they're not in the bowl yet – can you put them there? File: **Fruitbowl.psd**

15: BY THE BOOK

All those books get very dusty. It would be much better if they were behind glass. File: **Bookshelves.psd**

16: AGE AND BEAUTY

This woman is in her mid 20s, I'd guess. How will she look in 30 years' time? Will she still have a silver nose ring? File: **Ageing.psd**

17: REFLECTIONS

It looks like someone forgot to put any glass in the mirror. Can you oblige? File: Mirror.psd

18: METAL MALLARD

The artist Jeff Koons pays a fortune to have kitsch objects coated in chrome. Can you turn this duck to metal? File: **Duck.psd**

19: STONE CARVING

Here's the text I'd like to be placed on this gravestone. Carved, not painted, of course! File: **Grave.psd**

20: BLOW THE LID OFF

I'm sure there was something of value in here. But I've lost the key. Dynamite, perhaps? File: **Safe.psd**

21: HAVE A MEDAL

I'VE COMPLETED
HOW TO
cheat IN Photoshop

If you've got to the end of this book, you really deserve a medal. A shiny silver one. File: **Medal.psd**

22: SHUT HIM UP

Why is this man yelling at me? I'd like him bound and gagged to keep him quiet. File: **Bound.psd**

23: OPEN DOOR POLICY

This nightclub has closed its doors. I'd like to see how it looks with them open. File: **Doors.psd**

SHORTCUTS
MAC WIN BOTH

Index

From behind

We always need people shot from behind to draw the viewer into our images. Here are a few from 123RF's extensive collection.

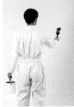

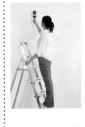
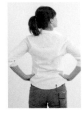
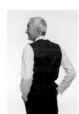

THERE ARE MANY IMAGE LIBRARIES OUT there, but 123RF has a refreshing approach. Its huge collection of over 11,000,000 images is available either on a subscription basis, or by buying credits. You need buy only the size of shot required for the job in hand, which really keeps costs down: and with images starting at around $1, this means the perfect picture element needn't be out of your price range.

123RF features images in just about every category you can imagine, but here I've concentrated on choosing those shots that are most elusive to the photomontage artist: people. They've generously allowed me to choose 100 high quality images to go on the DVD – I only have room to show half of them here – for you to use in your own projects (see the license terms in the 123RF folder). Best of all is the superb collection of exaggerated expressions, a real boon for everyone involved in photomontage.

Images from 123RF don't come with clipping paths, but the clean backgrounds make cutting the figures out much easier. Check out the whole collection for yourself today, at www.123RF.com.

Science

Where would we be without mad scientists? Here's a small selection suitable for compositing into your own montages.

Action poses

It's never easy to find shots of people in motion. 123RF has a great range of action shots – here's a small selection of what's available.

Everyday poses

A selection of action and everyday poses that are perfect for incorporating into your work. Just a tiny part of the 123RF catalog.

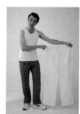

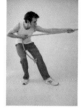

Expressions

One of the hardest tasks for the montage artist is finding a suitable expression for the main characters. 123RF has a glorious collection of models pulling faces, with several expressions in each shot. I'm delighted to be able to include a selection of these to really bring your montages to life.

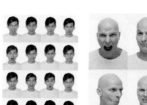

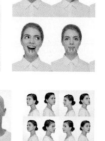
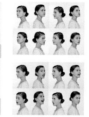
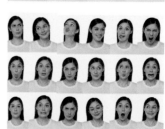

As you'll have realized by now, *How to Cheat in Photoshop CS6* deals with techniques, explaining how to achieve particular effects quickly and easily. Two more books take the process further.

Art & Design in Photoshop looks at how we design the book and magazine covers, posters, cartoons and packaging that we see in the world around us. Just like *How to Cheat in Photoshop*, it's divided into easily digestible double page spreads, each one taking the reader through a particular aspect of the design experience. In *Art & Design* you'll learn how to create covers and posters for thrillers, comedies and textbooks; examine retro poster design; and look at contemporary design styles, from *The Simpsons* to line action, urban graffiti and texture-heavy imagery – and it also explains how to simulate the work of some of the world's most famous artists, including Seurat, Turner, Francis Bacon, Matisse, Andy Warhol and more.

100% Photoshop takes the photography out of photomontage. Starting with a blank canvas, it shows how to create stunning artwork directly in Photoshop, without using any images, third party plug-ins or other applications. It shows how to draw a huge range of objects and scenes, from household items to fantasy figures, from outdoor scenes to a classical still life. Written in the same clear, step-by-step approach as *How to Cheat in Photoshop CS6*, it takes your Photoshop skills to a new level.

Available online and from all good bookstores.

ISBN: 978-0-240-81109-3

ISBN: 978-0-240-81425-4